D0164499

ALEXANDER CALDER

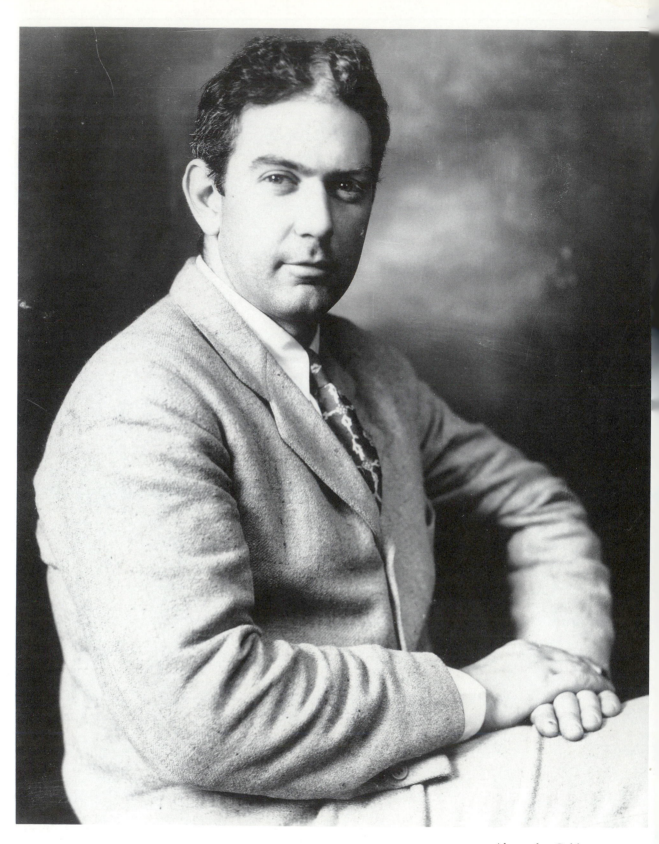

Alexander Calder, c. 1930.

ALEXANDER
CALDER

Joan M. Marter

*The right of the
University of Cambridge
to print and sell
all manner of books
was granted by
Henry VIII in 1534.
The University has printed
and published continuously
since 1584.*

CAMBRIDGE UNIVERSITY PRESS
Cambridge · New York · Port Chester · Melbourne · Sydney

O
NB
237
.C28
M34
1991

Published by the Press Syndicate of the University of Cambridge
The Pitt Building, Trumpington Street, Cambridge CB2 1RP
40 West 20th Street, New York, NY 10011, USA
10 Stamford Road, Oakleigh, Melbourne 3166, Australia

© Cambridge University Press 1991

First published 1991

Printed in the United States of America

Library of Congress Cataloging-in-Publication Data
Marter, Joan M.

Alexander Calder / Joan M. Marter.

 p. cm.

Includes bibliographical references and index.

ISBN 0–521–33038–6
1. Calder, Alexander, 1898–1976 – Criticism and interpretation.
2. Mobiles (Sculpture) – United States. I. Calder, Alexander,
1898–1976. II. Title.
NB237.C28M34 1991
730′.92–dc20 91–15692
 CIP

A catalog record for this book is available from the British Library.

ISBN 0–521–33038–6 hardback

Works by Alexander Calder, Jean Crotti, Pablo Gargallo, and Joan Miró, copyright
© 1991 ARS N.Y. / ADAGP. Works by Paul Klee and Jean Arp, copyright © 1991
ARS N.Y. / COSMOPRESS. Work by Henri Matisse, copyright © 1991
SUCCESSION H. MATISSE / ARS N.Y.

For further photographic and literary credits, please see page 302.

LONGWOOD COLLEGE LIBRARY
FARMVILLE, VIRGINIA 23901

Contents

Illustrations

Acknowledgments

FOR THIS STUDY OF ALEXANDER CALDER I am indebted to many people. First, I must thank the late Alexander Calder, whom I first met in 1972. In the following years I visited him several times in Roxbury, Connecticut, and in Saché, France. I am grateful for access to all of the works in his studios and residences, and for the assistance of the Calder family with my queries. The artist's sister, the late Margaret Calder Hayes, was particularly helpful on many occasions. Although conversations with Calder did not center around the concepts underlying his work, he did help me locate a number of early works for a catalogue raisonné of his sculpture (1926–40) prepared as a section of my doctoral dissertation, "Alexander Calder: The Formative Years" (University of Delaware, 1974). Since that time I have continued to study Calder's later works and have interviewed fellow artists, friends, curators, collectors, and writers. Among those to thank for their information and insights into Calder's personal history and his art are: the late José de Creeft, Stanley William Hayter, Alexander Brook, Jean Hélion, Clay Spohn, Betty Parsons, Theodore Roszak, and Ilya Bolotowsky. Appreciation is also extended to Pedro E. Guerrero, John Piper, Chaim Gross, Dorothy Dehner, Peter Grippe, and Ibram Lassaw. Special thanks to Helen Farr Sloan, Myfanwy Evans, Klaus Perls, Barnett Owen, and the late Pierre Matisse, Carl Zigrosser, Agnes Rindge Claflin, James Johnson Sweeney, Herbert Matter, and H. Harvard Arnason.

My research on Calder has been supported by a Chester Dale Fellowship, National Gallery of Art, and by grants from the National Endowment for the Arts and the Research Council, Rutgers University. I am grateful to William B. Walker, Patrick Coman, and the staff of the Thomas J. Watson Library, The Metropolitan Museum of Art, for providing me with space in the Jane Watson Irwin Center for my research and writing. Thanks to Garnett McCoy and the staff of the Archives of American Art. Colleagues Corinne Robins, William I. Homer, Judith Zilczer, Doreen Bolger, and Roberta Tarbell have provided useful information and encouragement. Lois Fern edited early

drafts of this manuscript with great care. I am indebted to David Sokol for his thorough reading of the book and his comments. My deepest gratitude goes to Beatrice Rehl, fine arts editor at Cambridge University Press, for her excellent advice and her unfailing efforts to bring the manuscript to publication. My family has been helpful and patient during the preparation of this book, for which I am very grateful. For many years, my husband, Walter H. Marter, provided much-needed technical assistance with word processing and photography. I dedicate this book to Professor Wayne Craven, University of Delaware, for his contributions to the study of American sculpture.

Introduction

ALEXANDER CALDER IS AMONG the most innovative creators of sculpture in the twentieth century. He was the first American artist of his generation to win an international reputation for his achievements, and his "mobiles" – a term borrowed from Marcel Duchamp – are to be found in major museums throughout the world. Large-scale abstract constructions he called "stabiles" have been installed in urban spaces in the United States and abroad, contributing to the major resurgence of public sculpture in recent decades. *La Grande Vitesse*, a stabile for Grand Rapids, Michigan, was the first monumental sculpture sponsored by the National Endowment for the Arts in postwar America and was crucial in launching the Works of Art in Public Places Program. Calder's exuberance and wit are also familiar to us, thanks to his lively autobiography and to various films of the artist at work. The stocky white-haired man in the red flannel shirt continues to be featured daily in a film at New York's Whitney Museum of American Art – *Calder's Circus* – that immortalizes the artist's manipulation of his acrobats, trapeze artists, and circus animals.

Although many picture books on Calder's work have appeared – most of them stressing the range of his achievements from sculpture and toys to cooking utensils and airplane designs – what is needed is a serious analysis of his major innovations, the mobile and the stabile. The ways in which Calder combined his engineering skills and personal ingenuity with his knowledge of the avant-garde deserve far closer consideration than they have received. My intention is to view Calder's invention of the mobile and stabile in the context of his involvement with European and American modernists, and his use of contemporary developments in science and technology. The mobiles, for example, resulted from his fascination with astronomical discoveries of the 1930s as well as his interest, shared with other modernists, in cosmic imagery. The importance of Calder's training in physics and engineering and his artistic heritage from a family of sculptors has never been fully assessed. The performing arts of the thirties and forties, especially the dance, led him

1

to consider differences between human and mechanical mobility. Moreover, Calder's origins in American art and his acceptance by the European avant-garde need additional consideration.

Calder spent time in France and England, where he created many works and became closely identified with abstract artists of the 1930s and 1940s. Championed by European artists and literati, he remained distinctly American, combining Yankee ingenuity, modernist principles, and machine aesthetics to create innovative constructions. Calder's art conveyed the approach to modern technology that Marcel Duchamp so much admired in Americans. And Calder's mobiles and stabiles were typically American in the bold affront to traditional concepts of academic sculpture given by an artist trained as an engineer. Calder was not only willing to join industrial technology with the aesthetics of modernism, but he considered scientific discoveries and engaged popular culture in creating his art.

Calder's link to French modernism has been considered in literature up to now, but his indebtedness to Bauhaus artists has not been discussed fully. Although it is sometimes acknowledged that his works bear a resemblance to the fantastic images of Paul Klee, his links to the ballets of Oskar Schlemmer and to other Bauhaus stage designers have never been established. Having witnessed revivals of Schlemmer's dance productions of the 1920s, I believe Calder was inspired by some of these ballets in the creation of his early mobiles. Connections with Bauhaus dances have not been explored because Calder's set designs and ballets have not been examined for links that specific documentation cannot supply.

Works of the 1930s are particularly emphasized in this study. It was in this decade that Calder successfully assimilated the aesthetics of Constructivism and abstract Surrealism to form his mature style. His involvement with stage designs deepened his interest in theatricality, an interest that first appeared in his miniature circus and marked the large-scale mobiles thirty years later.

Why is it that Calder has not been taken seriously? The artist himself discouraged penetrating study of his imagery and sources, but his contribution to kinetic sculpture, his brilliant synthesis of abstract Surrealism and Constructivist trends are worthy of serious consideration. Calder revitalized public art in his late years, and yet most books devoted to this artist rely on humorous anecdotes and biographical data. No art historical study of the creation of the mobile and stabile has appeared.

In the early 1970s I had the pleasure of visiting Alexander ("Sandy") Calder several times at his homes in Roxbury, Connecticut, and in Saché, France. Although our conversations were enjoyable, the artist's laconic manner offered little help in understanding his sculpture. Many years before my visit he had declared a moratorium on discussing his work, saying that to respond to such queries would leave no time for making art. My survey of

the Roxbury and Saché studios proved more enlightening. I had the sense that Leonardo da Vinci would have approved of what I found there. Like Leonardo, Calder was primarily interested in problem solving, in experimenting with materials, mechanical systems, and devices. The studio was like a laboratory, with experimental works piled into corners or suspended from hooks in the ceiling.

One day in Roxbury I found a dusty, mouse-eaten carton of sketches from the 1930s. In these preliminary studies for motorized mobiles, Calder had made careful measurements for each kinetic element and had determined the direction of motion. The precision of these drawings confirmed my suspicion that the playful movements of his constructions were initially as much a product of calculation as of intuition. In Calder's early years as an artist, it seemed he was systematic in his approach to "composing motions."[1] Later, having perfected his technical methods, he became ever more inventive with his moving sculpture. Research into Calder's engineering curriculum at the Stevens Institute of Technology further supported the conclusion that his study of kinetics and his knowledge of scientific instruments were essential to his creation of motorized and wind-driven mobiles.

Calder's early statements about his work suggest that initially he was willing to admit the seriousness of purpose underlying his mobiles, some of which demonstrate principles of physics. Although the memory of his hulking figure roaring like a lion in the film of his circus performance lingers, Calder's mobiles also convey the inventive spirit of their creator. The monumental stabiles are a different but equally significant contribution to the definition of public sculpture in recent decades. These colossal abstractions now can be found in outdoor plazas around the world, and will probably come to represent the finest achievements in public sculpture of the 1960s and 1970s.

Over the years, a number of retrospective exhibitions and publications have celebrated the breadth of Calder's creative genius. This monograph is admittedly more expansive on Calder's early years than on the later decades of his artistic activity. The 1920s through the 1930s is the most significant period in his development of a personal idiom. Although he continued to receive deserved acclaim in the following decades, his sculptures remained similar to those produced earlier. Only in the final years of his life did Calder expand his oeuvre significantly, with the creation of his monumental stabiles. For his mobiles and giant stabiles alone, Calder must be ranked as one of the most technically accomplished and innovative sculptors of the twentieth century.

Calder's bibliography has featured lively writing about the artist and his work, but most essays fall short on scholarly documentation. Few attempts have been made to consider Calder within the historical context of American and European modernism. James Johnson Sweeney, whom the artist befriended in the 1930s, wrote articles and arranged exhibitions of Calder's

work, culminating in a retrospective exhibition at The Museum of Modern Art in 1943. Sweeney's essay in the accompanying catalogue ranks among the most informative discussions of Calder's early years.[2] Many other catalogue essays appeared in subsequent decades. Among the most notable are those by Bernice Rose for The Museum of Modern Art in 1969,[3] Albert Elsen's insightful essay for Chicago's Museum of Contemporary Art in 1974,[4] and Maurice Besset's study for a Calder exhibition in Munich, 1975.[5]

Of the books on Calder, many have texts of fewer than sixty pages. For example, H. H. Arnason prepared a monographic study with a brief text in 1966, and in 1971 published statements by the artist and substantive reviews by critics.[6] Jean Lipman's *Calder's Universe*, the catalogue for a retrospective exhibition at the Whitney Museum of American Art, attempted to present the rich variety of his achievement but offered little scholarly apparatus other than a detailed chronology of the artist's career.[7] Reminiscences by friends and associates of Calder were included in Lipman's book, but she mixed previously published and unpublished statements while including no footnote citations for any of these remarks. Sources for this information, and for other factual data included in Lipman's text, are impossible to verify.

More recent additions to the literature on Calder have offered brief and rambling homages to the artist. Giovanni Carandente prepared a short text for a 1983 retrospective of Calder's art in Turin, and Daniel Marchesseau's *The Intimate World of Alexander Calder*, 1989, like many of the other publications, includes many factual errors as well as an inconsequential essay.[8]

This book, therefore, is the first full-scale study of Calder, offering a serious consideration of the artist's relationship to his peers among European and American modernists. Such an undertaking is fraught with difficulties. Although Calder is generally recognized as a leading American sculptor of the twentieth century, scholarly writing on this artist does not compare with the attention given to other American artists. There are many reasons for the dearth of scholarly literature on Calder, including the reluctance of the artist to talk about his work as well as his unwillingness to discuss how he formed his personal idiom.

In Calder's autobiography few specific works are mentioned, but the artist does provide information about his friendships with artists and his travels. Because the autobiography was transcribed from conversations with Calder, some data is inaccurate. But the autobiography has assumed more authority than it warrants because Calder wrote only a few other statements about his art. Ultimately, the record of Calder's production and the assessment of his formation of a personal style must be deduced from an examination of the works themselves as well as a consideration of the period of their creation. Over the years Calder had friendships with artists and associations with dealers, critics, and art historians. Calder's extended circle of art world personalities has provided some important information and insights to his work. Since 1971 I have been interviewing those who knew Calder and studying

the decades of Calder's artistic activity. Through my research on the artist and his contemporaries – including Theodore Roszak, José de Rivera, Ibram Lassaw, and David Smith – I have interpreted Calder's relationship and indebtedness to the painters, sculptors, and architects with whom he was associated.

1

Formative Years: Early Drawings and Paintings

ALEXANDER (SANDY) CALDER was a third-generation sculptor who grew up surrounded by artmaking, even serving as a model for both his parents. He was born in Philadelphia, Pennsylvania, on July 22 (or August 22) 1898,[1] the son of Alexander Stirling Calder (1870–1945), a successful sculptor, and Nanette Lederer (1866–1960), who was active as a painter all her life. Both his parents had studied at the Pennsylvania Academy of the Fine Arts, as had his grandfather, Alexander Milne Calder (1846–1923), a prominent sculptor in nineteenth-century America. Therefore he was the descendant of two well-known sculptors who created public monuments for American cities.

Born in Scotland, the boy's grandfather, Alexander Milne Calder, studied in London and Paris before coming in 1868 to Philadelphia, where he studied with Thomas Eakins at the Pennsylvania Academy of the Fine Arts. The elder Calder, good-natured and debonair, took special delight in his only grandson, Sandy Calder. Margaret Calder Hayes, Calder's sister, recalled: "Whenever we were living in the east, Grandfather often came to our house to play with Sandy and me and to discuss art in general and sculpture in particular with Father. Because the two men had very different attitudes toward their work, the discussions often became quite heated."[2]

Alexander Milne Calder is remembered for his sculptural program for Philadelphia's City Hall, particularly its statue of William Penn atop the clocktower.[3] In 1872, John McArthur, the project's architect, chose Calder to design decorative sculptures for both exterior and interior of the enormous structure. Calder prefigured the monumental scale of his grandson's work in his own full-length likeness of William Penn (see Fig. 159). At the time, this thirty-six-foot, twenty-seven-ton statue was the largest bronze ever cast in a native foundry and represented a technological advance in American sculpture. This City Hall commission, which included 250 statues, reliefs, and sculptural groups, was the largest of its kind for any building in the United States.[4] The abundant wildlife in Calder's decorative cycle included giant bronze eagles –

with a wingspread of fifteen feet – for each of four entrances to City Hall, as well as lion heads, elephants, bison, birds, foxes, and an otter with fish. The sculptor was also commissioned to produce numerous commemorative statues for outdoor sites, including *General George Meade*, an equestrian monument installed in Philadelphia's Fairmount Park in 1887.[5]

Alexander Stirling Calder was first exposed to sculpture as a child, when he posed for his father and assisted him in the studio. Because of the son's fascination with the theater, he might have been an actor, except for shyness. Instead, at age sixteen he entered the Pennsylvania Academy, where four years of study included some instruction with Thomas Eakins. Thomas Anshutz became his favorite instructor, and his young associates included Robert Henri, John Sloan, William Glackens, and Everett Shinn. In 1890, Calder went to Paris where he attended the Académie Julien for one year before enrolling at the Ecole des Beaux-Arts for study with Jean-Alexandre Falguière. In 1892 he returned to Philadelphia, just as his father was concluding the decorative sculptures for City Hall. While working as an assistant in the advanced anatomy classes at the Pennsylvania Academy, Stirling Calder met a talented painter, Nanette Lederer, whom he married in 1895. His first commissions included a portrait statue of Dr. Samuel Gross for the Army Medical Museum in Washington, D.C. In 1903, Calder began teaching at the School of Industrial Art in Philadelphia. In the next year, he gained national recognition for his decorative sculptures at the St. Louis Exposition, where he was awarded a silver medal.

In 1906 Stirling Calder's bout with tuberculosis resulted in a move to Arizona, and then to California. By 1910 the Calders had returned to New York, and the sculptor became an instructor at the National Academy of Design. In 1913, he moved his family back to the West Coast, this time as chief of sculpture for the last great Beaux-Arts sculptural program, the Panama-Pacific Exposition held in San Francisco in 1915. Plans were initially drawn up in New York, and represented an unprecedented collaboration among sculptors, architects, and landscape architects. Like his father's work at City Hall, this full-scale sculptural program was Calder's responsibility, and included monumental groups representing "The Nations of the East" and "The Nations of the West" flanking the Court of the Universe. Animals were included in many of the sculptural groups, including an elephant, camels, and horses among the splendors of the Asian nations. On the plaza immediately adjacent to the main entrance, Stirling Calder's *Fountain of Energy* (see Fig. 57) was installed. A tribute to the completion of the Panama Canal, this ambitious sculptural group was his finest achievement at the Exposition. Atop a globe (Earth), a muscular nude man who personified Energy stood astride a prancing horse while figures of Fame and Glory were balanced on his massive shoulders. This group undoubtedly impressed Sandy Calder who created his own "fountain of energy," *Mercury Fountain* (see Fig. 134), at the Paris exposition twenty-two years later.

In 1918, Stirling Calder was commissioned by the architects McKim, Mead and White to create a standing figure of George Washington for New York City's Washington Square Arch, intended as a memorial to New Yorkers who had died in World War I. Although the main figure is conventional academicism, the relief panel depicting personifications of Wisdom and Justice positioned behind Washington features stylizations that complement the overall architectural design.

Young Calder probably developed his sensitivity to the relationship between sculpture and its site from witnessing his father's interaction with architects. In the early 1920s, Stirling Calder collaborated with architect and friend Wilson Eyre to produce Philadelphia's *Swann Memorial Fountain* (see Fig. 158), which included allegorical figures of the city's three principal waterways. Part of an elaborate scheme for an expanded parkway and circle imitating the Champs-Elysées in Paris, the fountain of Logan Circle, dedicated in 1924, was designed for the point of convergence of five broad avenues and was intended as a focal point of the urban design.[6]

In 1932, Stirling Calder created a monument to Shakespeare in Philadelphia's Logan Circle, and was awarded the McClees prize by the Pennsylvania Academy. Among the greatest achievements of his later years was a heroic statue of Leif Eriksson, presented in 1932 to Iceland by the people of the United States. For this monument, installed near the Parliament Building in Reykjavik, Iceland, he received a gold medal from the Architectural League of New York. Although Stirling Calder continued to seek commissions well into the 1940s, in his later years his reputation declined in favor of his son, who at times sought commissions for him.[7] The elder Calder lived to see his son recognized in a major retrospective exhibition at New York's Museum of Modern Art in 1943. He died in New York City in 1945.

Calder's legacy from his father and grandfather was a long-standing familiarity with public sculpture commissions. Like them, he would collaborate closely with architects, solve many technical problems involved in the execution of commissions, and adapt his works to specific outdoor spaces. His father also communicated to him his own lifelong interest in the theater, a fascination Sandy Calder would come to share.

Calder's mother, Nanette Lederer, was born in Milwaukee in 1866 but spent most of her childhood in Philadelphia. She attended the Académie Julien in Paris during the early 1890s, then returned to the Pennsylvania Academy. Lederer and Stirling Calder were married when she was twenty-eight and Calder was twenty-five. Immediately they left for Paris and a studio on the Left Bank.[8] Their first child, Margaret, was born there in 1896; Sandy Calder was born two years later, after the family's return to Philadelphia. Despite frequent moves to different parts of the country for her husband's sculpture commissions, and his prolonged bout with consumption, Nanette Calder managed to continue her painting. Wherever the family lived, she hired models for her figure studies, and even paid her children a small al-

lowance for posing. Occasionally she received commissions for portraits. Her style, like that of the French Impressionists, featured a high-keyed palette and the shimmering effects of sunlight.

Peggy Calder remembered her mother as "warm-hearted, buoyant, and full of the joy of life."[9] She recalled that her parents had endless discussions about art, frequently disputing the relative merits of color and form. Nanette Calder was also called upon to critique her husband's works in progress. Her comments were highly valued but could result in a desultory reaction. By all accounts Alexander Stirling Calder was a serious, even morose, individual who was preoccupied with Cruel Nature, a theme that appeared in his uncompleted sculptural studies. Sandy Calder seems to have taken his optimistic outlook from his mother, as well as something else that could be greatly admired: her perseverance as an artist despite many obstacles.

In his autobiography, Calder recalled his father's studio in Philadelphia where, at the age of four, he posed for *Man Cub* and produced his first sculpture, a clay elephant.[10] When he was only nine, Calder cut and soldered together a small dog of sheet brass, which suggests he was already experimenting with materials different from the Plasticine and clay used by serious academicians like his father.[11] His predilection for animal imagery appeared even at this early age, and continued throughout his artistic career. In addition, Calder, perhaps unwittingly, conformed to the modernist advocacy of industrial metals and other new materials for sculpture.

Although Sandy Calder probably watched his father working, his written recollections of his childhood include no reference to parental instruction on sculptural methods. At age twelve, he posed for another portrait by Stirling Calder (Fig. 1). Originally modeled in clay, this image strikingly conveys the lively disposition of the youth – who would remain playful throughout his life. But young Calder was not receptive to the clay and Plasticine models produced by his father but was increasingly fascinated by mechanical devices. The studio equipment of the academic sculptor attracted the attention of the young boy. Enlarging devices, armatures, wire, and tools would have been available for his experimentation, and indeed inspired some of his first constructions.

Calder's innate talent for working with mechanical apparatus and materials was encouraged by both his parents as well as by his father's brother, Ronald Calder, the mechanically inclined member of the family. When Calder was nine years old, his uncle Ron helped him construct a special coaster wagon.[12] After this experience the youngster was eager to set up his own workshop.

> At that time on Euclid Avenue in Pasadena, I got my first tools, and was given the cellar with its windows as a workshop. Mother and Father were all for my effort to build things myself – they approved of the homemade. I used to make all sorts of things, little seats or a tonneau for my coaster wagon.[13]

10

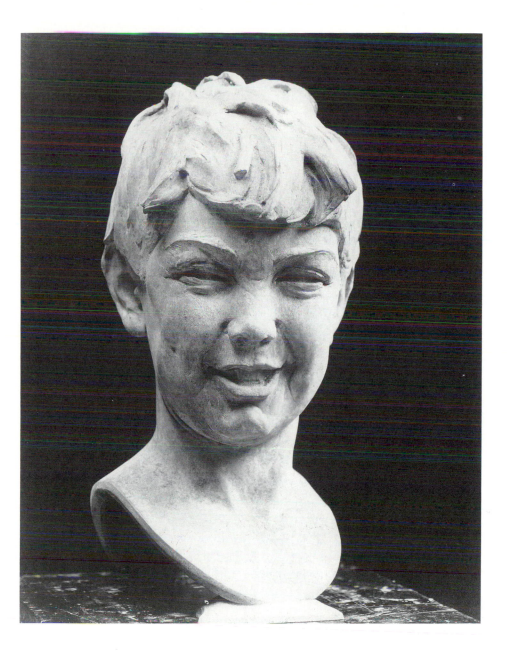

FIGURE 1. Alexander Stirling Calder, *Laughing Boy*, 1910 (Sandy Calder at twelve). Photo: Peter A. Juley & Son Collection, National Museum of American Art, Smithsonian Institution, Washington, D.C.

Although they moved often, the Calder family set up workshops for their son in each new house, and the boy continued his experiments with wire, sheet metal, and wood in successive cellar–workshops.

In Pasadena (c. 1908–9) young Calder met a neighbor, Arthur Jerome Eddy, a Chicago lawyer and patron of modern artists.[14] Eddy, who was in his fifties at the time, befriended the youth, and eventually gave him a bicycle to encourage physical fitness. Through Eddy, Calder learned of the "modern Paris group," as he called them,[15] and as a result he realized that his father was working in a conservative style. Although Eddy commissioned Nanette Calder to do a portrait of his son,[16] Calder recalled that his parents could not

11

understand their neighbor's lack of interest in Stirling Calder's sculpture, and noted: "It is funny too that father had books on Picasso and Matisse, but that he never seemed to be influenced by either."[17]

Despite Stirling Calder's association with Beaux-Arts commissions, he had a continuing friendship with Robert Henri, Everett Shinn, and John Sloan, artists who were among "The Eight," a group of realist American painters who exhibited together in 1908. During the 1890s the elder Calder regularly had attended artists' meetings in Henri's Philadelphia studio, informal discussions that also included Sloan, Shinn, William Glackens, and sometimes George Luks.[18]

Stirling Calder remained friendly with a number of these artists, later identified as the "Ashcan School," but only one was mentioned in Sandy Calder's autobiography as having visited his family: Everett Shinn. Calder remembered several occasions when Shinn came to their home in 1910, when they lived in Croton, New York. The painter, who was thirty-four at the time, helped Calder rig up a gravity system for his mechanical trains.[19] Shinn's own artistic career had remarkable similarities to the direction young Calder would take within five years of this meeting in Croton. From boyhood, Shinn had been fascinated with the design and building of engines, and at age fifteen he attended Spring Garden Institute in Philadelphia, were he worked successfully on rotary engines.[20] But after completing his technical training, he found little satisfaction as a draftsman for a lighting factory, and soon he was studying art at the Pennsylvania Academy of the Fine Arts. While there, Shinn also worked as a staff artist on a newspaper, predicting another aspect of Sandy Calder's own student years.

Judging from Calder's fascination with a letter he received from Shinn that featured an envelope illustrated with cowboys, the artist had made a deep impression on the youth.[21] Was Calder also familiar with Shinn's paintings? Calder made no reference to this, but Margaret Calder Hayes recalled that charcoal drawings of nudes by Everett Shinn and Robert Henri hung in the living room of their Croton home.[22] Her family memoir also mentions occasional visits from John and Dolly Sloan, and political discussions that went on for hours.[23] Young Calder's admiration for Shinn, and his father's long-standing friendship with Henri, Sloan, and Shinn, probably had some effect on his early paintings at the Art Students League, most of which were realistic scenes of New York. All three artists exhibited with the original Eight in 1908 and were known for frank depictions of urban life.

While Calder was a student at Lowell High School in San Francisco, he often visited his father's studio on the grounds of the Panama-Pacific Exposition of 1915. Sandy recalled his visit to the studio in a large iron workshop.

> [I] was very much interested in the pointing machine for enlarging small sculpture. This consisted of two parallel needles, one longer than the other, according to the enlargement. It

worked with a parallelogram. The small sculpture and the framework for the large sculpture were placed on two turntables which turned together through sprockets and a bicycle chain.... I'd be particularly fascinated by the mechanics, the rotating motions and the parallel needles of the process.[24]

Calder's attraction to this pointing device would actually lead to a motorized construction of 1933 entitled *Pantograph*, but this recollection of his youth also indicates that in 1915 he was more interested in tinkering with machines than in claiming his position as the third generation of Calder sculptors in America.

In his autobiography, Calder offered no comment on one of the other sensations of the Panama-Pacific Exposition – the first exhibition of the Italian Futurists in America. Two plaster sculptures by Umberto Boccioni were installed in a large room filled with the dynamic abstract paintings of Boccioni, Giacomo Balla, Luigi Russolo, and Gino Severini.[25] In her family memoirs, Margaret Calder Hayes recalled that she and Sandy overcame their aversion to art exhibitions to "romp through" the Palace of Fine Arts.[26] According to guidebooks at the exposition, the Futurist paintings and sculpture were in an annex to the Palace of Fine Arts,[27] and it is unlikely that young Calder would have missed seeing them. During the 1930s, he would cite the Futurists for their early experimentations with motion, and the painting, sculpture, and theatrical designs of the Futurists had a major impact on his art.

Because of his fascination with construction and industrial materials Calder decided on a career in mechanical engineering. His parents were pleased; they had discouraged their children from becoming artists because it was a life filled with hardships and economic uncertainty.[28] In 1915, Calder enrolled at the Stevens Institute of Technology in Hoboken, New Jersey, where he obtained a bachelor's degree in engineering. His training in physics and kinetics served him well in his later experimentation with motorized devices and with wind-driven mobiles made from materials of varying weights and densities. In the few written statements Calder made about his early mobiles, he ascribed some of his concepts of motion to Marcel Duchamp, the Futurists, and Fernand Léger's film *Ballet Mécanique*, but he used scientific terminology to explain his method of constructing kinetic devices. The technical precision and equilibrium found in Calder's motorized and wind-driven mobiles are partially a result of the engineering curriculum at Stevens.

After his graduation in 1919, Calder tried many different jobs, including working as a draftsman for New York Edison Company, as a salesman for International Harvester, and as an assistant to a hydraulics engineer. None of these jobs proved satisfactory, and Calder returned to live with his parents in New York City.

In 1922, Clinton Balmer,[29] an English artist and friend of the Calder family from Pasadena days, came to New York and began teaching elementary char-

coal drawing at a school on East 42nd Street. Stirling Calder suggested that his son take night classes offered there, and young Calder enthusiastically attended every session. In the drawing classes, he made studies in charcoal of a nude model, recalling, "It was a real pleasure for me to find myself in a group that shared the same interest."[30] Balmer suggested crosshatching over old lines before adding new descriptive lines to his drawings. Later, in his preliminary sketches for stabiles and mobiles, Calder employed the same technique.[31]

In June 1922, with the help of the Hayes family, Calder found a position as a fireman on the passenger ship *H. F. Alexander*, traveling from New York to San Francisco via the Panama Canal. His mechanical ingenuity was put to use. During the voyage Calder rigged up a baffle to direct fresh air toward him as he worked in the boiler room.[32] It was on this trip that the "wonders of the universe" were impressed upon him.

> It was early one morning on a calm sea, off Guatemala, when
> over my couch – a coil of rope – I saw the beginning of a fiery
> red sunrise on one side and the moon looking like a silver coin
> on the other. Of the whole trip this impressed me most of all;
> it left me with a lasting sensation of the solar system.[33]

After another series of jobs – including one in a logging camp in Independence, Washington, and another as a draftsman for railroad construction in Aberdeen, Washington – Calder was ready to return to New York. In the summer of 1923, while he was staying with his sister and her family in Aberdeen, their mother arrived for a visit, bringing his paints as he had requested. Calder told her that what he really wanted to do was to be a painter.[34]

According to Calder, he made the final decision to study art after seeking employment with a Canadian engineer, a friend of his father's, who advised him to do what he really wanted to do.[35] Although none of the positions he had found as an engineer really satisfied him, some would prove useful in his later work. Decades later, for example, Calder would compare his mobiles designed for the open air to sailing vessels,[36] and in his late years he constructed giant stabiles by using templates like those used in shipyards.

In September 1923, Sandy Calder enrolled at the Art Students League. His grandfather had died the previous June, and perhaps Calder was drawn to art as he began to comprehend this loss of an artist he had much admired. Art was, after all, what Calder knew best, having watched his parents in their studios from his earliest years. Yet why, given his father's successful career as a sculptor, would young Calder have declared his intention to become a painter? Perhaps it seemed impossible for him to pursue any sculptural style other than the academicism of his father (painters at the League were definitely more progressive than the sculptors teaching there). Perhaps he chose

painting, the medium practiced by his mother, so as not to compete directly with his father and grandfather. (He recalled in his autobiography that Stirling Calder had once rhapsodized about the smell of oil paint after visiting some of his painter friends, and young Calder never forgot his remark.)[37] That Stirling Calder was on the sculpture faculty of the League might have also been a factor in his choosing to study drawing and painting. In any case, his mother became actively involved in his decision to study painting, and selected Calder's instructors at the Art Students League. She favored, of course, John Sloan – a friend of the family – and George Luks. Later, when Calder decided to go to Paris, she sent him seventy-five dollars a month until he was able to support himself.[38] Both parents realized that their son had shown little enthusiasm for his postgraduate jobs, and they facilitated his natural inclination to become an artist.

By the time of Sandy Calder's enrollment at the Art Students League in 1923, American artists had been offered many opportunities to see the works of Cubist, Futurist, and Dada artists from abroad. The Armory Show of 1913 had been a full-scale introduction to the European vanguard and American modernists. Certain New York galleries, notably Alfred Stieglitz's Photo-Secession Gallery (popularly known as "291"), were of particular importance in exhibiting the work of leading artists from Europe while also supporting such young Americans as John Marin, Arthur Dove, Georgia O'Keeffe, and Max Weber.[39] In 1917, the newly established Society of Independent Artists offered nonjuried exhibitions for Americans who had difficulty showing with the National Academy of Design or other art institutions. The Société Anonyme, the first Museum of Modern Art, was founded in 1920 by Katherine Dreier, Man Ray, and Marcel Duchamp; more than any commercial gallery or arts organization, the Société was active in bringing a knowledge of International Constructivism to an American audience.[40] With an ambitious exhibition schedule, publications, and lectures, this organization was a predominant force in sustaining the interest in European modernism in America. Despite continued involvement with vanguard developments abroad, the 1920s was a problematical decade for American artists. In the postwar period, the general disillusionment about the state of the world caused many artists, in both this country and Western Europe, to retreat from abstraction.

Having decided to become an artist, Calder, then in his mid-twenties, pursued his new career with vigor and enthusiasm. He sketched incessantly, made dozens of large canvases, and also created etchings and lithographs,[41] although no examples survive from this period. Calder's works dating from his years at the League indicate no involvement with Cubism or Constructivism, but remain close to the Post-Impressionist style and subject matter preferred by his teachers. The young artist found subjects in the world around him: the streets of New York, shop windows, sports events, and the circus.

At times a modified "Fauvist" palette appeared, but generally his paintings retained the loosely brushed representational style popular among League instructors.

During the 1920s the Art Students League faculty largely comprised The Eight – the group that had revolutionized the subject matter of American realism in the first decade of the century – along with younger followers and other artists who shared a similar philosophy. Robert Henri, John Sloan, George Luks, Kenneth Hayes Miller, Maurice Sterne, Boardman Robinson, and Guy Pène du Bois were instructors at the League while Calder was a student there.[42] These artists continued to produce the loosely brushed realist views of urban life, supported by the American isolationist policies of the postwar years. During the 1920s, when social and political turmoil seriously affected artists in Germany, Russia, Italy, and France, a number of Americans who had been deeply involved with European modernism turned to subjects of their native land, again employing a representational approach. But Calder's teachers were already the establishment, firmly associated with realism for decades. Instructors at the Art Students League incorporated neither the nonobjectivity and technological innovations taught at the Bauhaus in Germany during the same decade nor the interest in fantasy and psychic automatism among the abstract Surrealists then emerging in France. Although the League artists did not modify their own style to reflect current trends in European modernism, in their teaching they acknowledged more progressive developments in art.[43] They generally advocated freedom of artistic expression rather than a rigid adherence to realism.

Calder's student years in New York were crucial in several respects. During this period, the young artist established contacts with some of the progressive American painters active in such groups as the Whitney Studio Club and the Penguin Club. In John Sloan's evening class at the League, for example, Calder became "best friends" with the monitor, John Graham,[44] a Russian émigré who had spent time in Paris in 1921 and was fluent in French. Later, Graham also collected art and became part of an international circle of artists and critics. He had a profound influence on many young American artists, introducing them to the latest trends in European modernism. Although Calder mentioned only Graham's single-line drawings in his autobiography, family members recalled Sandy's Russian friend from the League who often accompanied him in New York.[45] Both Graham and Calder showed paintings at the Sociey of Independent Artists in 1925. Graham returned to Paris in August 1925, and his American friend made his first visit there nine months later. Calder must have remained friendly with Graham at least until the early 1930s, for it was then he made a wire portrait of the Russian.[46] Such associations helped Calder find opportunities to exhibit his work and offered him the encouragement of professional colleagues. During his early years of study, Calder also took a job as an illustrator, perfecting the lively drawing style that

led to his early experimentation with wire caricatures created as single-line drawings in space.

Records at the Art Students League indicate that Calder's teachers included George Luks, John Sloan, Boardman Robinson, Guy Pène du Bois, and Charles Locke.[47] Calder spent a few days in the class of Kenneth Hayes Miller without actually meeting him, and then joined the class taught by George Luks, the instructor his mother had preferred for him.[48] At the same time, Calder enrolled in evening classes with John Sloan, also a personal friend of his parents. For Calder, Sloan was a "good instructor, not trying to do it his way but urging you to develop some capabilities of your own."[49] He continued with Sloan throughout his stay at the League, and even returned to Sloan's drawing classes when he visited New York in 1928. But Calder stayed with Luks only three months before moving to the class of Guy Pène du Bois.[50]

Calder's reminiscences of his years at the Art Students League are mostly anecdotal, but examination of some of the works he produced while a student indicates the impact of his instructors' approach to realism. His drawings and paintings of this period show his quick mastery of illustration, the forte of many of his teachers. With a penchant for direct observation and a facility with pencil and pen, Calder gained a reputation among his fellow students. Classmate Clay Spohn recalled:

> He was one of the "real" characters there – very humorous, very funny – always joking and kidding around, never seeming to take anything seriously. He was always (or so it seemed) drawing pictures of circus animals – little crude drawings of elephants, etc. . . . I do remember one or two occasions when I saw him attempting to be serious in working from the model. But after a few minutes of this he would be drawing comic things on his sheet of paper, making cartoons with one character saying something humorous to another character. . . .
>
> Calder was one of the few persons at the League who was a threat to the dangerous over-seriousness of the academic group and instructors who were there at that time. He was a real menace to them. . . . In any event no one took Calder seriously, least of all Calder himself – or so it seemed on the surface. But in actuality I do believe that he did take himself and his sense of humor very seriously since he kept showing his humorous little drawings around to everyone, obviously for the purpose of wanting to have an audience and to become known – to be recognized (to be acceptable and accepted).[51]

Calder credited Boardman Robinson's instruction in drawing with helping him get a job as an illustrator for the *National Police Gazette* in 1924. He wrote

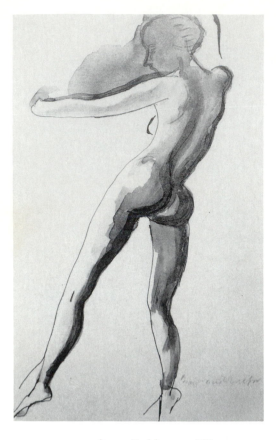

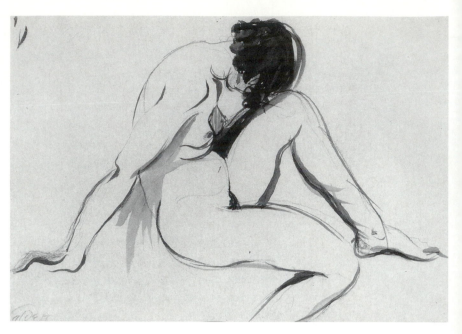

about Robinson, "He was an excellent teacher. I guess it was he who taught me to draw with a pen and single line."[52]

Boardman Robinson's *Dancing Nude* (1922; Fig. 2) was typical of his drawing style in the 1920s. The sources for his studies in pen, ink, and wash were line drawings by Henri Matisse and sketches of the nude figure in motion by Rodin. Robinson's skillful use of a single uninterrupted stroke to outline the figure from torso to foot indicates his mastery of the technique.

Helen Farr Sloan, also a student of Robinson's, recalled that her teacher often demonstrated pencil sketching to his classes and favored croquis drawings from the model as a suitable means of instruction. Students made drawings in one-, two-, and three-minute poses of the model, or drew from memory.[53] Another student recalled:

> In the content of his teaching there was very little that was unusable, perhaps not always at the time of its origin was the thought applicable, but later a need would bring to memory the few words that illuminate.... When Mike [Robinson] demonstrated a point in criticism by sketching on the margin of a student's drawing, his emphasis was on the movement and structure of the forms – not on classical proportions. He had a violent antagonism to formulas and when he saw them in a student's work, he never refrained from demolishing them.[54]

FIGURE 2. (*left*) Boardman Robinson. *Dancing Nude*, 1920. Wash drawing, 9½″ × 6½″. Collection unknown.

FIGURE 3. (*right*) Alexander Calder. *Seated Nude*, c. 1924. Watercolor and pastel on paper, 11¾″ × 17½″. New York: The Metropolitan Museum of Art. Gift of Mrs. Darwin Morse.

18

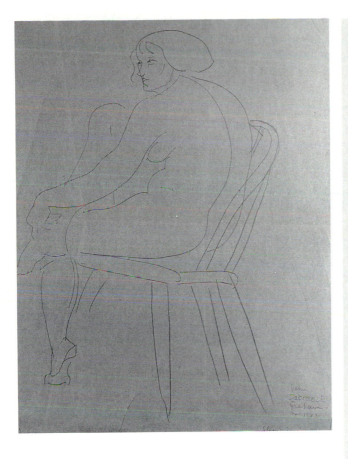

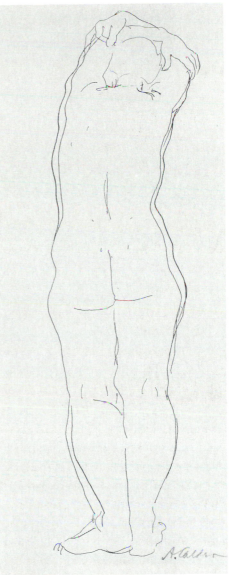

FIGURE 4. (*left*) John Graham, *Seated Female Nude*, 1923. Pencil on paper, 20″ × 15″. Greensboro: Weatherspoon Art Gallery, University of North Carolina.

FIGURE 5. (*right*) Alexander Calder. *Drawing of Nude*, c. 1925. Ink on paper, 15¼″ × 13⅞″. Philadelphia Museum of Art.

Calder's drawings of these years (Fig. 3) were indebted to Robinson, and this early development of linear expression was the groundwork for his later achievements in wire sculpture.

John Graham's drawing style also interested Calder, who later acknowledged that he observed Graham (whose Russian name was Ivan Dombrowsky) in John Sloan's class: "Debrowsky [*sic*] first attracted my attention by drawing a nude with two pencils, one red and one black, and starting with the feet and running right up."[55] Graham's *Seated Female Nude* (1923; Fig. 4) is inscribed as a study from Sloan's class, and gives credibility to Calder's admiration for his facility as a draftsman. A pen-and-ink study of a standing female nude (Fig. 5) is Calder's response to the lively single-line drawings of Graham

as well as to the instruction offered by Boardman Robinson. Both Graham and Robinson also might have acknowledged Picasso's drawings of the 1920s, which featured single-line studies.

Calder's *Seated Nude* (c. 1924; Fig. 3) lacks Boardman Robinson's skill in summarizing the underlying musculature of the figure. Combining a chalk study with a wash of color, Calder produced a static composition, with some distortions in the anatomy of his subject. Such studies of nudes were not Calder's principal interest in these years, however, and his commercial illustrations involved different subjects and a style close to caricature.

While working for the *National Police Gazette* in 1924 and 1925, Calder created the first works on a theme that was to engage him for the remainder of his career: the circus.[56] An issue of the tabloid dated Saturday, May 23, 1925, featured "Seeing the Circus with 'Sandy' Calder." The text accompanying Calder's sketches explained:

> Recently in Madison Square Garden, Just Prior to the demolition of the Historic Amphitheatre. The "Big Show" is the Best Sort of Spring tonic for the grown-ups as well as the youngsters. It preserves some of the Romance of Youth that the Rush and Bustle of City Life So soon impair or destroy. Calder shows us not only the main show but the freaks of the side show.[57]

Under a sketch of three sea lions, Calder included the caption "The jury brings in a sealed verdict." Assigned to cover the Ringling Brothers, Barnum and Bailey Circus for the tabloid, Calder began with quick sketches of performers under the "big top." The circus was a popular pastime in a decade fraught with economic uncertainty, and Calder reveled in the spectacle of performing animals, acrobats, clowns, and trapeze artists. What began as a journalist's assignment continued into a full-scale iconography, shared with European modernists Pablo Picasso, Joan Miró, Jean Cocteau, and others. Later, Calder created renditions of circus animals and acrobats in oil, registering his enchantment with the spatial dynamics of the circus, the energy and excitement, and the ever-changing choreography of creatures in motion. The subjects recorded in Calder's early circus studies, whether single animals performing or an overall impression of the exuberant activity beneath the big top, appear in an assortment of mobiles, stabiles, and drawings in the fifty years following his sketches at the Barnum and Bailey Circus.

Sports events, including boxers, skaters, and cyclists, were represented in the drawings Calder produced for the *National Police Gazette*. *Rink Skating in the Metropolis* (Fig. 6) is an example of the simplified action drawing that Calder produced while working as an illustrator for the tabloid. The sketch includes a series of skaters in momentary poses, the artist having worked quickly but skillfully to summarize the activities at the skating rink. The illusionistic spatial area is compressed and Calder changed the scale of the figures at will to

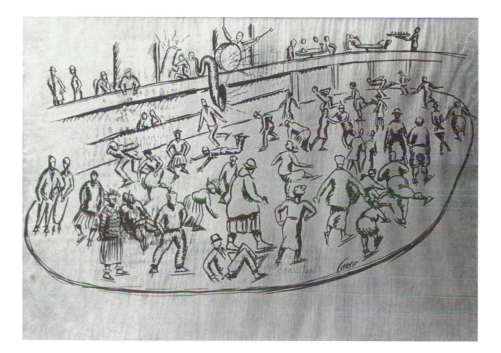

FIGURE 6. Alexander Calder. *Rink Skating in the Metropolis, National Police Gazette*, February 21, 1925.

emphasize particular performers. The artist's summary linear approach and the penchant for caricature found in this sketch prefigure his wire sculptures. In addition, the freely drawn oval in the center of the composition resembles the planar elements so often utilized in his mobiles.

Sunday outings and sports events were not his only subjects for illustrations. In one issue of the *National Police Gazette*, he re-created a few scenes from Charlie Chaplin's latest film, *The Gold Rush* (Fig. 7). Comic subtitles are included with these and other sketches.

Most of the illustrations Calder produced for the tabloid are surprisingly static when compared to the lyrical single-line drawings of animals in motion he produced in 1925. These informal sketches made at the Central Park Zoo show Calder's early fascination with animals in motion, an interest that continued to inspire his work for decades. For *Lionesses* (Fig. 8), Calder outlined the animals with ink applied with a brush, and added watercolor washes. Summary lines eloquently capture the essential characteristics of the animal with an economy of means. A few quick black strokes convey the sinister nature of the stalking feline. To make these works Calder rigged up a device that held bottles of India ink and that could be strung around his neck, facilitating his sketching sessions at the zoo.

In 1926 Calder published *Animal Sketching*, for which he wrote a brief text and prepared all of the illustrations. The purpose of this small book was "to create a stimulant to the younger artist, to draw things as he sees them."[58] Even at this early date, Calder's penchant for describing the movement of a living form can be found in the drawings as well as in the text:

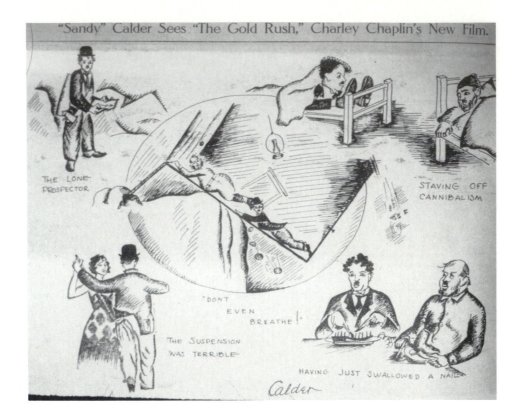

"Sandy" Calder Sees "The Gold Rush," Charley Chaplin's New Film.

THE LONE PROSPECTOR

STAVING OFF CANNIBALISM

"DON'T EVEN BREATHE!"

THE SUSPENSION WAS TERRIBLE

HAVING JUST SWALLOWED A NAIL

Calder

ANIMALS – ACTION. These two words go hand in hand in art. . . . Their lives are of necessity active and their activities are reflected in an alert grace of line even when they are in repose or asleep. Indeed, because of their markings many animals appear to be awake when they are sleeping, and many mammals sleep so lightly that even when apparently asleep they will move their ears in the direction of a sound that is inaudible to us. . . . So there is always a feeling of perpetual motion about animals and to draw them successfully this must be borne in mind.[59]

FIGURE 7. Alexander Calder. *Sandy Calder Sees "The Gold Rush." National Police Gazette*, October 31, 1925.

All of the drawings for this book are active, linear designs that incorporate negative space in a manner similar to Calder's later wire figures, where the flat line-drawings become three-dimensional and capture spatial volumes. The drawings of cats in particular (Fig. 9) testify to his powers of observation and show an astonishing mastery of the feline form. These pen-and-ink sketches recording momentary impressions of movement in bold strokes that vary in thickness with the weight of the animal's body anticipate Calder's wire sculptures and mobiles. In each sketch the artist has emphasized the sweeping linear curve of the cat's back as the predominant descriptive element, in much the same way that he later featured a single curved wire to which all of the suspended elements are related in many of his mobiles. One cat is positioned

22

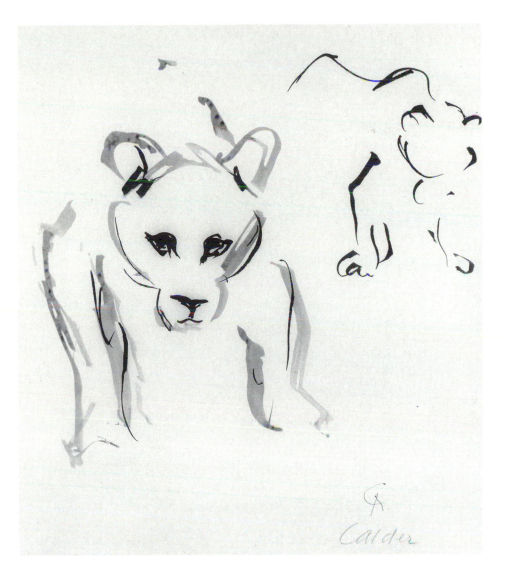

FIGURE 8. Alexander
Calder. *Lionesses*, 1925. Wa-
tercolor and ink, 16⅝″ ×
13⅝″. New York: Private
collection.

with its tail rising vertically, suggesting the dynamic suspension of forms from a single wire.

Calder's animal drawings (Fig. 10), remarkably accomplished for a second-year art student, resemble Japanese brush drawings (Fig. 11). A number of Japanese students were at the League when Calder was enrolled there, including the photographer Soichi Sunami — who was also Sloan's student — and Calder may have learned to do *sumi e* ink-and-brush paintings from one of his fellow students. Or perhaps he arrived independently at a drawing style approximating that of the Japanese calligraphers; the artist certainly indicated a preference for the brushes used in oriental paintings and drawings.[60] But whether he came to the style through instructions, through example, or simply through use of brush-and-ink, variations in the width of line and his reduction of the descriptive form to a few bold strokes link Calder's sketches of birds to Japanese brush drawings.

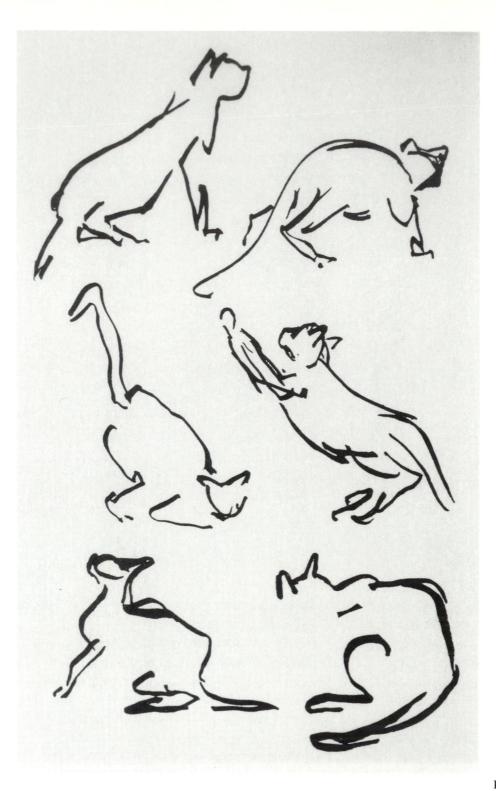

FIGURE 9. Alexander
Calder. *Drawings of Cats*.
Alexander Calder, *Animal
Sketching*, 1925.

24

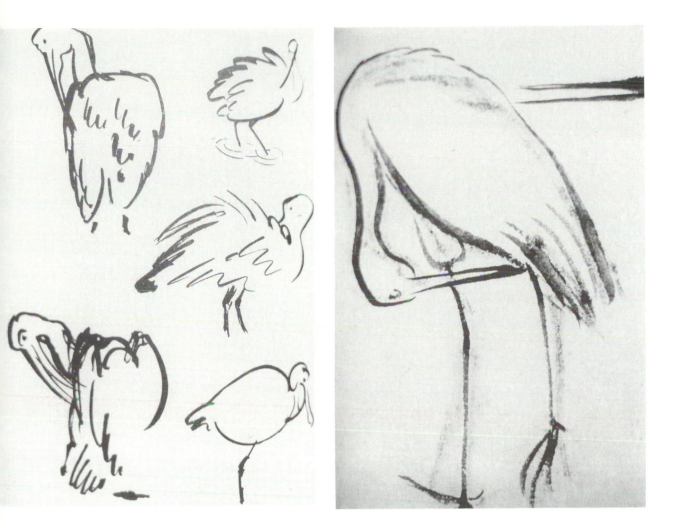

FIGURE 10. (*left*) Alexander
Calder. *Drawings of Birds.*
Alexander Calder, *Animal
Sketching*, 1925.

FIGURE 11. (*right*) Ogata
Kōrin. *Sketch of Bird.* Japa-
nese, early eighteenth
century.

John Sloan, who spoke of the beauty of Japanese drawings in his classes,
may have encouraged Calder to study oriental brush drawings.[61] In *Gist of
Art*, compiled from students' notes taken during Sloan's classes, we find some
of the ideas and techniques that appeared in Calder's drawings of the 1920s,
such as the drawings of *Cats* (see Fig. 9). Concerning "line," Sloan said:

> ...it is entirely a sign, a mental invention. You don't see lines
> in nature, only contours of tones. Unless you try to imitate the
> outside edge of something as the eye sees it, you are making
> a sign every time you draw a line. Lines can mean form, depth,
> shadow, and light. Look at the work of the Japanese and
> Chinese. Notice how the variation of size and strength of the
> line indicates form and texture.[62]

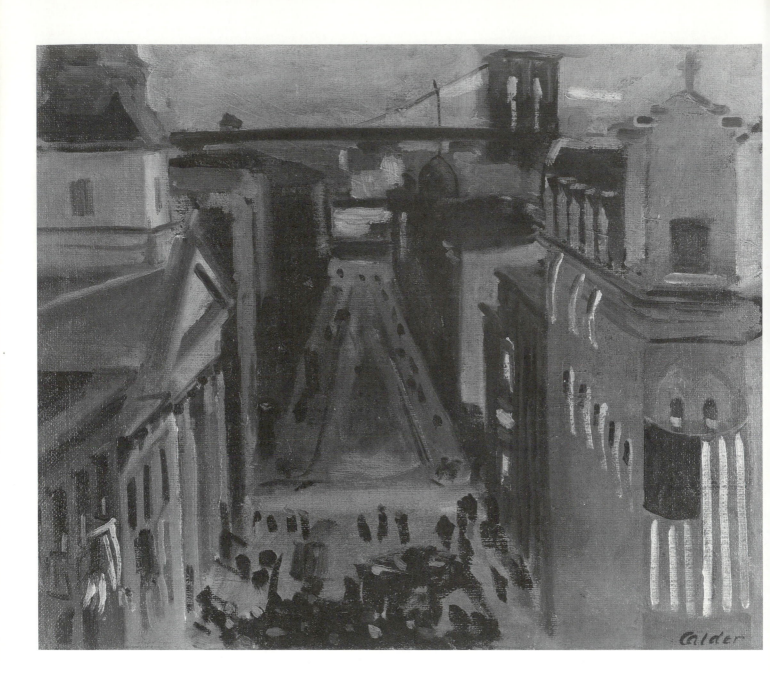

Calder supported himself through his newspaper illustrations and other commercial art projects, including decorating the Spalding sporting goods store with drawings of famous athletes. But he thought of himself primarily as a painter, and actively sought to exhibit and sell canvases. An exhibition of Calder's paintings at the Artists' Gallery in New York in January 1926 earned him a critical mention in the *New Yorker*,[63] and a painting entitled *The Horse Show* was published in the *Boston Evening Transcript* in May 1926.[64] The paintings of these early years – landscapes, portraits, cityscapes, scenes of sporting events and the circus[65] – show the strong influence of his teachers,

FIGURE 12. Alexander Calder. *View of Brooklyn Bridge*, 1925. Oil on canvas, 20″ × 24″. Oberlin, Ohio: Allen Memorial Art Museum, Oberlin College.

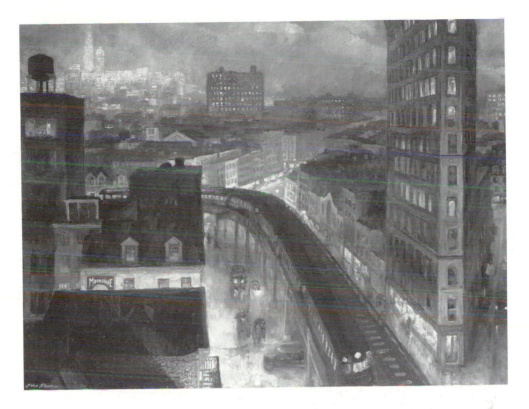

FIGURE 13. John Sloan. *The City from Greenwich Village*, 1922. Oil on canvas, 26″ × 33¾″. Washington, D.C.: National Gallery of Art. Gift of Helen Farr Sloan.

particularly Luks and Sloan. Calder's rapidity of execution and attempts at atmospheric effects with tonal harmonies relate to the style of George Luks as found in such works as *Roundhouses at Highbridge* of 1910.[66] Like Luks and Sloan, Calder favored thin washes of color, and loosely brushed strokes to describe form.

The substantial modeling, stylish figures, and social satire favored by Calder's teacher Guy Pène duBois are not found in the young artist's paintings. However, Calder expressed admiration for duBois's work, and his early carvings of fashionably attired women seem to be derived from the plastically conceived figures in his teacher's paintings.[67]

In addition to the teacher–student relationship, John Sloan and Calder shared a warm friendship during and after Calder's student years at the League. Helen Farr Sloan, Sloan's student in 1927, remembered several occasions when Sandy Calder, having returned from a year in Paris, appeared in Sloan's drawing class.[68] The older artist's instruction had a profound impact not only on Calder's drawing style but also on his early paintings. Even such crudely executed works as *View of Brooklyn Bridge* (1925; Fig. 12) echo the palette and painterly technique of Sloan's *The City from Greenwich Village* (1922; Fig. 13). Like Sloan, Calder had used an aerial viewpoint to give an impression of the densely packed urbanscape. Often depictions of city streets included figures, but these were observed at a distance and were often faceless. Both artists favored thin washes of color and loosely brushed strokes of black to

describe form, and both built up areas including specific images to an impasto of brilliant color.

In other paintings of city scenes both Sloan and Calder used orange, yellow, and burnt sienna to suggest the illumination of city architecture at night, and both applied small touches of yellow pigment with a loaded brush over a thinly painted surface to indicate streetlights and illuminated rooms in office buildings. Calder's competence in rendering the illusion of depth on canvas did not match that of his teacher, even though Calder seems to have limited himself to basic one-point perspectival schemes. *View of Brooklyn Bridge* is an overview of a busy city street with buildings, vehicles, and pedestrians rendered in summary fashion. The work lacks the dynamism and wit of his brush-and-ink sketches of animals.

Calder's paintings are less successful than his drawings of the same period and give no indication of his potential for mastery of dynamic forms in motion. Although the artist's facility with line enabled him to create skillful action drawings, it could not sustain him through the more methodical preparation of an oil painting. Calder provided some idea of his painting method in his autobiography when he recalled a trip to the country with Ralph Robinson, secretary of the *National Police Gazette* and an amateur painter:

> It was a rather dreary day and there was a Long Island farm in the distance. Robinson set up his canvas on an easel and started to paint the farm. I nailed my canvas to a tree behind him and started to paint him. As I did not buy new canvases, but old ones from the League, there was a naked lady on mine who gradually retired as Robinson increased. He saw it midway and was horrified.
>
> I remember another time I was out painting . . . on the Stevens campus overlooking the Hudson. This time I had an old canvas. I finally covered it with a penetrating Prussian blue then proceeded to paint on it a red derrick on a barge that was passing before me. Due to the Prussian blue, the red derrick became pink.[69]

Calder's method of painting directly over another image on a wet canvas indicates a deliberately haphazard and crude approach that was certainly not favored by The Eight or their successors, who worked in a more systematic buildup from thin, dark washes to an impasto of brilliant hues. The young artist also indicated the rapidity of his execution by his comments on the red derrick. Since the blue ground was not allowed to dry but was painted over immediately, all of his colors were modified accordingly. Although George Luks might have favored this freedom of execution, John Sloan and Guy Pène duBois were more deliberate in their preparations of a canvas.

Landscape with Country House (Fig. 14) represents one of Calder's attempts to work in nature, but it is not successful. The frieze of trees and shrubs in

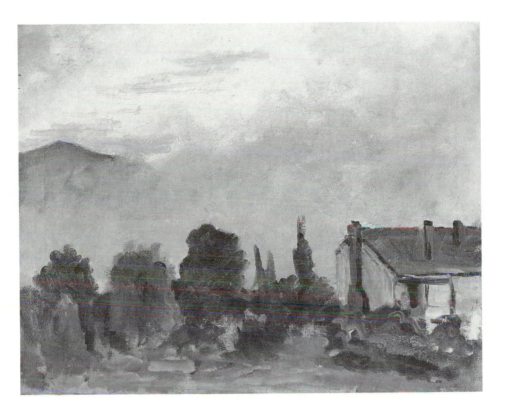

FIGURE 14. Alexander Calder. *Landscape with Country House*, c. 1923–6. Oil on canvas, 16⅛″ × 20″. Oberlin, Ohio: Allen Memorial Art Museum, Oberlin College.

the foreground forms a planar element that does not relate very successfully to the view of the sky and a distant glimpse of a mountain peak. Such compositions suggest the young artist's struggle to define a personal direction. Calder also used subjects related to his illustrations of sporting events for some of his oil paintings. In the collection of his college classmate William Drew (who remained a lifelong friend) are several oils of "spectator sports," including a grandstand view of a tennis match at Forest Hills, New York (c. 1925; Fig. 15). In this broad overview of the event, players and spectators are rendered as static as the distant buildings of the club, and the exuberance that characterizes his action drawings fails to appear. What remains is a grandstand view of a roughly circular playing field-cum-court as the unifying compositional element.

The Flying Trapeze (1925; Fig. 16) is set at closer range to the action, and conveys a dramatic effect, by comparison. This work is one of Calder's earliest depictions of the circus, a subject that recurred frequently in his artistic production of the succeeding half-century.[70] Here the high-keyed palette includes touches of brilliant color to enliven the surface. Large planar forms predominate, and the solid black netting anticipates the large angular sheets of metal that Calder was to favor in his late stabiles. The suspended swings of the trapeze artists similarly foreshadow Calder's suspended mobiles. Calder has focused a bright spotlight on the trapeze artists suspended from their swing, a light that also illuminates the tent's smoky interior. The trapeze performers,

29

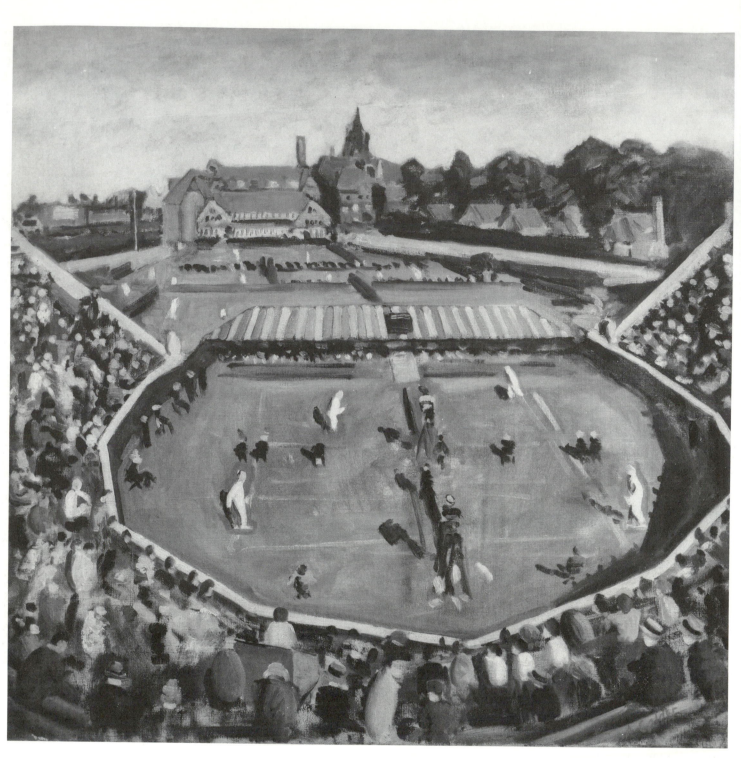

FIGURE 15. Alexander Calder. *Match at Forest Hills*, c. 1925. Oil on canvas. New York: Collection of Mrs. William B. F. Drew.

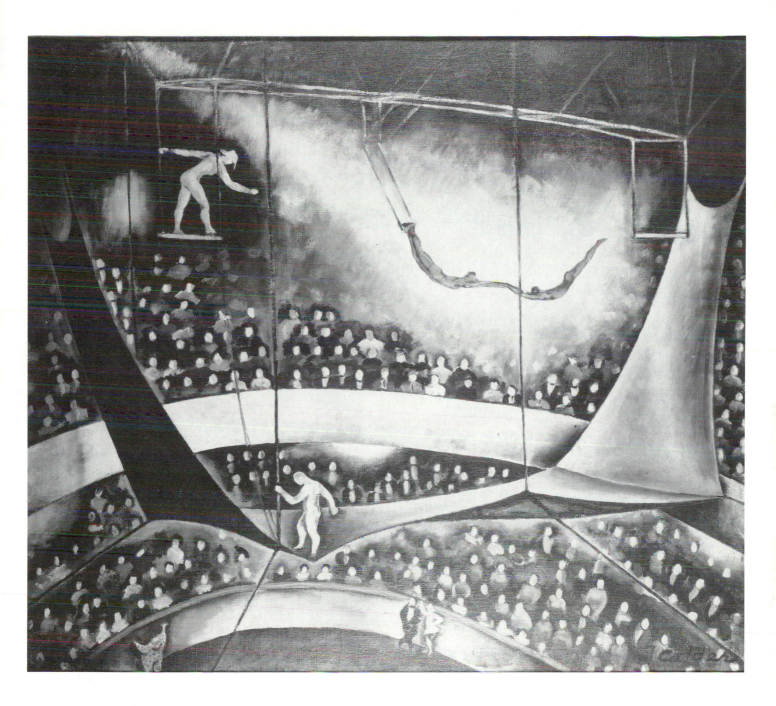

FIGURE 16. Alexander Calder. *The Flying Trapeze*, 1925. Oil on canvas, 36″ × 42″. New York: Perls Galleries.

rendered at a moment in time, are counterbalanced by other stationary figures and elements to form this remarkable composition.

In his student years Calder also attempted portrait studies, including a self image (c. 1925; Fig. 17). This full-face study is somewhat different from the intense expression and broadly brushed surface of another early self-portrait, given to his sister.[71] These likenesses of the artist in his mid-twenties

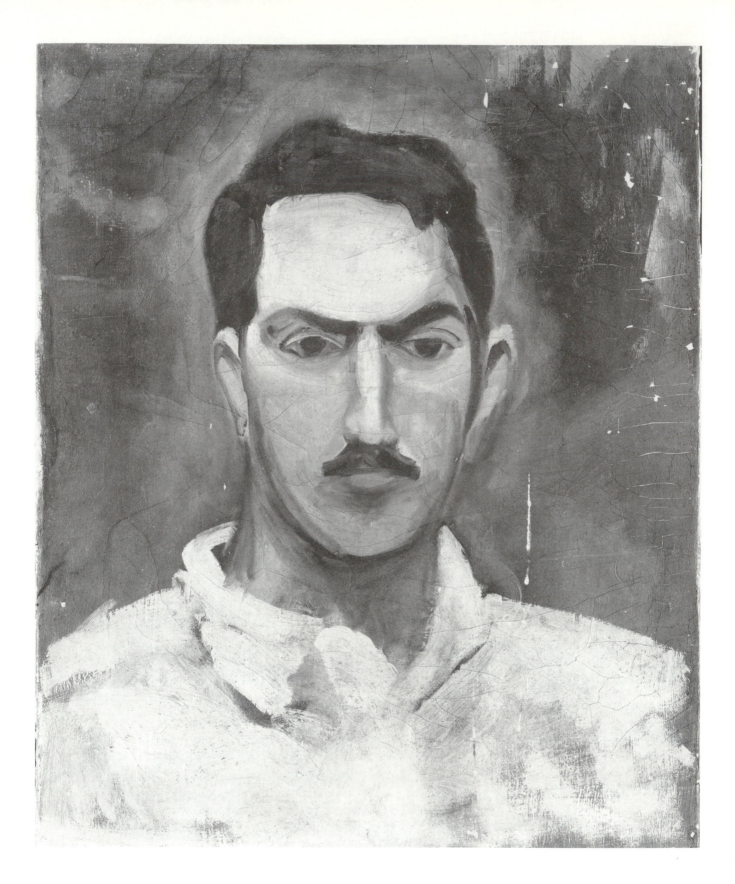

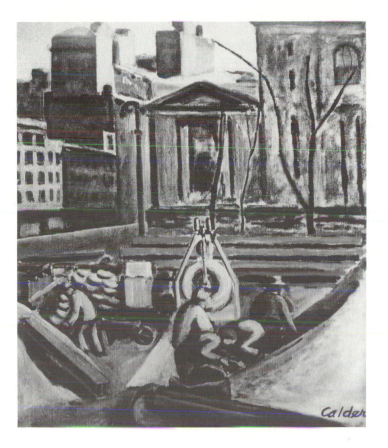

FIGURE 18. Alexander Calder. *Excavation in Bryant Park*, 1925. Oil on canvas, 36¼″ × 30″. New York: Perls Galleries.

show him with dark hair and a thick mustache, contributing to the sense of maturity, the intensity that he wished to convey. The deliberately "sketchy" style of the portrait and the use of brilliant hues suggest Calder's rebellion from the Post-Impressionist style found in his mother's portrait studies. With *Excavation in Bryant Park* of 1925 (Fig. 18), Calder achieved greater compositional harmony, and he executed this painting more carefully than others of the same period. Like *The Flying Trapeze*, created in the same year, this painting is one of the most successful oils by Calder during his formative period. Diagonally placed steel girders lead the spectator into a triangular enclosure with an architectural backdrop. In the center foreground is a chevron-shaped grouping that echoes the triangular space. Shirts of the individual workmen are painted yellow, blue, violet, and green, hues that echo the dominant color scheme of the painting.

There are several possible explanations for Calder's use of a palette with more intense and varied colors here. He may have become interested in the paintings of American artists influenced by the Fauves,[72] or he may have been experimenting with the Maratta color system favored by John Sloan.[73] The Maratta pigments were carefully premixed combinations of primary, secondary, and tertiary colors.[74] In this painting Calder used a greenish yellow, cadmium red, deep orange, and violet that appear to be from the Maratta

FIGURE 17. (*opposite*) Alexander Calder. *Self-Portrait*, 1925. Oil on canvas, 20″ × 16″. Washington, D.C.: National Portrait Gallery, Smithsonian Institution. Gift of the artist.

palette. Touches of blue and green found on the stone building, and the use of bright red for the steel girders, also suggest that Calder had assimilated the Fauvist palette of some American modernists.[75]

No paintings from Calder's formative period suggest an acceptance of Cubism or Futurism. Even though he must have been aware of the work of the "ultra-moderns," as the Cubist and Futurist painters were called by John Sloan and Robert Henri, Calder stayed within the ambience of League instruction in adhering to a more representational approach to painting. By the 1920s, Calder's instructors were an older generation who were not willing to absorb Cubism and Futurism; but the appointment of Jan Matulka, who was committed to Cubism and advanced abstraction, to the League faculty in 1929 caused the generational gap to be altered. For the three years that Calder was enrolled at the Art Students League, however, he remained within the confines of American art-practice that was most popular among his teachers as well as the majority of his fellow students. Probably his growing awareness of the limitations of his associates at the League compelled him to make a trip to Europe in 1926.

In his autobiography Calder provides no information about his membership in artists groups during his student years, nor does he discuss exhibitions that he saw while he attended the League. However, his name appears in the list of members of the Society of Independent Artists in 1925, and he exhibited a painting entitled *The Eclipse*.[76] This painting has been lost, but does suggest Calder's early interest in cosmic phenomena. His involvement in the Society of Independent Artists is not surprising considering that John Sloan was president of the organization throughout Calder's student years. In 1926, Calder exhibited a painting entitled *The Stiff* in the Independents show at the Waldorf-Astoria, and listed the price – a rather "stiff" one compared to other participants – as two hundred dollars.[77] In a letter of 1926, Calder described this painting, now lost, as "showing medical students cutting up a stiff," and found it amusing that visitors, and particularly some cub reporters assigned to cover the exhibition, were startled by his work.[78]

In correspondence with family members, Calder also mentioned that he had shown his work with the Whitney Studio Club in their annual exhibition at the Anderson Galleries in New York, a canvas that received favorable notice but was not purchased.[79] Calder's involvement with the Whitney Studio Club in 1926 came after a few months of residence with Alexander Brook on West Tenth Street.[80] Brook, who had been a student at the League from 1915 to 1919, was a realist painter, the author of reviews and articles on artists, and an assistant director of the Whitney Studio Club during the 1920s. It is most likely that Brook had some role in arranging for Calder to show with the Club.

The artist's sister, Margaret Calder Hayes, remembered visiting Sandy in the fall of 1925, and found him sharing a studio on Bleecker Street with

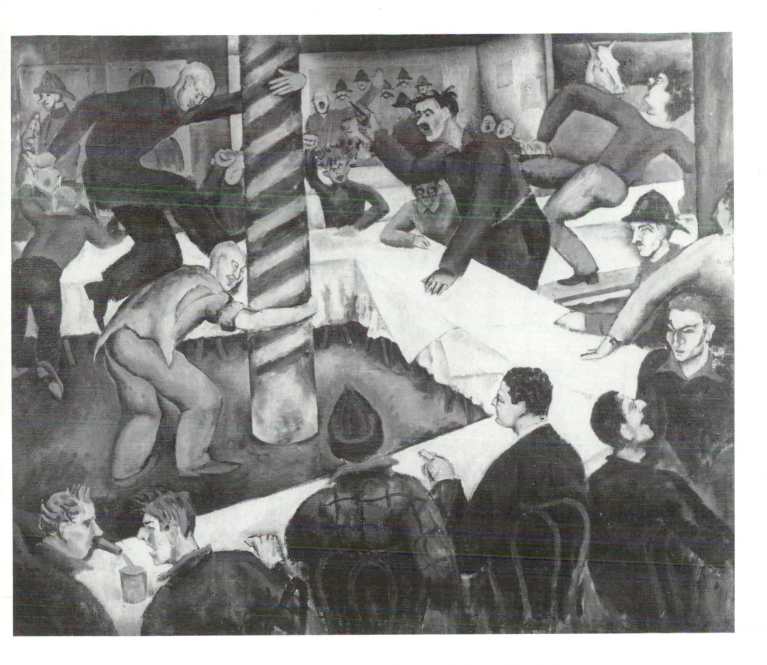

FIGURE 19. Alexander Calder. *Firemen's Dinner for Brancusi*, 1926. Oil on canvas, 36″ × 42″. New York: Whitney Museum of American Art. Gift of the artist 63.58.

Charles Howard, a young painter from Berkeley, California.[81] In fact, Sandy must have made many friends among young American painters in these years. Although limited documentation exists for Calder's involvement with American modernists of the 1920s, *Firemen's Dinner for Brancusi* (1926; Fig. 19) suggests that Calder had become friendly with young artists in New York, some of whom were active in the Whitney Studio Club and the Penguin Club. These Americans decided to hold a dinner in honor of Constantin Brancusi, who was visiting the United States at the time, the event recorded in Calder's lively painting.

Firemen's Dinner for Brancusi immediately preceded Calder's first trip to Paris in the spring of 1926. Although the work is not among Calder's most successful of the period, it offers a glimpse of an amusing gathering. The dinner represented took place at the fire station of the Union Square Volunteer Fire Brigade on February 27, 1926. According to the artist, the work celebrated Brancusi's visit to New York during an exhibition of his work at the Wildenstein Galleries. Brancusi was not included in the painting because Calder had not met him.[82] The diaries of Louis Bouché include more specific information about the stag dinner of the Union Square Volunteer Fire Brigade.[83] In addition, Calder provided details on the painting to the Whitney Museum of American Art when he later gave them the painting. A number of American artists were included among the "firemen" depicted by Calder: Yasuo Kuniyoshi, Walt Kuhn, Niles Spencer, Louis Bouché, and Alexander Brook.[84] Many of the participants were members of the Penguin Club, organized by Walt Kuhn in 1916.[85] This private club of artists held exhibitions and sponsored various social events.

Alexander Brook, a Penguin Club member, recalled that Calder was a boarder in his flat at 142 West 10th Street and "tagged along" to the dinner in honor of Brancusi although he was not a member of the club.[86] Brook also recalled that the two bald men cavorting in the center (the Howard brothers) were later evicted by Louis Bouché, who is shown admonishing them in the painting. Calder included himself to the right of Bouché, where he appears to be engaged in a vigorous solo dance.

Although Calder never mentioned in print the American artists he knew in the early 1920s, except for John Graham and his teachers at the League, he was at least conversant with young American painters who were involved with advanced European trends. Early in 1926, however, Calder was ready to see the art of Europe for himself. His parents had traveled abroad in 1924 and returned with glowing reports of Greece, France, and England. Probably they encouraged young Calder to go to Europe. Arrangements were made for him to work his way to England by painting the hull of a cargo ship, the *Galileo*.

Calder had gained practical experience and useful technical instruction during the three years he spent at the Art Students League. His instructors' attachment to subjects from everyday life influenced his work over the rest of his career. Although Calder turned to abstraction in the early 1930s, representations of nature remained important to him, and he was committed to an art that related to the experiences and pleasures of his personal world. Asked later whether he considered himself a realist, Calder declared that he was "because I make what I see. It's only the problem of seeing it. If you can imagine a thing, conjure it up in space – then you can make it."[87]

Calder's original aim was to become a painter, and he continued to draw and paint throughout his career. If his three-dimensional works now over-

shadow his pictorial works, Calder's artistic maturity nevertheless was a result of his early achievements in drawing and painting. The frequent allusion to line drawing in space rather than traditional modeling, and the concern with forms in a state of dynamic equilibrium, were more directly indebted to his early training as an engineer and painter than to traditional sculptural methods and materials.

First Years in Paris:
Wood and Wire Sculptures,
1926–1930

LIKE MANY AMERICAN ARTISTS before him, Calder was eager to study abroad. In June 1926 he made the first of many trips to Paris. But even before his departure, he had begun to create wire constructions and wood carvings, initiating the innovative works he would continue for the following four years. Calder had made toys, jewelry, and whimsical devices all through his student years, and as he became familiar with American modernists he realized that his ingenuity in fashioning small objects could be used in making sculpture. In 1925, therefore, during the final year of Calder's study at the Art Students League, he had begun to work in three dimensions, reviving his lifelong interest in objects made from simple materials.

By 1925, Calder was prepared to accept two essential concepts of modernism: that sculpture could be based on sources other than the classical tradition; and that the process of making handcrafted objects – whether by metal construction or carving directly in wood – had superseded the clay modeling and bronze casting of academic sculptors. Thus Calder was able to create three-dimensional works remarkably different from the Beaux-Arts production of his father.

Several developments in American art circles of the mid-1920s propelled Calder in new directions: the growing awareness of folk art as a viable source for modern sculpture, the interest in direct carving, and the stimulation generated by exhibitions of International Constructivism. Also significant was the presence of Cubist sculptor Alexander Archipenko, who emigrated to the United States in 1923, and the 1926 visits of the renowned direct carver Constantin Brancusi, a Rumanian émigré associated with the School of Paris.

At the Art Students League, new approaches to sculpture were acknowledged with the appointment of the French-American Robert Laurent in 1925.[1] This artist was a direct carver and an avid collector of folk art, and Calder's first sculpture, also made in 1925, suggests the importance of new ideas shared with Laurent and other American modernists. Calder had needed a timepiece

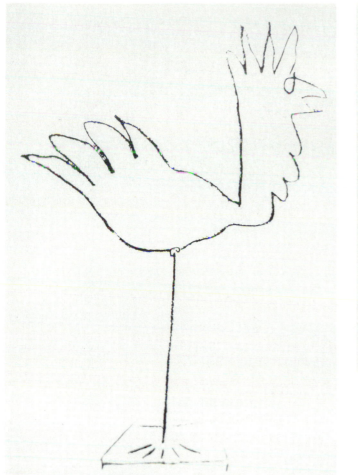

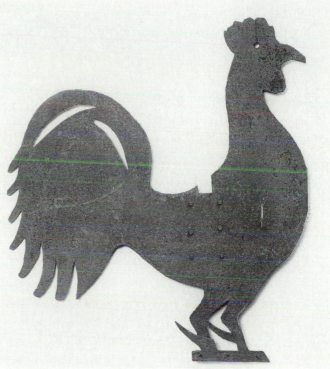

FIGURE 20. (*left*) Alexander Calder. *Wire Rooster*, 1925. Wire (lost work). Alexander Calder, *Autobiography with Pictures*.

FIGURE 21. (*right*) American Folk Art. *Rooster*, 1715. Sheet iron, 43½″ × 38½″. From a church, Saddle River, New Jersey. The Newark Museum.

for the small bedroom of his apartment in Manhattan, and instead of simply purchasing a clock, he had designed a wire rooster (Fig. 20) to use as a sundial. In his autobiography Calder recalled: "I had no clock and faced south, so I made a sundial with a piece of wire – a wire rooster on a vertical rod with radiating lines at the foot indicating the hours. I'd made things out of wire before – jewelry, toys – but this was my first effort to represent an animal in wire.[2]

Calder's comment on representing an "animal in wire" suggests that he saw this amusing wire construction as something different from the toys and handmade objects he had produced earlier. The wire rooster was a sculpture, and such wire animals and figures occupied Calder for the next five years. The artist's use of a wire rooster as a sundial can be related to early American timepieces and weather devices. A weather vane topped by a metal rooster (Fig. 21) is a possible antecedent for the work, and such devices in sheet iron or copper were very popular in the eighteenth and nineteenth centuries.[3]

Calder's *Wire Rooster* sundial is also derived from the single-line drawings

of animals that he had produced in the preceding two years. That Calder constructed his first wire sculpture in 1925, well before his first trip to Paris shows he was already willing to interpret his studies of animals into the materials he had always used to fashion toys. A growing interest in folk art among American modernists may have provided the incentive. In February 1924 the first public display of American folk art was held at the Whitney Studio Club. Juliana Force, who served as director, had begun to collect animal toys of painted wood. Calder's friend Alexander Brook wrote an article on folk art in 1925, suggesting that the modern artist's attraction to folk art could be the foundation for future American art.[4]

According to Calder, his first sculpture in wood was carved in the spring of 1926, shortly before he left for Paris.[5] Certainly the young artist had no intention of becoming an academic sculptor like his father and grandfather, but he was fascinated by the work of the direct carvers active in New York during the 1920s. Direct carving (or *taille directe*) involves the process of chiseling a sculpture from a piece of wood or stone. The material used is carefully chosen by the artist, and its inherent properties help to determine the final appearance of the work. Direct carvings are improvisational, and the final form takes shape only while the sculptor is working the material.

Flat Cat (Fig. 22), probably Calder's first wood carving,[6] may have been inspired by Brancusi's exhibition at Wildenstein Galleries four months earlier, for the Rumanian master caused a sensation when he arrived from Paris. But Calder would also have been aware of folk art animals made of wood, and of direct carvings by Robert Laurent, William Zorach, and John B. Flannagan, the principal American sculptors involved in direct carving.[7] Calder's sculpture of a cat is carved in relief from an oak fence rail and initiated an interest in direct carving that continued for the next four years. Even in this early example, the silhouette of the animal echoes the strong linear patterns created by the rich graining of the wood. *Flat Cat* was an isolated attempt to explore the possibilities offered by an exciting new technique, and did not signal a

FIGURE 22. Alexander Calder. *Flat Cat*, 1926. Oak, 6½″ × 19″ × 1½″. Rochester: Memorial Art Gallery, University of Rochester. Gift of Mrs. Charlotte Whitney Allen.

sudden conversion from painter to sculptor in direct carving. It does, however, suggest the range of Calder's knowledge of contemporary trends in art.

These two sculptures, one constructed of wire and the other in wood, suggest that the young artist had ample opportunities to keep abreast of contemporary European and American artistic trends through art periodicals and exhibitions organized by the Société Anonyme, the Salons of America, and the Society of Independent Artists, and by such progressive New York galleries as Weyhe, Kraushaar, Daniel, Bourgeois, and Brummer, and the Intimate Gallery.[8]

During the 1920s American sculptors including John Storrs, Robert Laurent, and John B. Flannagan moved beyond traditional approaches to sculpture to produce abstract works in wood and various metals. Some three-dimensional works of the 1920s, like the experimental abstractions of the previous decade, are related to Cubism and Futurism. Other works can be associated with International Constructivism. During these years a number of art institutions helped prepare a generation of sculptors to use constructivist concepts. Exhibitions of the Whitney Studio Club and the Little Review Galleries, and publications of the Société Anonyme, the *Little Review*, and other journals disseminated information about contemporary developments abroad. Under the auspices of the Société Anonyme, for example, American artists and patrons had the first opportunity to see works by Constructivists from Russia, Germany, and Holland, as well as abstract works from France. This organization, also called the "first Museum of Modern Art" in the United States, promoted the cause of the avant-garde by an ambitious series of lectures, symposia, and publications. In order to create the sculpture that was to emerge, American artists had to be afforded firsthand exposure to the daring methods of fabrication and the frankly exposed industrial materials used by artists of International Constructivism. Some artists found this abroad, while many others relied on exhibitions in this country and avant-garde publications to learn of contemporary European art.

In leased rooms at 19 East 47th Street, the Société Anonyme arranged a series of exhibitions, and in the same building maintained a library of books on modern art and recent art periodicals for the public. Sculptors were included in group shows of the Société Anonyme, and the participants included Kurt Schwitters, Constantin Brancusi, Raymond Duchamp-Villon, and Kasimir Medunetsky. Archipenko's constructions were included in an exhibition of Russian painting and sculpture held at the Brooklyn Museum in 1923 and at other galleries during the 1920s.[9] Archipenko and Storrs were also given solo exhibitions.

Archipenko was a sculptural innovator of the early twentieth century. Associated first with the Cubists, in 1912 he invented *sculpto-peinture* – works that combine painterly effects with constructed reliefs. In these constructions of 1912 to 1918 he was among the earliest to introduce such nontraditional materials as metal, glass, and found objects. He also created freestanding

sculpture in which the dynamic interplay of solid and void is given predominance by the piercing of the sculptural mass. Archipenko came to the United States in 1923, and in the following years became an art instructor, introducing modernist concepts to a generation of American students. He lectured and taught sculpture throughout the country,[10] and introduced young Americans to his sculptural innovations of the Cubist years. He also invented a kinetic device called *Archipentura* or *Peinture Changeante*, a motorized work that produces variable images in sequence. The artist was granted a patent in 1927 for this invention, which he dedicated to Thomas Edison and Albert Einstein. Archipenko had criticized the Dadaists and Futurists for representing only fragments of machines, and called for a new art that would "speak of its time, the Epoch of Action."[11] He noted that *Archipentura* was inspired by Einstein's theory of relativity as well as by "the ambience of the most modern city of the world, New York."[12]

Shown in New York's Anderson Galleries in 1928 (where Calder had exhibited earlier), the device could have influenced Calder and other artists who experimented with kineticism in the following years. In the catalogue, Archipenko described at length the history and nature of *Archipentura*. Commenting on movement as a language provoking emotions and sensations that are much more powerful than those elicited by static forms, Archipenko also wrote of time and space in relation to his invention:

> Since *Archipentura* paints movement and since movement does exist outside of time, the duration and the speed of action intervene inevitably as elements of creation in *Archipentura*. . . . *Archipentura* offers the possibility of executing and representing in even the same point of space, different objects, movements, transformations, and displacements.[13]

Calder might have been fascinated by Archipenko's notion of using the time–space continuum in art and his success in overcoming the limitations of static representation. Through the exhibition of the inventive productions of these years, and his teaching at various art institutions, Archipenko therefore was of great importance to the dissemination of Cubist–Futurist sculptural concepts.

In addition to the support given to Archipenko, the Société Anonyme can be credited with introducing other members of the Russian avant-garde to an American audience. As early as 1923, works by Kasimir Malevich, Kasimir Medunetsky, El Lissitsky, and Nadezhda Udaltsova were exhibited in New York. In 1922, Katherine Dreier saw works by Medunetsky and other artists of the Russian avant-garde in Berlin at the *Erste Russische Kunstausstellung*. From this show Dreier purchased Medunetsky's *Construction No. 557*. This tin, brass, and iron sculpture in polychrome was one of the first Constructivist sculptures to be bought in the West, and must have been shocking when it

was shown in New York after its purchase in 1922. The work in various metals was related to some of the Bauhaus sculptures of the 1920s that also used industrial fabrication methods. In Medunetsky's openwork structure, interpenetrating planes of metal combine with several geometric forms.

A major effort of the Société was the preparation of the comprehensive catalogue to accompany the International Exhibition of Modern Art in 1926.[14] This show, also referred to as the "Brooklyn Exhibition," was the most spectacular achievement of the Société Anonyme. Held at the Brooklyn Museum from November 19, 1926, to January 1, 1927, this was the most comprehensive international exhibition since the Armory Show, and presented the full range and complexity of the modern movement. When the Brooklyn Exhibition opened, there were more than 300 works of art by 106 artists representing twenty-three countries.[15] The show was seen by 52,000 people before it closed in January 1927. Dreier placed special emphasis on the twenty-three countries involved in the exhibition – hoping to demonstrate that modernism had spread and was of truly international importance. No exhibition of the decade compared in scope to this one sponsored by the Société Anonyme.

Assimilation of modernism did not proceed steadily after the Armory Show, and the criticism of the mid–1920s indicated the retrogressive, isolationist posture that America had assumed during and after World War I. Although this exhibition had limited influence on various aspects of American culture and society,[16] it attracted the attention of young artists and prepared the public for the opening of two museums devoted to this art: the Gallery of Living Art, which opened in 1927, and the Museum of Modern Art in New York, established in 1929.[17]

Various organizations were responsible for the intellectual and artistic climate that encouraged the assimilation of International Constructivism during the late 1920s. The *Little Review*, a journal of the arts, opened a gallery in New York in 1923, managed by one of its editors, Jane Heap, where European modernists were given exhibitions. The journal also published articles about contemporary developments in painting and sculpture. The *Little Review* is remembered for a series of expositions including the "International Theatre Exposition" of 1926 and the "Machine-Age Exposition" of 1928.[18] But these relatively limited activities of the *Little Review* could not compare in impact to the scope and messianic nature of the Société Anonyme's approach to the presentation of modernism.

The Société Anonyme sustained the spirit of the international vanguard through the 1920s, when art in America was dominated by realism and when politics were isolationist. In addition, its exhibitions not only afforded American artists and public alike an opportunity to examine the work of French modernists, but actually gave greater exposure to the German, Russian, and Hungarian artists.

It is therefore conceivable that Calder's exploration of wood and wire sculpture could have continued to develop for some time in America; but it

was the more progressive artistic ambience of Paris that stimulated him to produce his most innovative works: the mobile and the stabile. Alexander Calder and Isamu Noguchi both worked in Paris during the late 1920s, and there they met European artists. Their abstract constructions transcended American involvement with direct carving and primitive art to include the Surrealist–Constructivist methods favored by such Parisian artists as Julio Gonzalez, Pablo Picasso, Antoine Pevsner, Lazlo Moholy-Nagy, and Naum Gabo.

Calder's true motivation for going to Paris has never been explained. In his autobiography he suggested that his search for better employment opportunities resulted in his decision to go abroad. It is almost certain that his teachers at the League and fellow artists urged him to go. José de Creeft mentioned the Prohibition laws as an incentive for Calder's decision.[19] Calder wrote: "So Paris seemed the place to go on all accounts of practically everyone who had been there and I decided I would also like to go. My parents were favorable to this idea."[20]

Calder had chosen a propitious time to begin his Paris sojourn. By the mid–1920s, France had become very attractive to Americans, for the postwar financial crisis had devalued the French franc and Americans with only a modest subsidy could live comfortably there. During the 1920s, the dollar reached a record high of fifty French francs, and thousands of Americans flocked to the French capital.[21] Among the celebrated American émigrés of that decade were writers F. Scott Fitzgerald, Ernest Hemingway; composers Virgil Thomson and George Antheil; and artists Gerald Murphy and Man Ray.[22] Americans were very popular in postwar Paris, as were all aspects of Americana. For young Americans, Paris was an exciting and inexpensive place to live – until the 1929 stockmarket crash forced many to return home.

The art capital of the Western world, Paris seethed with the latest developments among European modernists. In 1925 the first major group exhibition of the newly formed Surrealists opened at the Galerie Pierre. Certain artists, such as Max Ernst and the American Man Ray, previously had been associated with Dada, but new heroes included Joan Miró, André Masson, Jean Arp, and even Paul Klee. Also in 1925 was the spectacular International Exposition of Decorative and Industrial Arts (Exposition Internationale des Arts Décoratifs et Industriels Modernes), a show that helped to establish the term "art deco" for the streamlined stylizations in design of the 1920s. Shortly before Calder's arrival in Paris, Man Ray had a solo exhibition of his paintings and objects at the Galerie Surréaliste; "primitive" sculptures of the Pacific Islands from the collections of André Breton, Paul Eluard, and Louis Aragon were also included in the show.

Calder, then twenty-eight years old, arrived in Paris in June 1926 and soon enrolled in drawing sessions at the Académie de la Grande Chaumière. There was no formal instruction, and most of the students worked on their own, producing croquis drawings – sketches of a nude model who held a pose

for a time determined by the instructor.[23] Calder also sketched on the streets of Paris. Clay Spohn renewed his acquaintance with Calder at this time, and the two former students of the League became good friends. Spohn later wrote:

> Calder arrived in Paris in the late spring or early summer of 1926. I was sitting at a table on the terrace of "the Dôme" with a few friends one afternoon, watching the parade of people walking by. It must have been June because the terrace was so crowded with people, mostly American tourists. And that was about the time they started arriving in Paris – the tourists and the students from everywhere.
>
> Suddenly I saw someone in a bright striped suit, straw hat and cane. The suit had orange and light brown stripes that were almost one inch wide running lengthwise. It was a heavy, woolly suit and the man in it was large and stout and he had long, sandy colored mustaches and beady blue eyes. I was startled to recognize him as "Sandy" Calder.... I looked up a moment in the direction of the street, on the Boulevard Montparnasse side where there were benches so people could rest while waiting for the buses. The benches were doubled up so that they were back to back, some facing the massive throng sitting at the tables on the terrace. It seemed there were about 250 or 300 persons there.
>
> On one of the benches sat Calder facing the crowd. But instead of sitting on the seat of the bench, he was sitting on the top of the back support with his feet on the seat part so he could get a better view of the tables and crowds on the terrace. He had a sketch pad in one hand and a pencil or pen in the other and he was making a drawing of someone on the terrace. He would look at the person on the terrace he was making a sketch of and then draw. And as he would draw and then look up again the mass of two or three hundred people on the terrace would look at him. He was serious (at least his expression was) and they were too. He kept working and the mass of people (which by that time seemed like thousands) cooperated with him. They all held a dignified pose, even though his interest was concerned with only one.[24]

Calder's first sojourn in Paris lasted only a couple of months: When the Holland America lines engaged him to draw shipboard activities for an advertising brochure, he returned to New York in August 1926. Calder's rapid pen-and-ink sketches of passengers enjoying recreational activities recall his humorous action drawings for the *National Police Gazette*. There is also a prefiguration of his wire caricatures in these single-line drawings that summarily capture the pose and salient features of his subjects.

45

Calder returned to Paris a month later, in September 1926, and rented a studio at 22 rue Daguerre in Montparnasse. His first studio was in the heart of the district where artists and craftsmen lived and worked during the 1920s. Gradually he became acquainted with a number of American and English artists working in Paris who provided him with opportunities to participate in such group exhibitions as "The Salon of American Artists," held at the Galleries of Jacques Seligmann in July 1928.[25] Through his friendships with English-speaking artists, Calder met many European artists including Jules Pascin, José de Creeft, Joan Miró, and Piet Mondrian.[26]

Calder did not speak French, although soon he began to take lessons. Therefore, his initial associations with artists included those with whom he could communicate easily. For example, he did not meet Picasso, who had evolved a late Cubist series in the early 1920s and was soon to collaborate with Julio Gonzalez on direct-metal construction in an openwork format. Calder would become aware of this sculpture as well as the transparencies of Jacques Lipchitz, which also emphasized open spatial volumes outlined with planar or linear elements in metal. The Surrealists had yet to make sculpture, but Miró attached collage elements to his canvas and made a richly evocative, personal statement that would attract Calder's attention. By the 1920s, therefore, Calder shared with many European modernists the incentive to search for new forms, materials, and content, particularly for sculpture.

One of the first artists Calder met upon his arrival in Paris was the English printmaker Stanley William Hayter.[27] Although Hayter's Atelier 17 became a popular meeting place for a number of Surrealists in the 1920s, Calder did not work there until the 1930s. Hayter and Calder both had scientific training, for Hayter had worked as a chemist before turning to art. Despite a lasting friendship between the two, which included sharing a summer house in St-Tropez during the summer of 1927, Calder never discussed science or his work with the Englishman. Hayter recalled that both he and Calder shunned the café discussions popular among the French artists, and that the American had no time for the factional bickering that often took place there.[28]

Calder became aware of contemporary trends in art through his friendships with Hayter and with José de Creeft. His further efforts in direct carving and metal construction were stimulated by frequent visits to the studio of de Creeft.[29] Hayter recalled that until de Creeft left for New York in 1929, a group of young American and English artists used to "frequent" de Creeft's studio on the rue Broca near the Santé. José de Creeft, whose personal interests were in direct carving and metal sculpture, had lived in Paris since 1905 and, according to Hayter, "knew everyone."[30] A small, friendly man who was very serious about his work, de Creeft knew but was often overshadowed by his fellow Spaniards working in Paris, especially Picasso, Gonzalez, and Gargallo. In de Creeft's studio Calder saw not only de Creeft's wood and stone carvings, but also direct-metal constructions by the Spanish artist Pablo

Gargallo. At the time, de Creeft had begun to work in direct metal, a technique favored by his friend Gargallo.[31]

Writing about his studio on the rue Daguerre, Calder recalled, "I still considered myself a painter and was happy to be in my own workroom in Paris."[32] Because paintings Calder created during his first years in Paris have not been located, it is impossible to determine whether these works resemble earlier examples from his years of study at the Art Students League. Stanley William Hayter remembered only Calder's drawings of this period, which the latter attempted to sell to advertising agencies.[33] Calder drew single-line portraits at this time, which were a further development of the technique he had mastered at the Art Students League. Portrait drawings of department store buyers,[34] a series commissioned by the *Paris-Herald Tribune* in 1927, parallel Calder's first wire portraits of that same year. These pen-and-ink sketches were created in lines of uniform width, which make them pictorial equivalents of Calder's single-gauge wire sculptures.

Although Calder still preferred to think of himself as a painter, by 1927 wire, pliers, tools, and a workbench were installed in his studio. Calder realized that the wood and wire "toys" he could design would provide a better source of income than his sketches. Clay Spohn recalled that Calder received a number of commissions:

> Calder got an idea for a mechanical display piece for a cleaning and pressing establishment on the Boulevard Raspail. . . . It was made of wire and cardboard with a clock attachment so that it would operate continuously. The cardboard was attached to the wire, which in turn was attached to the clock in some way. On one piece of cardboard there was painted a man bending over with a surprised look on his face and his arms and hands outstretched. This was a cutout to fit the dimensions of the man. Then there was another piece of cardboard cut out to resemble just a leg and foot (without showing where it came from). Every so often the leg and foot would move up and kick the man bending over in the seat of the pants causing the man to be lifted off the ground. It was a very humorous sort of thing. Just the sort of thing the French would be amused with. And it did attract considerable attention.[35]

Throughout his long artistic career Calder instinctively put aside his brushes and paints for metalworkers' tools and wire. In an article for the *New York Herald* in 1927, Calder wrote:

> But it seems that during all of this time I could never forget my training at Stevens, for I started experimenting with toys in a mechanical way. I could not experiment with a mechanism

as it was too expensive and too bulky, so I built miniature instruments. From that the toy idea suggested itself to me so I figured I might as well turn my efforts to something that would bring remuneration.[36]

Although he initially had orders for several mechanical window displays from local merchants, he also began to make toys. The toys were not "mechanized" but were equipped with moving parts. Articulated animals and cowboys on horseback could be pulled along by a string or pushed by a wooden bar attached to the back of the toy. Wheels turned and the heads of animals bobbed back and forth as the toys advanced. Hayter recalled:

> It was then possible to live with very little money in Paris, although we all had problems finding the small sums needed and around this time Sandy's activity in making toys must have started. I can remember his naive astonishment at the coldness of toymakers to his ingenious models which so delighted children and ourselves.[37]

Clay Spohn remembered that Calder dropped out of sight for more than a month and announced that he did not wish to be disturbed. Later his friends discovered that he was working on toy designs for a French manufacturer. Calder had hoped to earn a steady income in royalties so that he would have the financial security to continue his wire sculptures, but no French companies were interested in his designs.[38] Later an American company did purchase some of his moving animals.

Calder's toys were the immediate precedent for his first major artistic production, his miniature circus. They are also an important step in the development of his wire sculpture. Through these designs, which were essentially caricatures of animals articulated in wood and wire, he isolated the essential characteristics of the animals to be represented, as he had done earlier for *Animal Sketching*. Lengths of wire were combined with pieces of wood to describe the animal forms. Eventually the wooden elements were eliminated and the entire toy was constructed completely in wire. In *Horse and Rider* (Fig. 23), head, tail, forelegs, and back legs all move separately as a result of Calder's skillful twisting of lengths of wire through a pierced wooden cylinder. The horse is attached to small wheels, and by means of a rope it can be pulled along the ground. In his autobiography Calder credited his friend Clay Spohn with the idea of constructing figures completely from wire,[39] but Spohn recalled only that when he visited Calder's studio in Paris, the two artists shared a mutual interest in tactile sculpture.[40]

> We talked about the possibilities of various kinds of material to work with in order to create new sensations and effects. It

48

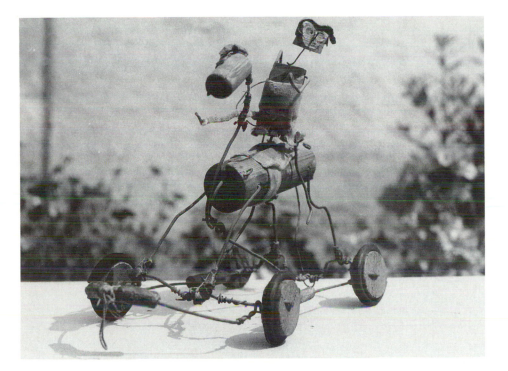

FIGURE 23. Alexander Calder. *Horse and Rider*, 1926. Wood, cloth, cork, and wire, 9" × 9½". Collection unknown.

was then that we discussed the possibilities for tactile objects to be touched and felt – a combination of various materials and surfaces for the purpose of giving new experiences to the persons who felt them – "touchables" I expect one might call them. As we talked Calder pulled out a length of wire he had on him someplace, then a pair of pliers, and he started making a wire sculptured portrait of me.[41]

Calder's first wire sculptures in Paris, such as *Josephine Baker* (Fig. 24) and *Boxing Negro* (Fig. 25), were not only the result of conversations with Clay Spohn but were related also to his earlier line drawings made under the tutelage of John Sloan and Boardman Robinson. And there are interesting precedents by other artists for Calder's portraits in wire (Fig. 26), begun in 1927. Jean Crotti's wire *Portrait of Marcel Duchamp* (1915; Fig. 27) is a possible source of inspiration. Swiss-born Crotti came to New York in 1914. Within a year he had met Marcel Duchamp, his future brother-in-law, and had begun his short-lived Dada period. Crotti was given a solo exhibition at Montross Gallery in 1916. In the following year his *Portrait of Marcel Duchamp* was shown at Montross Gallery in a joint exhibition with Duchamp and Jean Metzinger.[42] Calder, who was then at the Stevens Institute of Technology, might have seen this exhibition while visiting his parents in New York. There was also a large sketch of the *Portrait of Marcel Duchamp*[43] that Calder might have seen reproduced, as a photograph of the sculpture was published in *The Soil* in December 1916.[44] Calder may have met Jean Crotti through the American artist Man

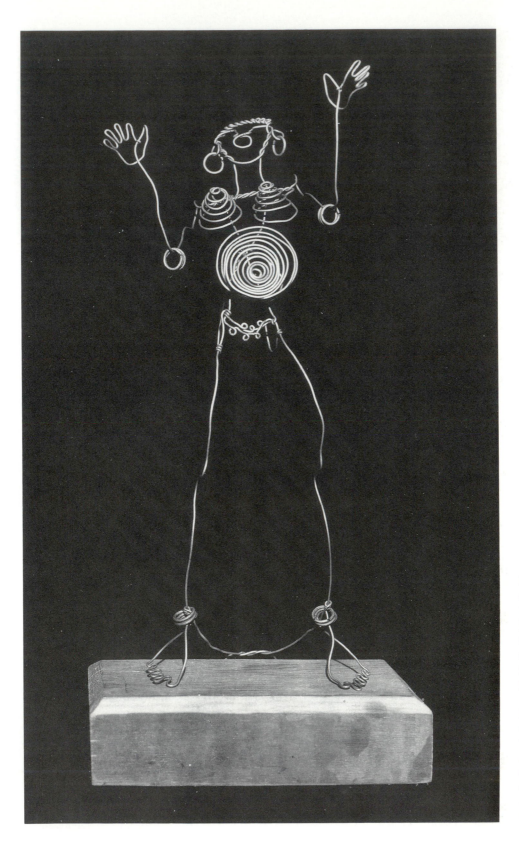

FIGURE 24. Alexander
Calder. *Josephine Baker*, 1926.
Wire. Collection unknown.
Photo: Peter A. Juley & Son
Collection, National Museum
of American Art, Smithson-
ian Institution, Washington,
D.C.

FIGURE 25. Alexander
Calder. *Boxing Negro*, 1926.
Wire. Collection unknown.
Photo: Peter A. Juley & Son
Collection, National Museum
of American Art, Smithson-
ian Institution, Washington,
D.C.

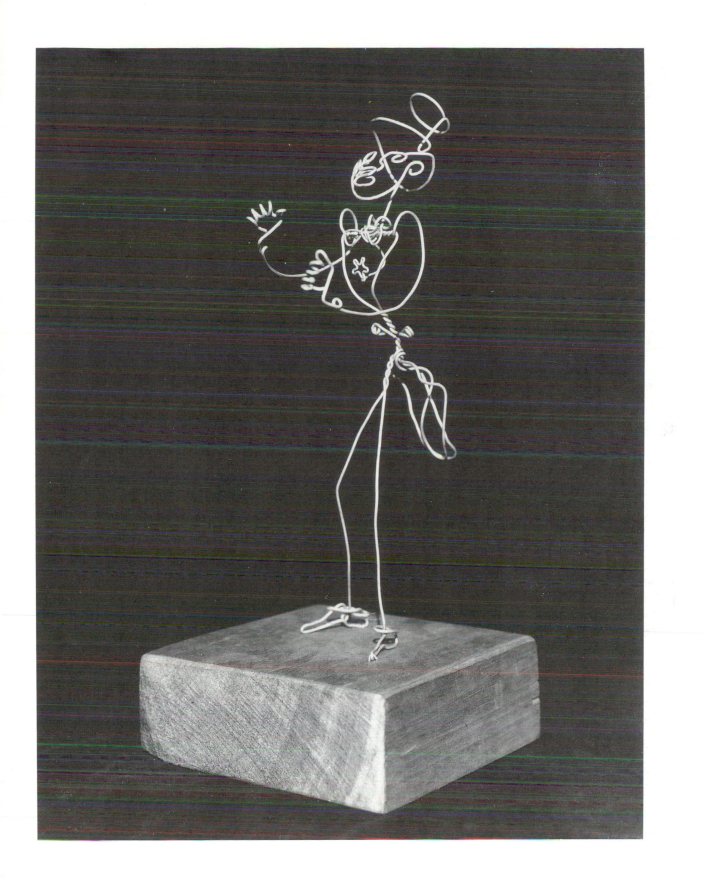

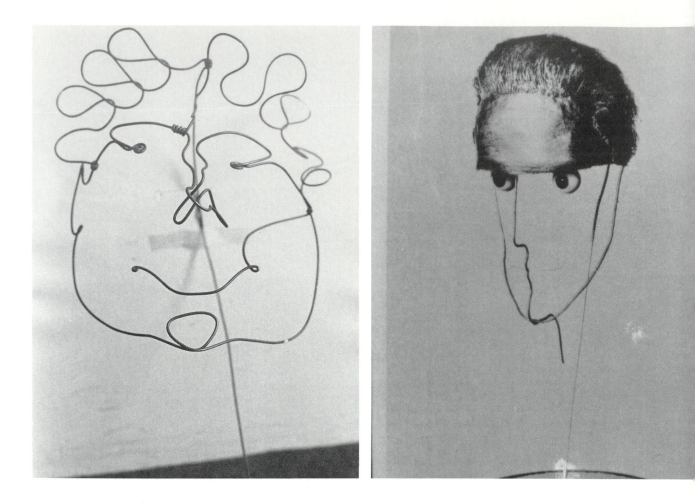

Ray, who befriended Crotti's wife, Suzanne Duchamp, in the 1920s.[45] Both Calder and Crotti outlined the volumes of the head by twisting and bending a single length of wire and supported the portraits by attaching one piece of thicker wire connecting the back of the head to the base. Calder's portraits are more complex in formal terms than this unique example in the oeuvre of Crotti, but the approach to the wire medium is basically the same. In the *Portrait of Marcel Duchamp*, some of the distinctive features of the French artist are suggested by the addition of porcelain eyes and a fabric pate. Calder preferred to construct his likenesses (Fig. 28) completely out of wire. He was skillful in capturing not only features but something of the personality of the subject. When questioned about his method of constructing a wire portrait, Calder said, "Where you have features you draw them, where there aren't any, you let go."[46]

Calder later acknowledged his attraction to the works of Paul Klee. Although no direct contact between the two artists can be established, the American certainly had ample opportunities to see exhibitions and publications that

FIGURE 26. Alexander Calder. *Portrait of Carl Zigrosser*, 1928. Wire, 21¼" × 10¼". Philadelphia Museum of Art.

FIGURE 27. Jean Crotti. *Portrait of Marcel Duchamp*, 1915. Wire, porcelain, fabric (destroyed). *The Soil*, 1, December 1916.

included Klee's works on paper. The single-line drawings of Klee (Fig. 29) are remarkably similar to Calder's wire caricatures. Two years later, Calder's involvement with Klee's drawings can be specifically documented.

There are other possible sources for Calder's wire sculpture. In 1915, the Italian Futurist Giacomo Balla created constructions of wire and other materials that were three-dimensional equivalents of the interpenetrating vortexes found in his paintings. These abstract works were illustrated in *Futurist Reconstruction of the Universe*, a manifesto prepared by Balla and Fortunato Depero in March 1915. Balla's wire sculpture entitled *Line of Speed + Vortex* (known only in a later reconstruction)[47] was succeeded in 1922 by a series of dancing figures created as lively, single-line drawings. Later Balla fashioned some wire sculptures of dancers (Fig. 30) based on these drawings commissioned as murals for the Bal-Tik-Tak, the first nightclub decorated by a modernist in Rome.[48] Although Calder probably did not see these wire sculptures, he may have known Balla's drawings of dancers. Calder's *Acrobats* (1929; Fig. 31) are similar to Balla's drawings of two figures, though the latter are admittedly more decorative. The supple bodies of the acrobats are captured in Calder's spirited drawings in wire. With his mastery of the significant line rendering both contour and expressive movement, the artist demonstrates his skill in suggesting figures in motion. By contrast, the wire figures of Balla appear more angular and abstract, composed of calligraphic lines, not always descriptive of form.

The American artist's first exposure to the Italian Futurists – if not specifically to Balla's sculpture – had been in 1915 when they exhibited at the Panama-Pacific Exposition in San Francisco. Alexander Stirling Calder supervised all sculptural programs for the exposition, and his son, seventeen at the time, visited them.[49] Although Giacomo Balla's paintings were shown in San Francisco, his related sculptures were not. But his works were known to the Parisian avant-garde of the 1920s. He was included in a Futurist exhibition at the Galerie Reinhardt in May 1921, and at the International Exposition of Decorative and Industrial Arts, Balla, along with Depero and Enrico Prampolini, was a major exhibitor in the Italian Pavilion. Balla came to Paris at the time of the 1925 exposition, where his "overall" decorative project for the cabaret Bal-Tik-Tak was probably on view. The Futurist's sculptural and decorative projects of the 1920s were also known through contemporary journals.[50] Calder's wire acrobats and dancers could be related to Balla's figures. Although Calder did not specifically mention Balla as a source of inspiration, he did acknowledge the Futurists and their interest in motion in a catalogue essay prepared for the Berkshire Museum in 1933. Calder seems to have been more interested and aware of Futurist art and theory than has been previously acknowledged.

Calder's wire sculpture was in itself a significant extension of the Cubist and Futurist notions about sculpture. In 1912, the Cubist Archipenko – whose work, as we have seen, was frequently shown in New York in the 1920s – had

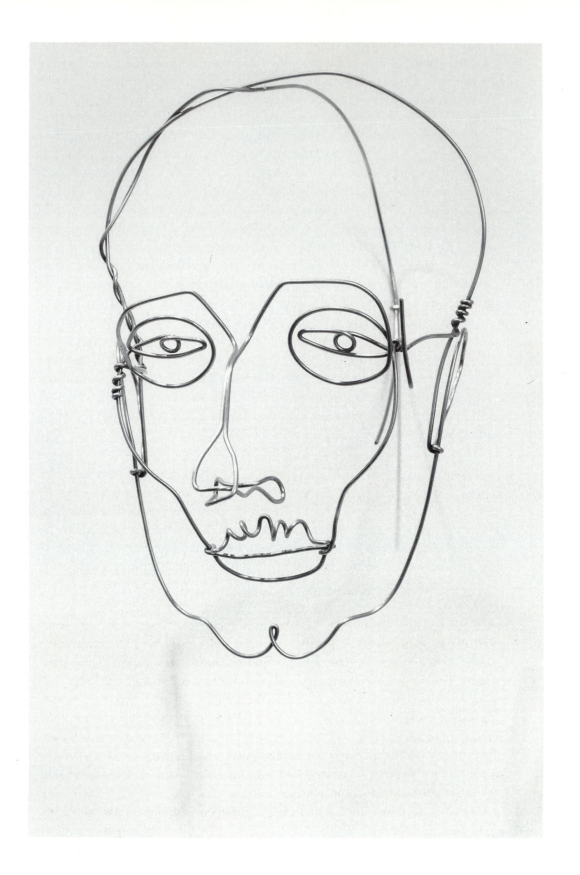

54

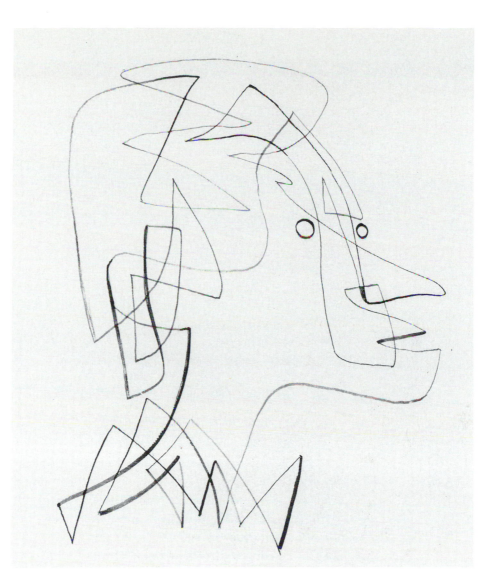

FIGURE 29. Paul Klee. *Verging on Despair, Portrait*, 1927. Ink on paper, 18¼" × 12". New York: The Solomon R. Guggenheim Museum.

FIGURE 28. (*opposite*) Alexander Calder. *Portrait of a Man*, c. 1929. Brass wire, 12⅞" × 8¾" × 13½". New York: The Museum of Modern Art. Gift of the artist.

been among the first to pierce the sculptural mass and to introduce space as part of the composition. Both the incorporation of space as an active component in sculpture and the introduction of industrial materials were proposed in Boccioni's "Technical Manifesto of Futurist Sculpture." Balla and Depero's *Futurist Reconstruction of the Universe* described the possibilities for movement, transparency, and even sound for the new sculpture. Wire, foil, mirrors, and celluloid were suggested as materials for sculpture, and Balla's abstract works in wire, string, and woolen yarn were reproduced in this manifesto.[51] In the early twenties Russian Constructivists Naum Gabo and Antoine Pevsner made abstract sculptures that stressed space over mass and used linear elements (or sculptural edges) to realize their perceptions of the world, to convey the direction of forces.

In 1926, the Cubist sculptor Jacques Lipchitz introduced his own version

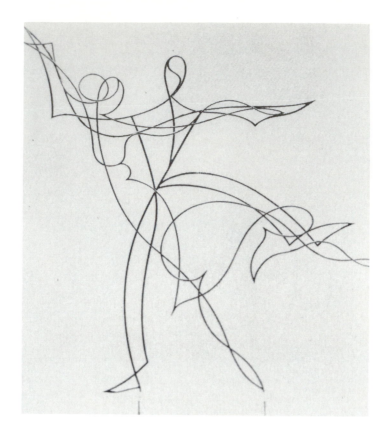

of a drawing in space with his "transparents." Even before the more "linear" drawings, a small bronze, *Seated Man* (1925; Fig. 32), reinterpreted the human figure from sculptural mass to abstracted, calligraphic symbol – balancing spatial volumes with curvilinear forms. Whereas he had previously created Cubist sculpture based on tightly interlocked volumes, by the mid–1920s Lipchitz employed linear forms that curved through space.[52] However, Lipchitz chose to cast his transparencies in bronze, using a traditional method rather than the direct construction in metal favored by Gonzalez and Picasso. Calder's wire sculptures seem far more descriptive of his subject than Lipchitz's transparencies, but Calder worked directly in industrial metals, which afforded more possibilities for varied abstract – and eventually kinetic – works.

Pablo Picasso and Julio Gonzalez began soldering pieces of wire into open-form sculptures in the late twenties.[53] Their constructions, more abstract than Calder's, were mainly composed of straight pieces of metal or wire soldered together. Calder rejected welding techniques but could bend and twist wire to rival the fluidity of a continuous line drawing. His sculptures were more literal interpretations of the subjects represented, and he used a medium-gauge wire, which was more flexible than the iron rods preferred by Picasso and Gonzalez. His choice of material eliminated the need for soldering and enabled his sculpture to quiver when touched, perhaps an early indication of an interest in movement. Calder continued to use flexible wire throughout his

FIGURE 30. Giacomo Balla. *Pas de Deux*, c. 1922 (reconstruction). Wire. Collection unknown.

FIGURE 31. Alexander Calder. *Acrobats*, 1928. Wire, 34". Honolulu Academy of Arts.

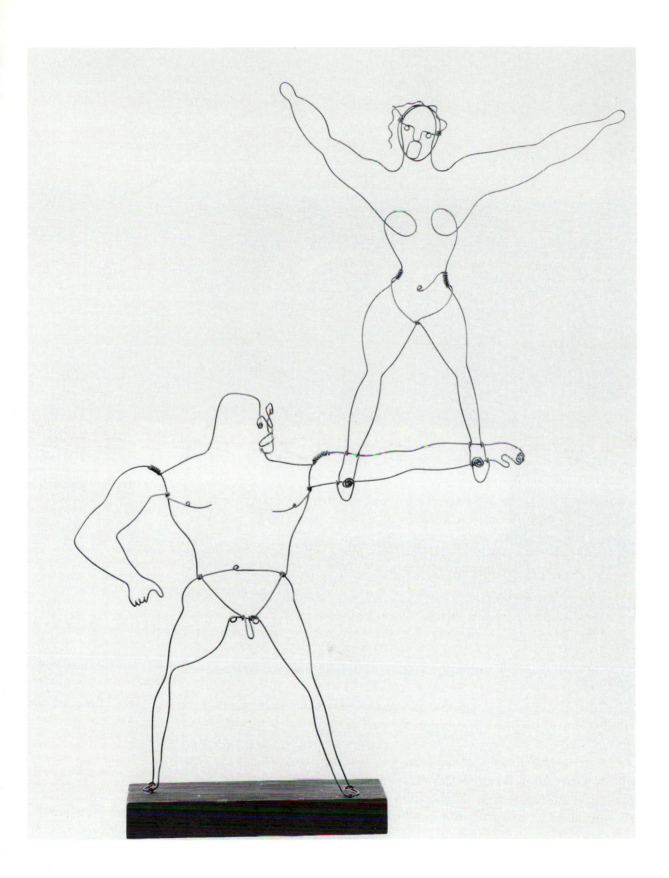

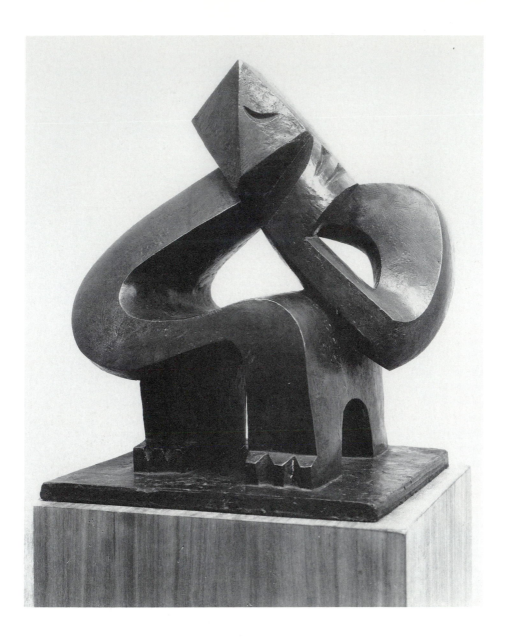

artistic career, and realized the full implications of the Cubist–Constructivist sculptural idiom.

Rearing Stallion (1928; Fig. 33) is one of Calder's most ambitious wire sculptures, and he submitted it to a group show of American artists in Paris.[54] The work, almost twenty-five inches high, is considerably larger than most of his other sculptures of the period and foreshadows the dynamic equilibrium of his stabiles. The horse, balanced on its rear legs, is a figurative prototype for later monumental works composed of sheets of metal that appear to have a similar buoyancy. The circus animals in motion drawn during his student years were a fitting preparation for this line drawing in wire, which captures a momentary pose with similar vitality. Calder has skillfully rendered the line,

FIGURE 32. Jacques Lipchitz. *Seated Man*, 1925. Bronze 13½″ × 12″ × 9⅝″. New York: The Museum of Modern Art.

FIGURE 33. Alexander Calder. *Rearing Stallion*, 1928. Wire, 22¾″ × 13½″ × 9¼″. New York: Perls Galleries.

58

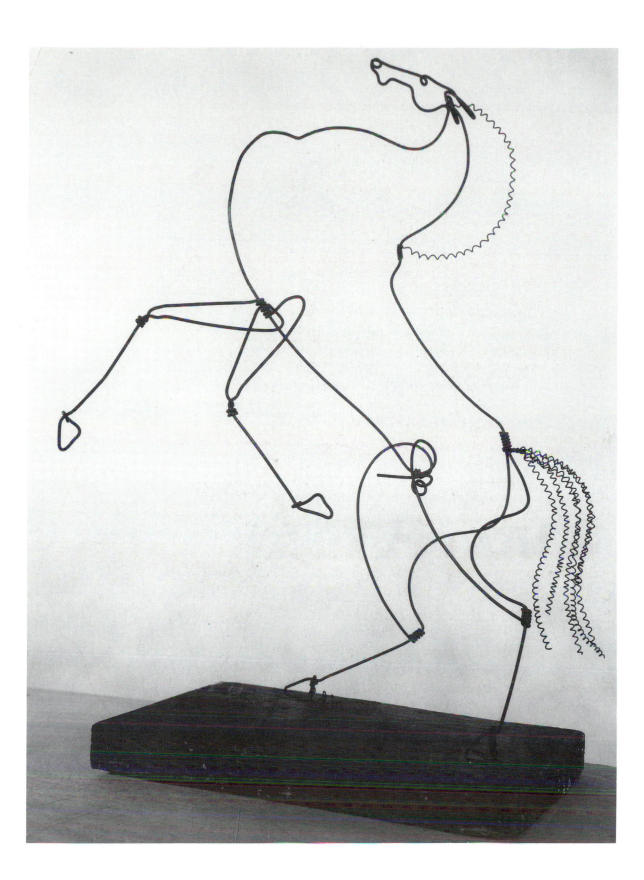

which describes the volumes of the horse's body rather than merely a silhouette.

Calder's most important innovation in the development of his wire sculpture was the suspension of these works from a single wire thread. A small wood-and-wire caricature of a monkey was the first, soon followed by several caricatures of Josephine Baker, in 1925 the international sensation of *La Revue Negre* and star of the Folies-Bergères[55] (Figs. 34–35). The American-born Baker came to Paris when she was nineteen and startled European audiences with her uninhibited sexuality and exuberant dancing. Calder intended the supple wire body to be free to quiver, sway, and rotate at will, a fitting parallel to the agility and sensuality of actual performances by the show-stopping "Ebony Venus." These suspended wire constructions took Calder one step closer to the creation of his wind-driven mobiles of the 1930s. Even before he began composing abstract elements to form mobiles, Calder had taken into account the delicate equilibrium the sculpture would need to hang properly and move freely. Kineticism had first appeared in the Futurist sculpture of Balla and Depero, and had also been advocated by the Russian Constructivist Gabo in his motorized construction of 1920. Another precedent for Calder's suspended wire sculpture is Alexander Rodchenko's *Suspended Composition* of 1920. These hanging constructions of concentric circles could move freely in space and suggest the rhythms of the modern era.[56] *Josephine Baker* is more literal and descriptive of an agile body, but it is Calder's first essay in kineticism, an interest that occupied him for decades thereafter.

During the winter of 1927, performances of Calder's circus began in his small studio on the rue Daguerre, and soon European artists and the literati were gathering to see them. The twenty-five-franc admission charge produced a welcome source of income,[57] and for the next few years Calder continued the performances, bringing together an assortment of artistic notables.

The first circus figures were made early in 1927 when Calder was designing toys for the Salon des Humoristes of the same year. His fascination with the circus, as noted in Chapter 1, had begun at least as early as the months he worked as an illustrator for the *National Police Gazette*. It had inspired some of his early paintings and continued in his construction of performers made of wire attached to cork, wood, or cloth. From these humble materials he now formed acrobats, tightrope walkers, jugglers, and animals.

The circus troupe grew in the following years, as did its popularity in Parisian art circles. Many Americans were living in Paris at the time, and there was a great fascination among Europeans for all that was American. Of course, Paris had its own great circuses, including the famed Cirque Fratellini, which Calder surely attended because of his friendship with the Fratellini brothers, clowns for whom he made a toy dog.[58] But Calder's handcrafted miniature circus was a novelty to the French. By word of mouth, probably, Calder's circus came to be known. Such artists as Pascin, Miró, Man Ray, such critics as Gustave Fréjaville and Legrand-Chabrier, writers, and composers came to

FIGURE 34. Alexander Calder. *Josephine Baker*, 1927. Iron wire, 39″ × 22⅜″ × 9¾″. New York: The Museum of Modern Art. Gift of the artist.

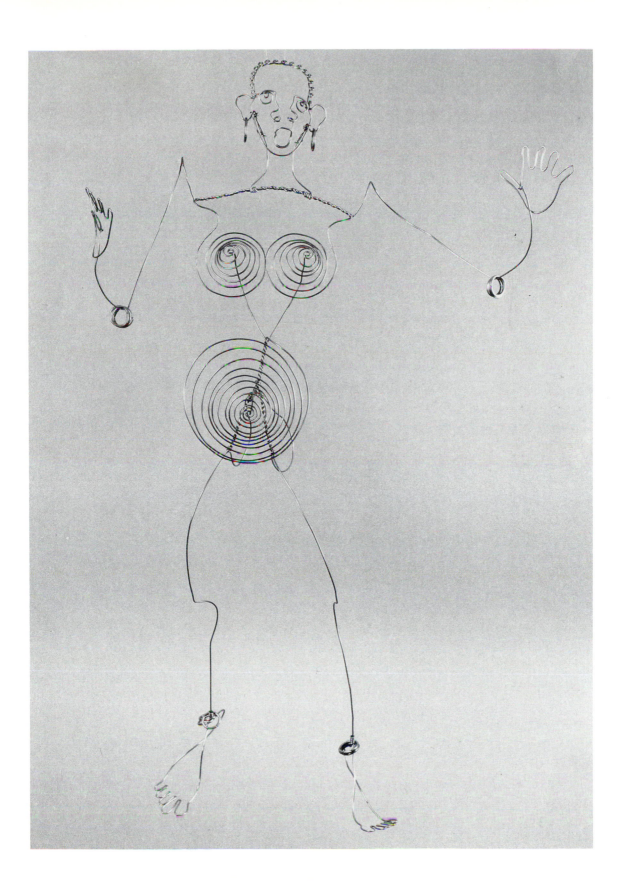

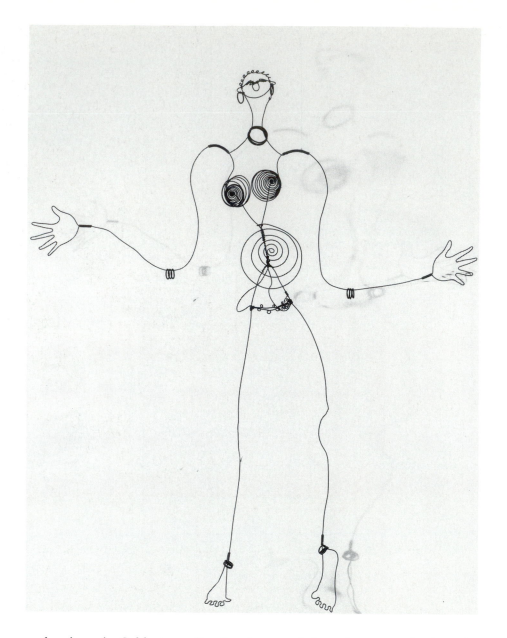

see the circus in Calder's studio. Surely one of the primary motivations for creating and expanding the circus was economic necessity. In his autobiography Calder mentioned that he paid his rent on one occasion by giving performances of the circus on four consecutive evenings at four dollars per person.[59] In Calder's modest flat, the circus was a unique event. "Bleachers" were made of empty champagne crates, and the artist knelt on the floor to operate his articulated wonders, while music blared from a nearby phonograph – different songs to announce the various acts. There was laughter, clapping, and considerable imbibing on these evenings of fun. Whether the audience consisted of the affluent or the bohemians of Paris, Calder offered his audience the same seating – and the same remarkable show.

FIGURE 35. Alexander Calder. *Josephine Baker*, 1927. Wire, 38″. Paris: Musée National d'Art Moderne.

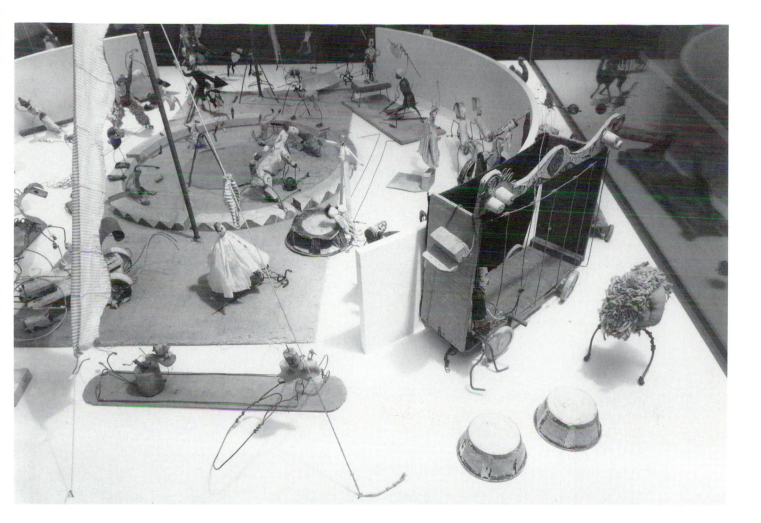

FIGURE 36. Alexander Calder. *Calder's Circus*, 1926–31. Mixed media. Wire, wood, metal, cloth, yarn, paper, cardboard, leather, string, buttons: 54″ × 7′10¼″ × 7′10¼″. New York: Whitney Museum of American Art. See acquisition credits on page 302.

Not only was the *Circus* a pilot experiment with a group of kinetic objects and a means of financial support, it also attracted attention to Calder's other works and resulted in exhibition reviews in Paris, Berlin, and New York during the late 1920s. Such writers as Gustave Fréjaville and Legrand-Chabrier were soon featuring Calder's sculptures in articles for *Candide*, *Comoedia*, and *La Volonté*.

For years thereafter Calder gave performances of his circus at the homes of friends or private collectors, in his own studio, and in vacant storefronts.[60] When asked by a critic what interested him about the actual circus that might have had an impact on his own work, Calder responded: "I was very fond of the spatial relations. I love the space of the circus. I made some drawings of nothing but the tent. The whole thing of the – the vast space – I've always loved it."[61]

Photographs of Calder's miniature *Circus* (Fig. 36) reveal an emphasis on spatial relationships. A later filmed performance produced by Pathé shows Calder unfolding carpets, putting up poles, and hanging wires for the min-

iature trapeze and tightrope acts. With a few slender supports, an improvised net, and an assortment of wooden planks, the circus became a complete spatial statement. In the midst of all these devices, animals and figures manipulated by the artist activated the surrounding space. Calder blew whistles and made animal sounds to add to the excitement. The *Circus* is a kinetic and spatial composition that foreshadows Calder's years of experimentation with abstract kinetic devices. The tiny articulated figures interact with one another or perform independently in constantly changing spatial relationships; later the individual elements in a mobile "performed" in a similar manner. The use of chance, surprise, and suspense, inherent in circus performances, is found also in the wind-driven mobiles.

Twenty-five years earlier, Picasso's paintings of the "rose period" showed the circus as a microcosm of the human experience. Amid the laughter and excitement generated by Calder's *Circus* there is also a poignant note. In an interview with Cleve Gray, Calder recalled a performer who "did a hundred flops hanging by her wrist from a wire."[62] After commenting on his fascination with the spotlight that illuminated the performing figure, Calder continued: "I remember going down once when she took off the leather wrist band from which she flopped and flopped; her wrist had abscesses on it. Later on when I saw her in Paris she could only do sixty flops and finally she was killed."[63]

In his typically laconic manner, Calder added only this brief remark about the human condition as it is reflected in his *Circus*: "Most people see the surface that's funny, but there's a lot that goes on."[64] Calder recognized in the circus something that suited his temperament. Outwardly clever and carefree, the life of the circus performer is often filled with personal torment, with the compulsion to entertain, even at the expense of health, and with the need to shield one's true feelings behind a laughing mask. Like other modernists, Calder was able to express the concerns of his age, the alienation of modern life, in a subject derived from popular culture.

For various reasons, including their disenchantment with the bourgeoisie and their desire to escape from the realities of a strife-ridden world, the Surrealists, especially Joan Miró, were attracted to the Parisian circus. In fact, the literary and artistic patrons of the circus so delighted in Calder's miniature version that it became one of the most popular pastimes in Montparnasse. Early in 1927 the English novelist Mary Butts encouraged Jean Cocteau to attend. He was joined by a number of circus critics, who acclaimed Calder's production in *Candide*.[65] Gustave Fréjaville provided additional publicity.[66] Calder's *Circus* was his first work to receive considerable critical attention, although short articles and illustrations of his wire sculpture had appeared in the French press as early as August 1927.[67]

When Calder met José de Creeft, probably early in 1927, initially he was drawn to the carved sculpture that filled the other artist's studio. According to de Creeft, Calder liked his work and carefully examined many of his carvings. De Creeft recalled, however, that the two of them never discussed

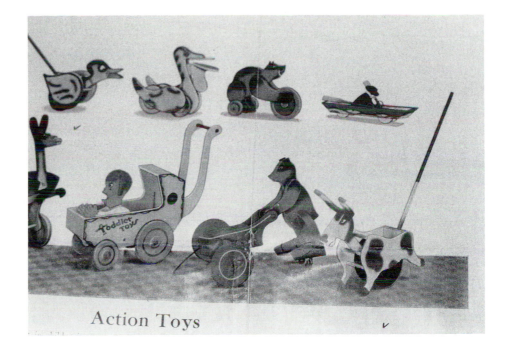

Action Toys

FIGURE 37. Alexander Calder. *Action Toys* brochure, 1926. Washington, D.C.: Archives of American Art, Smithsonian Institution, Calder Papers.

direct carving, and de Creeft was not even aware of the quantity of wood carvings Calder made within the following years. It was de Creeft who persuaded Calder to submit some of his humorous toys made of wire and cork to the Salon des Humoristes in March of 1927. This Parisian salon had a long history extending back for decades, and featured the work of artists and craftsmen who made toys and whimsical devices in a variety of materials. De Creeft had sent some of his own works to the salon and was enchanted with Calder's playful creatures. For example, Calder devised a wire dog that he attached to a spigot in de Creeft's studio. The dog lifted its hind leg when the water was turned on.[68]

Art of any kind was rarely discussed during Calder's encounters with de Creeft. The Spaniard knew very little English, and although Calder was learning French, he did not speak it fluently. Some of Calder's wood carvings, however, show that he was strongly inspired by what he saw in de Creeft's studio. The older artist summarized Calder's contact with his work: "He look and then he do."[69]

Calder returned to the United States again, in the fall of 1927, probably to find a buyer for his toy designs and to arrange for a show of his sculpture. He traveled to Oshkosh, Wisconsin, where the Gould Manufacturing Company hired him to design a set of children's toys. Calder's *Action Toys* (Fig. 37), gaily painted wooden animals attached to wheels, were closely related to some of the mechanical animals in his *Circus* and gave him additional experience with the representation of moving forms.[70] All of his toys seem to continue the fanciful animals created by American folk artists. Some of these amusing folk art toys, complete with movable parts, suggested many possi-

bilities for Calder's creation of colorful and amusing animals on wheels. But his surpass earlier examples in the inventive use of moving parts. Having carefully observed the actions of certain animals in his student years, Calder was now able to mimic the frog's jump or the way a duck bobs forward.

During the winter of 1927–8, Calder lived with his parents at 9 East Eighth Street in New York City, where he continued to make wire sculpture. On February 20, 1928, Calder's first one-man show opened at the Weyhe Gallery and Bookstore, 794 Lexington Avenue. Carl Zigrosser – later a distinguished author and specialist on prints – who was then director of the gallery, remembered Calder as a frequent visitor to Weyhe's exhibitions of young American and European modernists.[71] When Calder brought some of his wire constructions to Zigrosser, the director agreed to show his work. Zigrosser had an excellent record in selecting American modernists and was an early champion of the carvings of John B. Flannagan. Many artists were given deserved recognition in the 1920s through Zigrosser's efforts on their behalf.

To attract pedestrians along Lexington Avenue to the second-floor gallery, Calder fashioned a wire sign to hang outside the shop's entrance. The sign (Fig. 38) was suspended from a single hook, leaving the acrobat free to swing back and forth as if she were balanced on a trapeze. The swinging sign is related to traditional ornamental wrought-iron signs outside taverns and shops and suggests the continuing impact of folk art on Calder.

Zigrosser and Calder chose about fifteen works for the exhibition and priced them from ten to twenty dollars.[72] Reviews of the show acknowledged that Calder's wire sculpture seemed at first "only an inordinately clever trick, vastly amusing," but that the artist "made of his subjects designs that are not only humorous but telling."[73] One critic was concerned that Calder was merely a "trickster," but recognized in his "acme of elimination" something innovative.[74]

By March 1928, Calder's wire sculptures had grown in scale well beyond the small circus figures, and he entered two of his largest pieces – *Spring* (Fig. 39) and *Romulus and Remus* (Fig. 40) – in the annual exhibition of the Society of Independent Artists.[75] According to Zigrosser, Calder caused a sensation among pedestrians along Fifth Avenue by wheeling his nine-foot-long sculpture of *Romulus and Remus* in a wagon to the Independents' show at the Waldorf-Astoria.[76] Calder requested that a photograph of *Spring* be included in the catalogue at his own expense, and he listed the price of the work as $99.44.[77] Although Calder had a flair for the sensational, it is certain he considered these large wire figures to be a serious artistic undertaking. The pieces he submitted to the Independents' exhibition were larger than life-size and had the same monumentality of conception as academic bronzes. It is possible, therefore, to see these works as a challenge to the academic sculpture of Alexander Stirling Calder, who had created the stone likeness of George Washington that stood at the end of Fifth Avenue in Washington Square. Young Calder's answer to his father's image of the Founding Father was to

FIGURE 38. Alexander Calder. *Wire Sculpture by Calder*, 1928. Wire, 49½″ × 26″ × 6″. New York: Whitney Museum of American Art. Purchase, with funds from Howard and Jean Lipman 72.168.

66

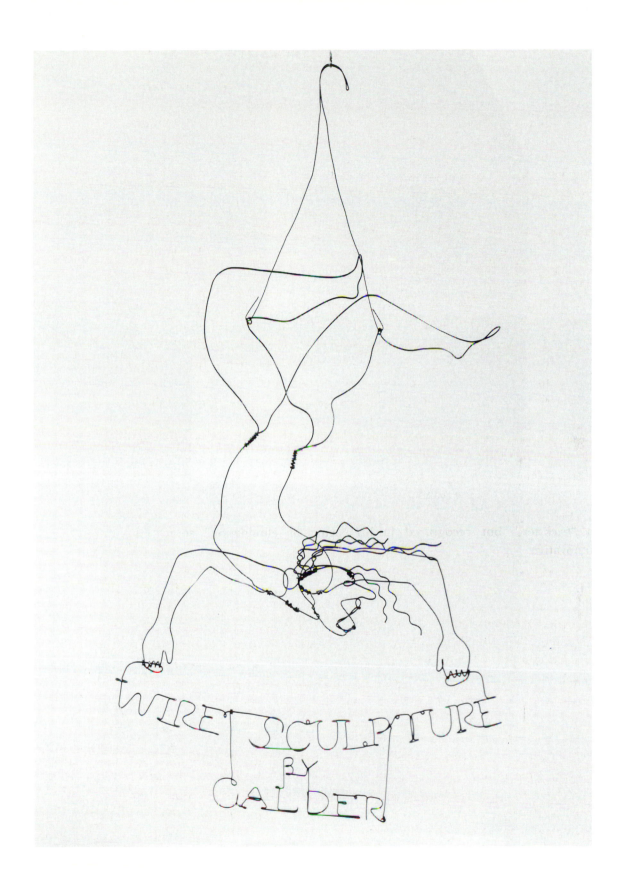

WIRE SCULPTURE BY CALDER

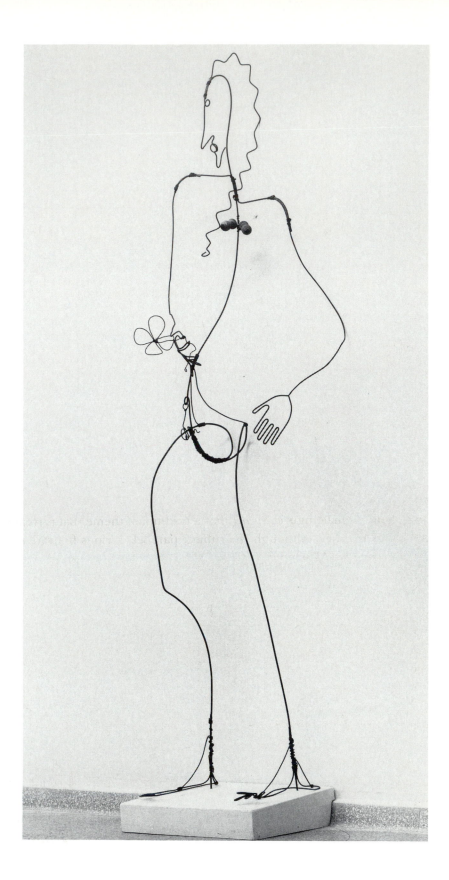

68

FIGURE 40. Alexander Calder. *Romulus and Remus*, 1928. Wire and wood, 31″ × 112″ × 30″. New York: The Solomon R. Guggenheim Museum.

FIGURE 39. (*opposite*) Alexander Calder. *Spring*, 1928. Wire and wood, 94½″. New York: The Solomon R. Guggenheim Museum.

represent the legendary founders of Rome out of wire embellished with doorstops.

The standing female figure, *Spring*, has a traditional theme that is treated in a humorous manner. Although the subject parallels serious figurative allegories in bronze by Alexander Stirling Calder, his son chose different materials with more amusing and innovative results. In the Dada spirit of the "found object," Calder fashioned the breasts of *Spring* with wooden doorstops purchased at a New York variety store.

Inspiration for *Romulus and Remus* may have come from the bronze *She-Wolf with Romulus and Remus* (c. 500 B.C.) in the collection of the Palazzo dei Conservatori.[78] Calder owned a postcard illustrating this piece.[79] With this work the artist attempted a twentieth-century rendition of a classical subject, but rather than copy the ancient bronze, Calder created a witty caricature of it, consistent with his new materials: wire and commercial wooden knobs. This is the first of a series of contemporary versions of classical subjects that Calder created during his career.

Throughout his stay in New York in 1928, Calder attended John Sloan's evening classes at the Art Students League and made large gestural drawings from the model.[80] Sloan expressed admiration for Calder's wire sculptures and urged his students to see *Romulus and Remus* at the Independents' exhibition.[81] It is no wonder that John Sloan was pleased with Calder's *Spring* and

69

Romulus and Remus, for in them his student had realized the full implications of Sloan's teaching methods. Calder had taken the basic ideas about drawing he had learned from Sloan and transformed them into very personal and innovative works, combining the lesson of the "line that contains the form" with his own mechanical ingenuity and innate humor.

By exhibiting at the Weyhe Gallery and the Independents, both of them mainstays of American modernism, Calder maintained his contact with progressive trends in New York. Many young American modernists were given exhibitions at the Weyhe Gallery in the 1920s, and carver John B. Flannagan's works had been shown there repeatedly. Probably Calder intended to interest Carl Zigrosser in his own carved works.

Most of Calder's wood sculptures were made in New York during the spring and summer of 1928. Years later he remarked about his early carvings, "I made things in wood, taking a lump of wood and making very little alteration in its shape, just enough to turn it into something different."[82] Although he may have been inspired by the peculiarities of a piece of wood, his fascination with caricature also appears in his carvings. Not until the early 1930s did Calder use a lump of wood truly as a "found object."[83] The wood carvings are not the most successful of his early works, nor are they significant antecedents for his mobiles and stabiles of the 1930s. They are massive, static in conception, and rigid in execution, often retaining the original blockiness of the piece of wood. Calder's shift away from fluid, open sculpture in which void dominated mass to solid sculptural volume produced pieces that lack the spontaneity and verve of his earlier wire constructions. What is important about Calder's direct carvings is that they indicate the range of his interests in methods and materials during his formative years. Although Calder's contact with José de Creeft and European modernists in the late 1920s has been acknowledged, his affiliation with such American sculptors as Chaim Gross and John B. Flannagan has often been ignored. The approximately forty sculptures carved by Calder from 1928 to 1930 attest to more than a passing interest in direct carving. During the same period in which he created highly imaginative linear constructions in wire and metal, he returned again and again to the volumetric solidity of wood and traditional carving methods.

Certain stylizations in Calder's early carvings and his preference for exotic woods link him with Chaim Gross, and the latter recalled talking with Calder about direct carving.[84] Gross remembered meeting Calder at the Independents' exhibition of 1928 where both were exhibiting. Gross had submitted a small female nude carved in a tropical wood, and Calder expressed an interest in this work and others that Gross was exhibiting. Calder asked where he could buy tropical woods for carvings, and Gross told him about Monteath's in Brooklyn.[85] Calder recalled buying wood from Monteath's in his autobiography[86] but made no mention of Chaim Gross and their conversation in 1928. However, both Calder and Gross carved most of their wood sculpture from such tropical woods as lignum vitae, cocobolo, rosewood, and ebony.

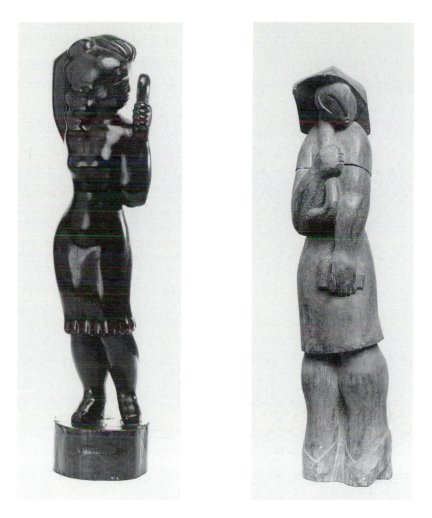

FIGURE 41. Chaim Gross. *Girl with Mirror*, 1928. Snake wood, 23″ × 6″ × 4½″. New York: Collection of Renée Gross.

FIGURE 42. Alexander Calder. *Woman with Umbrella*, 1928. Wood, 25″. Andover, Massachusetts: Addison Gallery of American Art. Gift of Curt Valentin.

Although Calder did not acknowledge his contact with Chaim Gross and his carvings, the visual similarities are too convincing to be ignored. A motif popular with both Gross and Calder in 1928 was the fashionable genre figure. Bulky legs, squat proportions, and an overemphasis on the natural curves of the female form characterize the carvings of both artists. High-heeled shoes and fashionable attire (Fig. 41) became the standard idiom for Gross,[87] which Calder easily assimilated. Calder's *Woman with Umbrella* (Fig. 42) represents his version of Gross's fashionable woman. The bulky legs and high-heeled shoes appear in this carving and in other works by Calder. The sculpture also resembles women in genre paintings and cityscapes by Kenneth Hayes Miller and Guy Pène du Bois. In his autobiography Calder noted his admiration for the paintings of du Bois, whose sophisticated female figures "looked like wood carvings."[88] Gross and Calder also shared a predilection for carvings of acrobats. Heavily proportioned totemlike figures were carved by both artists. While there are some similarities in subject matter during the late 1920s, Gross's carvings are far different from Calder's. Gross favored massive, even

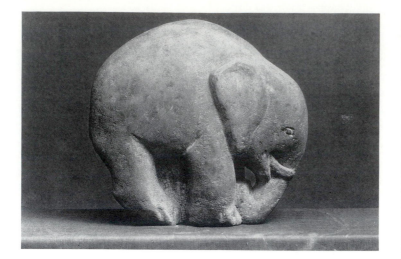

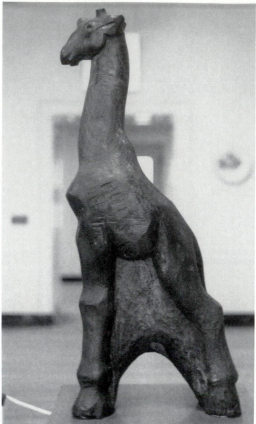

FIGURE 43. John B. Flanna-
gan. *Elephant*, 1929–30.
Bluestone, 13¼″ × 15″. New
York: Whitney Museum of
American Art 31.24.

FIGURE 44. Alexander
Calder. *Giraffe*, 1929. Rose-
wood, 45″ × 16″ × 8″. Pri-
vate collection, New Jersey.

bulbous forms in his carvings; Calder's figures and animals are sleek, cylin-
drical, elegant. His acrobats are redolent of "primitive" sources to which the
artist was attracted, and his animal carvings are lively and directly stated.
Calder's production as a direct carver lacks the fussy detail, bulbous anatomical
details, and squat proportions of Gross's carvings.

Although the direct carvings by John B. Flannagan are more austere in
form, more serious in conception, and more completely inspired by his chosen
material, he shared with Calder an interest in animals and influenced his sculp-
tures in wood. As already mentioned, Calder's experience had included direct
observation of circus animals and life studies at the zoo, and he demonstrated
a sensitivity and skill with animal carvings similar to Flannagan's. Calder's
contact with Flannagan's carving can be established by the fact that both artists
exhibited their sculpture at the Weyhe Gallery in the late 1920s. Only two
weeks before Calder's first solo exhibition at Weyhe's in February 1928, Flan-
nagan's work was shown there. Calder often stressed the humorous aspects
of his subject, whereas Flannagan created animal sculptures with dignity and
intensity. Flannagan's *Elephant* (1929; Fig. 43), carved in bluestone, can be
contrasted with Calder's larger carving, *Giraffe* (Fig. 44), which is forty-five

inches high and features exaggerated proportions and the humorous demeanor characteristic of many of his carvings.

But some subjects carved in wood were more serious and traditional. The female nude was a frequent choice for Calder. In *Woman* (Fig. 45), Calder demonstrated his understanding of the essence of the direct carving aesthetic: a tradition that extends back in time to Michelangelo and that was practiced by Calder's contemporaries Brancusi, de Creeft, and some American modernists. Out of a cylindrical chunk of wood, the sculptural form came into being as the artist chiseled the material. Calder's female nude paralleled a favorite subject of the sculptor Robert Laurent. As noted, Calder had known Laurent's work even before leaving New York for Paris (Laurent's two solo shows held at the Valentine Gallery in New York in May 1926 and March 1928 would have been accessible to the young artist). A *Torso* by Laurent that was published in 1926 may have inspired Calder's female nudes.[89] Works by Laurent and Calder share the same general proportions for the female figure. The extreme tilt of the head of Calder's *Woman*, suggesting it is not connected to the neck, and the use of stylized parallel incised lines for strands of hair also compare to similar techniques found in Laurent's carving. Calder does not mention Laurent in his autobiography, but it is possible that the two artists encountered each other at the Art Students League and that Calder continued to be drawn to this artist who shared his fascination with folk art.

During his first years in Paris, Calder returned to the United States regularly. Probably he was arranging for shows of his art in New York and seeking commissions, but he also remained close to his family in these years and was also eager to maintain his contact with New York artists. When he returned to Paris in November 1928, Calder demonstrated the impact of José de Creeft's sculpture on his renewed involvement with wood carving. In *Creative Form* (Fig. 46), de Creeft carved a spiraling, stylized figure with limbs entwined around a columnar base while consciously attempting to reveal the natural beauty of an exotic wood. De Creeft's sensitivity to the special character of his materials, and his ability to express a modernist's vision of reality through the skillful use of various woods must have impressed Calder, whose *St. George and the Dragon* (Fig. 47) of the same year resembles de Creeft's work in the intricately entwined figures. Because he admired sculpture from Cambodia, de Creeft often adopted the flattened-out noses, incised eyes, and elongated brow line found in the art of Southeast Asia. Calder used similar devices in his work, in addition to creating a visual parallel for the powerful encounter of opposing forms in an intricate composition. It is interesting to note that four years earlier this subject was used by his father for a commission in bronze. *St. George and the Dragon* (Fig. 48) was commissioned from Alexander Stirling Calder for the new dormitories of Princeton University in 1925.[90] One can only speculate whether by using materials and methods favored by American modernists Calder was attempting to make his own version of the same subject in direct competition with his father's more academic approach.

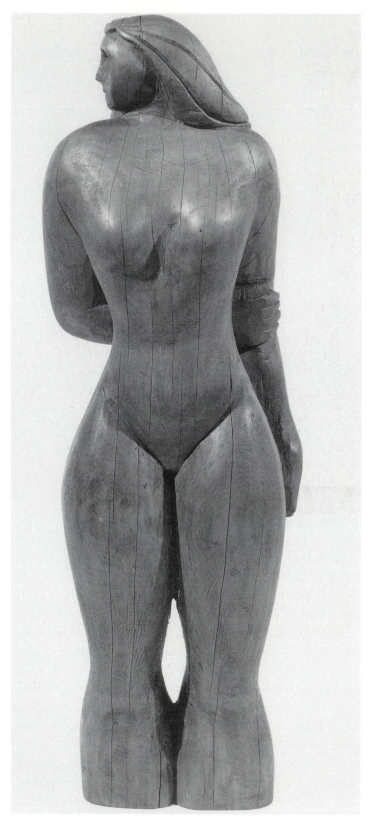

FIGURE 45. Alexander
Calder. *Woman*, c. 1929.
Wood, 24″ × 6½″ × 6″.
New York: Whitney Museum of American Art. Gift
of Howard and Jean Lipman
75.27.

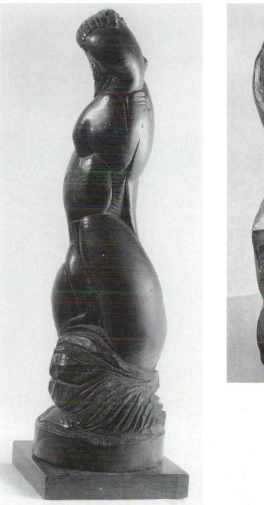
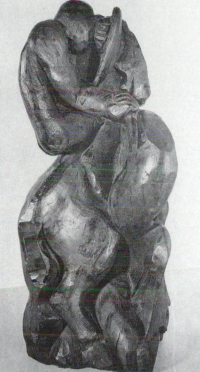

FIGURE 46. José de Creeft. *Creative Form*, 1928. Wood, 25″. New York: Collection of Lorrie Goulet de Creeft, Courtesy Childs Gallery, New York.

FIGURE 47. Alexander Calder. *St. George and the Dragon*, 1929. Wood, 24″ × 11″ × 10″. Chicago: Private collection.

Thus, after two years of making mechanical toys, suspended wire caricatures, and large sculptures in wire, Calder became totally involved in the creation of direct carvings. His friendship with José de Creeft and his contact with American sculptors stimulated him to produce a large number of wood carvings in 1928. He shifted from a fluid openwork sculpture of wire, in which void dominated mass and the form suggested the spirited movement of a figure through space, to actual sculptural volume lacking most of the spontaneity and verve of his earlier wire constructions. However, by carving three-dimensional wood sculptures during the spring and summer of 1928, Calder gained skill with plastic form that was of great importance to the volumetric character of his subsequent work in wire, sheet metal, and bronze.

In addition to creating wood carvings for possible sale, Calder sought other opportunities to generate income. Through the photographer Victor Keppler,[91] Calder obtained an order for five wire athletes to demonstrate the

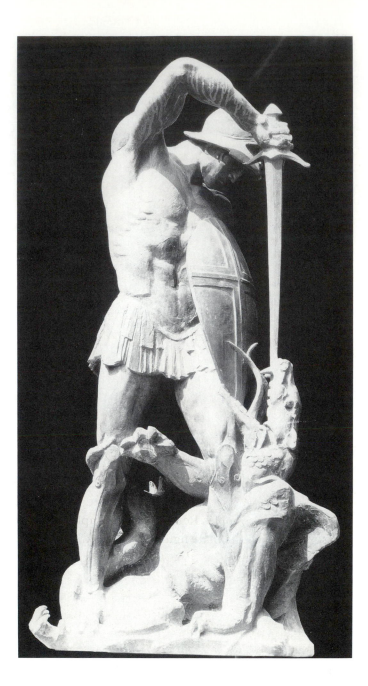

strength of eyeglass frames. In the fall of 1928, the advertising firm Batten, Barton, Durstine and Osborn paid the sculptor a thousand dollars for the figures.[92]

In late October, Calder entrusted Keppler with many of his recent wood carvings and sailed for Europe aboard the *De Grasse*. He debarked at Le Havre on November 3, 1928, and returned to Paris immediately.[93] His second residence in the European art capital was characterized by increased interaction with the abstract Surrealists probably initiated through his friendship with Miró. Calder was to meet Masson, Arp, Ernst, and Tanguy as well as many

FIGURE 48. Alexander Stirling Calder. *St. George and the Dragon*, 1925. Princeton University. Photo of maquette: Peter A. Juley & Son Collection, National Museum of American Art, Smithsonian Institution, Washington, D.C.

of their friends, and in turn these friendships had an impact on his developing career.

This European sojourn came at a time when Calder was still pursuing his interest in three-dimensional works, and mostly carvings. In actuality, few direct carvings were produced in Paris that year because Calder had developed a greater interest in his wire figures, and began to show these works. On the ground floor at 7 rue Cels in the 14th *arrondissement*, Calder rented a studio with "a big door in the rear, in case you wanted to do a large sculpture."[94] Calder's comment on this studio indicated a shift in interest from painting, which had been his chief concern at the beginning of his first sojourn in Paris. The year spent in New York apparently had influenced this change, for Calder seemed eager to continue his wood carvings.

At the Café du Dôme, Yasuo Kuniyoshi, whom Calder knew from his association with Penguin Club artists, introduced him to French painter and bon vivant Jules Pascin. Born in Bulgaria in 1885, Pascin lived in America for six years beginning in 1914. In 1920 he returned to Paris, then traveled extensively in Spain, Portugal, and North Africa until his death ten years later. Pascin had associates among American and European artists of many schools, and spent much of his time in cafés. He was the one who encouraged Calder to participate in such group exhibitions of European artists as the Salon de l'Araignée,[95] and he arranged for Calder's first solo exhibition in Paris at the Galerie Billiet in January 1929. Pascin, an acquaintance of Alexander Stirling Calder, encouraged his son to make studies in wire of works by the ancient Greeks, just as Stirling Calder had executed plaster models inspired by ancient sources.[96] Perhaps Calder constructed his *Hercules and Lion* (Fig. 49) in reaction to Pascin's remarks. *Hercules and Lion* is a classical subject, but Calder's conception of it more closely resembles Renaissance examples of the theme. The spiral composition, in which the male figure straddles the lion while grasping its jaw and chin, is found in such woodcuts and engravings of the Renaissance as Dürer's *Samson Killing the Lion*.[97] The pyramidal arrangement of Calder's figures is also similar to Dürer's composition, but Calder's sculpture also captures the overt sexual references and fanciful drawing style of Pascin himself. It is worth noting that three generations of Calders were inspired by classical art, but the third Alexander Calder synthesized the classical tradition with the modern idiom.

Calder's friendship with Joan Miró was of primary importance to the American artist's stylistic development, for Miró encouraged Calder's use of fantastic animal forms. The two first met in December 1928, but the full impact of Miró's abstract biomorphic imagery did not appear in Calder's sculpture for several years. At the time, Miró was working on a series of Spanish dancers,[98] consisting of sheets of cardboard with feathers, corks, and postcards glued to them. Calder's only comment on these works was "It did not look like art to me."[99] Calder gradually absorbed Miró's personal abstract idiom as their friendship deepened during the next few years. Finally, in the

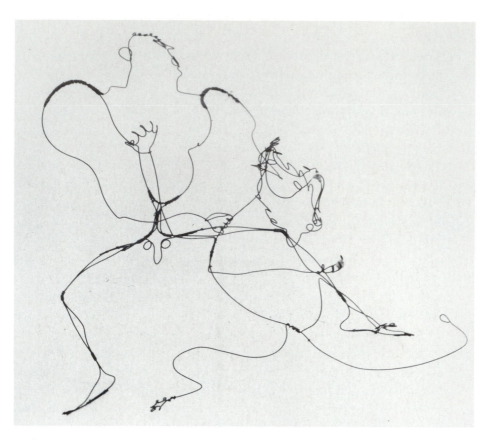

early 1930s, Miró's imagery was completely assimilated into Calder's three-dimensional style. Miró might also be credited with encouraging Calder's interest in the work of Paul Klee. Although it cannot be determined if Calder actually met Klee,[100] the Swiss artist's witty caricatures and whimsical animals executed as single-line drawings in the 1920s paralleled Calder's own drawing style as well as his more abstract fantastic figures and animals created in wire.[101]

In addition to Miró, Calder came to know many other European modernists in 1928. Although Calder did not specifically mention all of his associates in Paris at this time, Hayter stated that Calder probably knew André Masson, Max Ernst, Ossip Zadkine, Tsugouharu Foujita, Yves Tanguy, Robert Desnos, Jean Cocteau, Alberto Giacometti, and Edgard Varèse.[102]

Within the first three months of 1929, important solo exhibitions of Calder's work were held in three different countries. The Galerie Billiet on the fashionable rue la Boëtie in Paris presented sculpture by Calder from January 25 to February 7; wood carvings were shown at the Weyhe Gallery in New York in February; and in April an exhibition was held in Berlin at the Galerie Neumann-Nierendorf.[103]

While sitting with his friends on the terrace of La Coupole, Pascin wrote an introduction for Calder's show at the Galerie Billiet, which was published in a small catalogue and in several Parisian journals.[104] In part, the introduction read:

FIGURE 49. Alexander Calder. *Hercules and Lion*, 1929. Wire, 48″. Collection unknown.

78

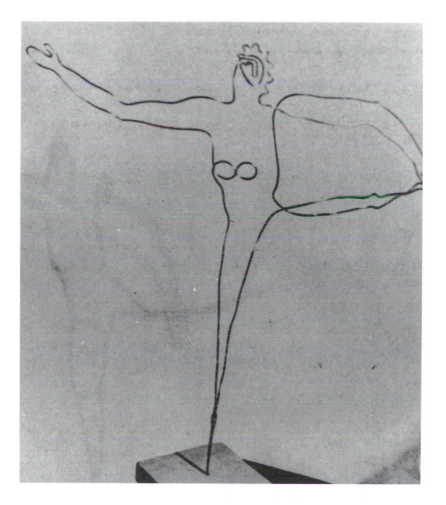

FIGURE 50. Alexander Calder. *Dancer*, 1929. From Galerie Billiet Exhibition. Washington, D.C.: Archives of American Art, Smithsonian Institution, Calder Papers.

He [Sandy Calder] is frankly not as handsome as his father. But now, having seen his work I know that very soon he will be well-established in spite of his ugly mug and that he will exhibit with terrific success next to his father and other great artists such as I, Pascin, who will tell you.[105]

Critical reaction to Calder's show at the Galerie Billiet was favorable. One critic acclaimed this "new and original exhibition" and remarked, "by means of the external line of the objects represented the artist attains very curious effects of movement and life, and shows his perfect knowledge of the human body and its attitudes."[106]

Dancer was the only work illustrated in the small folder (Fig. 50) announcing Calder's exhibition at the Galerie Billiet. The expressive action and economy of means found in this work suggest an inspiration from the single-line croquis drawings executed in the classes of Boardman Robinson and John Sloan at the Art Students League. In 1929 the nude was a favorite subject

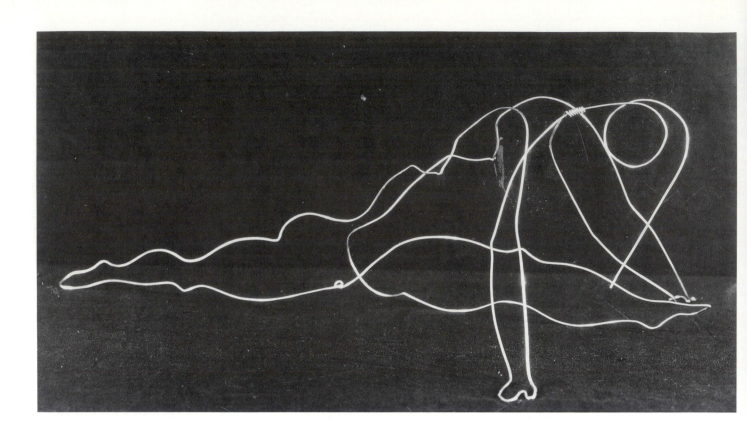

for Calder and inspired some of his most appealing wire sculptures. *Grand Ecart* (Fig. 51) and *Standing Nude* (Fig. 52) both capture the supple grace of the female figure. With Calder's mastery of the significant line rendering both contour and expressive movement, the artist showed he could summarize the movements of a dancer as he had once depicted animals in motion. These single-line drawings in space also resemble sketches by Henri Matisse, an artist for whom Calder later expressed special admiration in a published interview.[107] Like Matisse, Calder combined the expressive pose of the subject with descriptive outline, and continued an uninterrupted line from the head of the woman to her lower torso. Vanguard artists were fascinated by Calder's wire drawings. Stanley William Hayter later acknowledged that Calder made him aware of the importance of three-dimensional drawing.[108]

For his 1929 exhibition at the Weyhe Gallery, Calder designed a woodcut which was printed on the invitations (Fig. 53). The circus animals and figures included in the roughly cut block were similar to the subjects of the sculpture in the show. Later, Calder used woodcuts as invitations for performances of his *Circus*. The exhibition at Weyhe included many of the wood sculptures which Calder had carved during the summer of 1928. Included in the show was *Cow* (Fig. 54), which Zigrosser sold in 1930 for $350.[109] Its purchaser, George D. Pratt, was one of the first American collectors to acquire a work by Calder.

FIGURE 51. Alexander Calder. *Grand Ecart*, 1929. Wire (lost). Photo: Peter A. Juley & Son Collection, National Museum of American Art, Smithsonian Institution, Washington, D.C.

FIGURE 52. Alexander Calder. *Standing Nude*, 1929. Wire, 34″. Paris: Musée National d'Art Moderne, Centre Georges Pompidou.

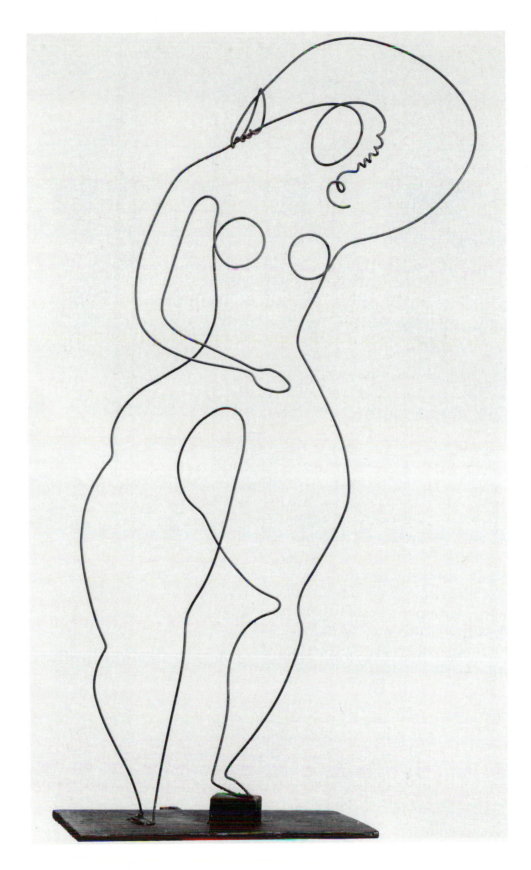

81

Original woodcut printed from the block

YOU ARE INVITED TO AN EXHIBITION OF WOOD CARVINGS BY

ALEXANDER CALDER

AT THE WEYHE GALLERY · 794 LEXINGTON AVE · N.Y.

FEBRUARY 4TH TO 23RD 1929

Calder was aggressively seeking more customers as well as opportunities to exhibit his work, and was more ambitious and serious about his artistic career than the humorous anecdotes in his autobiography suggest.[110] For example, correspondence exchanged between Calder and Zigrosser during the early months of 1929 indicates that Calder actively sought competitions to enter as he shrewdly discussed the best opportunities for exhibitions in Paris, London, and Berlin.[111]

A photographer, Sasha Stone, helped Calder arrange his solo show at the Galerie Neumann-Nierendorf in Berlin. A well-illustrated catalogue listing all of the works shown was produced, and many articles about Calder were published in the German press. These enthusiastic reviews were some of the first serious evaluations of Calder as an artist. Emil Szittya wrote in *Kunstblatt*:

> A few weeks ago Pascin introduced me to an amusing man,
> constantly laughing, who had an old-fashioned moustache. He
> described him as the most interesting American sculptor...
> one expects almost nothing from Americans in the area of art
> at the outset. Unjustly, as Calder in fact proves. Calder is an
> artist... I sought out Calder in Paris, found not a studio littered
> with clumps of clay, plaster figures and Greek and Roman
> molds, but rather a workshop. Mr. Calder bustled about like
> a father who has just wrapped toys for the Christmas tree,

FIGURE 53. Alexander Calder. Invitation to Weyhe Gallery Show, 1929. Woodcut. Washington, D.C.: Archives of American Art, Smithsonian Institution, Calder Papers.

82

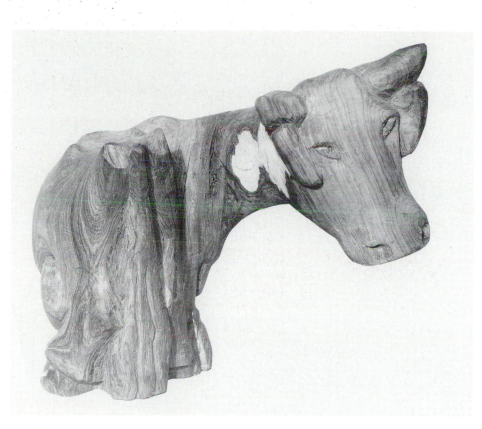

FIGURE 54. Alexander
Calder. *Cow*, 1928. Wood,
12⅝″. Private collection.
Photograph by Pedro E.
Guerrero.

seeking wood and wire to play with. Calder makes sculptures
out of wire. These are actual plastic sculptures although many
regard them as frivolities.[112]

The cover of the catalogue for Calder's exhibition in Berlin featured *Dancing Couple* (Fig. 55). One of the sculptural groups produced by Calder in this period, it also represents an early attempt to combine sheet metal and wire. Although the piece is a figurative work, it anticipates the nonobjective mobiles of the 1930s in its combination of at least two materials. Several possible sources can be mentioned for *Dancing Couple*, including the direct-metal sculpture of Pablo Gargallo, but the closest counterparts are the nickeled-wire models by Suzanne Fentan, which were exhibited at the Salon d'Automne in 1928 and subsequently reproduced in *Creative Art*.[113] Whatever the antecedents for the work, it was undoubtedly one of the most successful pieces in Calder's first show in Berlin.

On June 22, 1929, Calder embarked for New York aboard the *De Grasse*.[114] His enlarged troupe of circus performers also returned with him to America. There were opportunities to present the circus in private homes and in a showroom on 56th Street, where his friend Elizabeth Hawes designed clothes. The artist continued to supplement his income by charging admission to performances.

From December 2 to December 14, 1929, a large solo show of Calder's

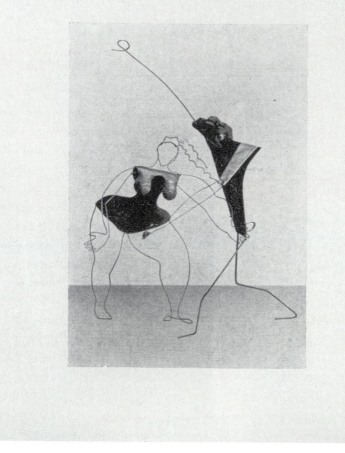

GALERIE NEUMANN-NIERENDORF
BERLIN W 35 LÜTZOWSTR. 32

AUSSTELLUNG
ALEXANDER CALDER
SKULPTUREN AUS HOLZ UND AUS DRAHT

FIGURE 55. Alexander
Calder. *Dancing Couple*,
1929. From Galerie Neu-
mann-Nierendorf exhibition
catalogue. Washington, D.C.:
Archives of American Art,
Smithsonian Institution,
Calder Papers.

wire and wood sculptures, drawings, and even some textile designs was held
at the Fifty-sixth Street Galleries in New York.[115] The galleries were owned
by the Roman Bronze Works, and exhibitions were held on three floors. While
Calder's work was being displayed, Ivan Meštrović's sculpture, wax caricatures
by a Mexican artist, and a selection of mechanical birds were also on view.

One of the larger pieces in Calder's show was *The Brass Family* (1929; Fig. 56), which is more than five feet high. Based on Calder's performers in his miniature circus, this large wire sculpture includes individual figures that had appeared in the earlier work. Basically pictorial in conception, the descriptive information is found in the frontal view, suggesting a derivation from Calder's single-line drawings. However, the work is fully sculptural, and describes muscular figures by contouring spatial volumes. As sculpture, *The Brass Family* is an exercise in the balancing of opposing forces. Here is another foreshadowing of the abstract constructions of the 1930s that include several forms balanced precariously on a horizontal platform. An elaborate composition of six acrobats balanced on the spread arms of a large male figure, *The Brass Family*, may also be Calder's attempt to reinterpret a work by his father in a modern material, brass wire. Alexander Stirling Calder's sculptural *Equestrian Group* for the *Fountain of Energy* (Fig. 57) was commissioned for the Panama-Pacific Exhibition in 1915; it, too, included a large male figure easily balancing the weight of several smaller figures on outstretched arms. Calder's images appear to have been drawn not only from contemporary events and experiences but also from classical art and the Beaux-Arts sculpture of his father.

The most significant and innovative object in Calder's show at the Fifty-sixth Street Galleries was a wire fishbowl, a last-minute addition.[116] *Fishbowl with Crank* (1929; Fig. 58) demonstrated Calder's predilection for mechanical devices. He had taken one of the gadgets he used in the circus, a crank that activates an animal to move around the circus ring, and applied it to a new sculpture. Two wire fish and some tropical plants are suspended within a rectangular wire frame. When a crank is turned, the fish "swim." Calder devised the two wire fish in three segmented parts, and because only the middle wedge-shaped section is activated by the crank, the heads and tails of the fish are free to move asynchronously, suggesting a degree of spontaneity within a mechanical device. The artist had noticed the mechanical birds being exhibited at the Fifty-sixth Street Galleries, and these may have inspired him to construct his work. The creator of the mechanical toys has not been identified, but there is another artistic source: Calder indicated later that he had been aware of Klee's *Twittering Machine* (Fig. 59), which makes a striking visual comparison to this work.

> I once intended making a bird that would open its beak, spread its wings and squeak if you turned a crank, but I didn't because I was slow on the uptake and I found that Klee had done it earlier with his "Twittering Machine" and probably better than I could. In about 1929, I did make two or three fishbowls with fish that swam when you turned a crank.[117]

Fishbowl with Crank represents a turning point in Calder's work. One of his earliest abstractions, *Crank-Driven Mobile* (1931–2; see Fig. 75) was a vari-

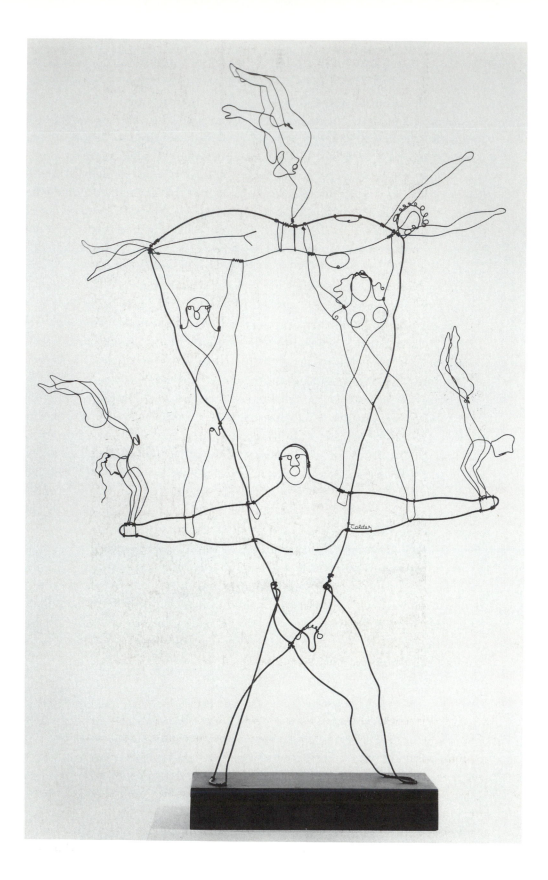

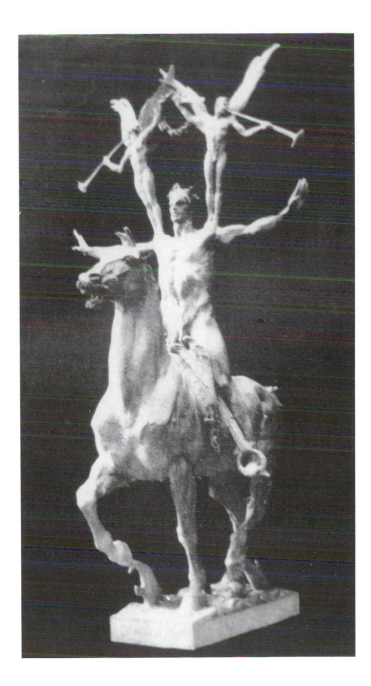

FIGURE 57. Alexander Stirling Calder. Equestrian Group for *The Fountain of Energy*, 1915 (destroyed). Panama-Pacific International Exposition, 1915.

FIGURE 56. (*opposite*) Alexander Calder. *The Brass Family*, 1929. Brass wire, 64″ × 41″ × 8½″. New York: Whitney Museum of American Art. Gift of the artist 69.255.

ation of this work. Although Calder changed the figurative details to abstract elements in his early mobiles, he retained the mechanical apparatus.

Joan Miró shared Calder's interest in Paul Klee. At the time, Miró was alienated from the academic illusionism of Dali and Magritte, which had begun to dominate the Surrealist camp. By the end of the decade, Miró had turned increasingly to a more personal kind of abstraction. In the work of Klee, he found imagery peculiar to the Swiss painter, who was isolated from the burgeoning forces of Surrealism in France. Miró and Klee shared an in-

87

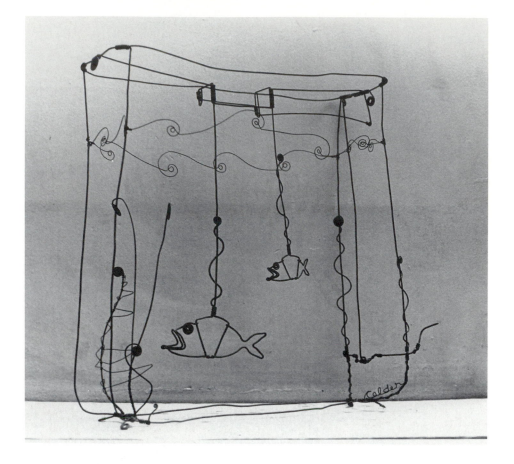

Figure 58. Alexander Calder. *Fishbowl with Crank*, 1929. Wire, 15⅞″ × 14½″. New York: Private collection.

terest in depicting whimsical creatures, but often a more serious – even sinister – aspect underlies the surface humor. In Calder's more abstract work still based on organic elements he shared their presentation of a more serious subject in a humorous format. In these artists are combined Dada irrational-ism and the Surrealist transformation of the natural world into private fan-tasy.

Calder absorbed much of Miró's personal approach to painting as well as his interest in Klee's work. Klee's fantastic imagery and personal style are reflected in the *Fishbowl with Crank* just cited, but even more dramatically in Calder's drawings of the period. By 1930, he had developed a completely new drawing style. The large gestural strokes of the pen, which recorded silhouette and movement in a linear shorthand, were replaced by more delicate and fanciful continuous-line drawings. At first this new drawing style might seem to result solely from Calder's wire sculpture. But the purposefully naive over-lapping of planes and the childlike imagery in *The Catch II* (1932; Fig. 60), for example, closely resemble Klee's drawings.

After a visit to Spain, where he attended a bullfight in Barcelona early in

88

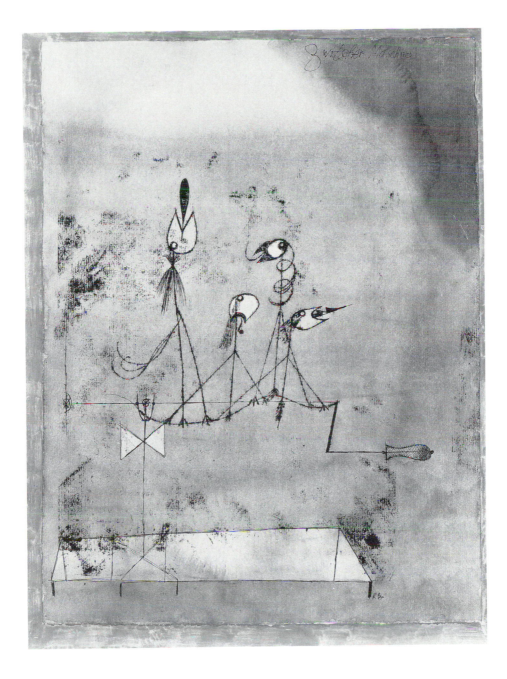

FIGURE 59. Paul Klee, *Twittering Machine*, 1922. Watercolor and pen and ink on color transfer drawing on paper, 25¼″ × 19″. New York: The Museum of Modern Art.

1930, Calder returned to Paris and fashioned *Old Bull* (Fig. 61) from sheet brass. With Calder's continued attraction to animals, one might imagine that he did not approve of bullfights, and his bull does have a pathetic demeanor. *Old Bull* is constructed of sheets of the metal that have been cut and folded. In appearance, this sculpture also seems indebted to the Spanish sculptor Pablo Gargallo, whose work Calder had seen in Paris, according to Hayter.[118] And Calder had been introduced to Gargallo's metal constructions stored in

89

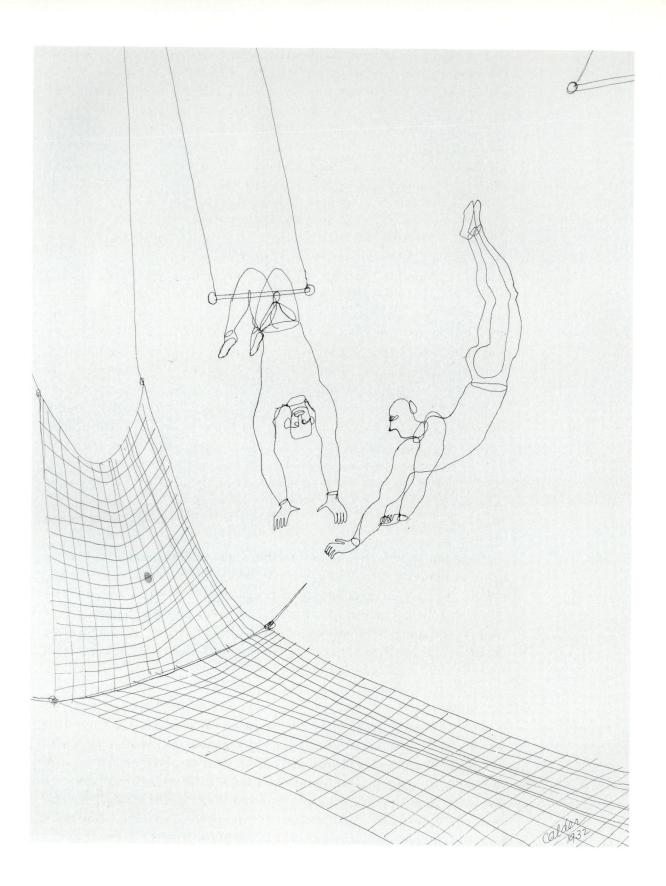

José de Creeft's studio. Gargallo, in fact, constructed his own *Bull* (1930; Fig. 62) from sheets of iron that same year. Although Calder did not employ the highly refined system of interlocking voids and solids found in Gargallo's *Bull*, his joining together of flat sheets to create volumes echoed the Spaniard's work. As a child Calder had already worked with thin sheets of metal, and now he was exploring the possibilities of making sculpture from this material. The lugubrious bull also bears some comparison to the iron weather vanes and signposts of bulls (Fig. 63) popular in nineteenth-century America. The skill Calder perfected in bending and twisting sheet metal was important to the more abstract constructions he would later produce.

In 1930, Calder also modeled several circus figures and animals and had them cast in bronze (Fig. 64). This was his first experience working with a traditional sculptural method, and he would not return to it until 1944. Having carved amusing animals in wood, Calder decided to use clay as he once had as a child. The cast bronze versions still bear the imprint of the artist's fingers working the original clay. Having demonstrated his ability to describe sculptural mass in the wood carvings made during the preceding two years, he now determined to explore similar themes by modeling in clay, the technique favored by his father and grandfather. But in their deliberate rejection of the elegant academicism of Alexander Stirling Calder, Calder's bronzes attain a remarkable energy and childlike whimsy. A series of acrobats exhibit exaggerated poses, a lack of anatomical detail, and uneven surfaces. For *Reclining Figure*, Calder may have been inspired by Henri Matisse's current sculptures, such as the series of *Reclining Nudes* of 1929. More carefully articulated than Calder's other bronzes, the figure still lacks the elegance and the skillful use of sensuous curvilinear rhythms found in the figures by Matisse.

In addition to his work in new methods and materials, Calder continued to create figures in wire. His portrait of *Kiki de Montparnasse* (1929; Fig. 66) indicates the artist's contact with the avant-garde in Paris. Kiki was the favorite model and the mistress of Man Ray and appeared in two of his films: *Emak Bakia* (1927) and *L'Etoile de Mer* (1928). A popular figure in Montparnasse art circles, she was known as the "Queen of the Paris Artists." When a short film of Calder at work in his Parisian atelier was to be made, he asked Kiki to act as his model.

Weight Thrower (1929; Fig. 65) is one of Calder's more abstract early works; it predates a seminal visit to Mondrian's studio in 1930, the result of which was that Calder would relinquish even this tenuous dependence on a subject. With *Weight Thrower*, expression of a dynamic movement seems to be the principal concern. The figure balancing on one foot is represented at the moment just after the weight has been hurled. This motif is similar to a Hellenistic figure, *The Borghese Warrior*, which Calder could have seen in the Louvre, and it shows his continued interest in subjects from classical art.

FIGURE 60. Alexander Calder. *The Catch II*, 1932. Pen and ink, 19″ × 14″. New York: The Museum of Modern Art. Gift of Mr. and Mrs. Peter A. Rubel.

91

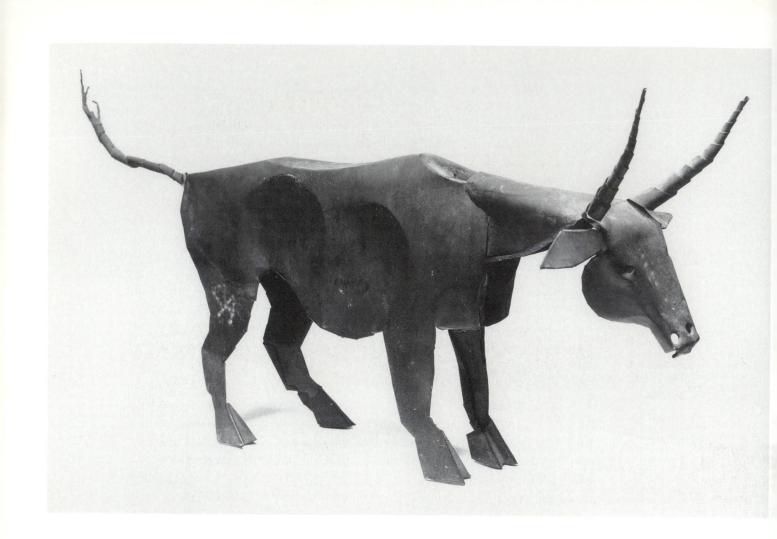

FIGURE 61. Alexander
Calder. *Old Bull*, 1930. Sheet
brass, 9″ × 18″ × 2¼″. New
York: Whitney Museum of
American Art. Purchase,
with funds from the Howard
and Jean Lipman Founda-
tion, Inc. 69.257.

During the years 1926 to 1930, Calder explored new materials, new tech-
niques, and mechanical movement. In his wire sculpture and mechanical toys
he was able to manipulate lengths of wire and to attach wooden objects without
destroying the delicate balance of the pieces. Such early projects were im-
portant preliminaries to Calder's first attempts to incorporate movement —
his suspended wire sculptures and crank-driven devices. Similar moving ob-
jects would reappear in his work in abstract form during the early 1930s.
Calder's *Circus* included hand-operated figures and devices, incorporated
chance and surprise, and featured a variety of materials. Eventually, Calder
would seek to overcome the necessity for a "puppeteer." Different as they are
from the *Circus*, the wind-driven mobiles of subsequent decades nonetheless
seem indebted to this production of Calder's formative period.

Calder's wood carvings can be viewed as an attempt to master more con-
ventional approaches to sculptural mass while incorporating the aesthetic of
direct carving favored by American modernists. With the exception of the
wood carvings, most of Calder's sculptures before 1930 express the vitality

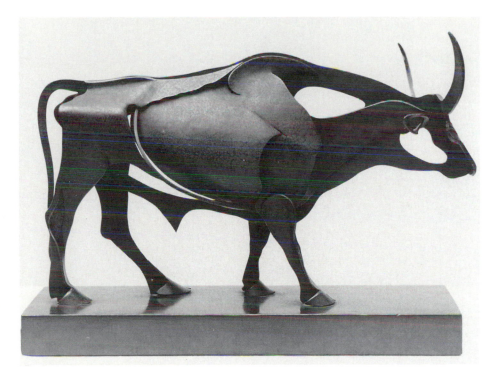

FIGURE 62. Pablo Gargallo, *Bull*, 1929. Iron, 28 cm × 39 cm × 24 cm. San Juan de las Abadesas (Girona): Fundación J. Espona.

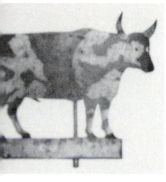

FIGURE 63. American Folk Art. *Bull*, nineteenth century. Iron, 33½″. Robert Bishop, *American Folk Sculpture* (New York, 1974).

found in his early single-line drawings. The wire sculptures are both pictorial and sculptural. They can be viewed as three-dimensional drawings that are perfectly legible on a planar surface – but simultaneously one experiences these works as complete sculptural volumes enclosed by wires defining the edges of spatial areas. Calder's space drawings adhere to the constructivist tradition and precede by five years similar experiments by his American colleagues David Smith, Ibram Lassaw, and José de Rivera.

Calder's early popularity in both America and Europe was acknowledged by a number of exhibitions and by many favorable reviews of his works. Even before he invented the mobile and the stabile, Calder was having solo shows in Paris, Berlin, Madrid, and New York. His exhibitions of wire and wood sculptures were reviewed in Parisian, German, and American newspapers, and he was the subject of many articles and reviews. By 1930, Calder was a full-fledged member of the European vanguard, not just another American artist working in Paris. He had advanced beyond other Americans of his generation to develop a personal idiom indebted to the most progressive Parisian styles of that period. This lively young artist had tried many directions for his art, had amused his audiences worldwide with fanciful animals and energetic circus performers.

Thus, already in the 1920s, Calder was an innovator among American sculptors of that decade. While he produced nonobjective sculpture in 1930, even earlier he had introduced industrial materials into his work and acknowl-

93

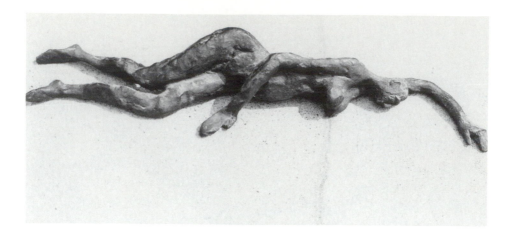

FIGURE 64. Alexander Calder. *Reclining Figure*, 1930. Bronze, 14″ long. Collection unknown.

edged actively the influence of his European contemporaries. Using medium-gauge wire that gave a certain flexibility to his constructions, Calder produced a full range of representational images including dancers, animals, and acrobats. Although his explorations of direct carving in wood before his arrival in Paris in 1926 were tentative, Calder's subsequent wood carvings remained close to the thematic material found in the work of other direct carvers in America.

One of Calder's principal means of introduction to vanguard European artists was his miniature *Circus*. During the late 1920s and early 1930s performances of this small hand-operated circus brought together an assortment of the Parisian avant-garde, literati, and critics. Although the *Circus* was Calder's first production to receive considerable critical acclaim, articles and illustrations of his wire sculpture appeared in the French press as early as August 1927.[119] Soon he was having one-person exhibitions in Paris, Berlin, and in New York.[120] Thus, even before his change to a nonobjective approach, Calder's constructions had substantial international exposure. The American found an easy rapport with certain modernists in Paris, notably Joan Miró and Stanley William Hayter, and was undoubtedly the first of his generation to receive critical recognition for his new sculpture, even when it remained representational. Before his change to an abstract style in 1930, Calder created sculpture in yet another industrial material: sheet brass. Sheet brass had been explored for sculptural abstractions two years earlier by his friend Isamu Noguchi, but Calder's use of the material in 1929 was confined to animal imagery.

During the 1920s in America the "climate" for the acceptance of constructivist trends and other forms of European modernism by a generation of American artists was formed because of the valiant efforts of Katherine Dreier and the Société Anonyme, a number of important exhibitions of vanguard

FIGURE 65. Alexander Calder. *Weight Thrower*, 1929. Wire, 27½″. Paris: Musée National d'Art Moderne, Centre Georges Pompidou.

94

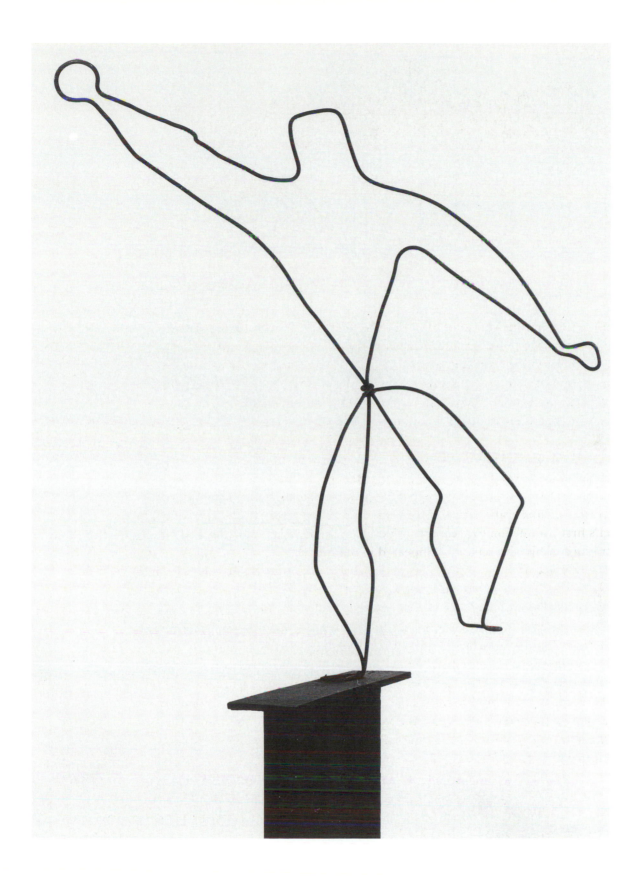

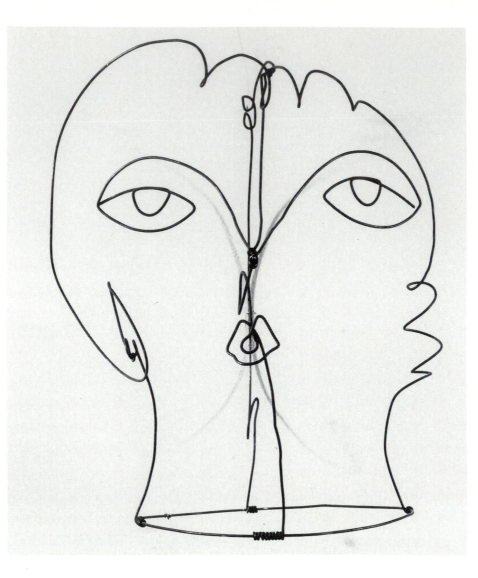

FIGURE 66. Alexander Calder. *Kiki de Montparnasse*, 1929. Wire, 12¾". Paris: Musée National d'Art Moderne, Centre Georges Pompidou.

sculpture, and the innovative production of a few American pioneers of abstraction. By the early 1930s a growing number of American sculptors assimilated the radical developments from abroad, and formed personal styles of great interest.

3

The Birth of an Abstract Style

IN 1930 CALDER MADE a major transition in his art, abandoning the wire and wood figures of the previous four years for abstract constructions. When asked about the motivation for his radical departure from earlier work, Calder credited his visit to Mondrian's studio in the fall of 1930 as initiating the "shock that started things."[1] But additional factors account for the new direction, not the least of which was his courtship of and marriage to Louisa Cushing James. Because he wished her family to view him as a professional, Calder pursued a more purposeful direction for his career, and put aside his playful wire animals for the more serious abstract sculpture espoused by his friends among the French modernists. Calder had met his future wife in June 1929 aboard the *De Grasse,* bound for New York, and had told her father that he was a "wire sculptor." The courtship continued for another eighteen months before they were married in January 1931. In the interim Calder visited Louisa in Massachusetts, and she came to see his family in New York. During the summer of 1930 she took a trip to Ireland and France, and visited Sandy in Paris.

Louisa James was born to an affluent New England family with liberal leanings (her father, Edward Holton James, had been beaten by the police in a Boston Commons demonstration protesting the Sacco and Vanzetti sentence in 1927).[2] She was the grandniece of author Henry James, and was an aspiring painter. Although Louisa seems not to have reacted when Sandy introduced himself as a "wire sculptor," her family had some concern about the future plans of this artist in his early thirties.[3] Calder's mother observed, "I think Louisa rather likes his erratic ways but expects to keep a proper *ménage* and her husband looking proper."[4] Calder's commitment to Louisa — and soon after, the prospect of a family — must have been among the motivating forces to his finding a clear direction for his work, a personal statement beyond the *Circus* and the amusing caricatures of his youth.

In May 1930, for example, Calder wrote his parents that he had presented

the *Circus* in the studios of Paris *Vogue*: "But since then I have shut up the show and am going to leave it there for a long time as it hinders my work."[5] It is hardly coincidental, therefore, that 1930, the year of his courtship, should also have been a time of sustained exploration in his sculpture. Calder tried working in metal, modeled clay, and cast the results in bronze. Later in the same year he turned to nonobjective paintings that were clearly indebted to Mondrian, and finally to abstract constructions. Nor was it merely by chance that his first exhibition of serious abstractions should have taken place in April 1931 (four months after his marriage), when he was increasingly involved with constructivist artists. Perhaps this new focus on his career was the motivation for becoming a member of Abstraction–Création in 1931, the only organization of artists he ever joined.

Calder had decided to work as an artist, not a humorist, and to devote himself to modernism and abstraction – not to toymaking and playful wire animals. No doubt Calder's meeting with such avant-garde artists as Man Ray, Joan Miró, Jean Arp, Piet Mondrian, and Fernand Léger set him on a new course for his art. Visits to these artists' studios, the surge of interest in Constructivism in Paris of the 1930s, and Calder's fascination with recent aesthetic theories made him realize the limitations of his previous works, and provoked him to seek more ambitious and progressive projects.

The 1930s were probably the most innovative and resourceful years of Calder's career. During this decade he invented the mobile and stabile – adding significantly to the sculptural vocabulary of the twentieth century. He also became internationally renowned – praised by artists and critics on both sides of the Atlantic. His production of the period included commissions for outdoor sculptures, projects for an International Exposition in Paris and a World's Fair in New York, designs and décor for several ballets, theatrical productions, and mechanical ballet projects. Calder's works were shown in solo exhibitions in Paris, New York, Madrid, Chicago, and London, and he was included in more than thirty group exhibitions in America and abroad. His works were purchased by American museums, most notably the Museum of Modern Art. The shift, thus, from figurative works to abstract constructions and kinetic sculpture had a profound effect on Calder's life and his future artistic career.

Calder's development of a personal, abstract idiom received encouragement from the artists of Abstraction–Création. In fact, Calder's initiation into abstraction took place at a time when Paris was the center of constructivist art. Although Paris had been the great attraction for young modernists for decades, during the 1920s more innovative abstract works had been created in Germany, the center of International Constructivism. By the early 1930s, however, the political situation in Germany had become intolerable, and many of these artists had emigrated to Paris.

Constructivism, related technically and aesthetically to architecture and engineering, had its roots among Russian artists in 1914. By the early twenties,

many of the Russian avant-garde had come to the West. Germany became the center for constructivist activity, and Russian émigrés and De Stijl artists from Holland joined younger German adherents in embracing constructivist aesthetics. By the 1920s, Constructivism was loosely defined to include works assembled from industrial materials, and also abstract paintings where the subject was the image itself – the essence of the reality of the world – independent of any specific associations. Although the image is not "abstracted" from nature, it can be related to the geometry of the natural world or to a mathematical model. Lines, shapes, and colors are believed to have expression, independent of their association with the world of appearances. The work appears "clean," with no surface treatment or gestural effects.[6]

During the early 1930s, several new groups formed in Paris to accommodate émigrés from Russia, Germany, and Poland, and to organize exhibitions of their work. The earliest group was "Cercle et Carré," organized in 1929 by Uruguayan painter Joaquin Torres-Garcia and Belgian writer Michel Seuphor (Ferdinand Louis Berckelaers). Seuphor had settled in Paris in 1925 and was associated with the major representatives of constructivist art. Regular meetings of Mondrian, Georges Vantongerloo, Sophie Taeuber-Arp and Jean Arp, Antoine Pevsner, and the Italian Futurist Luigi Russolo resulted in the formation of this group that sponsored an International Constructivist exhibition in April–May 1930 at the Galerie 23, rue la Boëtie, Paris.[7] Forty-six painters were exhibited including Arp, Jean Gorin, Kandinsky, Léger, Mondrian, Pevsner, and Vantongerloo (but not Calder). Two artists were noticeable by their absence: Theo van Doesburg and Moholy-Nagy. As the international exhibition was just ending in May 1930, van Doesburg issued his own journal, *Art concret*, which represented an opposing group including van Doesburg, Jean Hélion, and the Russian Leon Tutundjian. Preferring a scientific approach to Mondrian's intuitive one, van Doesburg's inaugural essay espoused the concretization of pictorial thought, independent of reality. The first and only issue of *Art concret* featured "The Basis of Concrete Painting," in which van Doesburg declared: "The work of art should be fully conceived and spiritually shaped before it is produced. It should not contain any natural form, sensuality or sentimentality."[8]

One of the largest and most influential groups to promote the cause of Constructivism was Abstraction–Création, founded in February 1931. Members exhibited together and published a yearly almanac that included reproductions and personal statements by the artists.[9] Jean Gorin, a prominent French member of the group, and a creator of relief constructions, declared:

> The aim pursued by the new constructive plastic art is not an individualistic one. It is not an ivory-tower art, as people might be tempted to suppose at first glance. On the contrary, the bases of this new plastic art are deeply rooted in the new age through which we are living, an age of great economic and

social upheaval, of the reign of science, collectivism, and universalism. Art has evolved parallel to science, and today a purely constructive aesthetic has been created, one free from the figurative formalism of the past; an abstract plastic art, based on universal values, and on precise, mathematical laws.[10]

Calder undoubtedly shared this notion that art could parallel science and have a basis in "precise, mathematical laws," and he now was able to fuse successfully his early training in science, physics, and mathematics with his new interest in abstraction.

Abstraction–Création not only brought together diverse approaches to abstraction but also enabled its artist-members to exert an influence as a unified group. In its ascendancy the group numbered more than four hundred members including French, German, Swiss, English, and Dutch artists. Thirty-five Americans were members of the group as of 1935.[11] Although it existed for only five years, Abstraction–Création assured the viability of nonobjective trends in art during the 1930s, a legacy eventually inherited by American as well as European artists in the postwar era. There were disagreements among the founding members, however, about abstraction and nonobjectivity. Although Abstraction–Création officially espoused "pure painting," many artists who included some recognizable imagery were permitted to exhibit with the group.

The formation of Abstraction–Création was motivated in part by a desire to counter the dominance of the Surrealists in Paris. In the early 1930s, Surrealist artists, led by André Breton, shifted from an emphasis on automatism and biomorphic abstraction to dream imagery, depicted in a traditional academic style. Joan Miró rejected the primacy of dream imagery promulgated in 1930 by Breton's second manifesto of Surrealism[12] and exemplified in the paintings of Salvador Dali and René Magritte. Miró's paintings became more abstract after 1930, and biomorphic forms dominated. Some artists, like Miró and Jean Arp, were acceptable to both the Surrealists and Abstraction–Création (Arp exhibited with both groups throughout the 1930s), but most artists active in France chose to exhibit with one or the other rival faction. However, the nonobjective orthodoxy of Abstraction–Création was too rigid for some: Miró, for example, refused to join even after he had broken with the Surrealists. His "magnetic paintings" continued to incorporate abstract signs for forms in nature. Throughout Calder's tenure with Abstraction–Création he combined the severe, geometric abstraction of Mondrian with the biomorphic surrealism of Miró to form his own style.

Although Calder claimed that his first visit to Mondrian's studio moved him to become an abstract artist, it was his friendship with Miró and his involvement with the artists of Abstraction–Création that helped sustain his initial creation of metal and wood constructions. Fashioning his first abstract sculptures and mobiles in a city charged with artistic tensions between Sur-

realists, Constructivists, and abstract sculptors, Calder soon synthesized the nonobjective art of Abstraction–Création, the biomorphic panels of Miró, and the fantastic biomorphs and personages of Arp, Alberto Giacometti, and others. To these many artistic influences Calder brought his mechanical ingenuity, his background in engineering, and his fascination with popular science. And he managed to exhibit with both the Surrealists and the Abstraction–Création group without proclaiming allegiance to the theoretical pronouncements of either.

Both Miró and Mondrian encouraged Calder, and he was inspired by their work. In these years Miró produced abstract relief-constructions as well as his magnetic-field paintings. His unique abstract imagery influenced Calder, while the American derived from Mondrian his use of primary colors and his initial preference for geometric forms. Some early works reflect the influence of one artist more than the other, but many of the abstract constructions acknowledge both. In general, Calder's sculpture of the 1930s manifests his interest in both Constructivist and abstract Surrealist concepts.

Calder's *Circus* had served as his introduction to many leaders of the avant-garde. Visitors to his studio in the autumn of 1930 included Fernand Léger, Frederick Kiesler, Le Corbusier, Theo van Doesburg, and Piet Mondrian. In October 1930, Calder, who had been introduced to Mondrian by Kiesler, accompanied William Einstein, an American artist, to Mondrian's studio. The "shock" that Calder experienced there was not caused by the individual paintings, but rather was toward a total environment that had been transformed by the Dutch artist.[13]

Mondrian, the major proponent of Neo-Plasticism, was in his late fifties at the time Calder first met him. He had long been recognized as a founding member of De Stijl in Holland, and his Parisian studio was a carefully ordered environment that realized his notions of the total work of art. In an essay, *Home-Street-City*, of 1926, Mondrian had declared:

> Home and street must be viewed as the city, as a unity formed by planes composed in neutralizing opposition that destroys all exclusiveness. The same principle must govern the interior of the home, which can no longer be a conglomeration of rooms – four walls with holes for doors and windows – but a construction of planes in color and noncolor unified with the furniture and household objects, which will be nothing in themselves but which will function as constructive elements of the whole.[14]

Mondrian proposed eliminating individual artworks to create a new Form and a new Space.[15] His best realization of these concepts for transforming the man-made world was his own living space, first in Paris, and then in New

York City during the early 1940s. At 26 rue du Départ, Mondrian occupied a third-floor apartment. His studio was a large, irregular room; its walls were painted white and on them big sheets of colored cardboard were tacked up. His worktable and wicker chairs were painted white, and all furnishings were carefully positioned. On the floor were two rugs, one gray and the other red. Mondrian considered the studio a metaphor for all living space, and thus had carefully applied his own principles to his environment. Implied in these choices was a new mode of behavior that resulted from this special "design for living." The importance Mondrian gave to his Parisian studio as a true application of his ideas can be gauged by the numerous photographs he had taken of it. He lived for thirteen years in this studio, where he received many visitors and created his most "classical" works.[16]

A measure of Calder's attraction to Mondrian's ordered environment was his own use of white (with black trim) for all of his subsequent living spaces, and his total involvement with primary colors. Calder later recalled:

> I was very much moved by Mondrian's studio, large, beautiful and irregular in shape as it was, with the walls painted white and divided by black lines and rectangles of bright colors, like his paintings. It was very lovely with a cross-light (there were windows on both sides) and I thought how fine it would be if everything there moved, though Mondrian himself did not approve of this idea at all.[17]

In his autobiography, written more than thirty years after this event, Calder elaborated slightly on his conversation with the Dutch painter: "I suggested to Mondrian that perhaps it would be fun to make these rectangles oscillate and he, with a very serious countenance, said: 'No, it is not necessary, my painting is already very fast.' "[18]

Although Mondrian was not interested in kineticism (nor, seemingly, in Calder's fun-loving approach to artmaking), he developed a lasting friendship with the American, who shared his passion for social dancing. Mondrian created no sculpture, but he had designed his studio as an abstract environment involving a number of plastic forms. (Calder noted that the Victrola had been painted red to conform to Mondrian's use of only primary colors for his art. Later, red became one of Calder's preferred colors for his constructions.) Although Calder had probably already seen Mondrian's paintings, it was this visit to a transformed interior, a spatial area ordered by the principles of Neo-Plasticism, that converted him to abstract art. In addition to his use of flat planes and primary colors plus black, white, and gray, as well as his belief in an equilibrium achieved through the proportions of plastic means, Mondrian felt that reality was the essential quality found in nature rather than in surface appearances. Although nature is constantly changing, the "inner" reality is constant – universal. Mondrian sought a universal art that

would parallel this inner reality. Calder equated his introduction to Mondrian's concepts with his earlier encounter with the solar system. Both experiences were to have major consequences for his work from the 1930s.

> The visit gave me a shock. A bigger shock, even, than eight years earlier, when off Guatemala I saw the beginning of a fiery red sunrise on one side and the moon looking like a silver coin on the other.... Though I had heard the word "modern" before, I did not consciously know or feel the term "abstract." So now, at thirty-two, I wanted to paint and work in the abstract.[19]

Several additional statements were made by Calder describing his 1930 visit to Mondrian's studio.[20] In a 1934 letter to the director of the Museum of Living Art, Albert Eugene Gallatin, Calder spoke of the atelier as having high white walls with cardboard rectangles painted red, yellow, blue, black, and white in various shades tacked on one wall. Calder admitted that these rectangles attracted him more than Mondrian's paintings did. He suggested to the Dutch artist that they could be made to oscillate in "different directions at different amplitudes."[21] Use of "amplitudes" suggests that Calder, even in his conversation with the artist Mondrian, used the language of an engineer or physicist. The scientific terminology that Calder first employed in Mondrian's atelier found final realization in his early constructions derived from astronomical instruments and scientific apparatus.

For two weeks after visiting Mondrian, with whom he remained friends until the Dutch artist's death,[22] Calder painted modest abstractions, exploring the compositional relationships of primary colors and geometrical forms; but soon he had reverted to wire and wood constructions: "...wire, or something to twist, or tear, or bend is an easier medium for me to think in."[23] The results of this radical change in style included a series of constructions using cosmic imagery. Clearly the American was searching for a personal idiom. Works in three dimensions suited him better, and by December 1930 he was using wire, small sheets of metal, and wooden spheres to make abstract constructions.

Calder left again for the United States in December 1930 to attend an exhibition "Paintings and Sculptures by Living Americans" at the Museum of Modern Art, which included four of his wood carvings. With one exception, Calder was the youngest artist to be included in a show that featured the leaders of American modernism.[24] By early February of the following year he had returned to Paris with his bride, Louisa James, and with a number of sizable checks presented to the young couple as wedding gifts. This money gave him some freedom to pursue his exploration of abstract constructions over the following year.[25] In February 1931 the artist William Einstein introduced Calder to Jean Arp and Jean Hélion, who persuaded Calder to join the newly formed Abstraction–Création group. Although Calder had solo

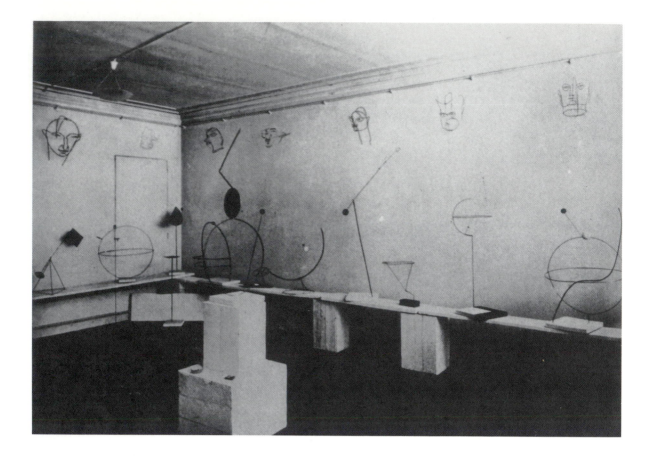

shows in Paris thereafter, he regularly submitted his abstract constructions to the group exhibitions of Abstraction–Création held at the Porte de Versailles.

Calder's first solo exhibition featuring his abstract constructions opened at the Galerie Percier on April 27, 1931. The gallery had an established interest in constructivist art, offering the first exhibition in France to Gabo and Pevsner in 1924.[26] A photograph of the installation (Fig. 67) shows that shelves were positioned against several walls supported by champagne crates that had been painted white. Strung from the molding at the top of the walls were wire caricatures. Probably Calder was urged to include these earlier portraits to assure some sales, but he wished to draw attention to his new abstract works, titling his exhibition "Volumes–Vecteurs–Densités" and listing the objects as "Sphérique, Arcs, Densités, and Mouvements Arrêtés." (These titles were to change in subsequent years: "Sphériques" became Universe and one of the "Arcs" became *The Pistil* – to encourage associative imagery for his sculpture.)[27] In the catalogue for "Alexander Calder, Volumes–Vecteurs, Densités–Dessins–Portraits," Fernand Léger wrote:

> Erik Satie illustrated by Calder? Why not? It's serious without seeming to be. A *neo-plasticien* at the beginning, he believed

FIGURE 67. Installation, Calder exhibition at Galerie Percier, Paris, 1931. Washington, D.C.: Archives of American Art, Smithsonian Institution, Calder Papers.

that two colored rectangles formed an absolute. His need for whimsy broke the tie [with Neo-Plasticism] . . . the wire became taut, geometrical, perfectly embodying the plastic in art, the present time, deliberate anti-romanticism dominated by a striving for equilibrium. Confronting these transparent, objective, precise new works, I think of Satie, Mondrian, Marcel Duchamp, Brancusi, Arp, those uncontested masters of inexpressible quiet beauty. Calder is of that line. He is 100% American, Satie and Duchamp are 100% French. How alike they are![28]

If there was a disadvantage to Calder's early acceptance in international art circles as one of the wittiest of artists, it was that his most ardent supporters were unprepared for the serious turn his work was now taking. To many critics and artists Calder was a humorist. His transition to a purely abstract style, his use of such words as "densities" and "vectors" in the title of his exhibition, and his use of geometric elements in his abstract constructions confused and disappointed those who had never taken him seriously. A critic wrote in *Beaux-Arts*:

> You will regret to see, moreover, the artist evolving a grandiloquent and esoteric formula for constructing "volumes, vectors, densities (?) and arrested movements (??). . . ." Calder loses much of his humor. . . . The only part of the actual exhibition truly acceptable and agreeable is a series of wire portraits; which is excellent. The various personalities are perfectly recognizable – the painter Léger is especially remarkable and the shadow of the small linear constructions traces a drawing on the white wall in the manner of Picasso.[29]

In one work exhibited at the Galerie Percier, *Kiki's Nose* (Fig. 68), Calder did continue the interest in fantasy that was appreciated by admirers of his early wire and wood caricatures. *Kiki's Nose* also shows his affinities with his new friend Jean Arp. A "personage" rising from a small base that also holds two small spheres can be found in several sculptures created by Arp in 1930.[30]

Calder chose *Little Universe*, two circles of wire intersecting at right angles to form a sphere, as his favorite construction from the show. In this work and others, such as *The Pistil* (Fig. 69), Calder demonstrated a fascination with cosmic imagery. He recalled:

> The *Universes* were in my 1931 show at the Galerie Percier and were the indirect result of my visit to Mondrian's studio in the fall of 1930. They weren't intended to move, although they were so light in construction that they might have swayed a little in the breeze. Although I was affected by Mondrian's

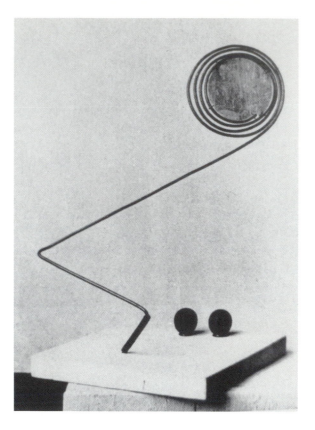

rectangular paintings, I couldn't do anything similar. After seeing him, I tried to paint for a couple of weeks, but then I came back to construction in wire. The circular forms, particularly interacting, seem to me to have some kind of cosmic or universal feeling. Hence the general title *Universe*. What I would like to have done would have been to suspend the sphere without any means of support, but I couldn't do it.[31]

FIGURE 68. Alexander Calder. *Kiki's Nose*, 1931. Wood and wire, 18″. Collection unknown.

Each *Universe* construction includes an open sphere, which corresponds to the universe, supporting small wooden balls, which represent the planets. In creating these forms Calder was inspired by a number of sources as well as by contemporary astronomical discoveries. Antecedents for Calder's constructions are found in such scientific devices as the armillary sphere (Fig. 70) and the eighteenth-century English planetarium known as the orrery (Fig. 71). In an interview Calder observed that even before he had studied engineering, he had been fascinated by "eighteenth-century toys demonstrating the planetary system."[32] These toys were actually mechanical orreries, and they seem to have been a major source of inspiration for his *Universe* constructions. Calder could have seen such devices in the Conservatoire des Arts et Métiers in Paris or in books on astronomy. The armillary sphere, one of

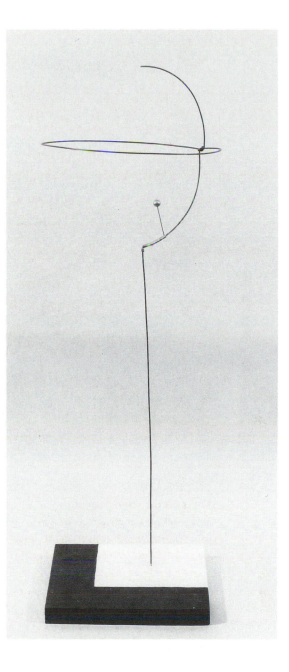

FIGURE 69. Alexander Calder. *The Pistil*, 1931. Wire and brass, 40″ × 12¾″ × 12¾″. New York: Whitney Museum of American Art. Purchase, with funds from the Howard and Jean Lipman Foundation, Inc. 70.12.

the oldest known instruments from the astronomy of antiquity, became more complicated as knowledge about the solar system developed: Supplementary concentric and movable rings were added to show the supposed orbits of the sun, moon, and planets.

In the interview just quoted, the artist stated his desire to suspend the constructed sphere without any means of support. This idea may have resulted from his visit to a planetarium, where orreries are frequently suspended by wires or rods from the ceiling in darkened chambers, and spotlighted spheres representing celestial bodies consequently seem to float in space. The orrery,

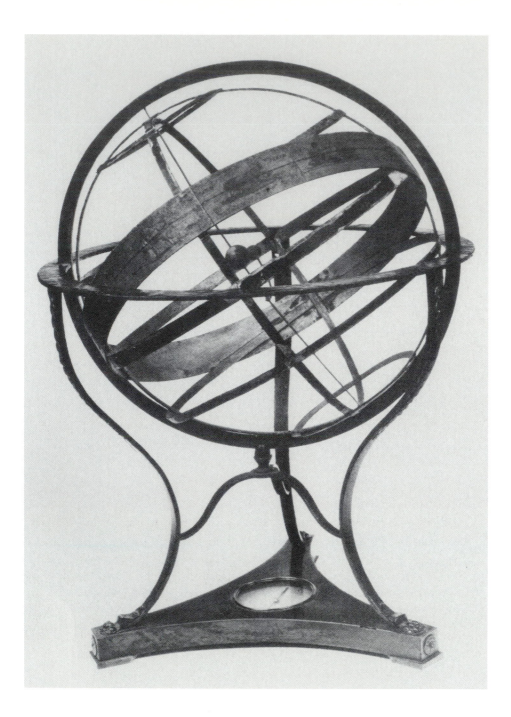

a mechanized planetarium that shows the planets in orbit around the sun, is used to demonstrate the Copernican heliocentric theory. Earlier versions of these instruments, which became popular in the eighteenth century, were operated by hand or by clockwork in order to describe the specific velocity and direction of orbiting planetary bodies.[33] Spheres of proportional dimensions representing sun, planets, and moons were arranged according to their respective orbital patterns.

FIGURE 70. Copernican Armillary Sphere. Metal, 22½″. Wynter & Turner, *Scientific Instruments* (New York, 1975).

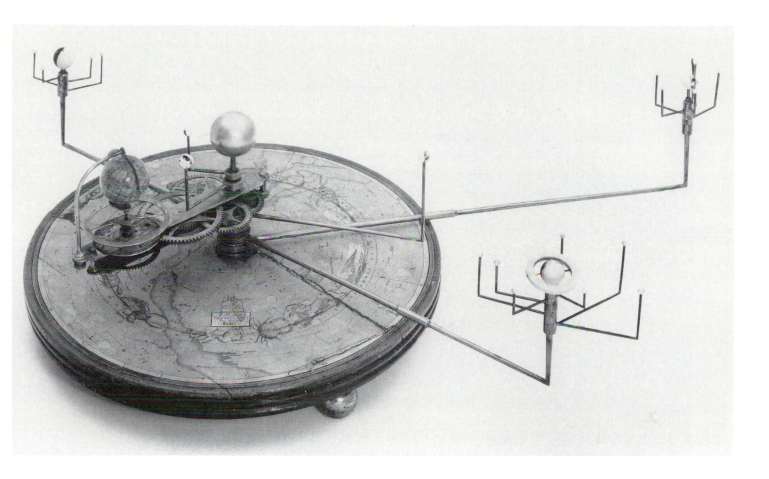

FIGURE 71. Portable Orrery by R. B. Bates, c. 1800. Wynter & Turner, *Scientific Instruments* (New York, 1975).

Calder's interest in cosmic imagery was shared by other artists, particularly Wassily Kandinsky, the Constructivists Laszlo Moholy-Nagy and Alexander Rodchenko, and by Mondrian himself. Cosmic forms related closely to the search for universalism in the arts based on the principles of equilibrium and harmony that form the universe, as undertaken by Bauhaus artists, by the Russian Constructivists, and by Neo-Plasticists. Moholy-Nagy, for example, believed that the creation of a dynamic process rather than a static object should be the artist's goal, and that this approach to artmaking was appropriate to an age in which science proposed a general model of a dynamic, rather than a static, universe.[34]

Because Calder was aware of cosmic forms in the works of his contemporaries, it is not surprising to learn of his preoccupation with the cosmos in 1931, when astronomical discoveries continued to make newspaper headlines around the world. On March 14, 1930, a ninth planet was identified, and hailed as the major astronomical discovery of the century. In subsequent months many newspaper and magazine articles reported on its orbit and speed. The name Pluto was selected for the new discovery in May 1930, and concurrently proposed theories about the solar system continued to interest

a worldwide audience. The identification of a ninth planet beyond the known solar system demonstrated the limitations of human knowledge about the cosmos. Scientists speculated about the origins of the planets and considered the possibilities of extraterrestrial life. By the fall of 1931, astronomers were proposing that a dozen additional planets might be discovered beyond the known planetary system. This new information about the solar system challenged established theories, and in these years Calder reacted to the general excitement that followed the discovery of a new planet, the sighting of numerous asteroids, and revelations about extragalactic island universes.

As Calder made final preparations for his first exhibition of abstract constructions, public attention shifted from Pluto to new reports on distant galaxies. In February 1931, Albert Einstein announced that the secret of the universe was directly related to the red shift of distant nebulae.[35] The red shift, or the speed of distant island universes (galaxies) receding from the earth, had been analyzed by Edwin Hubble, and Einstein abandoned his previous model of the universe as a result.

A group of minor planets, called "asteroids" or "planetoids," also made headlines during the early 1930s. These asteroids varied in size, the smallest being no more than chunks of rock, and most moved in orbits lying between those of Mars and Jupiter. Some moved outside this range, and a few came quite close to the earth. For example, on January 30, 1931, the asteroid Eros approached the earth to within a distance of sixteen million miles and was precisely measured. As a result, the distance of the sun as well as the dimensions of the whole solar system could be determined with better accuracy.

These dramatic astronomical discoveries and resultant hypotheses about the cosmos caused worldwide speculation. Hardly coincidental, therefore, is Calder's preoccupation with images of planetary bodies in motion. His ink and gouache studies (Fig. 72) were produced in those same years in which an eager public sought additional information about the solar system. Although Calder does not specifically mention the exciting events of the early 1930s, his drawings and constructions indicate a connection with them – which must have attracted an audience for his work at the time. Calder's drawings of the cosmos correspond to a statement he later prepared concerning the basis of his abstract forms:

> I think at the time [1930] and practically ever since, the underlying sense of form in my work has been the system of the Universe, or part thereof. For that is a rather large model to work from.
>
> What I mean is the idea of detached bodies floating in space, of different sizes and densities, perhaps of different colors and temperatures, and surrounded and interlarded with wisps of gaseous condition, and some at rest, while others move in pe-

FIGURE 72. Alexander
Calder. *Abstraction*, 1932. Ink
on paper, 22″ × 30″. Phila-
delphia Museum of Art.

culiar manners, seems to me the ideal source of form. I would
have them deployed, some nearer together and some at im-
mense distances. And great disparity among all of the qualities
of these bodies, and their motions as well.[36]

After his 1931 Galerie Percier presentation of abstract constructions re-
lated to the cosmos, Calder continued his involvement with such imagery,
introducing kinetic works in the years that followed.

In the summer of 1931, Calder drew single-line sketches for an edition of
the *Fables of Aesop*, the first of a number of commissions he received for book
illustrations.[37] The whimsical animals created for the *Fables* contrast markedly

with his contemporaneous experimentation with kinetic devices but indicate the range of his interests at the time.

The statement that Calder prepared for the first almanac of Abstraction–Création in 1932 is a striking reminder of his earlier training as an engineer as well as the new seriousness of purpose with which he approached his sculpture:

> How does art come into being? Out of volumes, motion, spaces carved out within the surrounding space, the universe. Out of different masses, tight, heavy, middling – achieved by variations of size or color. Out of directional line – vectors representing motion, velocity, acceleration, energy, etc. – lines which form significant angles and directions, making up one, or several totalities. Spaces and volumes, created by the slightest opposition to their mass, or penetrated by vectors, traversed by momentum. None of this is fixed. Each element can move, shift, or sway back and forth in a changing relation to each of the other elements in this universe.[38]

Calder's required engineering curriculum at Stevens Institute of Technology had included a laboratory in mechanical engineering and a course in applied kinetics.[39] The description of this course in the Stevens catalogue parallels the use of motion in Calder's early kinetic works:

> KINETICS. Discussion of the laws governing the plane motions of particles and of the mass-centers of rigid bodies, with applications to the motion of projectiles, vibrating masses, systems of connected translating bodies, constrained motions, and pendulums. Discussion of the laws governing the plane motions of rigid bodies, with applications to machines, compound and torsion pendulums, translating and rotating bodies.[40]

In *Red Frame* (also called *Construction*, 1932; Fig. 73), an example of an early Calder abstraction in metal, he used primary colors and attached separate planar elements to a frame – an approach that might be related to the rectangles tacked to Mondrian's studio walls. But the construction most closely resembles Miró's *Painting* of 1930 (Fig. 74), which also features circular forms on a solid ground. In Calder's *Red Frame*, the opposition of figure and ground advanced beyond the pictorial surface of Miró to include discs and spheres interacting in three-dimensional space. When Miró's shift from surrealist automatism toward more formal abstraction is considered, it is not surprising to find his American friend sharing the same concerns. Also in Miró's constructions and paintings, Calder would soon find inspiration for his abstract Surrealist objects and for mobile-panels featuring biomorphic forms placed on solid fields of pure color.

Gradually Calder introduced motion into his nonobjective constructions, but even the earlier abstract works were described in scientific terminology. Calder considered *Red Frame* to be one of the finest pieces from this period. He further explained such works: "In the earlier static abstract sculptures, I was most interested in space, vectoral quantities, and centers of differing densities."[41]

Elements Calder mentioned in this statement are certainly found in *Red Frame*. A wooden rectangle defines the outer edge of this spatial painting. Vectoral quantities are indicated by lengths of heavy-gauge wire projecting at varying amplitudes from the red frame. The colored metal discs and the white wooden sphere have different densities or "weights" within the composition. Certain colors advance toward or recede from the spectator as in Miró's magnetic-field paintings. In addition, the work is a plastic equivalent of the pure painting espoused by Mondrian and the Abstraction–Création group. Varying geometric shapes and colors oppose one another in a balanced but dynamic format, but as an embodiment of the scientific principles that interested the artist, *Red Frame* conforms to the statement just quoted. When one considers the different amplitudes of the varying elements in the composition as well as their respective densities, the center of mass falls precisely within the plane Calder has defined by the red frame.

For his first series of abstract constructions incorporating motion, Calder turned to a formula for moving elements he had used earlier. *Crank-Driven Mobile* (Fig. 75), for example, is a variation on a system for kinetic sculpture he had developed as early as 1929 with his *Fishbowl with Crank* (see Fig. 58). Within a wire frame he now positioned two rotating abstract elements, a helix and a metal disc. As with the *Fishbowl*, he prescribed the amplitude (range of movement) and velocity of each. But because the artist confined his kinetic objects within a frame, *Crank-Driven Mobile* should be considered an abstract painting in motion rather than a three-dimensional sculpture. Its components do not activate or interact with surrounding space but operate within their own limited area. With this object Calder remained close to the pictorial conceptions of Mondrian and Miró. He had not yet attempted to incorporate fully sculptural spatial relationships into his kinetic work.

The term "mobile" was offered by Marcel Duchamp in 1932 on his first visit to the Calders' spacious home and studio at 14 rue de la Colonie, where they had moved the previous year. Calder wrote several different accounts of Duchamp's visit.[42] In an interview he recalled Duchamp's response to his work:

> I don't think he liked the Circus – I don't think so. But he liked the other things I was making. There was one object I am trying to reproduce now, because it was destroyed in the war; it was squashed flat, and I have the workmen in France

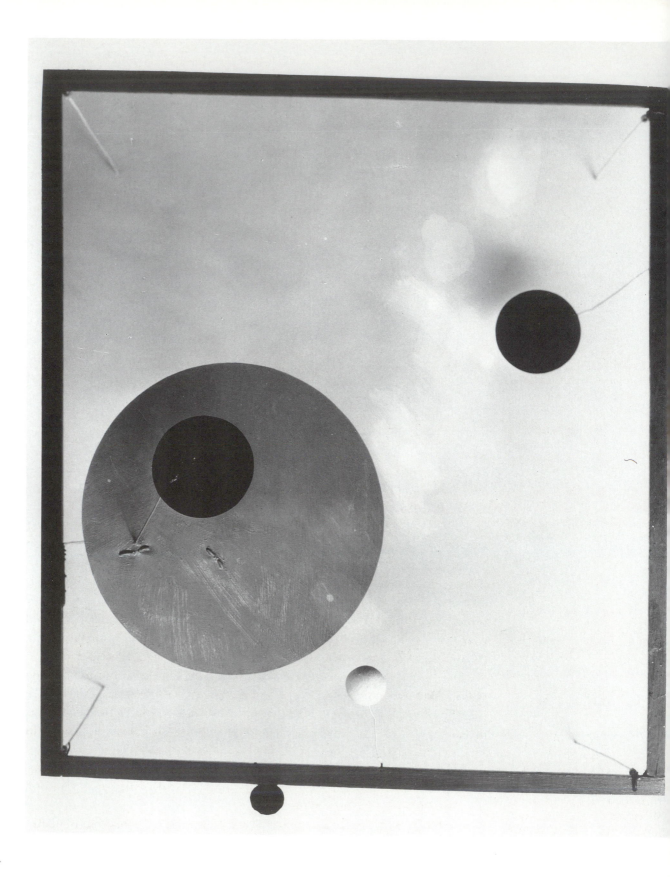

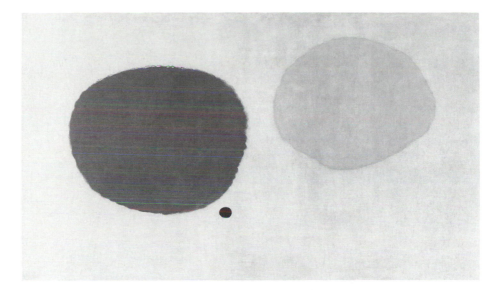

FIGURE 74. Joan Miró, *Painting*, 1930. Oil on canvas, 59″ × 88″. Houston: The Menil Collection.

trying to reproduce it from drawings. He saw that; I had just painted it, and he was so anxious to see it move that he pushed it, and he got all full of paint. That was in '32. It was then that he gave me the name of the mobile, which was what he called his things. . . . Mobile was a generic term. I made a drawing of one on a card and he got me to write on the card like restaurants do, "Calder, ses mobiles."[43]

Duchamp helped Calder to arrange a show of his latest works at Marie Cuttoli's Galerie Vignon, which opened on February 12, 1932. Following Duchamp's suggestion, the announcement included a drawing that was "un peu mécanique"[44] (Fig. 76). Likewise Calder accepted Duchamp's designation "mobile" for the kinetic constructions, and thereafter he preferred to use such a generic term rather than specific titles. Calder also recalled his fascination with Duchamp's first motorized device *Rotary Glass Plates* [*Precision Optics*] (1920; Yale University Art Gallery; gift of Collection Société Anonyme). Five painted glass plates, when set in motion and seen from a distance of one meter, formed continuous concentric circles.[45] The American-born Dada/Surrealist Man Ray also developed *Obstruction* in 1920, a suspended sculpture made entirely from wooden coathangers. Man Ray was friendly with Calder in Paris, and may have shown him photographs of the lost piece that could move slightly, and cast interesting shadows on surrounding walls.[46]

Calder's early kinetic constructions were referred to as "mobiles" or simply as "objects." Works of this kind were later given titles by Calder or museum curators for easier identification.

Duchamp had first used the term "mobile" in 1913 for his "ready-made" of a bicycle wheel mounted on a stool, and he had continued to experiment

FIGURE 73. (*opposite*) Alexander Calder. *Red Frame (Construction)*, 1932. Painted sheet metal, wire, and wood, 30¼″ × 35″ × 26½″. Philadelphia Museum of Art.

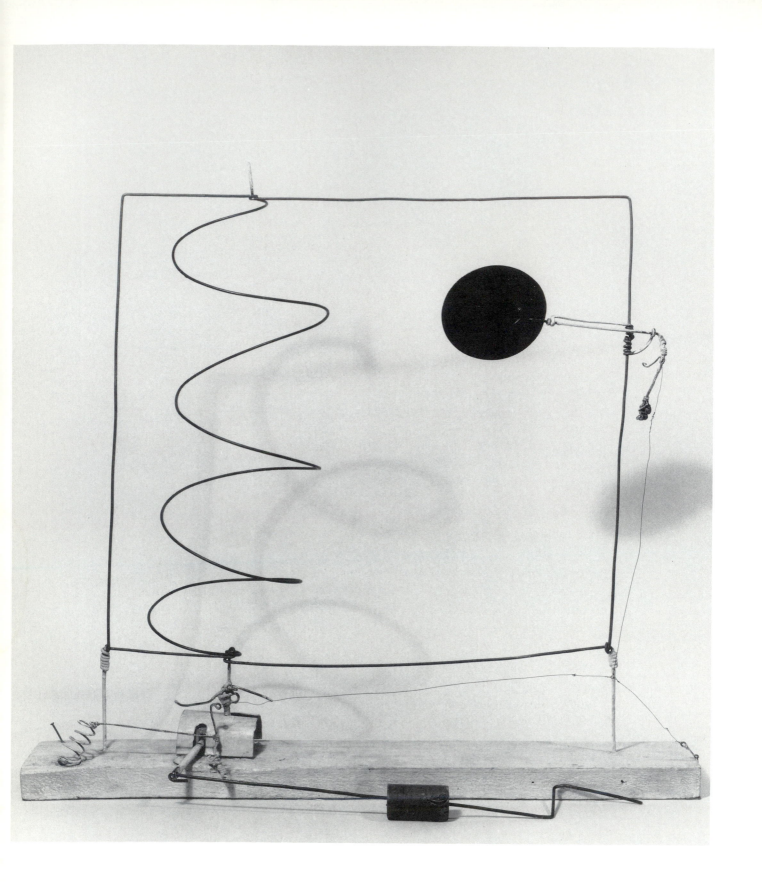

116

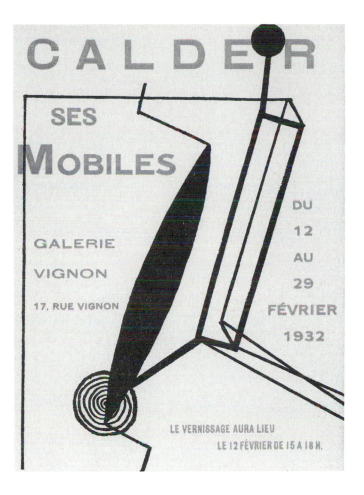

FIGURE 76. Alexander
Calder. Invitation, Galerie
Vignon, Paris, 1932. Wash-
ington, D.C.: Archives of
American Art, Smithsonian
Institution, Calder Papers.

FIGURE 75. (*opposite*) Alex-
ander Calder. *Crank-Driven
Mobile*, 1931–2. Wire, wood,
and sheet metal, 23″ ×
24½″. Washington, D.C.:
Hirshhorn Museum and
Sculpture Garden, Smith-
sonian Institution. Gift of
Joseph H. Hirshhorn, 1966.

with motion in his work.[47] Calder's reconstructed *The Bicycle, motorized mobile that Duchamp liked* (Fig. 77) included two wooden spheres and a tapered cylindrical device attached to wire rods. Each element worked independently and each described a different kind of motion. Here Calder constructed a piece that combined a diversity of forms, amplitudes, and movements. The work is a successful plastic realization of his stated intention for kinetic sculpture: "Why not plastic forms in motion? Not a simple translatory or rotary motion but several motions of different types, speeds, and amplitudes composing to make a resultant whole. Just as one can compose colors or forms, so one can compose motions."[48]

Albert Elsen observed that Calder's role as a sculptural "composer" has not been sufficiently acknowledged because of the attention given to his creation of kinetic sculpture.[49] The complex relationships between elements and the descriptions of various types of motion were of primary concern for the artist. *Motorized mobile that Duchamp liked* and *Dancing Torpedo Shape* (Fig. 78) were among Calder's earliest mobiles. The crudely fashioned crank-driven

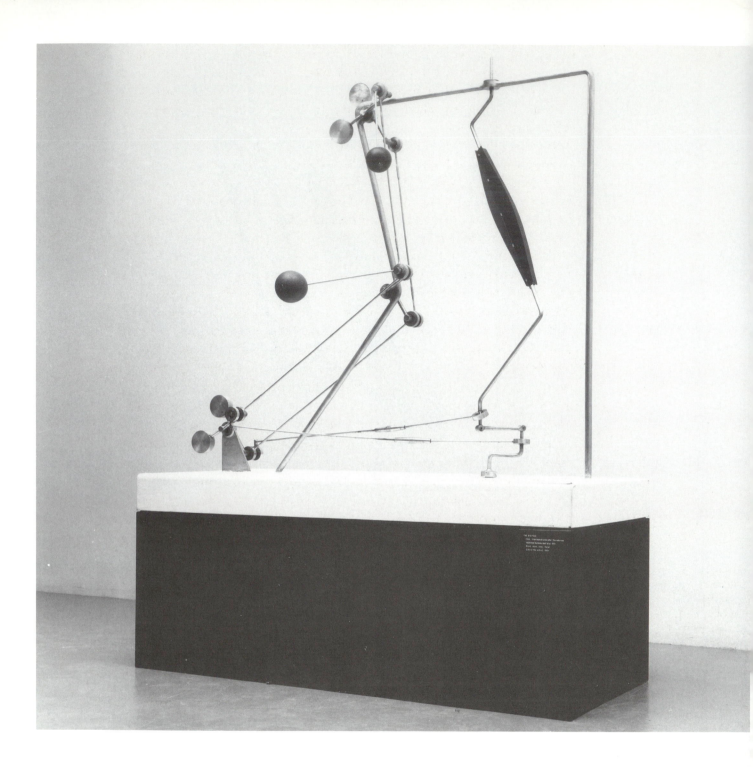

device of only three moving elements was quickly succeeded by constructions of greater complexity and refinement.

Dancing Torpedo Shape was one of thirty objects included in a Galerie Vignon exhibition in 1932. The title, given to the work later by a curator or dealer, refers to the cylindrical element that gyrates fitfully. From the beginning,

Calder was aware of the effects of shadows his mobiles cast on surrounding walls. In his later years the artist even had occasion to request that a spotlight be installed for a large-scale mobile.[50] In *Dancing Torpedo Shape* a network of lines and shapes casts reflections in changing configurations. The projection of the piece beyond its own spatial boundaries by the casting of moving shadows on the surrounding walls suggests that *Dancing Torpedo Shape* was derived from *Space–Light Modulator* by Laszlo Moholy-Nagy. This motorized device, which also cast shadows, featured abstract elements and colored light. The *Space–Light Modulator*, constructed at the Bauhaus in the 1920s, was shown in 1930 at the Exposition Internationale du Bâtiment in Paris, and reproduced in the first edition of *Abstraction–Création*.[51]

In the early 1930s Calder and other American sculptors such as Ibram Lassaw, Theodore Roszak, and José de Rivera determined to make an art relevant to their own times by using the materials and technology of modern industry. While Calder did not cite the importance of Moholy-Nagy's writings, both Roszak and Lassaw specifically mentioned the impact of concepts learned from the book of this Bauhaus master entitled *The New Vision*. Moholy-Nagy had developed his own concepts for sculpture in the machine age that were presented in *Von Material zu Architektur*, a book published in an English edition as *The New Vision*, in 1930. This Bauhaus book included reproductions of recent works by the author, Bauhaus students, and other avant-garde artists.[52] Moholy-Nagy wrote specifically about the new possibilities for sculpture, outlining five stages of development of three-dimensional pieces on the basis of the working of materials. Traditionally, he observed, sculpture was "blocked out, modelled or perforated," and he gave particular attention to "equipoised and kinetic sculpture." An exhibition of Russian Constructivists in Moscow was illustrated with the note: "The school concepts of mechanics, dynamics, statics, kinetics, the problem of stability, of equilibrium were tested in plastic form. The Constructivists reveled in industrial forms, so much so that a technical monomania governed them."[53]

Studies in balance were reproduced, and Moholy-Nagy proposed that sculptors could benefit from more knowledge of engineering. Interspersed with works by Gabo, Rodchenko, and even Picasso's sketch for a sculpture in wire are some studies in equilibrium (Fig. 79). Kinetic sculpture was designated by the author as "the highest sublimation of volume content, the creation of virtual volume relationships realized at the point of balance of taut forces."[54] The Bauhaus artist traced the history of kinetic sculpture back to the Middle Ages and the first clockwork automata. He discussed Boccioni's "dynamic" sculpture and the *Realist Manifesto* by Gabo and Pevsner, and quoted from "Kinetic-Constructive System of Force," which Moholy-Nagy coauthored with Alfred Kemeny in 1922:

> Constructivism in nature is the aspect under which life manifests itself, and is the spring of all human and cosmic evolution.

FIGURE 77. Alexander Calder. *The Bicycle*, 1968. (Free reconstruction of *The Motorized Mobile that Duchamp Liked* of 1932.) Motor-driven mobile of wood, metal, cord, and wire, 61½″ × 59″ × 26⅛″. New York: The Museum of Modern Art. Gift of the artist.

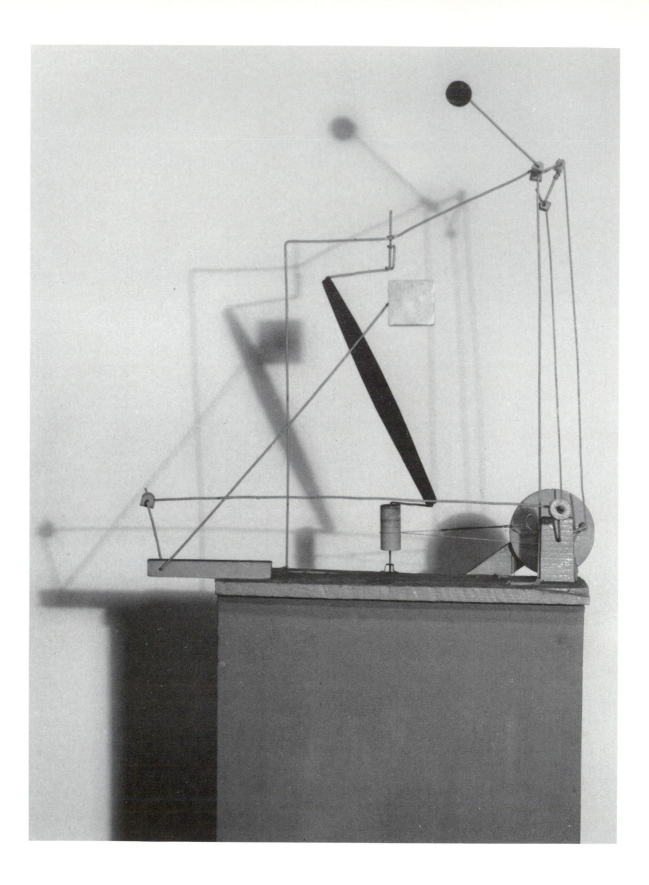

Fig. 1
Study

FIGURE 78. (*opposite*) Alexander Calder. *Dancing Torpedo Shape*, 1932. Wood, iron, and aluminum, 32½″. Pittsfield, Mass.: The Berkshire Museum.

FIGURE 79. (*top*) Johannes Zabel. *Construction in Equilibrium*, 1923 (illustrated in Moholy-Nagy, *The New Vision* [1930], p. 110).

FIGURE 80. (*bottom left*) Irmgard Sorensen-Popitz. *Equipoised Sculpture*, 1924 (illustrated in Moholy-Nagy, *The New Vision* [1930], p. 137).

FIGURE 81. (*bottom right*) Franz Ehrlich. *Study for a Mechanical Shop Window*, 1928 (illustrated in Moholy-Nagy, *The New Vision* [1930], p. 130).

Translated into art this means the activation of space by means of a dynamic-constructive system of forces, that is, the constructing within one another of forces actually at tension in physical space, and their construction within space, also active as force (tension). We must therefore put in the place of the static principle of classical art the dynamic principle of universal life.[55]

Moholy-Nagy's writings of the 1920s, therefore, established a basis for continued exploration of constructivist and kinetic sculpture in the following decade. For example, Calder's recurring use of the spiral in subsequent kinetic devices may be related to Moholy-Nagy's designation of the spiral as a "biotechnical" element of construction. Historically, the Hungarian Constructivist informed his readers, stereometric elements such as the sphere, cone, cylinder, cube, prism, and pyramid were considered the foundations of sculpture, but biotechnical constructional elements – the crystal, sphere, cone, plate (surface) strip, rod, and spiral – are the "basic technical elements of the whole world."[56] The spiral was singled out as an element leading to new conceptions of beauty apart from other aesthetic principles. Calder was also fascinated with the spiral and used the element in some of his early motorized mobiles (see Fig. 96), and even in later works. In addition, Calder's earliest constructions (see Fig. 84) bear some relationship to the equipoised sculpture reproduced in *The New Vision* as a work by a Bauhaus student (Fig. 80). *Dancing Torpedo Shape* (see Fig. 78) seems to be a simplified version of *Study for a Mechanical Shop Window* (Fig. 81) produced by Bauhaus artist Franz Ehrlich, also illustrated in the book. Calder's use of a pulley system for this and other kinetic constructions parallels the German example. Ehrlich included an arrangement of rectangular elements that were intended to move along parallel planes. Calder contrasted planar forms with other stereometric elements, but the motion encompasses only a series of planes rather than full, three-dimensional volumes.

Calder seriously considered the Constructivist dictum to incorporate space into his sculptures. The removal of his wire constructions from a solid base satisfied Moholy-Nagy's proposals for equipoised sculpture. Calder's wind-driven mobiles suspended from the ceiling are kinetic, like Rodchenko's early works, but less contained, in order to incorporate many volumes of space – as proposed by Moholy-Nagy. The major portion of Calder's constructions of the early years "extend" into space. No distinction is made between base and sculpture, and frequently the piece "rests" on a wire form, with no base attached. In Calder's attempt to release sculpture from the tyranny of gravity and traditional sculptural mass, he achieved an innovative and successful solution to Moholy-Nagy's proposals. The Hungarian Constructivist wrote of removing the static work of sculpture from the base and creating a volume that was self-contained with "no relationships to the directions of the earth:

horizontal, vertical, or oblique."[57] The author even proposed heightening the illusionism by the use of glass, or of almost invisible wires on which the materials could be fastened. In turn, Calder spoke of wanting to make the supports for his elements invisible to heighten the illusionism.[58]

Demonstrating his knowledge of the tenets of constructivism, Calder's early kinetic works suggest that his attempt to include "several motions of different types, speeds, and amplitudes"[59] compelled him to review his college instruction in applied kinetics. Translatory, periodic, and rotary motion were demonstrated in his course at the Stevens Institute of Technology. Because devices like the pendulum and the helix would have been used there to describe motion of different types and speeds, it is not surprising that scientific apparatus and elementary laws of physics became the source material for a number of abstract constructions that Calder fabricated in his early years of experimentation with kineticism.

The term "kinetic" was first used in connection with the plastic arts by Gabo and Pevsner in their *Realist Manifesto* of 1920, where they spoke of "kinetic rhythms." But the term "dynamic" was still used to denote movement in the plastic arts. Moholy-Nagy and Kemeny developed concepts about movement, while Léger, Schlemmer, and Kiesler all used the words "kinetic" and "cinematic." But Calder's mobiles of the 1930s were the first sustained exploration of virtual movement in sculpture, a concept that found a range of expressions in post–World War I Europe.[60]

A motorized mobile was published in the 1933 almanac of *Abstraction–Création*.[61] This work bears some resemblance to an unpublished drawing dating from the same period (Fig. 82). Four elements appear in this construction, and each describes motion differing in type, velocity, and amplitude from the others. The pendulum, helix, sphere, and metal plate are described in a text accompanying the illustration in *Abstraction–Création*:

> A "Mobile"
> Dimensions: 2 meters by 2 meters 50
> Frame: 8 centimeters, red
> The two white spheres turn very quickly. The black helix turns quickly and continuously appears to be rising. The metal plate turns even less quickly and the two black stakes appear to be rising continuously. The black pendulum, 40 centimeters in diameter, swings 45° from one side to the other, passing the frame at a rate of 25 strokes per minute.[62]

Measurements and precise calculations in the preparatory study (see Fig. 82) reveal nothing of the artist's purpose in devising such a work, but they show his rigorous scientific approach and parallel the diagrams prepared with great precision by mechanical engineers. Calder measured all the elements, projected the angles to be described when the objects were in motion, and

FIGURE 82. Alexander Calder. Preliminary Drawing for a Motorized Device, c. 1933. Collection unknown.

determined the amplitude of each moving element. The intention to compose with motions, forms, and colors, as articulated by Calder a year later in the written statement quoted earlier, was already taken seriously by the artist in 1932.

Another construction of this period, *Half-Circle, Quarter-Circle, Sphere* (Fig. 83), incorporates the curved lines and geometric planes found in paintings by Jean Hélion, Sophie Taeuber-Arp, and other members of Abstraction–Création in the 1930s,[63] but Calder eliminated the solid pictorial ground and constructed the abstract elements in wire and metal. By the addition of a motor, he created a composition in which the spatial relationship of the two devices is constantly changing. The sphere is actually an open form created

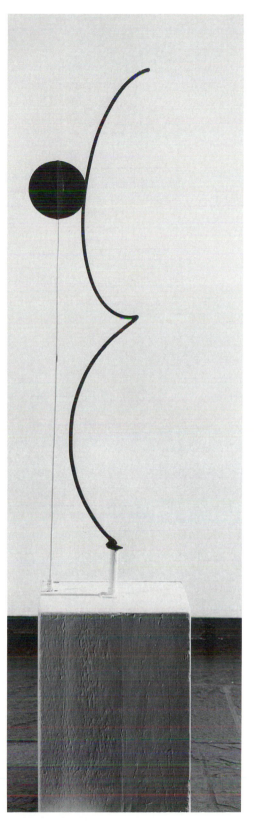

FIGURE 83. Alexander Calder. *Half-Circle, Quarter-Circle, Sphere*, 1932. Painted steel rod, wire, sheet metal, wood, and motor, 78¼″ × 24″ × 13¾″. New York: Whitney Museum of American Art. Purchase, with funds from the Howard and Jean Lipman Foundation, Inc. 69.258.

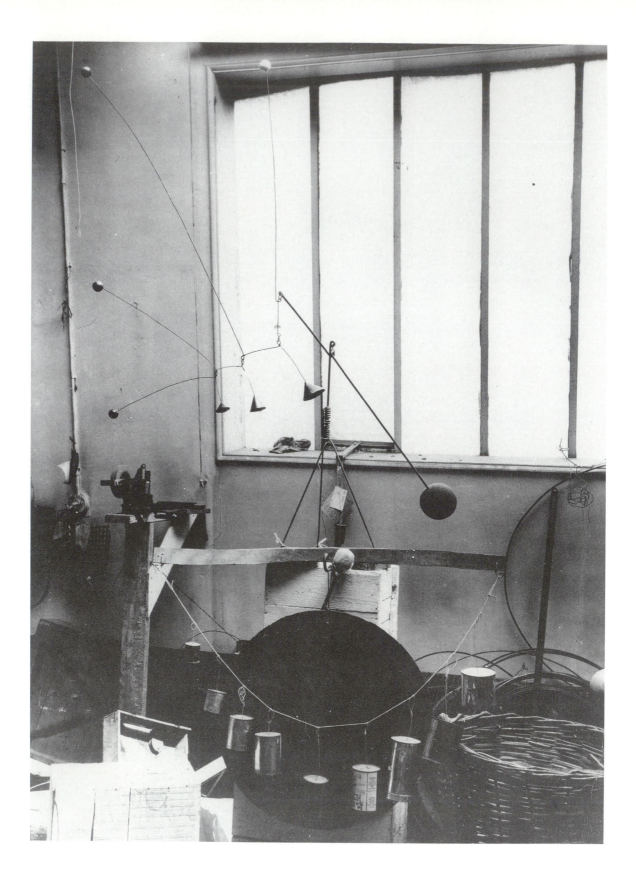

126

FIGURE 85. Center-of-Gravity Systems. *Apparatus for Physics*, Cambridge, Mass.: L. E. Knott Apparatus Company, 1925.

by the intersection of red and black discs. This open sphere, which appears to be derived from Naum Gabo's 1920 kinetic construction *Standing Wave* or *Tower* of the previous decade[64] swings back and forth like a pendulum. The heavy-gauge metal rod that forms the combined half-circle and quarter-circle element rotates around its own axis.

All the motorized devices just discussed were included in Calder's solo exhibition at the Galerie Vignon in February 1932. Critical reaction to the artist's earliest mobiles was generally very favorable. In an article titled "Sculpture Automobile," a French critic wrote: "The intent of the artist is less impenetrable than one may believe. On the contrary, it is evident that he wished to realize new harmonies of lines, volumes, and movements to appeal to the intellect rather than to the emotions, even in their appearance."[65]

Shortly after the exhibition Calder began to experiment with wind-driven devices. An untitled mobile (Fig. 84), shown in his studio at the rue de la Colonie, is an early example. The kinetic construction features a pyramidal wire base supporting a system of wooden and iron weights which demonstrate dynamic equilibrium. Calder's construction is derived from basic devices used in physics laboratories to demonstrate the laws of gravitation (Fig. 85). Here the artist demonstrated unstable equilibrium with the two opposing "arms," one with a large sphere and the other with a series of metal pieces attached to a network of wires. The composition is constantly in a state of flux as the different shapes and densities of the eight elements in motion create a succession of spatial configurations. The "formula" for balance established in this work was utilized for a series of constructions during this period and continued in standing mobiles that Calder constructed in the next four decades.

Object with Red Discs (1932; Fig. 86), later called *Calderberry Bush*, is one of the most interesting wind-driven mobiles of Calder's early years. He described the work in his autobiography:

> The *Calderberry Bush*: a two-meter rod with one heavy sphere suspended from the apex of a wire. This gives quite a cantilever effect. Five thin aluminum discs project at right angles from five wires, held in position by a wooden sphere counterweight. The discs are red and supporting members, including the heavy sphere, are black, while the wooden sphere is white.[66]

The artist claimed he never assigned the title "Calderberry Bush" to this construction.[67] In the early 1930s, the work was exhibited with its original designation, *Object with Red Discs*. The sculpture demonstrates the principles of dynamic equilibrium and seems indebted to a standard laboratory device such as the thirty-rod wave apparatus (Fig. 87), an instrument used to demonstrate the formation of transverse and longitudinal waves. On that device metal rods are attached at regular intervals to a steel ribbon, and metal balls are attached to the rods. The balls are painted different colors. When pressure

FIGURE 84. Alexander Calder. Untitled Mobile in Studio, 1932. Washington, D.C.: Archives of American Art, Smithsonian Institution, Calder Papers.

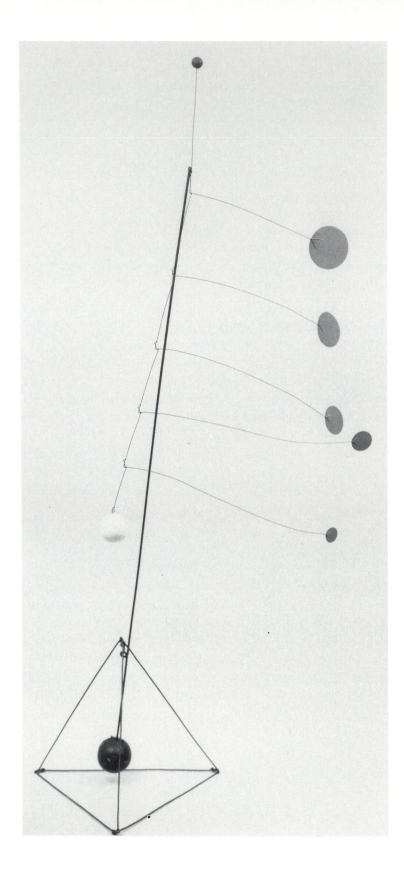

128

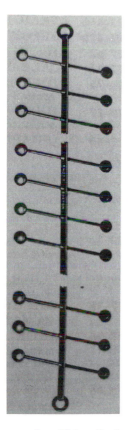

FIGURE 87. Thirty-Rod
Wave Apparatus. *Apparatus
for Physics*, Cambridge,
Mass.: L. E. Knott Appara-
tus Company, 1925.

FIGURE 86. Alexander
Calder. *Object with Red Discs
(Calderberry Bush)*, 1932.
Painted steel rod, wire,
wood, and sheet aluminum,
88½" × 33" × 47½". New
York: Whitney Museum of
American Art. Purchase,
with funds from the Mrs.
Percy Uris Purchase Fund
86.49.

is applied to one crosshead it is communicated to the other crossheads until all the balls are moving and describing a wave pattern. The advantage of such a device is that it slows down the process of wave propagation so that the shape of the wave can be easily observed. Such devices as the pendulum and the thirty-rod wave apparatus are standard demonstration pieces for physics laboratories and would have been familiar to the artist. Apparently in Calder's early exploration of kinetic constructions, such devices served as sources of inspiration, both in their form, and in the physical principles they demonstrated. In the case of *Object with Red Discs*, Calder achieved the same effect as that produced by the double row of metal balls on the wave apparatus by using a counterweight to balance the series of five discs attached to rods. The precise equivalent of the observable propagation of a wave pattern is not achieved in Calder's object because he limits the number of elements, but he has used a similar concept. When one red disc is moved, the others are set into motion and the result is an observable propagation of movement. By changing the weights on the ends of the thirty-rod wave apparatus, the speed of the wave propagation will be altered. Calder has varied the velocity of each of his metal rods by attaching discs of different sizes. A more random movement of elements is the result.

In another work of this period, *Black Ball, White Ball* (c. 1933; Fig. 88), Calder incorporated sound and used a pendulum as his basic source. Two balls of unequal size are attached to either end of a metal bar by wires of different lengths. When the piece is set into motion by a forceful push on the black ball, the two balls twirl around and dip periodically to strike the sides of an array of metal plates of varying dimensions. Calder considered this work one of his "noisemobiles."[68] The frequency of the sounds that result is based on the sizes of the plates and the force and position of each ball as it strikes a plate: generally, the smaller the diameter of the plate, the higher is the frequency. Here Calder has derived his construction from knowledge of a pendulum apparatus,[69] which demonstrates variation in the velocity and duration of the movement of an element based on changes in the length of the wire to which the element is attached.

The motion of *Black Ball, White Ball* is random, unlike the Foucault pendulum,[70] a standard device for demonstrating conservation of the plane of oscillation. Rather than maintaining a predictable directional movement, Calder's pendular device swings around, following no specific pattern, because one pendulum is not fixed to a stationary source but to a fulcrum that supports another pendulum. In addition, when either ball hits a plate, the exchange of forces further modifies the direction of movement. The randomness of the sound that results curiously parallels experiments in contemporary music. Calder's friendships in the 1930s with such modern composers as Edgard Varèse and Virgil Thomson, as well as his involvement with Dada and Surrealist painters and poets, may account for the incorporation of chance into this work.

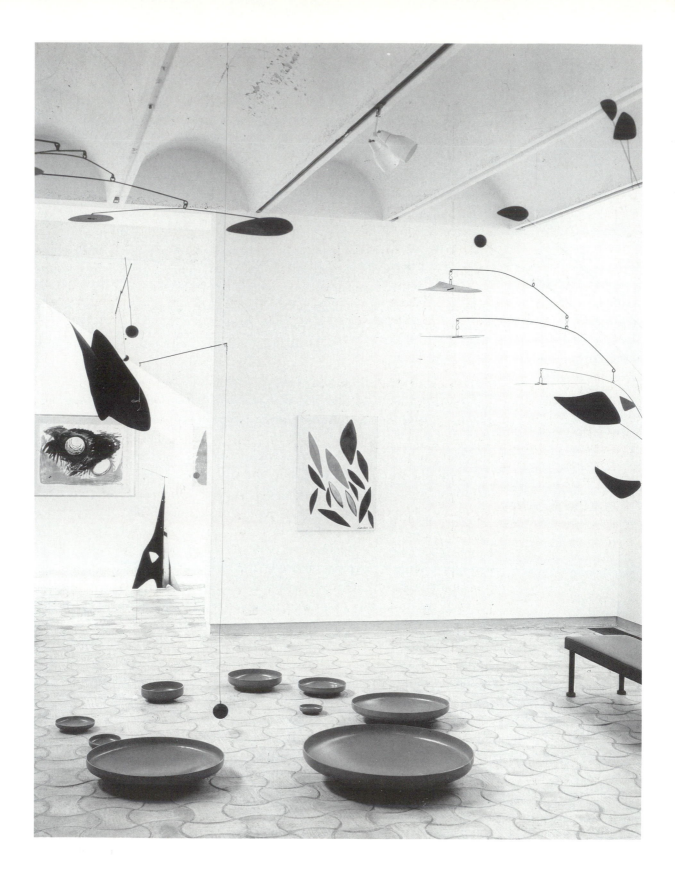

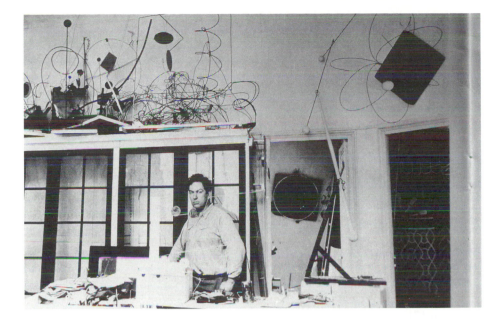

FIGURE 89. Calder in His Studio, Rue de la Colonie, Paris, c. 1933. Washington, D.C.: Archives of American Art, Smithsonian Institution, Calder Papers.

In a photo dating from 1932 (Fig. 89), Calder is seen in his studio at 14 rue de la Colonie. The artist is surrounded by some of the motorized constructions and other abstract pieces he had created in the preceding year. Throughout the early 1930s, the American maintained his friendships with Mondrian and with members of the Abstraction–Création group, with whom he continued to exhibit.

Many artists active in Abstraction–Création were associated with other vanguard groups, but Calder managed to avoid the rigorous polemics of rival factions among the membership. Moreover, although the charter issue of the journal *Abstraction–Création, Art Non-figuratif* (1932), announced in an editorial that only artists committed to a nonfigurative style were invited to join,[71] Calder was known to have continued his circus drawings in these years, and he even gave a performance of his *Circus* during an exhibition of the group at Porte de Versailles in 1931. Apparently his good-natured attitude brought many Parisians to his door. The artist recalled that on some occasions he and Louisa hosted almost a full reunion of Abstraction–Création members,[72] and at one time nearly a hundred people attended a performance of the circus in his studio.

Calder was unique among his American contemporaries of the 1930s. Except for Man Ray, who had emigrated to Paris in 1921 and who was primarily identified with the Surrealists, no other American had such a sustained association with European modernists or the attention and direct support of some of the leading artists in Paris. Arp, Duchamp, and Miró came to his studio regularly, he was included in most major group exhibitions with European modernists, and critics in Paris and London followed his shows with great interest. In all respects Calder was an internationalist. Not only did he

FIGURE 88. (*opposite*) Alexander Calder. *Black Ball, White Ball*, c. 1933 (reconstructed). Wire and metal plates, 96⅘" × 33½". St-Paul-de-Vence: Fondation Maeght.

reside in both Paris and the United States, but his works were respected among both European and American modernists. For American modernists who visited Paris in this period, Calder became an example of acceptance and renown in international circles.

The Calders sailed for New York in May 1932, after renting their house to Gabrielle Picabia, first wife of Francis Picabia.[73] Accompanying the artist was a large shipment of his mobiles and abstract constructions which were to be given their first exhibition in the United States at the Julien Levy Gallery in New York. Levy's memoirs include this account:

> At the end of my first season Alexander Calder appeared. The *gros bon* Sandy with Medusa (as I heard him call the lovely Louisa) and their dog Feathers, were now living in New York. . . . He had mechanized sculptures to show, and a few that were fixed and motionless. . . . Although complicated, the machinery repeated patterns mechanically and eventually became, it seemed to me, predictable and monotonous. . . .
>
> Now at my new gallery, Sandy wanted a show. I was not enthusiastic. As I have said, the repetitive, mechanical quality of these first mobiles dismayed me. It was spring and time to assemble my exhibitions for the following season. So it is to Joella [Levy's wife] that credit may be given for my staging Sandy's first New York show of mobiles. She adored Sandy and everything he did, and made all arrangements while I was away. The exhibition received an enthusiastic review by Henry McBride. . . .
>
> I lost Sandy as a potential member of the gallery group in spite of Joella's warm efforts. To my disgust, his electric motors blew fuses in the gallery, and worse, holes had to be dug in the pristine walls for new out-lets. I was furious, and no doubt, unduly sarcastic, and when the time came for another show, to present the new and beautifully balanced mobiles for which he became famous, he turned to another dealer, Pierre Matisse.[74]

Calder's first New York show of his abstract sculpture was well received by critics. In the *New York Times*, Edward Alden Jewell wrote:

> There is something absolutely new in sculpture at the Julien Levy Gallery, 602 Madison Avenue, where "Mobiles" by Alexander Calder were placed on view yesterday. . . .
>
> At first it all seems merely bizarre. You smile at the created antics of this big boy Calder, whose hair is beginning to grey. When that small red ball, pursuing its arc-rhythm focuses for an instant precisely in the centre of the circlet of wire that

moves also, with a rhythm of its own, there is a balanced universe, unresting and yet irrefragably sure in its minute, reciprocal calculations.... Amazing you agree, but is it art? And your question is not likely to be answered with definitive certainty, just as so many questions nowadays wait in breathless suspense for the definitive answer. What is art itself? At any rate, we seem to have here somehow, more than just an idle diversion.[75]

Henry McBride, writing in the *New York Sun*, declared that the expatriate Calder's sculpture could never have reached its "state of detachment from life" in America, and noted the cosmic imagery of the constructions, "we can be fascinated at once by the cute little motors that run these disks and wires and small planets.... And the Saturns and Jupiters, if that is what they are, move so lazily on their orbits, that, too, is fun."[76] According to the critic, Calder's art, resembling machinery, was not likely to be encouraged in the United States but had already received resounding acclaim in Paris. McBride observed:

> As for young Mr. Calder, we don't have to do anything in particular for him, since Paris has quite adopted him, much as she adopted Man Ray some time previously. There is no sense in lamenting these two artists as expatriates, since we cannot provide them with the sustenance necessary to their mental existences, and Paris can.[77]

Despite McBride's comments on Calder's greater acclaim in Paris than in New York, from the time Calder first showed his work in the United States he had an impact on American sculptors who were exploring Constructivism in their own work. Ibram Lassaw, for example, acknowledged the influence of Calder on his own development of open-space constructions.[78] His interest in kinetic sculpture was stimulated by Calder, and there are drawings in Lassaw's notebooks for motorized works, although none of these were realized. Later, Lassaw joined with George L. K. Morris, Charles Shaw, and Albert Gallatin to create a large motorized device for the New York World's Fair in 1939.[79]

During the 1930s, abstract sculptors in America were aware of Calder's international reputation, which distinguished him from their own struggles for recognition. Some of these American artists combined their efforts with painters in 1936, to form the American Abstract Artists group, an organization Calder never joined.[80] At a time when regionalist and social realism predominated, these artists had difficulty finding acceptance for their work. The sculptors had no solo exhibitions in this period, few sales, and virtually no critical attention. Calder was already identified with the European avant-

garde, and therefore remained separate from his American contemporaries, although some shared his involvement with Constructivist concepts.

Although direct carving of the figure occupied most "modernists" among American sculptors of the 1930s, a few were inspired by the European vanguard to explore new aesthetic concepts and materials. In addition to Calder, such artists as Ibram Lassaw, Theodore Roszak, and José de Rivera assimilated Constructivist principles and created nonobjective works that acknowledged modern technology, industrial methods, and scientific discoveries. These sculptors attempted to create a "machine-age" art and to establish a native style derived from industrial technology.[81] Roszak was among the most dedicated in his involvement with the machine as a means to create ideal and fantastic forms, but other artists shared his view that their art should be directly related to contemporary life, to the rhythms and forces of a technological age. Roszak learned Bauhaus principles while traveling abroad in 1929. By 1932 he was using industrial materials to produce sculptures and reliefs that paralleled the polished metal abstractions of Moholy-Nagy and Rudolf Belling. In addition to their undeniable "machine-made" appearance, Roszak's constructions seem equivalent to machines: turbines, engines related to aviation, or even fantastic rockets intended for travel in outer space.[82]

José de Rivera also made constructions based on the concepts of space and time developed by the Constructivists. Trained as a blacksmith and a tool-and-die maker, de Rivera used industrial materials for his sculptures, including *Flight*, a solid aluminum work commissioned for Newark Airport, which seems to describe airborn velocity. In the 1930s de Rivera also began to explore his own form of open-form kinetic sculpture, but only later examples of these linear configurations in space survive.[83]

Ibram Lassaw recalled seeing Calder's solo exhibition at the Pierre Matisse Gallery in 1934, as well as reproductions of his works. His interest in kinetic sculpture was stimulated by Calder, but Lassaw confined his production to nonobjective sculpture in wood, wire, and plaster. Open-space abstractions were Lassaw's principal interest, and he considered the innovative aspect of his work to be the creation of shaped voids.[84]

In contrast to Roszak, de Rivera, and Lassaw, David Smith had a different approach to industrial materials, incorporating bits of machinery into his sculpture and using curvilinear forms indebted to Gonzalez and Picasso. In 1933, Smith began to produce welded sculptures. In *Agricola Head*, for example, one of Smith's first works constructed completely of metal, iron and steel elements are combined to form an open head. This parallels metal constructions by Picasso in its humor and those of Gonzalez in the simplicity and geometric regularity of the chosen materials. Whereas the found objects used by European masters retain their identity and evoke the wit of the artists, Smith incorporated his metal fragments more completely and assimilated the machine parts into the new context he had created. Reclining figures, which appear in Smith's work beginning in 1934, relate to sculptures by Alberto

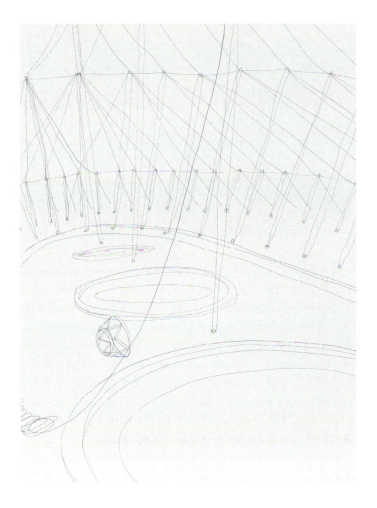

FIGURE 90. Alexander
Calder. *Circus Interior*, 1932.
Pen and ink, 19″ × 14″.
New York: The Museum of
Modern Art. Gift of Mr. and
Mrs. Peter A. Rubel.

Giacometti, who was associated with the Surrealists in these years. Later, Smith
not only adopted the cagelike structures used by Giacometti but also used
symbolic elements with personal (frequently sexual) meanings.[85] Thus, Cal-
der's American contemporaries continued to use Cubist–Constructivist prin-
ciples throughout the 1930s and 1940s, and their important legacy was
acknowledged by American sculptors of the postwar years.

After his show at the Julien Levy Gallery, Calder returned to the home
of Louisa's parents in Concord, Massachusetts.[86] During the summer months
he worked on a series of circus drawings (Fig. 90) that suggest his continuing
interest in the work of Paul Klee. In the previous year Calder had already
produced illustrations for *Aesop's Fables*, and his predilection for witty com-
positions of circus and animal figures continued, despite his commitment to
abstraction. Like Picasso, he felt free to work occasionally in a realistic mode
while primarily pursuing a constructivist approach. Perhaps his months of
isolation from the Abstraction–Création members allowed the artist to revive
his interest in representational imagery, which had been condemned by the

135

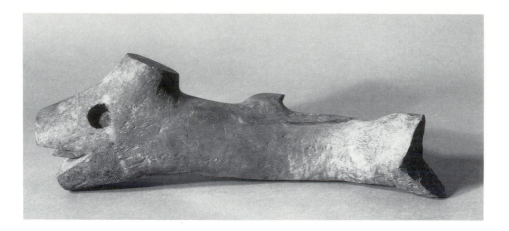

FIGURE 91. Alexander Calder. *Shark Sucker*, 1930. Wood, 10¾″ × 30⅞″ × 10¼″. New York: The Museum of Modern Art. Gift of the artist.

Parisian vanguard group. Calder also may have recognized that his amusing drawings were easier to sell in America than were his studies of the cosmos, since he had already developed a reputation for his witty circus scenes. American art of the thirties saw the ascendancy of social realism and regionalism, although a few abstract artists struggled to survive. Most American collectors and those commissioning panels for public projects (under the Works Progress Administration, for example) had little understanding of Constructivist art. Three weeks before his return to Europe, the artist wrote to Carl Zigrosser at Weyhe Gallery requesting a show of these drawings for the fall or winter.[87] Although Calder made additional drawings of smaller size than the first set and sent them to Zigrosser,[88] the drawing exhibition never materialized.

In August 1932, the Calders visited Miró at his family's farm in Montroig, near Barcelona. Calder's renewed contact with the biomorphic Surrealist stimulated a renewed interest in biomorphic forms after an extended involvement with the geometric severity of Mondrian. A few objects from the early 1930s, such as *Shark Sucker* (Fig. 91) and *Kiki's Nose* (see Fig. 68), appear to have been derived from biomorphic works by Jean Arp, but most of Calder's works of 1931 and 1932 conformed to the principles of the Abstraction–Création group.

After a second trip to Spain in January 1933, Calder's interest in Miró's biomorphic abstraction grew even stronger. Miró arranged for a solo exhibition of Calder's work at the Galeries Syra Amics de l'Art in Barcelona. At the invitation of Roman Gomez de la Serna, Calder also performed his circus and showed his work at the Sociedad de Cursos y Conferencias Residencia of the University of Madrid. Spanish critics hailed Calder for his mobiles and for his performance of "the smallest circus in the world."[89]

Calder produced *Cone of Ebony* (1933) as one of a series in which the artist returned to wood carving, though in a more abstract idiom than had appeared earlier in his work in wood. This mobile includes three large wooden elements suspended from wires as long as sixty inches. Only the cone is a geometric shape; the other two elements are biomorphic forms similar to those used by

Joan Miró in his paintings of the late 1920s. One resembles the strongly projecting beak of a fantastic bird found in Miró's *Hand Catching a Bird* of 1926.[90] *Cone of Ebony* was exhibited in a group show at Pierre Loeb's Galerie Pierre in the spring of 1933. The exhibition, which had been arranged by Jean Hélion, included works by Jean Arp, Alexander Calder, Jean Hélion, Joan Miró, Antoine Pevsner, and Kurt Seligmann. Anatole Jakovski, who wrote a series of essays to accompany the exhibition, discussed the importance of Calder's use of wire, "the most exciting material of the period." He commended Calder for rejecting established aesthetic values and compared him to the Dadaists.[91]

At the same time that Calder was exhibiting with several artists generally associated with Surrealism, he continued to exhibit with the Abstraction–Création group, which by this time had financial problems. Calder continued until 1934 to be included in the yearly almanac produced by the group, but only his mobiles composed of geometric elements were reproduced.[92] That Calder exhibited with both the Surrealists and the Abstraction–Création group explains something about the artist as well as these rival artistic factions. Throughout his artistic career, Calder preferred to remain independent of groups. His membership in Abstraction–Création was the sole example of his willingness to participate in such an organization, and his commitment to geometric abstraction was limited at the outset. Involvement with this group dropped off within three years of his joining, but he continued to be included in Constructivist exhibitions throughout the 1930s. On the other hand, Calder was unable to tolerate Salvador Dali, the predominant Surrealist painter of the 1930s, and he never joined the Surrealist group. Like his friend Miró, who had broken with the Surrealists in 1930, Calder remained wary of their orthodoxy. He had no objection, however, to including his biomorphic abstractions in their group exhibitions, and the Surrealists were more than willing to claim Calder's art for their movement – as they generally attempted to swell their numbers by including many artists. Jean Arp, who befriended Calder in this decade, found a similar situation in showing his sculptures ("concretions") and *papier déchirés* in the 1930s: He was included in exhibitions of Abstraction–Création and the Surrealists without the protests of either faction. What is suggested is that Calder and Arp had assimilated the concepts of the Constructivists and Surrealists into a personal vision of such importance that these rival groups were eager to claim them.

Calder had a solo exhibition at Paris's Galerie Pierre Colle in May 1933, and serious critical attention was given to his work. In *Mouvement*, Paul Recht described *Black Ball, White Ball* (see Fig. 88) as a work that consciously incorporated sound – resulting from the suspended balls striking the edges of large metal plates:

> The Pierre Colle Gallery has just presented an exhibition of
> the works of the American sculptor Calder. These structures

are articulated so that, at the slightest touch, they open up like flowers. . . .

Some of the structures are disconcerting in their freedom; you see two balls, one large and one small, attached respectively to wires of unequal lengths, which are in turn attached to the extreme ends of an arm – like the arm of a scale which hangs from the ceiling. Animated by a pendular and a rotary movement, the large ball drives the small ball, which describes the most unexpected scrolls in the air as it strikes the surrounding objects. Using means like gravity and centrifugal force, Calder has produced the most extraordinary visual variations on the theme of fatality.

Some of Calder's compositions are filled with celestial conjunctions, and other coincidences, which can be observed as the eye becomes aware of the recurrent cycles of movement.[93]

Another mobile, created in 1933, seems to have been inspired by a work created by Calder's friend Man Ray before 1920. *McCausland Mobile* (Fig. 92) exemplifies one of Calder's basic formulas for the construction of a wind-driven device hanging suspended from a wire. The fulcrum along a single metal bar is off center to balance the varying weights of suspended elements. Supported on one side of the horizontal bar is a folded sheet of metal painted blue and black on opposite sides. A smaller red wooden sphere and a yellow "torpedo shape" serve as counterweights for this intriguing volumetric form, which resembles Man Ray's *Lampshade*, a spiraling object cut from paper that hung suspended from the ceiling on a single wire. It should be noted that both artists were conscious of the shadows cast by their suspended plastic shapes and considered the varying shadows cast on walls as an integral part of the composition of their pieces.

Calder became concerned about the political situation in Germany early in 1933 (he later claimed that the European press carried articles about war preparations).[94] Also, Louisa had experienced a late miscarriage in Paris and was determined to return home to give birth in a tranquil environment.[95] As a result, in June the Calders returned to New York with their friend Jean Hélion. Soon after, they purchased a home in Roxbury, Connecticut. While the old farmhouse on Painters Hill Road was being repaired, the couple stayed in New Milford, Connecticut, with José de Creeft, Calder's sculptor friend from Paris who had emigrated in 1929.[96] Adjacent to the house in Roxbury was an old icehouse, which Calder soon transformed into the first studio he ever owned (his Parisian studios had been rented). The move to the country was of great significance in Calder's development. Working in a large house surrounded by fields and orchards (as opposed to an urban studio), Calder was able to increase the scale of his work. Soon he was constructing outdoor pieces on the eighteen acres adjoining his Connecticut home.

In the early 1930s Calder had gained some recognition in the United

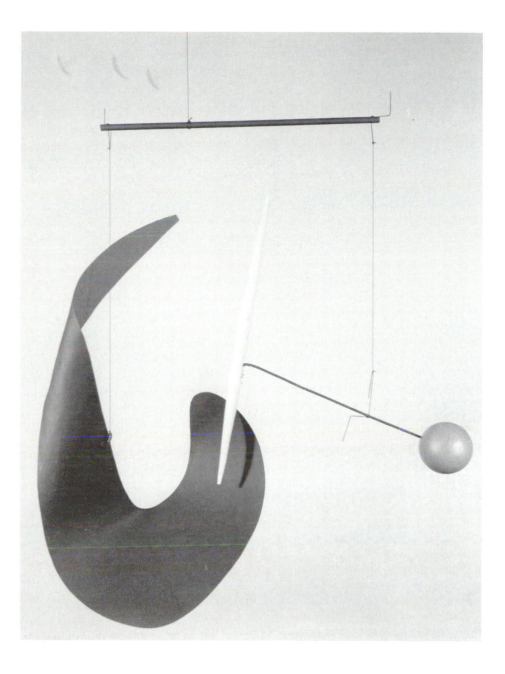

FIGURE 92. Alexander Calder. *McCausland Mobile*, 1933. Metal and wire, 25″ × 23″. Private collection.

States by participating in group exhibitions in various cities, and these shows continued. For example, in August 1933, Calder was included in "Modern Painting and Sculpture," held at the Berkshire Museum in Pittsfield, Massachusetts. To accompany *Dancing Torpedo Shape* (see Fig. 78) and *The Arc and the Quadrant* (Fig. 93), he prepared the following statement for the catalogue:

> The sense of motion in painting and sculpture has long been considered one of the primary elements of the composition. The Futurists prescribed for its rendition. Marcel Duchamp's

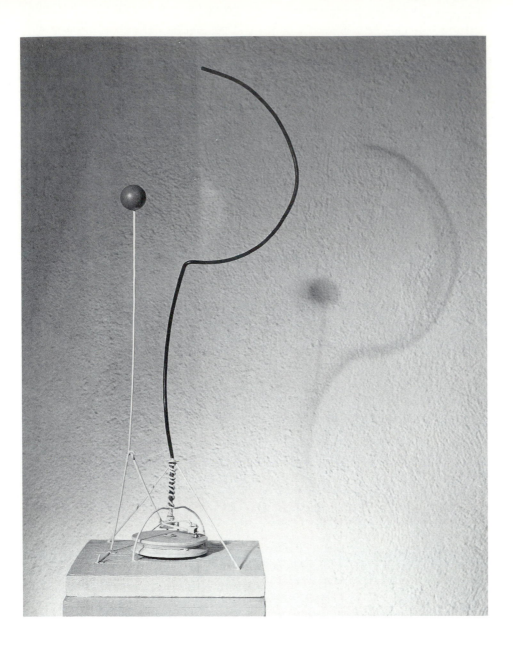

"Nude descending the stairs" is the result of the desire for motion. Here he has also eliminated representative form. This avoids the connotation of ideas which would interfere with the success of the main issue – the sense of movement. Fernand Léger's film, "Ballet Mécanique," is the result of the desire for a picture in motion. . . . The two motor driven "mobiles" which I am exhibiting are from among the most successful of my earliest attempts at plastic objects in motion. The orbits are all circular arcs or circles. The supports have been painted to disappear against a white background to leave nothing but the

FIGURE 93. Alexander Calder. *The Arc and the Quadrant*, 1932. Metal rods and wood, 32¼″ × 11½″ × 11¼″. Pittsfield, Mass.: The Berkshire Museum.

140

moving elements, their forms and colors, and their orbits, speeds, and accelerations.[97]

Both works exhibited by Calder were purchased by the Berkshire Museum in 1933, becoming the first two mobiles in a museum collection.[98]

The Arc and the Quadrant conforms to Calder's stated purpose and description of his work at the time. A red wooden sphere is mounted on the end of a vertical wire and is placed next to a metal rod that has been bent to form an arc. When the motor is operating, the two elements oscillate to create a constantly changing spatial relationship. This motorized device is reminiscent of Gabo's *Standing Wave*, a vertical metal rod attached to a motor, which was constructed in 1920,[99] but Gabo's work suggests a complete sculptural volume when in motion.

During the winter of 1933–4, Calder prepared for his first solo exhibition at the Pierre Matisse Gallery. The show opened on April 6, 1934, and Calder continued to have exhibitions at the Matisse Gallery until 1942. According to Matisse, the dealer had not known Calder before the latter visited his gallery at 41 East 57th Street in New York City. The American had come to see an exhibition of Miró's works on paper that was currently on view, and he then discussed with Matisse the possibility of having a show of his own there.[100] Known primarily for showing artists of the Parisian avant-garde, the Pierre Matisse Gallery did not exhibit Americans in those years.

A photograph of the installation at the Matisse Gallery (Fig. 94) shows that Calder chose to include both wind-driven and motorized devices. *Object with Red Discs*, on the left, had been exhibited earlier in Paris and was soon to be acquired by James Johnson Sweeney, who was associate editor of *Transition* from 1935 to 1938, and the author of *African Negro Art* (1935), a Museum of Modern Art publication. Sweeney was an early Calder enthusiast whose articles and essays brought the sculptor's work to national attention. *A Universe*, on the right, was purchased for the Museum of Modern Art by Alfred Barr, its director and one of the most astute critics of modern art in America during those years. Other works completed before the opening of the show included *White Frame* (1934; Fig. 95) and *Black Frame* (1934; Fig. 96).

In Sweeney's introduction to the catalogue, he wrote:

> The evolution of Calder's work epitomizes the evolution of plastic art in the present century. Out of the tradition of naturalistic representation, it has worked by a simplification of expressional means to a plastic concept which leans on the shapes of the natural world only as a source from which to abstract the elements of form.[101]

Pierre Matisse recalled that Calder's wind-driven devices were more popular than the motorized ones because the latter often needed to be repaired.[102]

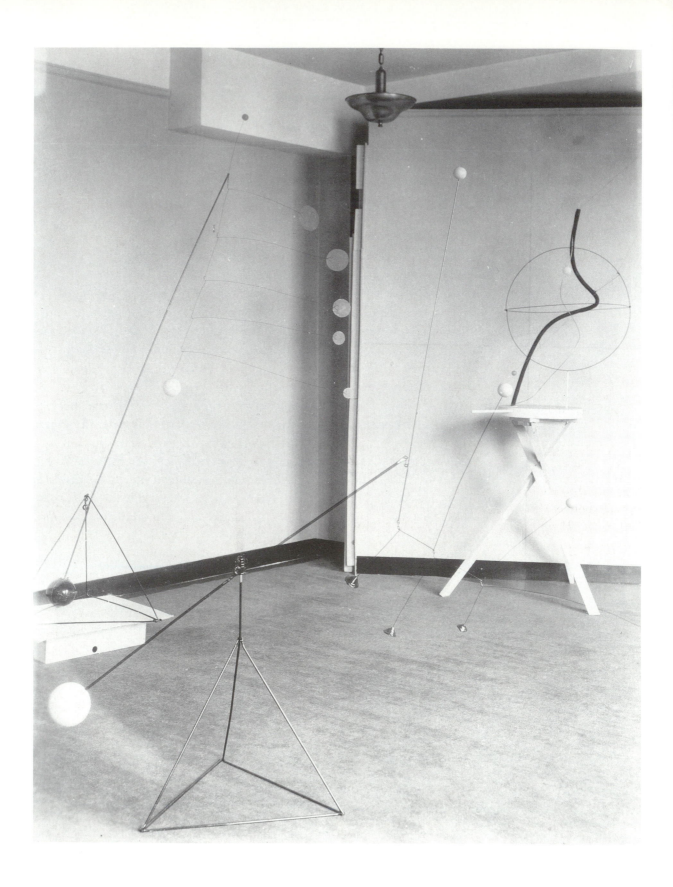

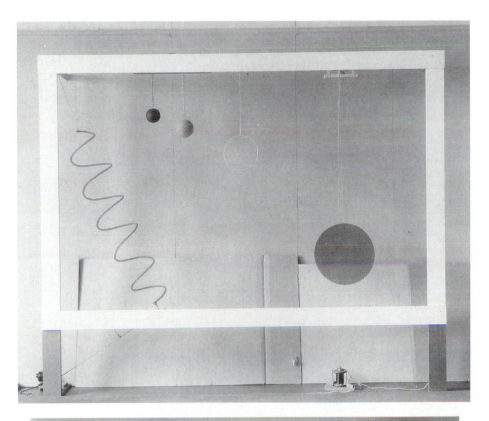

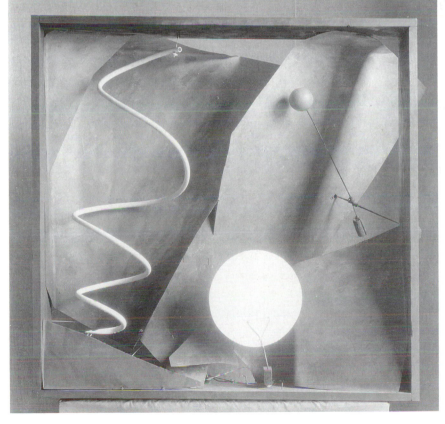

FIGURE 95. Alexander
Calder. *The White Frame*,
1934. Wood and wire, 90″ ×
108″. Stockholm: Moderna
Museet.

FIGURE 96. Alexander
Calder. *Black Frame*, 1934.
Wire, wood, and sheet metal
(lost). Photo: Peter A. Juley
& Son Collection, National
Museum of American Art,
Smithsonian Institution,
Washington, D.C.

FIGURE 94. (*opposite*) Calder
Installation, Pierre Matisse
Gallery, New York, 1934.
Photo: Peter A. Juley & Son
Collection, National Museum
of American Art, Smithson-
ian Institution, Washington,
D.C.

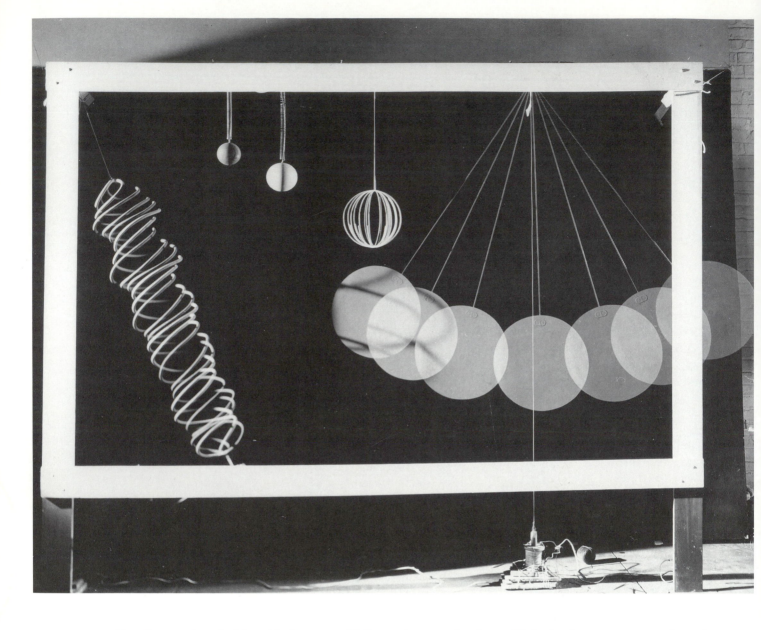

But few works of either kind were sold from these early shows.[103] Indeed, few abstract sculptors of his generation found American collectors for their work in this period.

One of the largest objects in the show was *White Frame* (see Fig. 95) measuring seven feet six inches high and nine feet wide. A harmony of shapes and colors, this large motorized device includes a symphony of movements. *White Frame* in motion (Fig. 97) can be viewed as a physics demonstration of various kinds of motion. The black helix exhibits simple rotary motion. Blue and yellow wooden balls suspended on springs, when set in vertical motion, are simple harmonic oscillators. The open wire circle indicates rotary motion when it spins. The large red disc swings back and forth like a pendulum and

FIGURE 97. Alexander Calder. *The White Frame* (in motion). Stroboscopic photograph by Herbert Matter.

144

therefore can be characterized as a periodic oscillator. Within the boundaries of a white wooden frame, Calder had fashioned a composition that included the primary colors, geometric shapes, and the basic types of motion demonstrated in elementary physics textbooks.

Here Calder chose a pictorial format he had favored two years earlier for *Red Frame* (see Fig. 73) and continued to use periodically during the next five years. His motorized works were often panels with a variety of geometric and organic elements suspended from the top and casting shadows on a colored backdrop. In 1934, Calder began to create more of these panels with painted backgrounds, and biomorphic imagery came to dominate the works of subsequent years.

Black Frame (see Fig. 96) includes some of the same elements, but here the helix, disc, and sphere have been combined with a series of overlapping metal plates that introduce light and shade into the composition. The plastic aspects of this construction are severely limited by the pictorial format, but the artist attempted to introduce a greater sense of three-dimensional space by bending and overlapping sheets of painted metal.

One of the finest works in Calder's exhibition at the Matisse Gallery, *A Universe* (1934; Fig. 98), was a motorized construction included in the First Municipal Art Exhibition held at Rockefeller Center a month earlier and acquired for the Museum of Modern Art immediately following the show.[104] Abby Aldrich Rockefeller purchased another Calder mobile from the Municipal Art Exhibition for the museum,[105] but Alfred Barr arranged an exchange for *Universe*. Writing to Mrs. Rockefeller to explain the arrangements, Barr noted that Calder had won a distinguished place for himself throughout the world and that he should be represented in the museum by a work the artist considered to be one of his best.[106]

Calder was in fact among many American painters and sculptors whose works were acquired by the Museum of Modern Art during the 1930s. However, the majority of these artists were older and had received recognition for their work decades earlier. Among the American sculptors of Calder's generation who were collected during the 1930s were Chaim Gross, John B. Flannagan, and Reuben Nakian.[107] Calder therefore was among a small group of Americans whose work entered the collection in the 1930s, but he was the only nonobjective artist who worked with industrial materials.

A Universe is a motorized device that includes moving spheres and therefore can be related to mechanized orreries (see Fig. 71). Here Calder attempted an imaginative model reflecting the concurrent revisionism among astronomical theorists. For *A Universe* Calder made a mechanical device (Fig. 99) that is placed alongside the construction and serves to activate two small solid spheres to follow curving paths created for them within an open sphere. A red and a larger white sphere move at different speeds, alluding perhaps to a binary star system. Like an astronomer, Calder considered the motion of two bodies in relationship to each other: Binary stars mutually revolve to complete

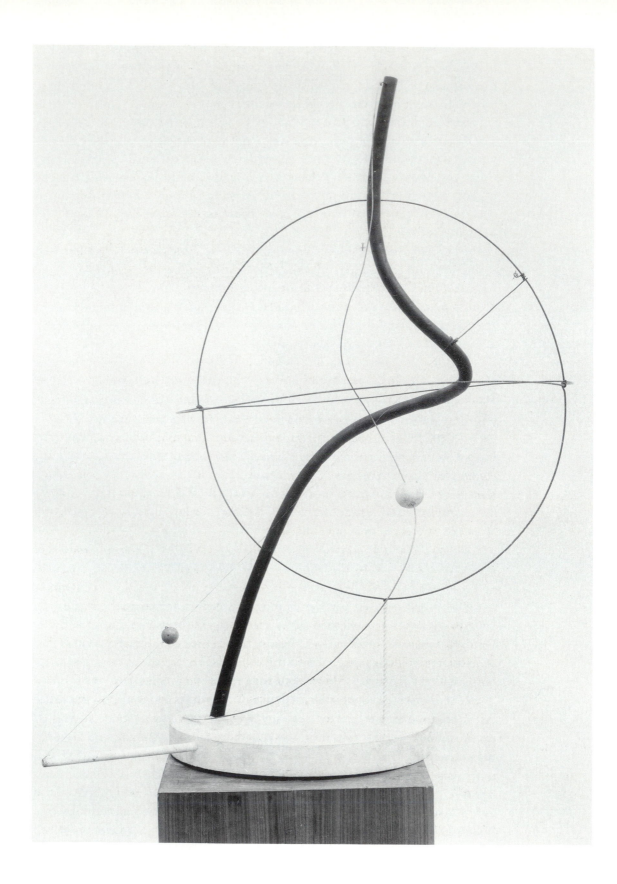

146

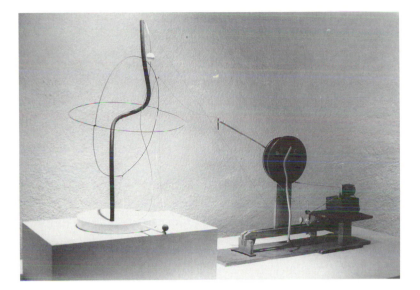

FIGURE 99. Alexander
Calder. Mechanism for *A
Universe*, 1934. Photograph
by Joan Marter, approved by
The Museum of Modern
Art, New York.

a full circuit.[108] In Calder's construction, the two forms follow different but related itineraries and complete a full cycle, suggesting that his interest in cosmic bodies ranged beyond the planetary system to stellar orbits as well.

In addition to this involvement with cosmic imagery, Calder's large-scale work was his contribution to the history of kinetic sculpture, which had continued for more than two decades. In 1912, the Futurists had written about movement in sculpture, including mechanical devices. Duchamp's *Bicycle Wheel* appeared in 1913, Depero and Balla's *Polychromatic and Mobile Plastic Complex* was created in 1915, Tatlin's maquette for a mobile structure, *Monument to the Third International*, appeared four years later, and was followed by Gabo's *Kinetic Construction* of 1920. In 1919, in the United States, Thomas Wilfred gave a Clavilux performance, a "kinetic" painting with colored light, and Archipenko exhibited *Archipentura*, a kinetic device, in 1928. Kineticism was advanced dramatically by Moholy-Nagy's *Space–Light Modulator* of the late twenties. In *A Universe*, Calder synthesized this decade-long evolution in kineticism, and his subsequent work demonstrated that his commitment to moving sculpture extended far beyond the experimental projects of earlier artists. The title suggests a continuation of the cosmic forms and universal imagery that first appeared in Calder's art in 1931. In this motorized universe he approached the mechanical orreries and alluded to the changing relationship of planetary bodies – a dynamic rather than a static model of the universe – as espoused by his contemporaries among both artists and scientists.

Placed on exhibition shortly after its arrival at the Museum of Modern Art in a show commemorating the fifth anniversary of the museum's opening,[109] *A Universe* has been included in every major Calder retrospective since then.

FIGURE 98. (*opposite*) Alexander Calder. *A Universe*, 1934. Motor-driven mobile: painted iron pipe, wire, and wood with string, 40½". New York: The Museum of Modern Art. Gift of Abby Aldrich Rockefeller.

At the same time that Calder was exploring mechanized movement and demonstrating his serious interest in theories about the system of the universe, he had begun to produce wind-driven devices that bear an affinity with the work of the Dada and abstract Surrealist artists. A few wind-driven mobiles produced after 1934 (Fig. 100) appear to be further experiments with orbiting bodies moving in space. In these examples, however, the painted spheres, so carefully deployed in his motorized devices to follow predetermined paths and to orbit at a constant rate of speed, are permitted to move randomly in response to currents of air. Although Calder may have found initial inspiration for such works in eighteenth-century orreries, the artist here suggests a cosmos with bodies moving through space in no predictable pattern.

Soon Calder's renewed interest in organic forms dominated his attention. His air-driven devices alluded to natural phenomena – the rustle of leaves, clouds floating across the sky, the flight of birds – rather than allusions to mechanical devices. *Steel Fish* (Fig. 101) is one of several large-scale standing mobiles that Calder produced in 1934. The ten-foot-high construction is also his first outdoor wind-driven device. The title is derived from the largest steel element, which hangs horizontally and resembles Brancusi's *Fish*[110] of 1924. Calder took extraordinary pains in preparing this large mobile. Preparatory sketches (Figs. 102 and 103) indicate his careful measurements of all elements to be included, and his precision in determining the placement of the fulcrum for the principal objects to be balanced. Except for the biomorphic black metal fish, all the elements are geometric. On one side of the mobile, the large fish-shape is combined with a red semicircle. Both are made of sheet metal and they function like a weather vane: When a current of wind hits them broadside, they set the entire mobile into a rotary motion. On the opposite end of the metal bar to which these two large sheet metal forms are attached is a series of fulcra, with discs and wooden balls fastened at the ends of the rods. *Steel Fish* could cause a great clatter when a strong wind set it in motion: Metal discs were struck by wooden spheres, and gonglike sounds emanated from the work. Calder had already explored the effect of sounds produced by sculptural elements striking against each other in *Black Ball, White Ball* (see Fig. 88), and now he again considered the incorporation of gonglike sounds. The outdoor works in particular seem destined to include some aural sensation, and Calder would have been delighted to produce these effects, like those of his composer friends Edgard Varèse, Virgil Thomson, and George Antheil.

In smaller mobiles of this period (Figs. 104 and 105) Calder incorporated "found objects" and small organic elements in the manner of Dada artists. Bits of colored glass, a small demitasse spoon, and a broken piece of stemware are attached to strings and set in motion. A number of wood carvings that Calder produced in 1934 bear signs of the influence of abstract Surrealism. *Diana* (1934; Fig. 106) combines the biomorphic shapes favored by Miró and Arp and the Surrealist personages then being produced by Giacometti and

FIGURE 100. Alexander Calder. *Mobile*, 1935. Wood and wire, 31″. New York: The Solomon R. Guggenheim Museum. Gift, Katherine S. Dreier Estate.

148

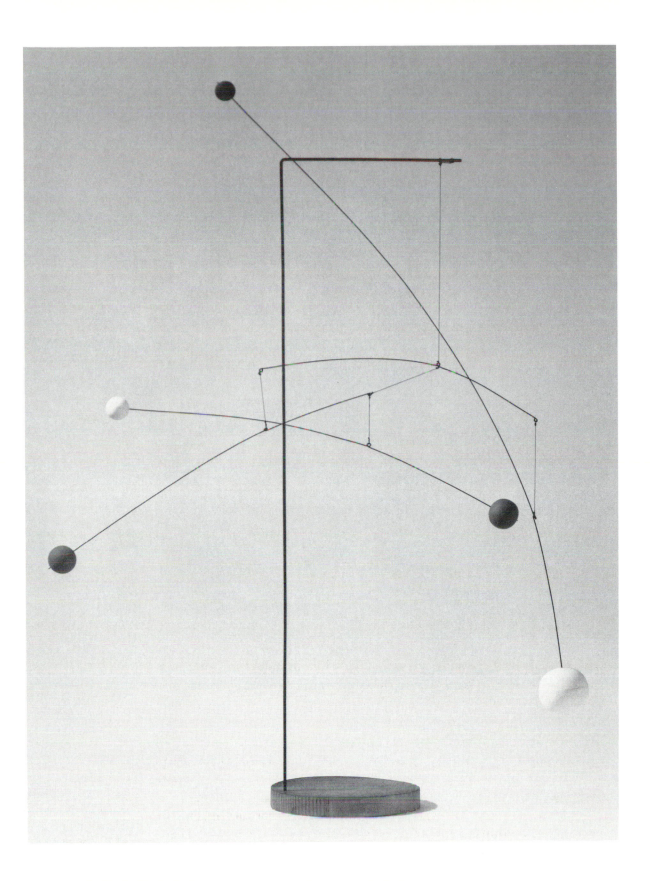

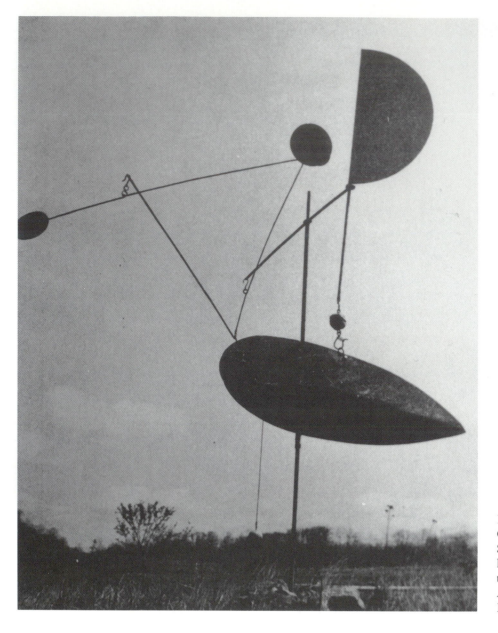

Figure 101. Alexander Calder. *Steel Fish*, 1934. Sheet metal and wire, 10′ high (destroyed). Washington, D.C.: Archives of American Art, Smithsonian Institution, Calder Papers.

Picasso with a classical prototype. Calder probably knew the Louvre's famous *Diana of Versailles* (Fig. 107), a Roman copy of a Hellenistic statue. Located in a room filled with replicas of classical statues, the Salle des Caryatides, *Diana of Versailles* represents the mythological huntress accompanied by a leaping stag. This statue had served as a source for American sculptor Paul Manship, and Calder wished to make his own abstract homage to it. The dynamism of the figure as it strides forward while reaching for an arrow was given a modern interpretation by Calder: He translated the tension of the *Diana*'s opposing

Figure 102. Alexander Calder. Working Sketch for *Steel Fish*, 1934. Pencil and ballpoint ink on paper, 11″ × 8½″. Richmond: Virginia Museum of Fine Arts.

150

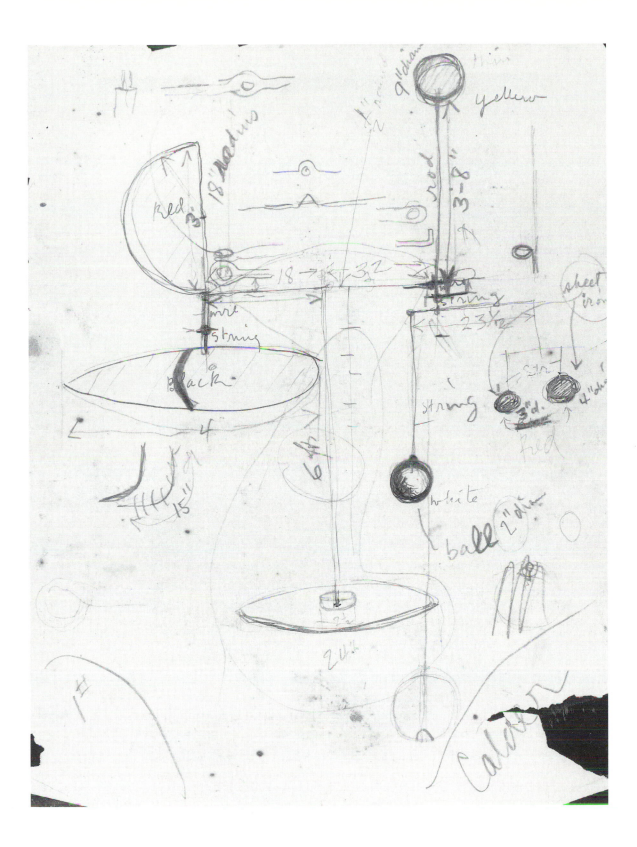

151

axes into a dynamic equilibrium of superimposed abstract elements that parallel those of the classical work. Just as Calder's earlier large-scale wire sculpture *Romulus and Remus* is a modern version of a famous antique piece, so his *Diana* represents the metamorphosis of a Roman goddess into a Surrealist personage. In addition, the attention given to the particular character of the wood links this work with early carvings by Henry Moore (with whom Calder developed a friendship in the 1930s) and Barbara Hepworth.[111]

In January 1935, Calder showed his motorized panels and wind-driven mobiles at the Renaissance Society of the University of Chicago.[112] *Black Frame* was included in the exhibition, which moved to the Arts Club of Chicago in February of the same year.[113] Returning from Chicago to Connecticut, Calder visited his friend Charlotte Whitney Allen in Rochester, New York. He was asked to plan a large mobile for her garden, which was being designed by Fletcher Steele. The mobile (Fig. 108) was completed in October 1935, when Sandy again visited Mrs. Allen. The artist later described the work: "As I remember, it consisted of some quite heavy iron discs that I found in a blacksmith's shop in Rochester and had then welded to rods progressively getting heavier and heavier."[114]

FIGURE 103. Alexander Calder. Working Sketch for *Steel Fish*, 1934. Pencil and ballpoint ink on paper, 11″ × 8½″. Richmond: Virginia Museum of Fine Arts.

FIGURE 104. Alexander Calder. *Mobile*, 1935. Glass, metal, pottery, and string, 25″. New York: The Solomon R. Guggenheim Museum.

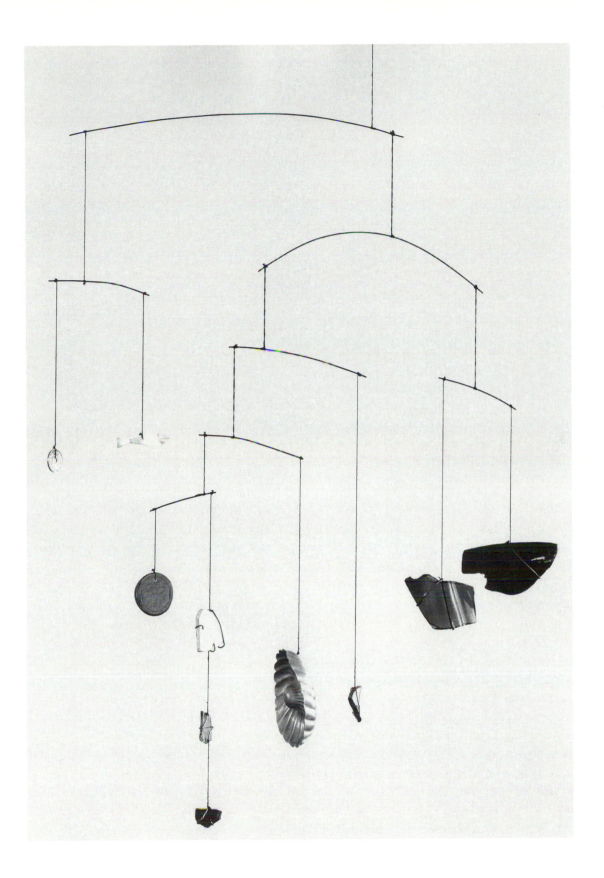

153

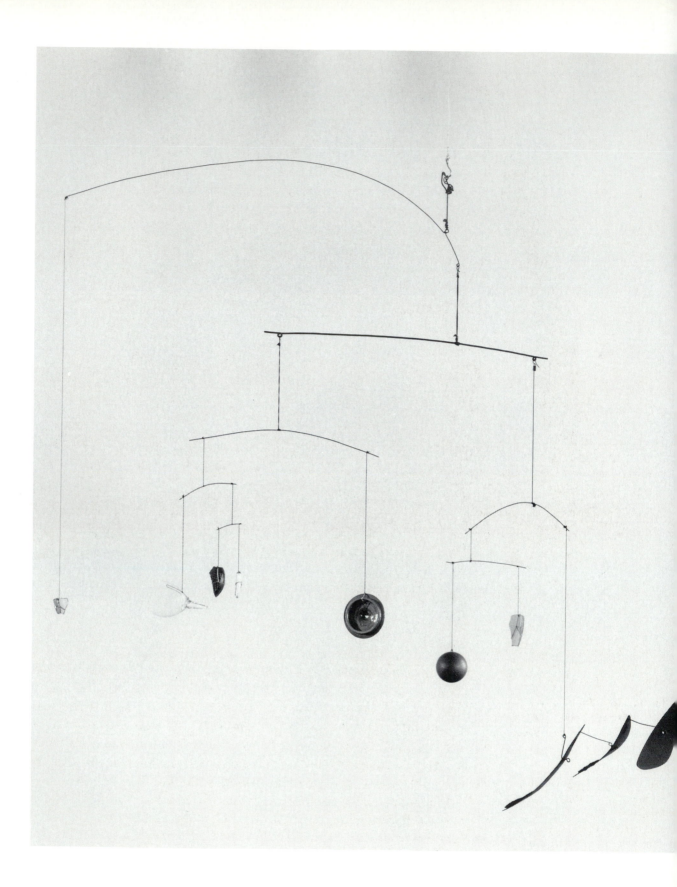

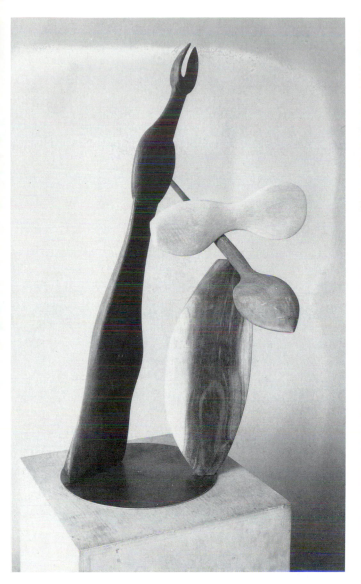

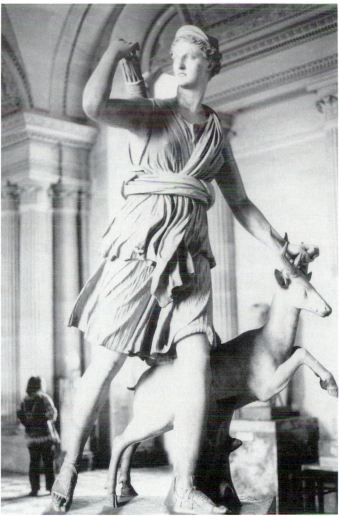

FIGURE 106. Alexander
Calder. *Diana*, 1934. Wood
and metal, 30¼". Boston:
Museum of Fine Arts.

FIGURE 107. *Diana of Ver-
sailles* (Roman copy of a Hel-
lenistic work). Paris: Musée
du Louvre.

FIGURE 105. (*opposite*) Alex-
ander Calder. *Mobile*, 1935.
Metal, glass, pottery, wood,
and cord, 49". New York:
The Solomon R. Guggen-
heim Museum.

The nine-foot-high mobile was an important prototype for standing mo-
biles of succeeding decades. The "formula" employed was the same as that
used for some of Calder's earliest wind-driven devices, but enlarged to a
monumental scale. Heavy iron discs were painted red, blue, yellow, and white,
respectively, while the counterweight was painted black. Unlike *Steel Fish*,
which is made of lighter materials, this mobile moves very slowly and remains
silent when the elements are set into motion by the wind.

Early in 1935, Calder had experimented with a construction made of
mirrors, which cast light patterns on the ceiling. He proposed this device to
the optical firm of Bausch and Lomb in Rochester for production, but his
offer was not accepted.[115] However, light patterns still interested him, and he

155

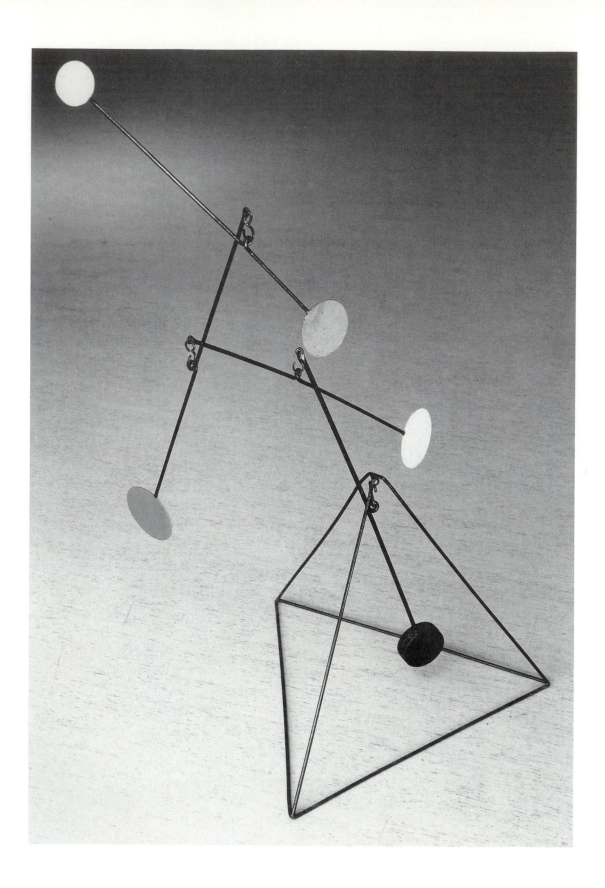

156

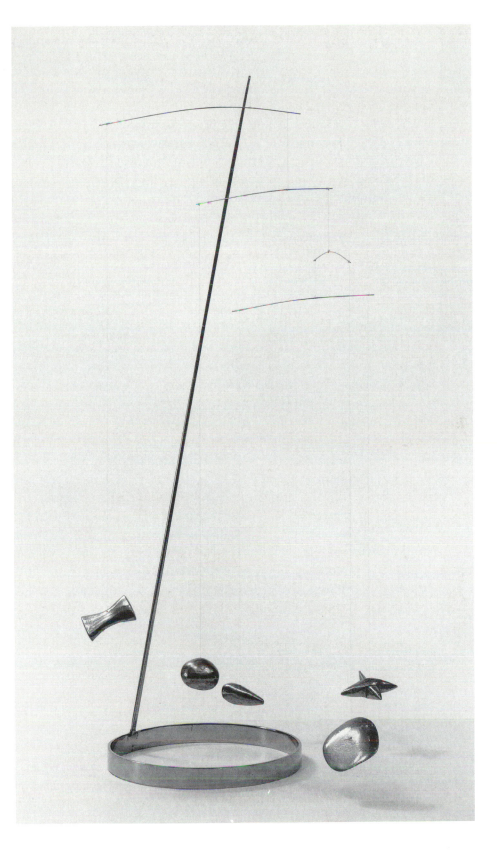

FIGURE 109. Alexander Calder. *Mobile*, c. 1934. Steel rod, wire, and nickel-plated wood, 42½″ × 11⅞″ × 20″. Northampton, Massachusetts: Smith College Museum of Art.

FIGURE 108. (*opposite*) Alexander Calder. Untitled Mobile, 1935. Iron and steel, 101″. Rochester, New York: Memorial Art Gallery, University of Rochester. Gift of Charlotte Whitney Allen.

continued to compose his mobiles in relation to fluctuations in light and shadow. Calder sold only two works through the Matisse Gallery in 1935. A motorized panel was purchased by the Wadsworth Atheneum in Hartford, and a splendid mobile of nickel-plated wood and steel (Fig. 109) was acquired by the Smith College Museum of Art.[116]

From 1930, Calder had sought to become a "modern" artist. Although in his written statements he focused only on his visit to Mondrian's studio as providing the incentive for a radical change of approach in his art, it is evident that his formation of an abstract style was much more complex. Adhering to a direction first explored by Kandinsky, Gabo, and Mondrian, among others, Calder affirmed the expressive potential of line, color, and spatial relationships. In creating his own abstract compositions, Calder added motion as a formal element to be explored.

Although the American sculptor joined Abstraction–Création, he never accepted the concept of "neutral" elements that made no reference beyond themselves. He was determined to avoid the figurative references of his earliest wood and wire sculptures, but his abstractions continued to have an inner life and to refer, however obliquely, to the natural world. As suggested in the discussion of Calder's use of astronomical instruments, the artist's fascination with the cosmos, which he shared with a number of Constructivists, arose also from the discovery of a new planet in 1930 and from other contemporary scientific revelations about the solar system. His invention of the mobile as a viable sculptural formula was derived in part from his study of applied kinetics as an engineering student years earlier.

Calder's contact with the complex theories of Mondrian – who believed in transcending the particular to express the universal – combined with the examples of Miró, Arp, and others, led Calder to the understanding that form and content were inseparable. These artists stimulated him to create his own vision of a mobile modern world, to form his own statement of the universe. During these years of direct involvement with European modernists, Calder's inventiveness surged forward, resulting in some of the most exciting works of his career.

4

Calder as Choreographer,
1936–1942

BY THE MID–1930s, wind-driven mobiles had come to dominate Calder's production. Motorized works still interested him, but the predictability of their movements and the need for frequent maintenance caused him to make only a few such works intended as models for possible outdoor public sculptures. As Calder sought to encompass a larger and more varied spatial area, the wind-driven mobiles offered many possibilities in the random movement of diverse elements through space. The artist became increasingly fascinated by unpredictable motions and chance relationships of forms. Inspired by contemporary music and modern dance, and Dada–Surrealist notions about chance, Calder attempted to present his moving shapes in playful interactions.

Calder's mobiles of the 1930s are similar to dancers in a ballet, where the performers continuously form new visual harmonies while in motion. This is not coincidental, for Calder himself enjoyed social dancing, and his development of a personal idiom of moving forms was nourished by his deepening involvement with ballet and theater, an interest that began in the 1930s and continued for the next four decades. His wind-driven mobiles are intensely theatrical: The artist even preferred to have his kinetic works spotlighted, as are solo dancers on a stage. Like a ballet, the mobile requires a considerable length of time to be fully experienced, and includes a series of elements that "perform." These moving shapes, rotating and constantly changing in their spatial relationships to one another, can be seen as metaphors for dancers performing in a defined space. Calder became the master choreographer, seeking ever more dramatic and dynamic variations of the space–time continuum.

Throughout his life Calder was fascinated by many forms of popular entertainment. In his youth it was the spectacular three-ring circus of Ringling Brothers, Barnum and Bailey that he frequently attended while working for the *National Police Gazette*. Later, avant-garde theatrical productions captivated him. His friendships with such composers as Edgard Varèse and Virgil Thom-

son encouraged this interest, and Calder eventually applied his talents to stage and costume design. By the time of his death in the mid-1970s he had received commissions for mobile set designs, décor, and costumes for more than a dozen dance productions and plays. Calder joined a roster of artists such as Picasso, who designed for the Ballets Russes; Léger, who created décor for the Ballets Suédois; Noguchi, who worked with Martha Graham; and many other artists who collaborated with composers and choreographers in scenery and costumes for ballets.[1]

Although Calder's *Circus* continued to be popular parlor entertainment on both sides of the Atlantic, by the mid–1930s he was also occupied with major commissions for professional theater and modern dance companies, projects that had broad implications for the future of his work generally. For Calder's own concerns paralleled those of choreographers of modern ballet: the expressive potential of the human body in motion – as a form through space. His "mechanical ballets" began as small motorized mobiles, featuring brightly colored elements that moved independently of one another. On several occasions during the 1930s, Calder expanded such models to full scale. For Martha Graham's dance company, for example, he created a mobile set that could be activated by live dancers and a ballet décor with moving parts that could be manipulated from offstage by a system of ropes and pulleys. His finest example is a set for Satie's *Socrate*, which involves no dancers but several mobile elements that "perform" to a musical accompaniment. These elements were set into motion by a system of pulleys and wires operated by a technician offstage.

As political tensions in Western Europe mounted with the ascendancy of Fascist leaders in Germany, Italy, and Spain, many artists turned to intensely personal work. Calder's involvement in various theatrical productions from 1935 on coincided with a decline in the appearance of cosmic imagery in his work and signaled a major change in his imagery from geometric abstraction to biomorphic forms. While creating mobiles as stage designs and "performers" for Martha Graham's dance company, Calder gradually changed the geometric severity of his mobiles, striving for new rhythms and more varied shapes. His primary interest was not simply in making sculpture that moved but in experimenting with complex compositions and the changing relationships of moving parts.

Early attempts to devise a mechanical ballet were described by Calder in a conversation with Myfanwy Evans, editor of *Axis*, an English journal. In 1937 Calder told Evans about a model for a motorized mobile that he had in his studio. A lost study for a large-scale piece may be related (Fig. 110).

> For a couple of years in Paris I had a small ballet object, built
> on a table with pulleys at the top of a frame. It was possible
> to move colored discs across the rectangle, or fluttering pennants
> or cones to make them dance or even have battles between

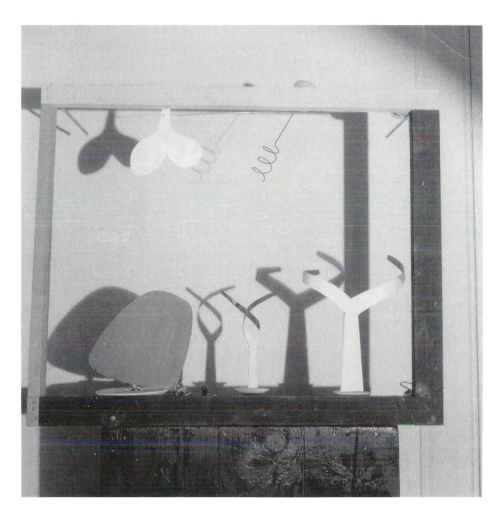

FIGURE 110. Alexander Calder. Model for Ballet Object, c. 1936 (destroyed). Photograph by Herbert Matter.

them. Some of them had large, simple, majestic movements; others were small and agitated. I tried it also in the open air swung between trees on ropes and later Martha Graham and I projected a ballet on these lines. For increase in size – working full scale in this way is very interesting. . . . My idea with the mechanical ballet was to do it independently of dancers, or without them altogether, and I devised a graphic method of registering the ballet movements with the trajectories marked with different colored chalks or crayons. . . . With a mechanical drive you can control the thing like the choreography in a ballet and superimpose various movements: a great number even, by means of cams and other mechanical devices. To combine one or two simple movements with different periods, however, really gives the finest effect, because while simple, they are capable of infinite combinations.[2]

Martha Graham, who had met Calder at a friend's home, asked him to design mobiles that her dancers could activate by strings for *Panorama*, a piece

to be premiered in Bennington, Vermont on August 14, 1935.[3] For *Panorama*, Calder designed overhead discs as mobiles that could be tugged or pulled by dancers with lines attached to their wrists.[4] In this, his first involvement with a dance production, Calder's role was limited to providing décor elements for a set by a professional stage designer.

Graham's New York season of 1936 featured Calder's "plastic interludes" created for *Horizons*, a dance in four movements. Here mobiles were attached to a pulley system that could be operated by stagehands behind the curtain while no dancers were on stage. Circles, spirals, and painted cubes rotated. Used as transitions between the various sections of the composition performed by dancers, these mechanical elements were intended to establish a mood for the next scene of the ballet.[5] The color of the elements, their spatial disposition, and the speed and character of their motion established a lively or languorous "stage" for the dancers' performance.

One dance critic, however, was not impressed. *Horizons*, which appeared at the Guild Theatre in New York on February 23, and March 1, 1936, was reviewed in *The Dance Observer:*

> "Mobiles," as used by Martha Graham in her presentation of *Horizons*, are groups of abstract designs, geometric still-life patterns in motion; spheres, cubes, hexagons, spirals, straight lines, utterly shapeless figures and the combinations of them, variously colored moving (by mechanical means) in a fixed design. It was as if a Paul Klee had projected itself out of its canvas and put itself under the Guild floodlights.
>
> The program note reads, "The 'Mobiles,' designed by Alexander Calder, are a new conscious use of space. They are employed in *Horizons* as visual preludes to the dances in this suite. The dances do not interpret the 'Mobiles,' nor do the 'Mobiles' interpret the dances. They are employed to enlarge the sense of horizon." . . . Somehow mobiles and Martha Graham do not speak the same language. Martha Graham has something to say (the artist communicates); the artist needs no aids to "enlarge the sense of horizon," and this is especially true of Graham.[6]

Apparently Graham herself found the circles and spirals that spun around on an empty stage inappropriate for her dance productions. Never again did she collaborate with Calder, nor did she attempt to use kinetic elements on the stage.[7] For the next decade sculptor Isamu Noguchi became one of her favorite designers of costumes and décor.[8]

Calder had a more successful outcome with *Socrate*, a most ambitious stage design of the 1930s and one that was actually produced. This symphonic drama was written by Erik Satie in 1920 and given its first orchestral perfor-

mance in America at the Wadsworth Atheneum in February 1936. Calder was given this commission by his friend Virgil Thomson, and by A. Everett Austin, director of the First Hartford Music Festival, then noted for avant-garde musical events. Austin was also director of the Wadsworth Atheneum and an astute spokesman for contemporary art. Thomson, who was music director of the Friends and Enemies of Modern Music, intended to revive the eighteenth-century practice of presenting concerts with stage settings. For the retelling of the life and death Socrates, one of Satie's last and most important compositions, Thomson thought a sculptural set design, rather than a painted backdrop, would be most appropriate. Austin wanted American artists to make the stage designs for his festival. Thomson had met Calder in Paris in the late 1920s, and he decided the young sculptor would be a good choice to design a set for *Socrate*. After a single performance of the work in Hartford, Calder's set was shipped to Colorado Springs for the opening of the Colorado College Fine Arts Center. *Socrate* was given two performances in Colorado before the set was scrapped.

The musical drama about the death of Socrates required an austere and sober design. Thus, Calder created a "ballet without dancers."[9] Virgil Thomson, who conducted the Hartford performance, gave this account of Satie's *Socrate*:

> Alexander Calder's set was an arrangement of geometric forms, all capable of motion. They were supposed to be moved mechanically; but the motors Calder had provided were too weak. So our lighting expert – Feder, as usual – with the help of a stagehand manipulated them by ropes. This mobile sculpture, simple to the eye and restrained in movement, was so sweetly in accord with the meaning of the work that it has long remained in my memory as a stage achievement.[10]

The design for *Socrate* was a particularly important one for Calder. It was produced at a time when he was beginning to create large outdoor pieces. The mobile set gave him an opportunity to transpose his kinetic constructions to monumental scale, as its elements resembled dancers moving to the music through space and time.

For Satie's work, the artist designed three moving elements that "performed" in sequence while two soloists remained motionless at either side, singing about the life and death of Socrates.[11] A preliminary drawing produced by Calder in 1936 (Fig. 111) shows the major elements in his mechanical set. The male singer who performs the role of Socrates and one female singer are combined with three kinetic elements: a red disc, a vertical rectangle, and two steel hoops at right angles on a horizontal spindle. As Calder later described the performance:

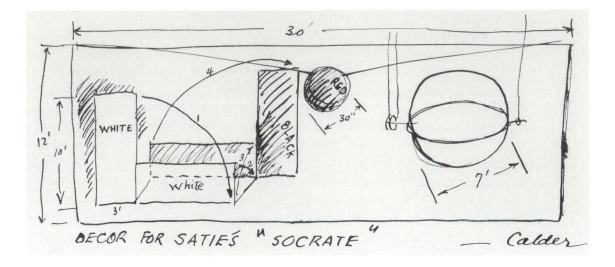

The whole dialogue was divided into three parts: nine, nine, and eighteen minutes long. During the first part the red disc moved continuously to the extreme right, then to the extreme left (on cords) and then returned to its original position, the whole operation taking nine minutes. In the second section there was a minute at the beginning with no movement at all, then the steel hoops started to rotate toward the audience, and after about three more minutes they were lowered toward the floor. Then they stopped and started to rotate again in the opposite direction. Then in the original direction. Then they moved upwards again. That completed the second section. In the third, the vertical white rectangle tilted gently over to the right until it rested on the ground, on its long edge. Then there was a pause. Then it fell over slowly away from the audience, face on the floor. Then it came up again with the other face towards the audience; and that face was black. Then it rose into a vertical position again, still black, and moved away toward the right. Then, just at the end, the red disc moved off to the left. The whole thing was very gentle, and subservient to the music and the words.[12]

FIGURE 111. Alexander Calder. Preliminary Drawing for *Socrate*, 1936. *The Painter's Object*, edited by Myfanwy Evans (London, 1937).

Calder designed other ballets in the 1930s that were not performed. For example, he created *Ballet in Four Parts* (Fig. 112) for American composer Harrison Kerr, but plans exist only in three sheets that depict the moving elements, sketches that have been unknown until recently. One drawing shows the four parts of the performance, and Calder inscribed on the image "Time of each part 1–100 units." Scene 1 included mobiles attached to strings; the second part featured motor-driven forms; then a panel with biomorphic forms was to be followed by two large black shapes that would "hover" and "perform gradual translations." The second sheet shows the choreography for some of

164

the elements (in a manner similar to Schlemmer's choreographic diagrams). Two large black forms and a small red circle move apart and together in four "scenes" of the third sheet. These remarkable drawings suggest that Calder was approached during the 1930s by a number of composers to devise avant-garde ballets. One, Harrison Kerr, had met Calder in Paris while studying with Nadia Boulanger, and visited the artist in Roxbury in 1934 to discuss their possible collaboration on a dance performance. (Kerr was also editor and cofounder of *Trend*, an avant-garde journal of the period.) The *Ballet in Four Parts*, if realized, would have been a significant addition to Calder's theatrical productions. By the late 1930s, he had become experienced in the creation of mechanical theater designs and maquettes for large motorized ballets, and there were more than a dozen fully staged productions in his career.[13]

When Calder was given commissions for mechanical stage designs in the 1930s, he recalled earlier examples of similar productions by Bauhaus artists and other Constructivists. Calder's exposure to such avant-garde theater design had probably begun even before his first trip to Paris a decade earlier. In February 1926, three months before he first left for Europe, the International Theatre Exposition opened in New York City. It had been arranged in part by Frederick Kiesler, a Viennese sculptor and architect associated with De Stijl, who had settled in the United States and was himself represented in the exhibition by his mechanical set for the Kapeks' *RUR*. The exposition also included stage designs by the Russian Constructivists and a Mechanical Marionette by De Stijl artist Vilmos Huszar. Léger's stage set and costumes for *La Création du Monde*, which premiered in 1923, were shown. This work was performed by the Ballets Suédois – the most vital movement in ballet after World War I. Leading painters and designers of the period engaged in Ballets Suédois productions that toured Europe and America in the early twenties, opening up new concepts in the relationship of dance to other arts. In *La Création du Monde*, for example, the décor was made to dance (rather than live performers). Léger's remarkable moving paintings anticipated Calder's as they emerged from the floors or floated in from the wings to perform a dance of abstract patterns.[14] Bauhaus designs by Oskar Schlemmer, Kurt Schmidt, Meong Teltschev, and others were also exhibited.[15] The International Theatre Exposition was accompanied by a special number of the *Little Review* with essays on theater by leading members of the European avant-garde that included many references to mechanized stage sets.[16]

Calder had also seen Fernand Léger's experimental film *Ballet Mécanique* (1923–4), which gave abstract kinetic forms distinctive personalities. The sculptor mentioned this film in the statement on motion that he prepared for the 1933 exhibition "Modern Painting and Sculpture" at the Berkshire Museum.[17] Léger's avant-garde production, which had no scenario and featured ordinary objects in motion, was a cinematic breakthrough.[18] Léger recalled:

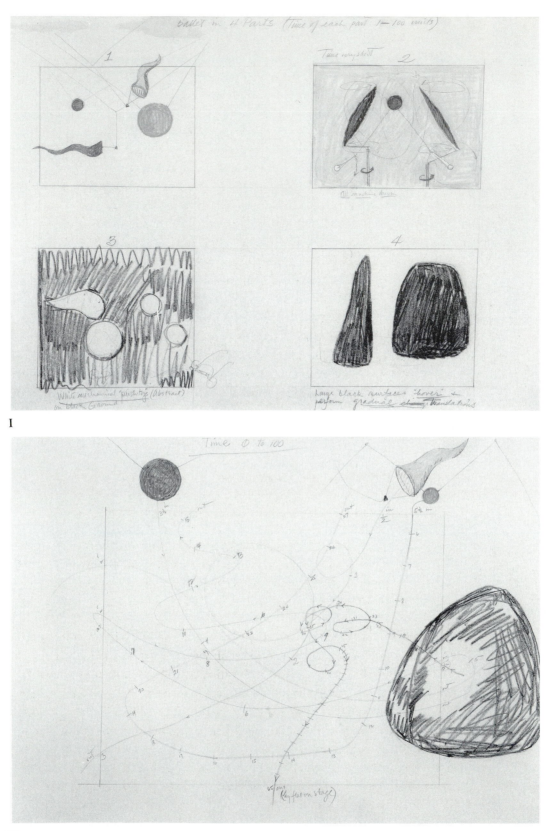

I

II

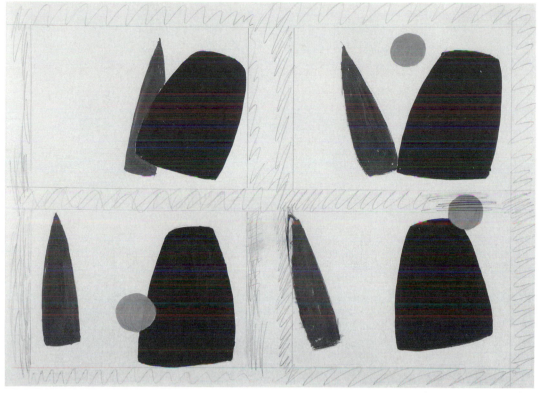

III

FIGURE 112. Alexander
Calder. *Ballet in Four Parts*
(Time of each part 1–100
units), c. 1935. Parts I and
II colored crayon, black wax
crayon and pencil on paper,
22″ × 30″. Part III gouache
and pencil on paper, 22″ ×
30″. Courtesy Rachel Adler
Gallery and Nancy Schwartz
Fine Art.

Ballet Mécanique dates from the period when architects talked
about the machine civilization. There was a *new realism* in that
period that I myself used in my pictures and in this film. This
film is above all proof that machines and fragments of them,
that ordinary manufactured objects, have plastic possibilities.
. . . There is also the fact of recognizing a plastic event that is
beautiful in itself without being obliged to look for what it
represents.[19]

James Johnson Sweeney mentioned in a June 1932 article that the Julien
Levy Gallery in New York was currently showing *Ballet Mécanique*.[20] This was
at the time when the first American exhibition of Calder's mobiles was installed
at the Levy Gallery. Léger and Calder had become friends in Paris earlier,
and Léger had written the introduction to the Calder exhibition catalogue
for the Galerie Percier show in 1931. Both shared the notion of "plastic
possibilities" for mechanized forms.

Set designs for mechanical ballets by Kurt Schmidt and other Bauhaus
artists were also important sources for Calder's stage productions of the 1930s.
Calder had access to a Bauhaus book published in 1925, *Die Bühne im Bauhaus*
(The Theater of the Bauhaus)[21] which included reproductions of stage sets

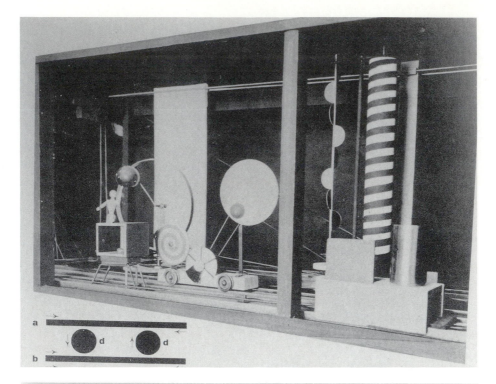

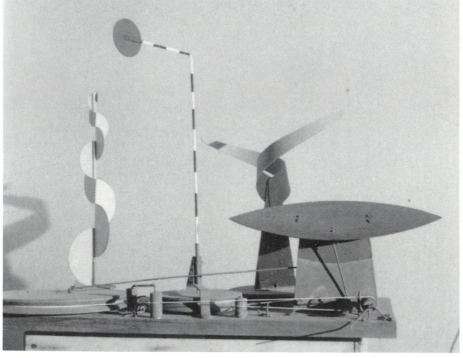

FIGURE 113. (*top*) Heinz
Loew. *Model for a Mechanical
Stage. Die Bühne im Bauhaus*
(Munich, 1925).

FIGURE 114. (*bottom*) Alexan-
der Calder. *Project for New York
World's Fair*, 1938. Approx 20″.
New York: Perls Galleries.

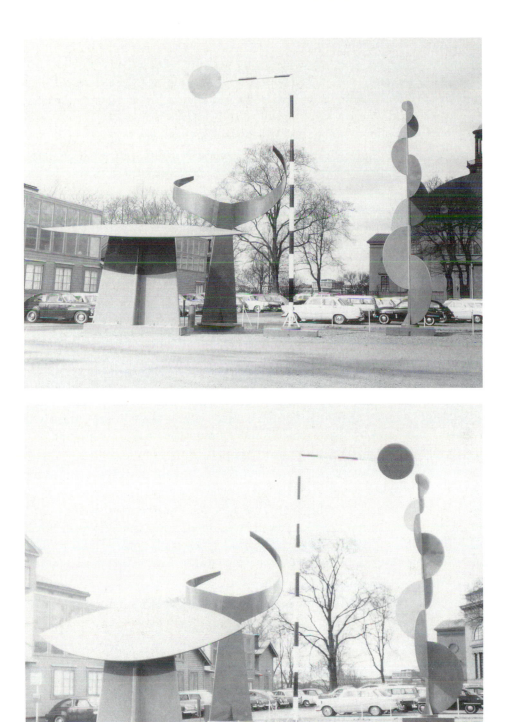

FIGURE 115. Alexander Calder. *Four Elements*, 1962 (two views). Sheet metal and motor, 30'. Stockholm: Moderna Museet. Photograph by Pedro E. Guerrero.

by Schmidt, Oskar Schlemmer, and others. For some of Calder's ideas for the mechanical theater it is possible to find striking parallels among Bauhaus works. For example, Heinz Loew produced a model for a mechanical stage (Fig. 113) in 1926. With its striped poles and rotating forms it seems a likely source for such motorized models as Calder's large-scale mechanized piece designed (but not executed) for the New York World's Fair of 1939 (Fig. 114). A free-standing work, the "ballet" consists of four individual elements of painted metal, which rotate by means of small turntables. A thirty-foot-high version of such a model, entitled *Four Elements* (Fig. 115), was finally constructed in 1962 outside the Moderna Museet in Stockholm. The motorized device includes an orange figure with outstretched "arms" that whirls, a black and white pole that slowly revolves, a black bastion with rolling top, and a vertical form of clustered half-circles in orange and yellow. The four elements are attached to separate motors, allowing for different speeds and directions in the movements of forms.[22]

Calder probably also knew the work of Laszlo Moholy-Nagy, who was living in Berlin in 1929. His Bauhaus theater designs for the *Mechanical Eccentric* offered a synthesis of form, motion, light, color, and scent, while his major sculptural project, the *Space–Light Modulator*, with its mechanical elements and lighting effects, also performs like an automaton.[23]

Oskar Schlemmer's designs for the stage and his interest in space in relation to forms in motion would have offered the greatest attraction for Calder. The performances staged by Schlemmer are of particular relevance but have never before been acknowledged as a possible source for Calder's theatrical work. Schlemmer's "Theory for dance scene" and his designs for the *Triadic Ballet* were shown in New York at "The International Theatre Exposition," which Calder probably saw in February 1926.[24] In March 1929, Calder was in Berlin for an exhibition of his wire constructions at the Galerie Neumann-Nierendorf, and it is possible he saw there the Schlemmer-conceived dances in which performers wearing padded costumes and masks were transformed into automata. At the time, these dances were gaining critical attention at Wolksbühne, a popular theater in the city. It was Schlemmer who wrote:

> We can imagine plays whose "plots" consist of nothing more than the pure movement of forms, color and light. If this movement is to be a mechanical process without human involvement of any sort (except for the man at the control panel) we shall have to have equipment similar to the precision machinery of the perfectly constructed automaton.[25]

Although Schlemmer himself did not develop the perfected mechanical stage, he did use dancers whose movements were in angular patterns, with gestures like automatons. For the *Gesture Dance*, Schlemmer drew up a diagram

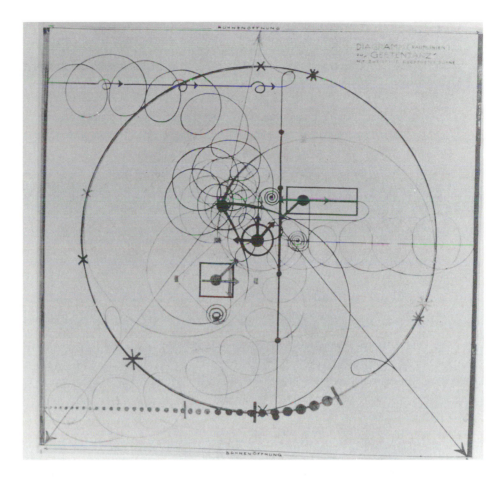

FIGURE 116. Oskar Schlemmer. *Diagram of the Gesture Dance. Die Bühne im Bauhaus* (Munich, 1925).

that includes linear indications of motion and projections of forward movement on the stage surface (Fig. 116). One of Calder's examples of ballet choreography was *Score for Ballet 0–100* (Fig. 117), an engraving related to the *Ballet in Four Parts* discussed earlier. This print included patterns of movement for mechanical forms and suggests an awareness of Schlemmer's diagram.

The revivals of Schlemmer's ballets in the 1980s revealed the striking similarities of the costumed dancers to sculptures. In performances such as the "Hoop Dance" and the "Pole Dance" (Fig. 118), the figures are clothed completely in black and perform on a black stage. The illumination is turned down in the auditorium so that the dancers "become" the poles and hoops that are attached to them or that they extend in their hands. The effect of moving shapes is similar to that in Calder's standing mobiles. Schlemmer's choreography is also determined by the appearance of the dancers' costumes. "The Spiral" (Fig. 119) in *The Triadic Ballet*, for example, wears a large spiral of curved wire around her torso and executes pirouettes in a tight circle

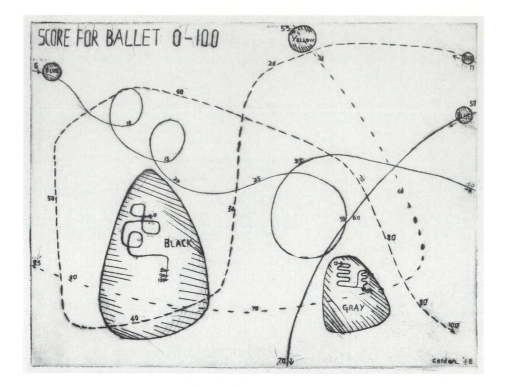

throughout the performance. The spiral dancer appears to relate to an early mobile by Calder (Fig. 120) that features wire hoops. In the "Form Dance" (Fig. 121) three figures hold aloft spheres and a pole that become extensions of their multicolored costumes and masked faces. In the "Hoop Dance," concentric circles of wire are turned by a dancer dressed in black; as a result, the moving sculptural elements are the principal "performers."[26]

Schlemmer's costumes, which were formed in such geometrical shapes as cylinders, disks, spheres, and spirals, transformed his dancers. For *The Triadic Ballet*, he described this effect as

> the first consequential demonstration of spatially-plastic costumery. Spatially plastic, for they are so to speak colored and metallic sculptures which, worn by dancers, move in space, whereby physical sensation is significantly influenced, in such a manner that the more the apparently violated body fuses with the costume, the more it attains new forms of dance expression manifestations.[27]

In Berlin, Calder may have seen the Bauhaus theater troupe performing Schlemmer dances in 1929. The following year Schlemmer mounted three of his Triadic figures in the German *Werkbund* exhibition in Paris (Fig. 122), where he met Mondrian and Arp. Calder, living in Paris at the time, could easily have seen this exhibition as well. In 1932, Schlemmer staged *The Triadic*

FIGURE 117. Alexander Calder. *Score for Ballet 0–100*, 1942. Paper engraving, printed in black, plate: 11⅜″ × 14⅞″. New York: The Museum of Modern Art. Gift of the artist.

172

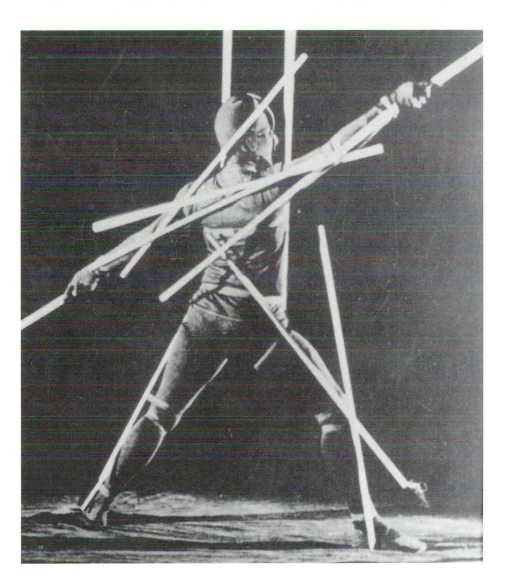

FIGURE 118. Oskar Schlemmer. "Pole Dance," 1927. *Die Bühne im Bauhaus* (Munich, 1925).

Ballet in Paris for an international dance competition. He was awarded a prize, and special recognition from Léger. Given Calder's close friendship with Léger and a circle of abstract artists who were also known to Schlemmer, as well as Calder's interest in dance and theater, it seems probable that the American would have learned of Schlemmer's innovative Bauhaus dances. Calder's mobile of wire hoops (see Fig. 120) dates from the year of the performances of Schlemmer's *Triadic Ballet* in Paris.

Although there is no written documentation of his attraction to Schlemmer's designs, Calder probably saw these "performing sculptures," which would account for his using many of the same motifs in his designs for mechanical ballets. From the Bauhaus dances of Schlemmer, Calder would have gained a notion of a human-scale "mobile" gesturing in space, the basis for many of his standing mobiles of the following four decades.

173

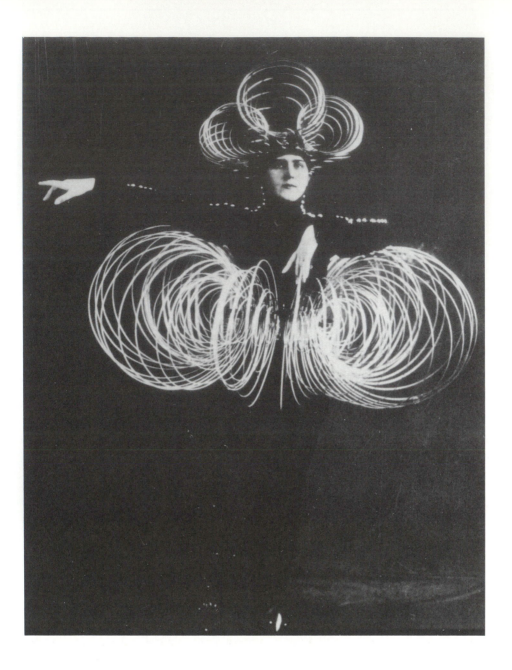

But Calder's practical training in engineering and his friendship with certain Surrealists meant that he was not likely to idealize the machine as did many of the Constructivists. Unlike Bauhaus artists and others who tended to fuse theatrical design with advanced technology, which resulted in the transformation of men into mechanical automatons, Calder was more playful, creating mechanical forms that mimicked human gestures (the Dada–Surrealist parodies of the machine as man come to mind). Calder's experimentation with mechanical stage sets during the 1930s provides a key to understanding his subsequent kinetic constructions. Ultimately, his choice of

FIGURE 119. Oskar Schlemmer. "Spiral" dancer from *The Triadic Ballet. Die Bühne im Bauhaus* (Munich, 1925).

174

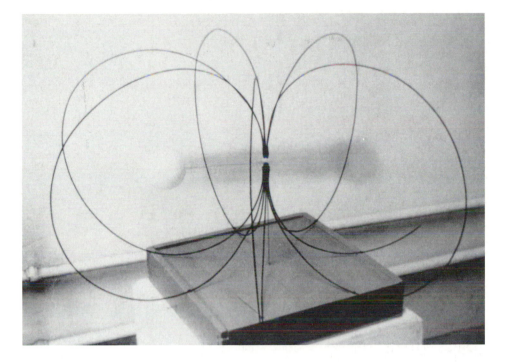

FIGURE 120. Alexander
Calder. *Wire mobile*, 1932
(lost). Herbert Read, ed.,
Surrealism (New York, 1936).

random rather than choreographed movements, and of sculptural elements
closer to the appearance of natural forms, would supersede his interest in
machine aesthetics and the transformations of living into geometric forms as
found in the work of Schlemmer, Moholy-Nagy, Kiesler, and others. For
Calder, the human creator was never subordinated to technology: The ma-
chine was accepted merely as another means by which man could realize his
full potential in the modern era. When asked what had influenced him more,
nature or machinery, Calder replied, "Nature. I haven't really touched ma-
chinery except for a few elementary mechanisms like levers and balances.
You see nature and then you try to emulate it."[28] The imagery of his wind-
driven mobiles has been aptly described in terms of the forms of nature:
leaves on branches, lily pads floating on a pond, the quiet grazing of animals,
the flutter of insects.

The inspiration of nature and the affirmation of the human spirit was
joyfully expressed in Calder's mature work only after he had fully explored
the relationship of art and technology, as he discovered it among Bauhaus
artists and other creators of the avant-garde theater. The artist's preference
after 1936 for wind-driven devices suggests he had begun to experience lim-
itations in tightly choreographed, mechanized forms. Calder became increas-
ingly fascinated by random motions and the consequent relationships of forms
in space. Inspired by the unpredictable and dissonant tonalities of such con-
temporary composers as Varèse and Thomson, and by the free, improvisa-
tional movements of modern dance, Calder now attempted in his kinetic

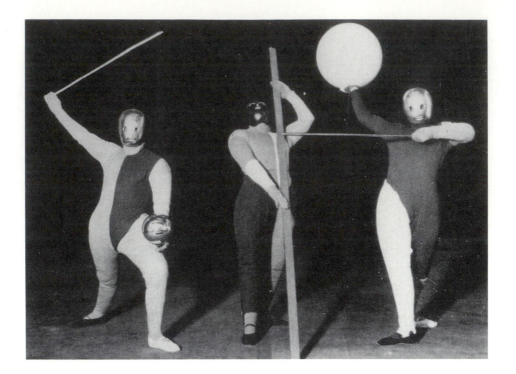

constructions to present his moving shapes in playful, random interactions. Like the Surrealists' involvement with automatism, Calder explored the rich associations to be derived from improvisational modes.

Calder's mobiles are theatrical in character: A series of elements "perform" within defined limits when set into motion by a draft of air. In constructing the mobiles he assumed the role of a choreographer of modern dance, allowing for a certain amount of "improvisation" but never completely rejecting the importance of prescribed motion. These wind-driven mobiles made their American debut in February 1936 as part of Calder's solo exhibition at the Pierre Matisse Gallery.[29] Critical reaction to the mechanized and wind-driven devices was mixed. An art critic for the *New York Sun* reported:

> The exhibition of "Mobiles" by Alexander Calder in the Pierre Matisse Gallery is recommended especially to amateurs with a liberal turn of mind. A mobile, in case you do not know, is an art object that moves, either with the assistance of a small motor or by the touch of the hand. The word "art" in connection with these contributions of Mr. Calder puzzles many people and pleases others. Some people have a finished and restricted notion of what art is, and that is why I recommended this work only to the liberals. . . . The mobiles that I like the best are those that respond with motion to the touch of the hand. They are so exquisitely balanced that they twist in and out for a sur-

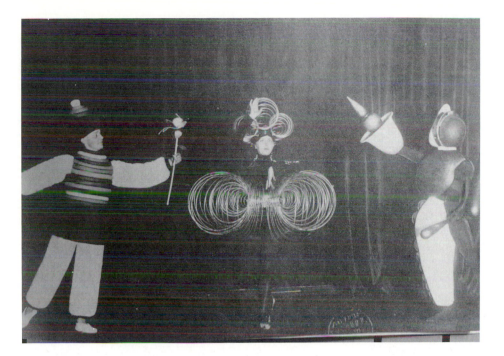

FIGURE 122. Oskar Schlemmer. *The Triadic Ballet. Die Bühne im Bauhaus* (Munich, 1925).

prisingly long time before they exhaust this "life" that has been temporarily given them, and some of them keep to a changing harmony that is quite mystifying. The idea involved in these moving forms opens a new world, and successive generations of inventive artists may carry it to an importance which we only dimly feel at present, but always in such a case, Alexander Calder will have been the Michelangelo of this art. Or, possibly, it would be safer to call him the Leonardo da Vinci.[30]

Another reviewer compared Calder's work to Miró's paintings: "They are very much like Miró abstractions come to life – simple, naive and yet immeasurably subtle – but with the bright spots of reds, yellows and blues imbued not with plastic implied movement but actual physical movement."[31]

Calder continued to produce works that reaffirmed his affinity with Miró, Arp, and the abstract Surrealists. *Form Against Yellow* (Fig. 123), a painted panel with mobile elements suspended from the top edge, is a three-dimensional equivalent of Miró's paintings of the 1930s. During this decade, Miró also constructed several wooden reliefs (Fig. 124) that are possible sources for his American friend. That Calder's work is often pictorial in conception is supported by such constructions, in which the elements describe only a limited movement and eschew sculptural volume for a relieflike relationship with the colored panel. The combination of linear, biomorphic, and geometric forms suspended over a solid-colored ground links this work with paintings by Miró and his standard device of changing the color of a form where it intersects

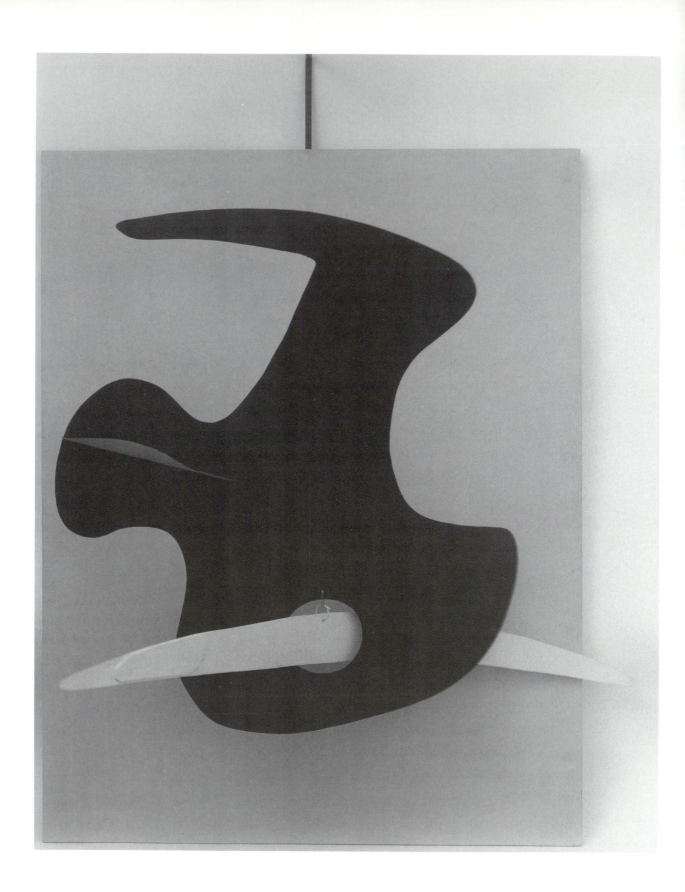

178

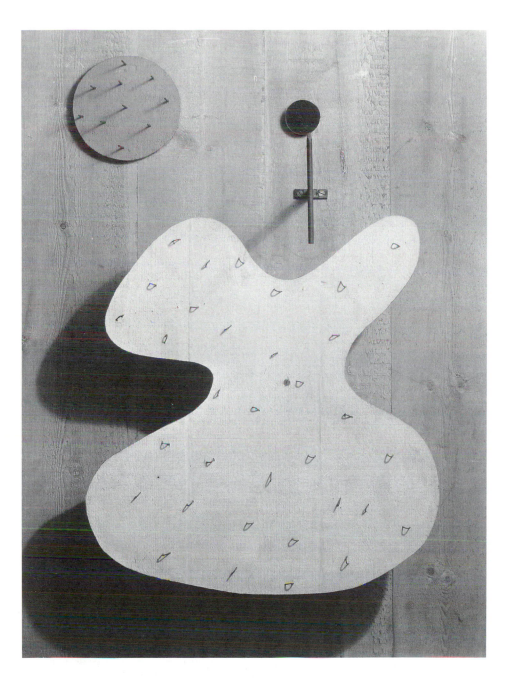

FIGURE 123. (*opposite*) Alexander Calder. *Form Against Yellow*, 1936. Painted sheet metal and wood, 42″ × 40″ × 3″. Washington, D.C.: Hirshhorn Museum and Sculpture Garden, Smithsonian Institution. Gift of Joseph H. Hirshhorn, 1966.

FIGURE 124. Joan Miró. *Relief Construction*, 1930. Wood and metal, 35⅞″ × 27⅝″ × 6⅜″. New York: The Museum of Modern Art.

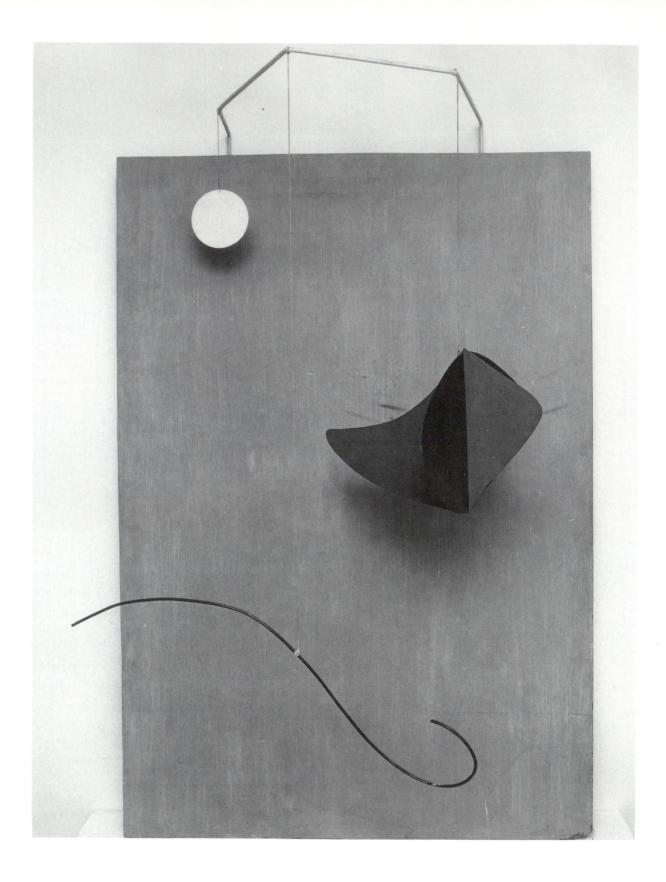

with another. Calder introduced a similar idiom into his own construction by painting two planar metal forms in red and in black, and attaching them at right angles to each other. The effect is similar to that of a Miró painting, even though Calder has traded planar intersection for plastic intersection. The shadows cast by the forms against the background are also very important to Calder.

Object with Yellow Background (Fig. 125) was one of Calder's contributions to "Fantastic Art, Dada, and Surrealism," which opened at the Museum of Modern Art in December 1936.[32] Earlier that year, Calder had also been included in "Cubism and Abstract Art" at the same museum. In the catalogue for the earlier show, Alfred Barr discussed Calder's work in a section reserved for "younger" artists who demonstrated "the remarkable renaissance of interest in abstract art among the younger artists who not only have strengthened recent developments but have actually resurrected problems which excited the vanguard of twenty years before."[33] Barr also noted that the geometric tradition was currently in the decline and that Mondrian had been deserted by his most brilliant pupils, Jean Hélion and César Domela.[34] Barr's generalizations about artists' lack of interest in geometric abstraction were in fact somewhat overstated, but it is true that by then Calder himself was showing a preference for the biomorphic forms of Arp and Miró.

Calder's acceptance into the circle of the Surrealists was further affirmed by his inclusion in the International Surrealist exhibition held in London in 1936.[35] Meanwhile, he continued to receive recognition in America. His imagery seems to have been more palatable than that of others associated with Surrealism, for Calder had a measure of playfulness and none of the menacing overtones of violence or sexual perversity common to certain Surrealists, such as Salvador Dalí and Alberto Giacometti.

Cello on a Spindle (Fig. 126) of 1936 is indicative of Calder's development of a more personal abstract surrealist style. A large, undulating piece of metal, almost cello-shaped but also similar to the biomorphic motifs of Jean Arp, pivots on a wire tripod. Loosely brushed patches of red and yellow pigment suggest antecedents in paintings by Joan Miró (later Calder would work only with unmodulated passages of pure color). An additional element assures the link to sculptures by Arp and Yves Tanguy: the presence of a large wooden object that rests precariously on the curved surface of the metal cello. This wooden form has strong affinities with the "annoying objects" that Arp affixed to the surface of his sculptures in the 1930s. As Jean Arp found broader acceptance, so Calder's biomorphic creations appealed to an audience seeking abstractions that had a basis in organic forms rather than geometric abstractions.

Despite Calder's involvement with the Surrealists, his palette remained firmly within the orthodoxy of Mondrian's Neo-Plasticism: the primary colors with black and white. Indeed, his use of polychromy was in line with the work of modern sculptors from the Cubist constructions of Picasso, Archipenko,

FIGURE 125. Alexander Calder. *Object with Yellow Background*, 1936. Painted plyboard, metal, 62″ × 40″ × 21″. Honolulu Academy of Arts.

and others, to Russian Constructivists and Futurists, although not all of these artists limited themselves to primary colors. Several American artists of the 1930s showed a similar interest in polychrome sculpture – David Smith, George L. K. Morris, Theodore Roszak, Gertrude Greene, and Charles Biederman, most of whom like Calder, were attracted to biomorphic constructions by Jean Arp as well as to paintings of the Parisian vanguard. Calder's interest in polychromy attests to his involvement with Mondrian, Miró, Léger, and Arp. By 1936, Calder was incorporating color into most of his constructions. Individual elements were painted in primary colors, according to the dictates of Neo-Plasticism. Pure colors, painted in even, unmodulated strokes, helped define the elegant biomorphs that appeared in Calder's mobiles over the next four decades.

Although polychrome sculpture was to occupy Calder's interests from the mid–1930s until his death, red gradually became the predominant color, with yellow and blue of secondary interest. His large stabiles were mostly black, until the final years when colossal red stabiles were also produced. At times color was used for expressive purposes, contributing to the overall demeanor of a kinetic work, but color was applied also for constructive purposes: to define form, and to clarify visual oppositions among elements. Color contributed to Calder's principal aim: to create sculptural compositions of forms, colors, and motions. But Calder's ultimate aim was a kinetic work that captured the rhythms, the spirit, the vitalism of the natural world.

With *Gothic Construction from Scraps* (1936; Fig. 127) the full sculptural vocabulary that Calder would use for decades of creative activity was fully synthesized. In this work, the artist bolted together small fragments of metal to re-create in miniature the interior space of a vaulted Gothic cathedral. Simultaneously he suggested the penetrable spaces and frankly visible structural system of modern architecture. This small stabile was to be the prototype for Calder's monumental stabiles of the 1960s and 1970s. The interpenetration of interior and exterior spaces, the buoyancy of the stabiles as they rest lightly on the ground, and the use of dynamic surfaces penetrating the surrounding space are prefigured in this small model from Calder's early years.

Although similar uses of sheet metal would result in some fanciful stabiles of "animals" in the late 1930s, Calder was still willing to adjust his imagery to suit a specific purpose. When he received a commission in 1936 from the Columbia Broadcasting System to design a trophy for the Annual Amateur Radio Award, he returned to Constructivist elements.[36] The model (Fig. 128) was made of wood and steel wire. The completed object was in stainless steel, and the form suggested global radio transmissions.[37] In the same year Calder constructed two mobiles to be permanently installed in the new auditorium of the Berkshire Museum (Figs. 129 and 130). These were designed specifically to be placed over the ventilators, so the elements would revolve when currents of air passed through them.[38]

Fantastic animal forms had begun to appear in Calder's art in 1937, as a

FIGURE 126. Alexander Calder. *Cello on a Spindle*, 1936. Painted metal, 62″ × 47″. Zurich: Kunsthaus.

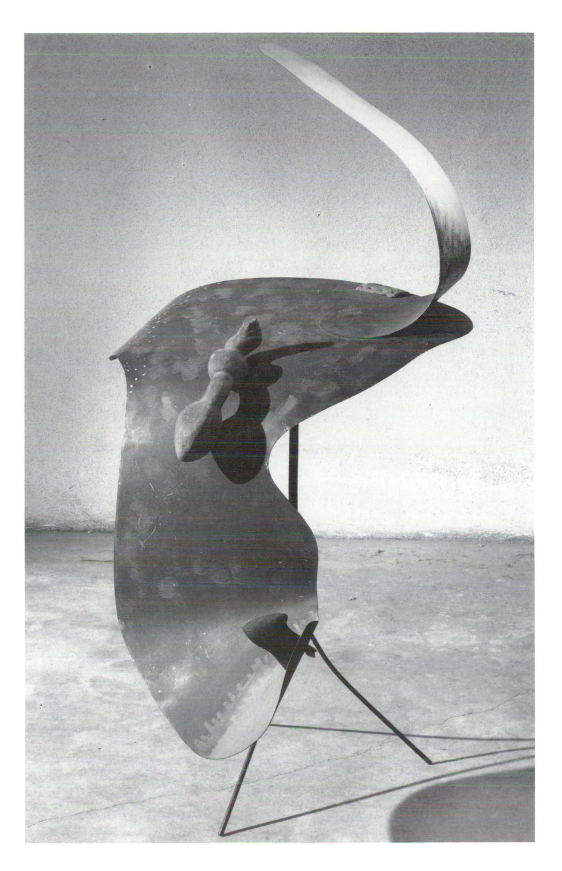

183

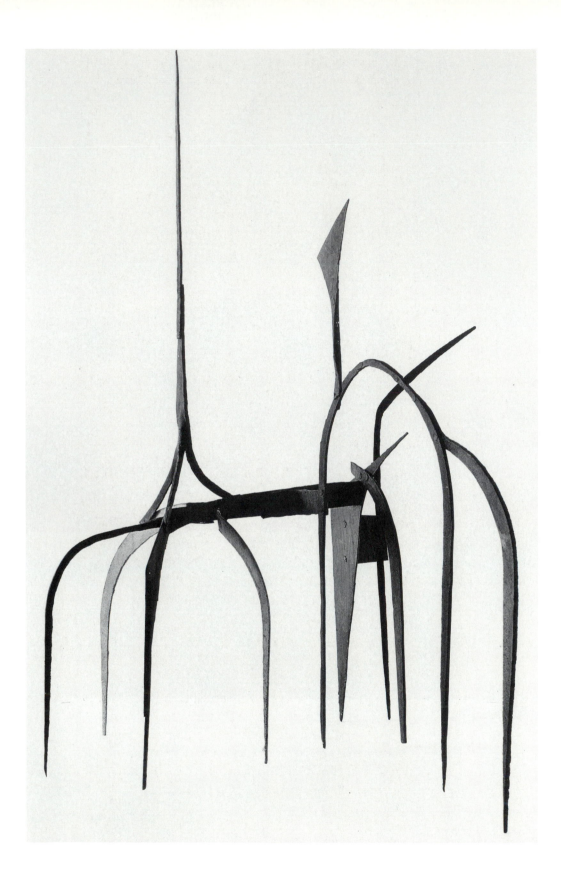

184

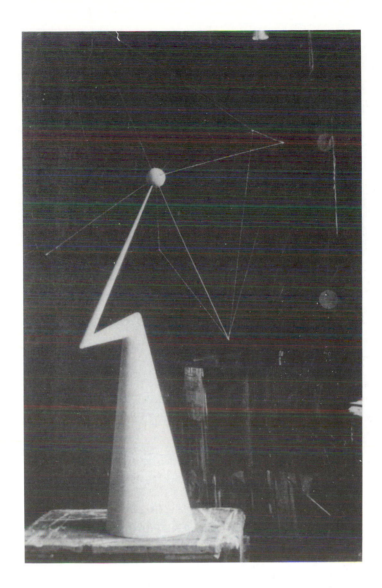

FIGURE 128. Alexander Calder. *Annual Amateur Radio Award*, Columbia Broadcasting System, 1936. Wood and wire. Location unknown. Washington, D.C.: Archives of American Art, Smithsonian Institution, Calder Papers.

FIGURE 127. (*opposite*) Alexander Calder. *Gothic Construction from Scraps*, 1936. Sheet metal, 31⅝". Location unknown. Photograph by Pedro E. Guerrero.

photograph of an installation at the Pierre Matisse Gallery shows (Fig. 131). Rosamund Frost wrote in *Art News:*

Greater variety and a more rich and whimsical invention than ever before in the latest work of Alexander Calder make his current show at the Pierre Matisse Gallery his most successful one up to date. The "mobiles and stabiles" on view include none of his familiar electrically propelled devices to be plugged into a socket instead of a curling iron, and thus offer a new departure in Calder's work. Here greater and more effective use is made of color which, together with less stress on mechanical ingenuity, creates better pictures. The undeniable beauty of turning machinery is replaced by more permanent

185

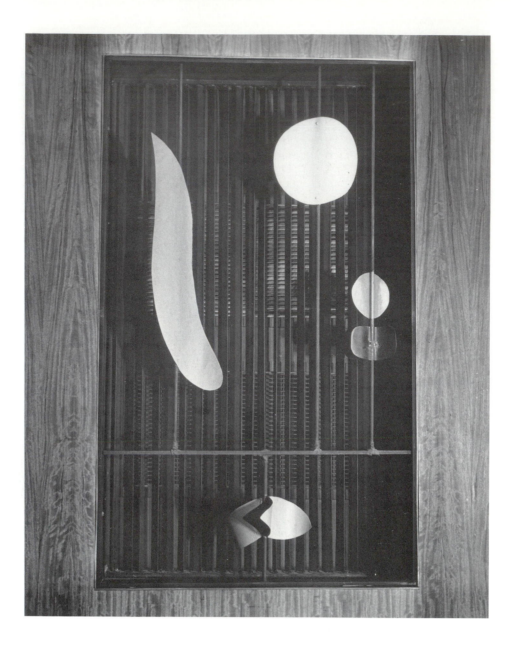

relations of form and color bringing Calder into the front ranks of American non-objective artists.

A relationship to Miró is evident in these works. Though less neurotic and more humorous than the Spaniard, Calder takes a lively enjoyment in *grotesqueries*....[An] outstanding stabile is the huge red and sheet metal chicken cutting bold curves.[39]

Big Bird, the "chicken" referred to above, appears with an assortment of fanciful smaller birds and animals in the installation view. These can be seen

FIGURE 129. Alexander Calder. Mobile over Ventilator in Auditorium, 1936. Sheet metal, 34″ × 57″. Pittsfield, Mass.: The Berkshire Museum.

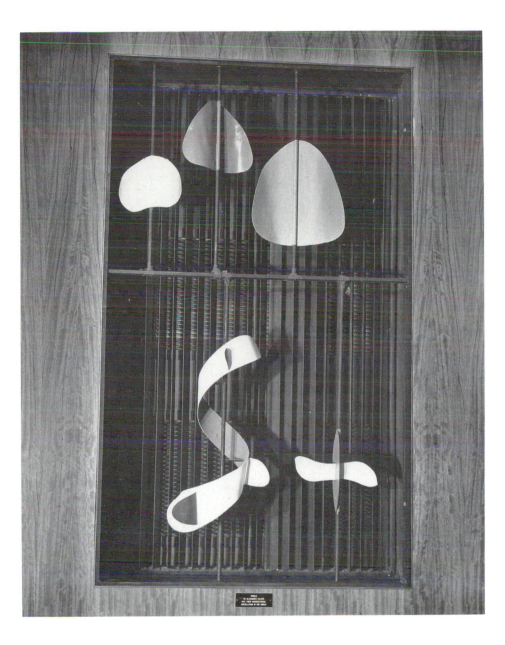

FIGURE 130. Alexander Calder. Mobile over Ventilator in Auditorium, 1936. Sheet metal, 34″ × 57″. Pittsfield, Mass.: The Berkshire Museum.

now as prototypes for Calder's giant stabiles of the 1960s and 1970s, which often represented fantastic birds, dinosaurs, or other large creatures. Here again the artist's whimsical animals bring to mind those in the paintings and drawings of Paul Klee, whose importance has been overlooked in the consideration of Calder's fantastic creatures, and for whom Calder expressed great admiration.[40] The humorous decoys of blue herons and ducks common to American folk art objects are another source for this work.

Also appearing in the 1937 show was a large stabile, *Whale* (Fig. 132), which is significant as Calder's first bolted sculpture. He assembled and bolted

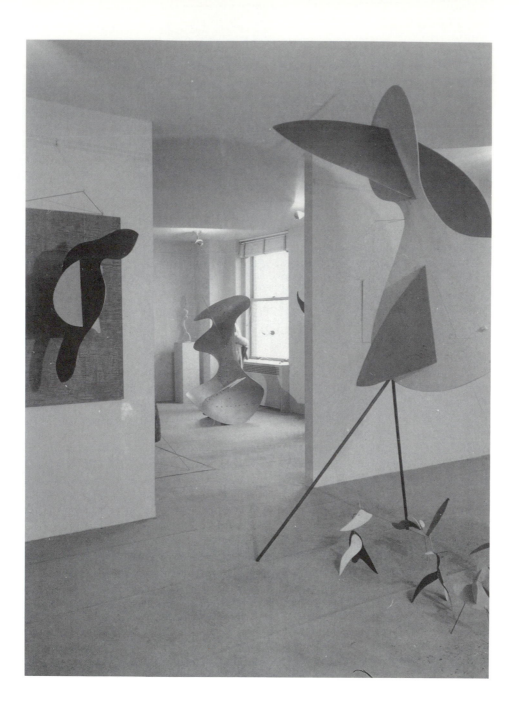

together curving sheets of metal to create a fantastic creature standing more than six feet high but balancing delicately on only a few points. *Whale* was an antecedent of the stabiles of Calder's later years. By joining sheets of metal the artist made a large sculptural form without mass. *Whale* can be compared to heads Gabo constructed of sheet metal or celluloid (also without mass), but it combines an innovative bolted construction with Calder's unique, fantastic animal form. Abstract circus performers also made an appearance at the

FIGURE 131. Calder Installation View, Pierre Matisse Gallery, 1937. Photograph by Herbert Matter.

188

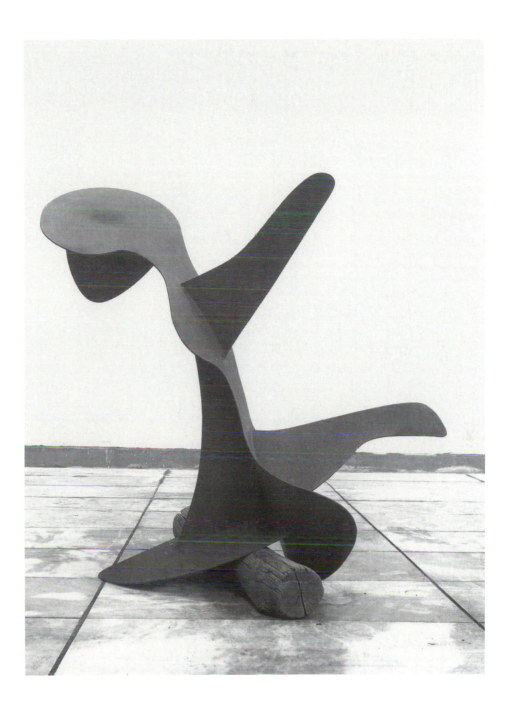

FIGURE 132. Alexander Calder. *Whale II* (1964; replica of 1937 original). Standing stabile: painted sheet steel, supported by a log of wood, 68″ × 69½″ × 45⅜″. New York: The Museum of Modern Art. Gift of the artist.

Pierre Matisse Gallery, in *Tightrope* (Fig. 133), which may have been inspired by the "mobile ballets" Calder had created for Martha Graham. The construction includes large wooden "personages" to which are attached the ends of a tightrope; balanced on the tightrope are several wire "dancers" who sway from side to side. Calder was including in this show an assortment of fantastic creatures that had appeared earlier in his work in more representational form.

The Calders accepted an invitation from architect Paul Nelson to join his

189

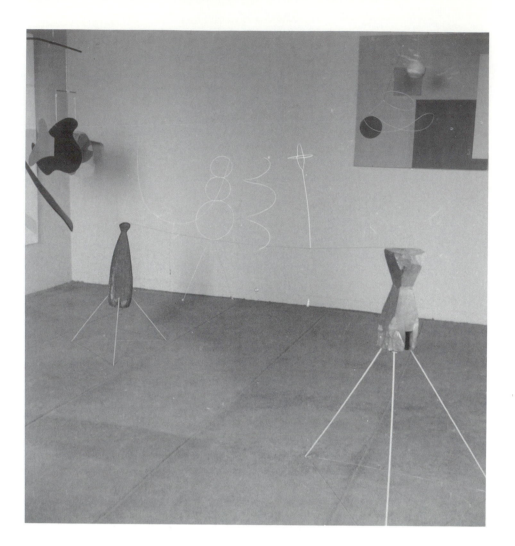

family for a summer outing in Varengeville, and the most remarkable outcome of this 1937 sojourn in Europe was Calder's brilliant success with his first major commission, *The Mercury Fountain*. In April 1937, Calder went to Paris for a visit, accompanied by Louisa and their two-year-old daughter, Sandra.[41] Soon after his arrival there, Calder was taken by his old friend Joan Miró to the Spanish Pavilion of the Paris Exposition, where Miró was creating a mural. There he met Spanish architects José Luis Sert and Luis Lacasa, and, moved by his sympathy for the Loyalist cause in Spain, Calder volunteered his services. Sculptors Julio Gonzalez and Alberto Sanchez were to contribute works to the pavilion, and Picasso's *Guernica* was also to be exhibited.[42]

The Spanish government intended to feature a display related to the mercury mines of Almadén, in the southwest of Spain, where the Spanish Loyalists had withstood a long siege by Franco's insurgent forces. Because this region supplied more than sixty percent of the world's mercury the natural

FIGURE 133. Alexander Calder. *Tightrope*, 1937. Wood, rods, and wire, 9'3" long. Location unknown. Photograph by Herbert Matter.

190

resource was a symbol of Spain's national pride, and holding on to the Almadén mines had been an important victory for the Loyalists.[43] In addition, mercury was essential to them for use in making the pivots of heavy artillery. When a Spaniard's mercury fountain design was rejected by the architects, Sert asked Calder for one. The American's model of sheet aluminum used a handful of ball bearings to simulate the mercury. The completed fountain of actual mercury (Fig. 134), which was installed near Picasso's *Guernica*, became a popular attraction at the exposition.

In *Technology Review*, published by the Massachusetts Institute of Technology, Calder wrote a lengthy technical account of the construction:

> A pump and a reservoir were placed under the stairs in the enclosed part of the building, and a large pipe to take the mercury from the basin to the pump and a small one to bring it back, under pressure, from the reservoir to the fountain, were laid under the paving. Due to the weight of the mercury, the extreme height permitted me from which to spill it was about a meter. Also, as the mercury splashes and wastes itself in very fine globules in all directions when permitted to fall for more than two or three inches on another surface of mercury, it was necessary to keep the whole thing very low.
>
> So I used three plates, of irregular form, and permitted the mercury to flow across one after the other, spilling over a lip at the end of each plate. This gave the spectator the opportunity to look down upon the surface of the mercury as it flowed and also increased the effective surface of the mercury and varied its forms.
>
> There were also limitations as to material – those I was given to work with being glass and polished steel. But the basin was made of concrete, lined with pitch; so I discovered that, too, was permissible. This was very fortunate, as pitch has a flat black surface, which gives the strongest possible contrast to the mercury, whereas glass or polished steel is much closer to the mercury in color value. So I made the plates of steel, and once they were in position, had the working surfaces covered with pitch, and the supports and under surfaces painted black. First I had the plates made according to my design, and then took them to the fountain, supported them on a falsework, and then designed the supports.
>
> As the design, thus far, was low, and the movement very gentle, I added a mobile element, which would increase the movement, add color, and also give the name of the mines from which the mercury came. This was composed of a rod, slung from a spot near its center and ending in a flat plate of irregular form, at the bottom, whose weight was sufficient to support a second, finer rod and maintain a steep slope. The

upper rod had at its bottom end a circular disk, painted red, and at its upper extremity it flaunted, made of a single piece of brass wire, the name of the mines, Almadén. . . . Thus there were five colors in the composition: brass, red, flat black, the gray of the stones, and the mercury.

The movement was caused by the jet of mercury flowing from the third plate, which was a sort of chute, with dams, tapping against the heavy plate, causing a swaying of the red disk and of the name Almadén.

Curiously enough, there was no mercury available at the time of the conception and construction of the fountain. So I bought some ball bearings and permitted them to flow over the surfaces of the small, rough model which I had made. And thus we were able to speculate as to what would happen with the mercury, once we had it. The mercury arrived exactly in the middle of the afternoon of the press opening of the pavilion. There were 200 liters valued, I was given to understand, at half a million francs. One hundred and fifty liters were put into circulation, and the rest held in reserve to take care of losses due to splashing, seepage, and so on.[44]

The *Mercury Fountain* represents a culmination of Calder's work as a Constructivist. He successfully combined his engineering skills with the inventive mobile and stabile forms to produce a compelling work of unique materials. This sculpture, which used liquid elements as part of a kinetic composition, was the first of several remarkable fountain projects for the American sculptor. Calder was amused to be the only non-Spaniard included in the Spanish Pavilion, and to have his fountain installed next to Picasso's mural-sized painting *Guernica*.

Stressing his technical expertise and probably seeking recognition from his alma mater as a successful artist-engineer, Calder published another description of the *Mercury Fountain* in the *Stevens Indicator*, the alumni magazine of the Stevens Institute of Technology. In this article the artist recalled: "The fountain proved quite a success, but a great deal was due, of course, to the curious quality of the mercury, whose density induced people to throw coins upon its surface."[45]

In making this fountain using mercury (which corrodes everything but glass and pitch) Calder rose to the technical challenge with great success, and created a popular attraction at the same time. In 1975 the *Mercury Fountain* was installed at the Miró Foundation in Barcelona, but water replaced the silvery liquid originally used.

Calder's first solo exhibition in London, at the Mayor Gallery in December 1937, was well received. Kenneth Clark, then director of the National Gallery of Art, purchased a mobile for his personal collection.[46] The *Manchester Guardian* critic noted:

FIGURE 134. Alexander Calder. *Mercury Fountain*, 1937.

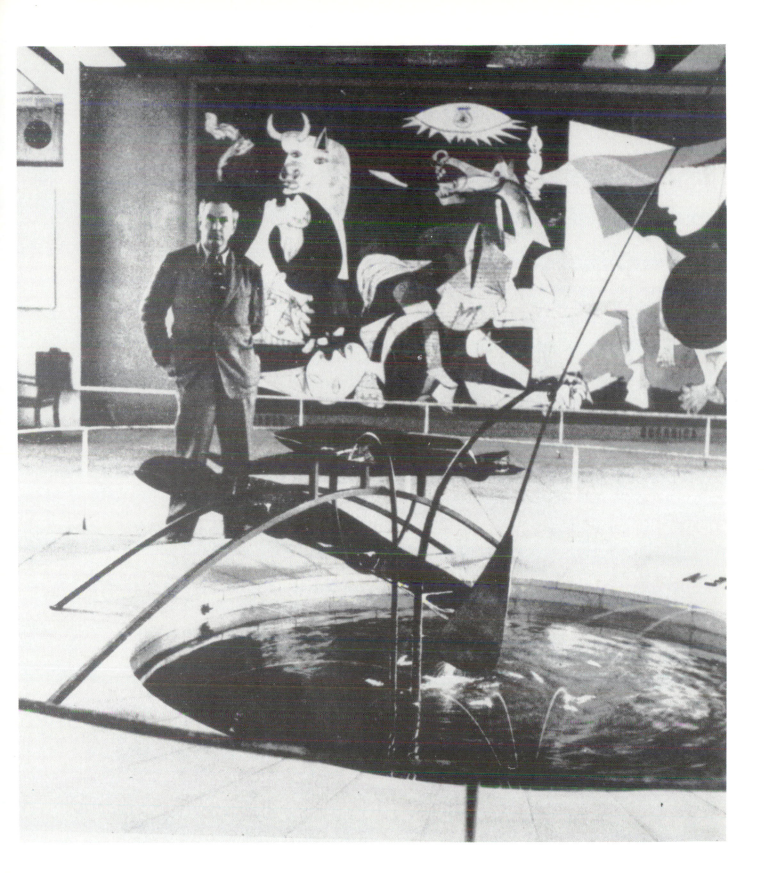

> Mr. Alexander Calder is an American who combines the en-
> gineer's interest in how things work with the artist's interest in
> how things look. In combining the two he has made an artistic
> innovation. His "mobiles" exhibited at the Mayor Gallery have
> no other object than to provide the spectator with mild aes-
> thetic entertainment, but in their construction he has exercised
> all the ingenuity of a mechanical engineer.... Ideal Christmas
> presents for harassed Cabinet Ministers who feel the need of
> a refuge from the immediate problem; they are at once trivial
> and cosmic.[47]

Calder's acceptance in London may have been related to the publication of his work in *Circle, International Survey of Constructive Art*, and to the support of the growing number of Constructivists who emigrated to England during the thirties. In *Circle*, Gabo wrote of the connections of science and art in finding a "new stable model for our apprehension of the universe."[48] Gabo's essay as well as those of Mondrian, Moholy-Nagy, and others had far-reaching consequences on English artists' involvement with Constructivist principles.

The Calders returned to New York in the spring of 1938. Works from the next few years include the surrealist *Apple Monster*, made from the branch of a tree and resembling a fantastic animal with different limbs painted red, green, and black. In standing mobiles such as *Spider* (Fig. 135) and *The Giraffe*, Calder returned to subjects he had explored in wire and wood in the late 1920s, but with a difference. By the late 1930s Calder had become proficient in the art of the mobile. In an abstract format and with subtly controlled movement he was able to suggest a giraffe grazing among leaves or a spider ensnaring insects.

Calder's first major retrospective was held in November 1938 at the George Walter Vincent Smith Art Gallery in Springfield, Massachusetts. At the same time that he was preparing for this retrospective, Calder was making maquettes for monumental motorized constructions intended for outdoor sites at the New York World's Fair of 1939.

One project for the World's Fair was an aquatic "ballet" Calder intended for the fountain outside the pavilion of the Consolidated Edison Company, designed by Harrison and Fouilhoux. Fourteen jets of water, rising at times to a height of forty feet, were to "perform" in five different "scenes," which Calder carefully plotted in timed sequence (Fig. 136). This ballet was regularly accented by bursts of water meant to return to the water basin with an explosive sound. In a 1939 article entitled "A Water Ballet," Calder wrote about this work:

> The center of the water basin [part of the facade of the Con-
> solidated Edison Building] itself serves as the stage for a water
> ballet whose acting elements are jets of water from 14 nozzles

194

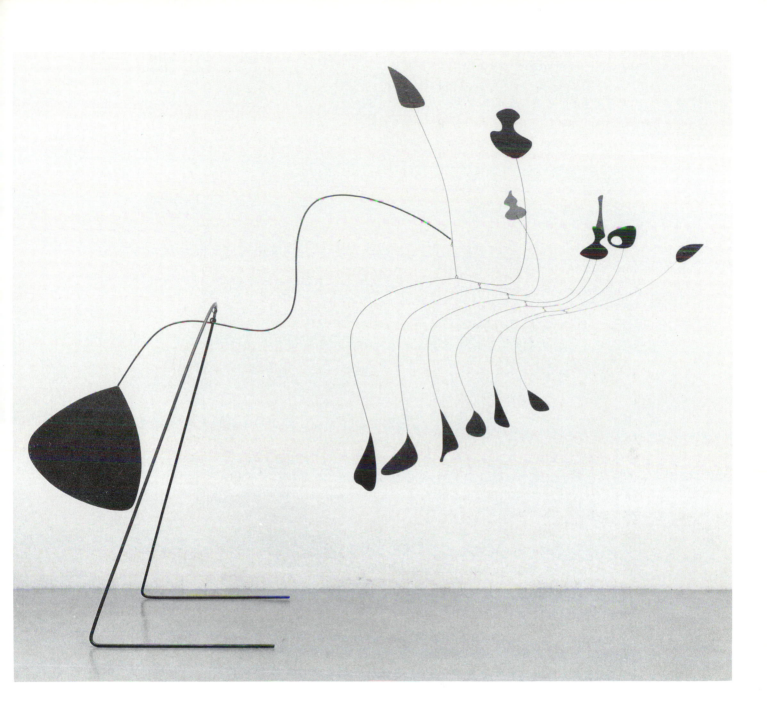

FIGURE 135. Alexander Calder. *Spider*, 1939. Standing mobile: sheet aluminum, steel rod, and steel wire, painted, 6'8" × 7'4½" × 36½". New York: The Museum of Modern Art. Gift of the artist.

which are designed to spurt, oscillate or rotate in fixed manners and at times as carefully predetermined as the movements of living dancers. The ballet is schemed to last 5 minutes, each time following the same fixed pattern, with 15 minutes or more between performances.[49]

As a visitor to many world's fairs, Calder must have been familiar with elaborate schemes for jets of water in fountains. He may have known Gabo's

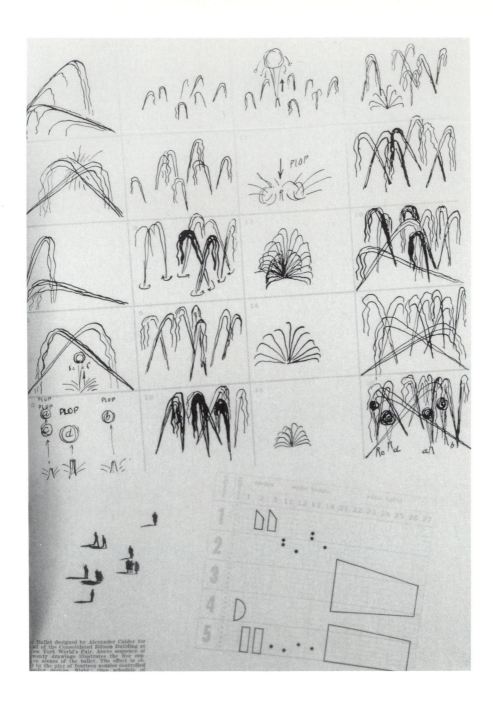

models for *Rotating Fountains* of the 1920s, but Calder's design was without sculptural parts, intended only as sequenced jets of water.

Although the choreographed water ballet did not function at the 1939 World's Fair, the project was the basis for a fountain commissioned in 1954 by the architect Eero Saarinen for the General Motors Technical Center in Warren, Michigan. In the later work, *Ballet of the Seven Sisters*, Calder pro-

FIGURE 136. Alexander Calder. Water Ballet for New York World's Fair, 1939. *Architectural Forum* 70 (February 1939).

grammed jets of water, varying in shape from slender vertical lines to rotating patterns and forceful streams, to create a complex aquatic mobile.

A more successful commission of 1939, and one that continues to delight its audience, is Calder's mobile for the principal stairwell in the new headquarters of the Museum of Modern Art. *Lobster Trap and Fish Tail* (Fig. 137) was a culmination of many ideas initiated during the 1930s. In this work Calder combined biomorphic elements derived from Arp with imagery indebted to Miró to create a work true to the spirit of abstract Surrealism. Also in the category of new variations on earlier interests is *Panel with Moving Elements* of 1941 (Fig. 138). This motorized piece is a refined and carefully determined reprise of his decade-long interest in Arp. The wood panel *Objects Arranged According to the Laws of Chance* (Fig. 139) and other examples by Arp come to mind when examining Calder's relief. In Arp's example the navel-like elements vary in size and seem to be attached to the wooden panel in a random fashion – or, as Arp aptly phrased it, "according to the laws of chance." Calder's elements are motorized; therefore the relationship of the biomorphs to one another and to the background panel is in a state of flux. The American artist "framed" his elements with a heavy wire formed into an arc that seems to enclose the biomorphs. The planar elements are cut metal shapes that can be related to Miró's magnetic field paintings of the 1930s, as well as Arp's reliefs of the same decade.

Although the playful character of Surrealist objects can be related to his art of the late 1930s, Calder manifested none of the obsessive sexuality or incipient violence found in Surrealist sculptures by Giacometti and Masson, or the fetishism of Dalí and André Breton. Calder considered his formal association with the Surrealists to be limited, but he continued, nonetheless, to be included in their exhibitions. He was, for example, one of the few Americans chosen for "First Papers of Surrealism," an exhibition of Surrealist artists held in New York in 1942,[50] and the only sculptor among a group made up primarily of émigrés from Western Europe. Sidney Janis wrote the foreword to the catalogue and observed that "Surrealism exists in the very lives of a people functioning in a power age, inherent in the fabulous unreality of living in a shockingly real period; that it is embedded in the fantastic implications underlying the bold mechanistic aspect of that age."[51]

Janis also spoke of the contemporary world as revealing "inner and secret processes which only fleetingly come into focus," and in this we find an analogy with Calder's kinetic works of the period, which are a means of communication, a mirror held up to the natural world.

By the late 1930s, Calder was firmly established as an artist who continually explored a range of unconventional materials. From mercury through plastics to broken glass as well as the industrial metals that replaced traditional marble and bronze in modern sculpture, Calder demonstrated an attraction to "new" materials as a means of creating innovative sculptural forms. By cutting out sheets of metal, using pliers to attach loops of wire, and joining the elements

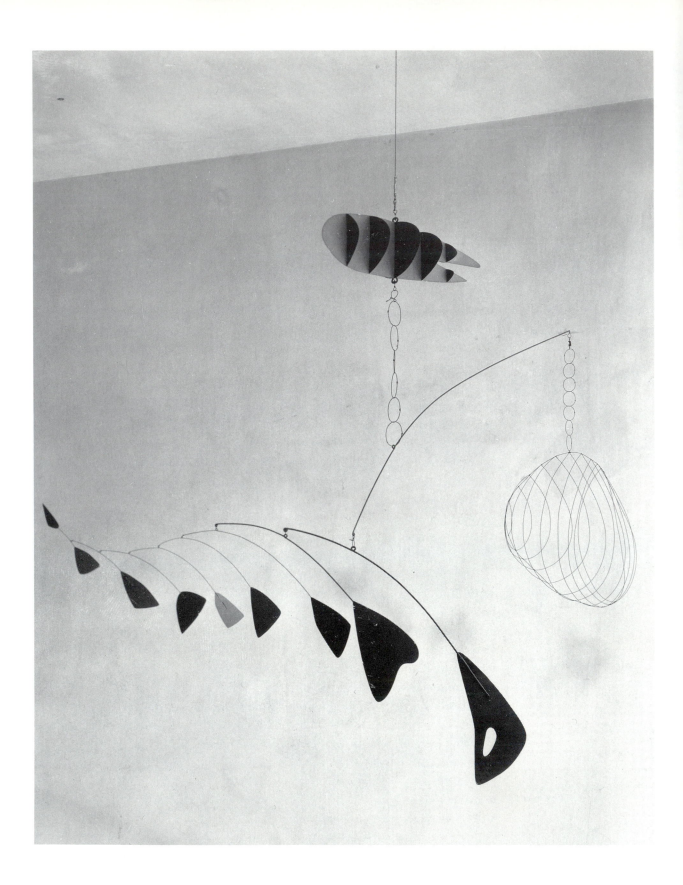

to iron rods, Calder was able to make an original, kinetic interpretation of the biomorphic imagery of his contemporaries.

Calder's mobiles and other sculptural commissions of the late 1930s were complemented by a growing assortment of designs from his studio for jewelry, wallpaper, and eventually tapestries. The first exhibition devoted to Calder's jewelry, held in New York, in 1940,[52] included humorous organic forms in brass wire. Spirals and curves abound in a large necklace, oversized brooches (often with rough-cut stones), and earrings resemble tiny mobiles. Natural forms recalling the amusing animals and circus performers of his formative years linger in these jewelry designs.

Biomorphic forms dominated Calder's production, and his earlier preoccupation with cosmic imagery had been superseded by a growing exploration of the space–time continuum as presented in dance performances. Elements in paintings and reliefs by his friends Joan Miró and Jean Arp clearly exerted an influence, but it was Calder's involvement in theatrical productions that accounted for his most important innovations from this period. Calder's mechanized ballets and other motorized works from the mid–1930s suggest his primary interest was not with kineticism per se but with the changing relationship between moving objects in time and space. His fascination with change – especially random change – led him further to develop forms able to perform unpredictably. His mobiles can be viewed as metaphors for the human body, in all their elegance of movement, energy, and spontaneity. Calder's approach may be humorous, but his message is profound: the triumph of the human spirit over technology. In this respect, he seems less taken with the technical wonders of the modern world than were some of his American contemporaries during the 1930s. As with his European friends Miró and Arp, living forms are at the core of this art.

James Johnson Sweeney stated in 1938 that "Mr. Calder is an original artist whose contribution is so unique that it may possibly only be appraised of its true value by the future."[53] Sweeney was correct in his assessment of Calder's importance, for in the postwar years Calder became one of the most renowned American sculptors of the twentieth century. As George Rickey has noted, Calder had the field of kinetic sculpture to himself for fifteen years and had, "single-handedly, established the validity of kinetic art as a branch of modern sculpture and thus opened the way for all others."[54] Henri Gabriel, a younger sculptor who creates suspended mobiles, has observed:

Calder's hanging mobiles use balancing volumes and corresponding weights of the parts, as well as the mechanics of lever calculation to make mobiles coherent works of art. Alexander Calder with his technical knowledge and engineering expertise, perfected the elements of the mobile and thus furthered

FIGURE 137. Alexander Calder. *Lobster Trap and Fish Tail,* 1939. Hanging mobile: painted sheet wire and sheet aluminum, about 8′6″ high × 9′6″ diameter. New York: The Museum of Modern Art. Commissioned by the Advisory Committee for the stairwell of the museum.

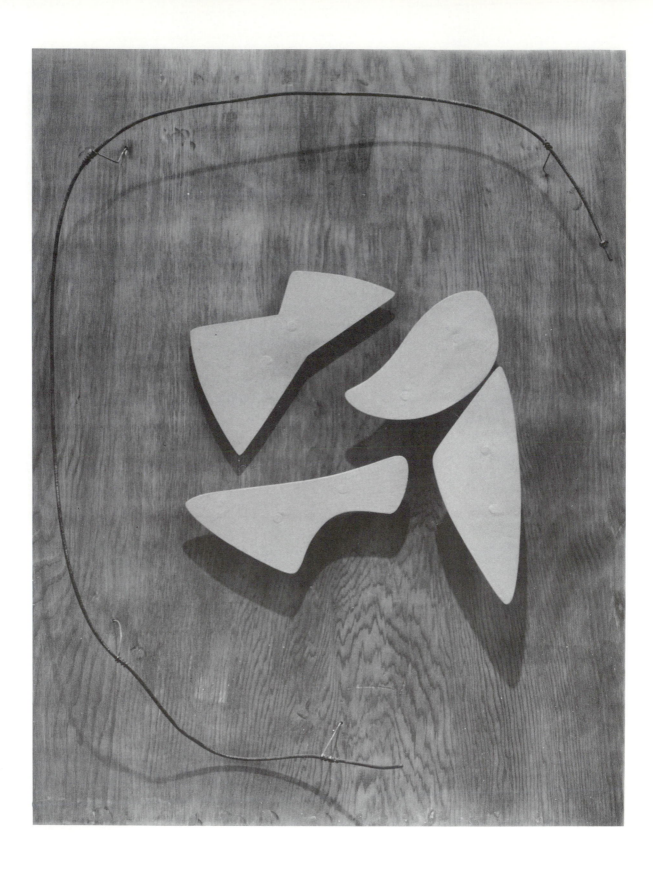

200

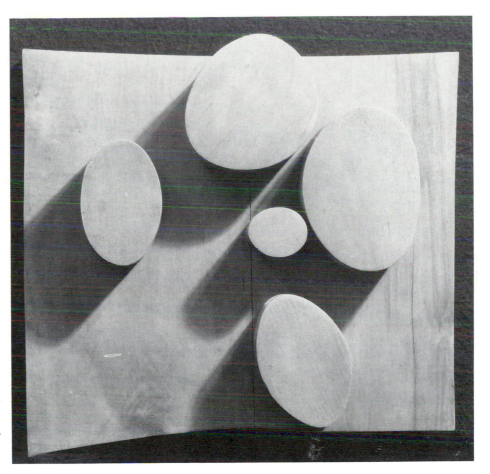

FIGURE 139. Jean Arp. *Objects Arranged According to the Laws of Chance*, 1930. Wood relief, 10⅜″ × 11⅛″ × 2¼″. New York: The Museum of Modern Art.

FIGURE 138. (*opposite*) Alexander Calder. *Panel with Moving Elements*, 1941. Wood, sheet metal, wire, and cord, 22½″ × 28″. New York: The Solomon R. Guggenheim Museum.

the development of a technical-artistic dualism in this medium.[55]

During the 1930s, Calder's innovations summarized the achievements of constructivist sculptors of previous decades. He brought the experimentation with kineticism to a successful realization in a coherent body of work. In subsequent decades many artists explored seriously the aspects of moving sculpture and the aesthetics of constructivism that Calder so adeptly and uniquely pioneered.

5

Calder as a Public Artist:
1940s and 1950s

IN SEPTEMBER 1943, Calder received recognition that must have been the envy of his American contemporaries – a retrospective exhibition at the Museum of Modern Art. This show acknowledged Calder's supremacy among American modernists, and also celebrated his position as the first American artist with a truly international reputation. (In some respects Man Ray preceded him, but Ray was closely identified with the Dadaists and Surrealists, lived in Paris exclusively from 1921 to 1940, and was considered a European artist. He had limited involvement with America before his return during the war years.) No American artist of his generation or earlier had captured the attention of both American and international audiences as had Alexander Calder. Before all of his American contemporaries, Calder had adeptly synthesized international trends with American modernism and traditional folk art.

Calder's Museum of Modern Art retrospective validated his position as a leading American artist of the period, for he was the youngest American to be so honored. Of his generation only sculptor John B. Flannagan had been given a retrospective – in 1942, the year of his death. Other Americans who received solo exhibitions at the Modern – such as Charles Sheeler, Edward Hopper, and Max Weber – had established themselves much earlier, and the museum's collection of American art was overwhelmingly confined to artists born before 1890. Not only with a major retrospective, but with acquisitions and several commissioned mobiles, the Modern gave recognition to Alexander Calder long before they did to the Abstract Expressionists, who gained critical attention in the late 1940s.

Calder's exhibition of more than eighty objects presented his sculptural achievements to an adoring public. The show was so popular, it was extended until January 1944. For Americans suffering anxieties and the malaise caused by World War II, Calder's humor was the perfect antidote. Other artists, drafted into the armed services, were unable to create during the war; but

Calder continued to amuse his audience with the products of his mechanical ingenuity and exuberant spirit. To be sure, his wartime imagery is sometimes more menacing – spiders and predatory insects abound – but his optimism and wit remained intact. Undoubtedly, Calder's insect imagery related to the Surrealists, particularly the disturbing sculpture of Alberto Giacometti (whom Calder knew), but the American developed a more playful effect with these themes.

Calder as an internationalist was unique among American artists, who did little traveling abroad in the forties and fifties. After the war, Calder renewed his practice of spending a major portion of each year in Europe while maintaining his home in Connecticut. In the 1950s the Calders bought two properties in France. They also traveled widely over the Continent, in South America, and in the Near East. Calder received many international commissions in these years, certainly more than any American sculptor had ever obtained. By the 1950s, major museums abroad, like many in the United States, owned examples of Calder's work. His public commissions abounded, and every major city seemed to want a work by him. In 1952, Calder won first prize for sculpture at the Venice Biennale; and by 1958 he had completed three large-scale public sculptures – in Brussels, Paris, and New York. A giant mobile won first prize at the Carnegie International Exhibition and was purchased for the city of Pittsburgh. Two years later, Calder was awarded a Gold Medal from the Architectural League of New York and was elected to the National Institute of Arts and Letters. These are only a few of Calder's many honors, commissions, and exhibitions during the 1940s and 1950s.

Why the artist had such popularity in these decades is a question worth exploring. As already mentioned, his spirited and graceful mobiles must have been a lively contrast to the deeply disturbing news reported during the war years. In reviewing Calder's 1943 retrospective at the Modern, Henry McBride observed:

> The present emergency is one of the most terrific that nature has ever experienced and it is only those among us most persuaded of nature's invincibility and power to recover from every rejection she gets at the hands of human beings . . . who rejoice in Sandy Calder's ability to salvage from our unlikely modern materials an art form that sways in the breeze like a bamboo reed on a river bank. . . . His exhibition in the Modern Museum contains an astonishing number of proofs that nature never can be entirely thwarted and that even when at the last gasp, as I presume nature is at the moment, she can still supply to poets and to genuine artists the manna which the soul craves and upon which alone the soul thrives.[1]

McBride's opinions were shared by others who found that Calder's art affirmed life and, although "abstract," it was replete with allusions to nature.

His mobiles made a contribution to the resurgence of culture in both America and Europe during the postwar years. As the United States became the most powerful and financially solvent nation after the war, so American artists, particularly established artists like Calder, became cultural leaders on the international scene.

Calder's mobiles were the appropriate complement to many stark architectural projects, for his large abstract forms were witty and buoyant in mood and appearance. Boldly formed biomorphs successfully contrasted with the severity of modern architecture and offered a humanizing element. In 1941, for example, a mobile was commissioned by architect Wallace K. Harrison for the ballroom of the Hotel Avila in Caracas, Venezuela. Calder's delicately balanced, rhythmical work was an appropriate complement to an architectural interior intended for ballroom dancing.[2] Predictable geometric components and the sleek surfaces of International Style architecture were enlivened by the sweeping rhythms of the mobiles.

By far the most engaging aspect of Calder's sculpture was its interaction with space. Mobiles participated in lively dialogues with their environs, reacting to air currents and to human touch. The stabiles enfolded and incorporated spatial volume. As they were fabricated in increasingly large dimensions, their appearance on a site became more aggressive, their spindly legs and splendid arches enclosing the spectator in a magical web.

Calder was also considered a safe choice for public works during the McCarthy era. Panels that commissioned him found no heavy-handed literary content, no overblown heroes, and no suspect moralizing. At a time when few sculptural styles were acceptable to both the general public and the avant-garde, and when the "wrong" choice of subject could cause trouble for all concerned, Calder's intriguing and somehow endearing abstract imagery made him the ideal recipient of public commissions.

How did international recognition affect the artist and his work? As Calder became a public figure rather than a personality appreciated by the cognoscenti alone, did he adjust his style in any way to his new status? Examination of Calder's work of the 1940s and the following decade leads to the conclusion that Calder now took few risks and made fewer dramatic innovations. He did introduce the wooden *Constellations* when metal became scarce during the war, but in the postwar years his mobiles and stabiles proliferated steadily in a style he had already developed in the 1930s. By 1940 he had basically solved the problems inherent in such constructions, and his subsequent work became predictable.

Calder was secure, both financially and professionally. He had the support of excellent galleries that promoted and sold his work. If a growing international clientele wanted to own "a Calder," this only served to encourage Calder's maintenance of a "signature style." Thus, although the scale of his work increased throughout the 1950s, the appearance of the mobiles did not otherwise change. With a few modifications, particularly for the large standing

mobiles, the formula was the same: Flat biomorphic shapes, usually painted red or black, were attached to curved wires. A new elegance characterizes these mobiles, but they are variations on earlier examples.

Calder's major retrospective at the Museum of Modern Art opened in late September 1943 and extended through mid-January of the following year. James Johnson Sweeney, who had befriended the artist in the early 1930s, wrote the essay for the exhibition catalogue, which remains one of the few serious statements on the artist.[3] Sweeney emphasized Calder's heritage as an American, and the use of humor in his art: "Calder's most original contribution is his unique enlivening of abstract art by humor. Through humor he satisfies the observer's appetite for feeling or emotion without recourse to direct representation."[4]

Sweeney recognized that Calder joined Constructivist ideas with figurative art and was indebted to folk art, thus joining the present and the past of America's cultural interests. In this catalogue essay and related articles Sweeney focused attention on Calder's importance:

> Alexander Calder's position is unique. During the last 15 years he has enjoyed the widest international reputation of any American plastic artist of his generation. In fact, he is the only plastic artist of his generation recognized by painters and sculptors abroad as an American able to preserve his national and personal idiosyncrasies in active balance with a dominant respect for form and its organization.[5]

Critical reception to the Calder retrospective was generally favorable. The November issue of *Artnews*, for example, featured a color reproduction of *Red Petals* (Fig. 140) and a review entitled "Calder Grown Up: A Museum-Size Show." Rosamund Frost suggested it was time for Americans to take Calder's work seriously, considering the attention he had received in Paris and from European museums and collectors. She acknowledged, however, that it was often Calder himself ("the incurable humorist") whose antics made it difficult to receive his work with deserved seriousness.[6] The critic for *Art Digest* noted: "In the nearly one-hundred pieces corralled for this show, buoyancy and good humor are never absent; ingenuity and unpredictability rule throughout."[7] Calder's technical ingenuity combined with defiance of artistic convention attracted his American contemporaries.

In the early 1940s Calder refined the standing mobile, a type of sculpture he had first developed a decade earlier. The range of Calder's involvement with geometric forms and organic imagery is suggested by comparing three examples: *Black Mobile* (Fig. 141) of 1941; *Red Petals* (see Fig. 140) of the following year, and *Morning Star* (Fig. 142) of 1943. The genre form of the standing mobile can be taken as alluding to a figure with gesturing arms, to

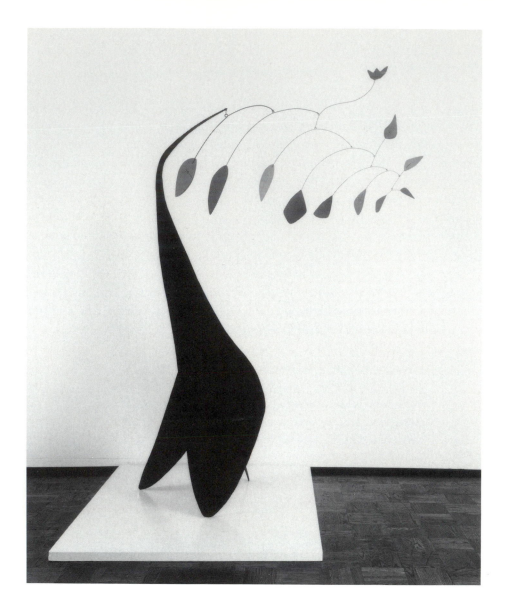

a tree with gently undulating branches, or to an animal with a long snout. Yet the three-foot-high *Black Mobile* is a strictly geometric formation of metal discs of varying dimensions. The system of balance and counterbalance employed for some of the mobiles produced during the 1930s is repeated here, and presented on a tripod base as before.

Red Petals represents a pronounced contrast with Calder's earlier geometric works, and signals the direction of his work for the next few decades: the combination of mobile and stabile elements. Unlike the earlier tripod bases used for standing mobiles, the base of *Red Petals* is no longer simply a support for the mobile portion but an autonomous form that alludes to an animal or plant. In the overall composition, the stabile portion holds parity with the

FIGURE 140. Alexander Calder. *Red Petals*, 1942. Sheet metal, 102″. Chicago: The Arts Club of Chicago.

206

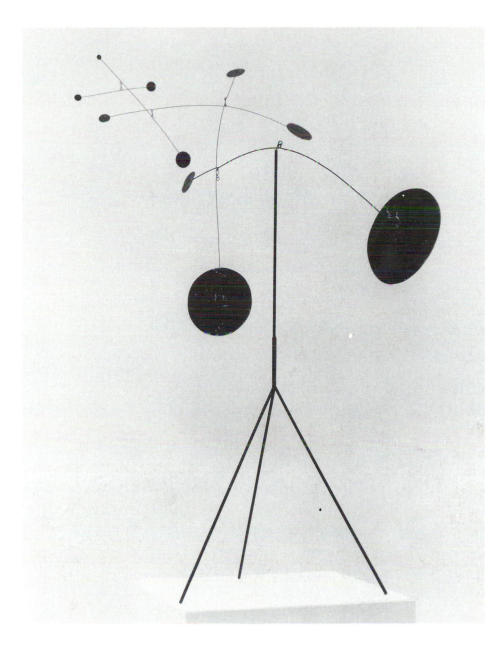

FIGURE 141. Alexander Calder. *Black Mobile*, 1941. Sheet metal, metal rods, and wire, 36½″ × 29½″ × 21½″. New York: The Solomon R. Guggenheim Museum.

mobile. *Red Petals*, a nine-foot-high standing mobile, had been commissioned by the Arts Club of Chicago, and Calder commented that he made the work larger than planned in order to dwarf the paneled room where it was to be installed.[8] This sculpture is a harbinger of the gracefully arching mobiles of subsequent years. Its plantlike base extends a variety of "petals" on gently curving wire tendrils. The effect of the piece is of a living form with the unpredictable movements of plants in nature.

Morning Star, although it resembles the two standing mobiles just described, is actually a stabile – a stationary sculpture that incorporates space – with a

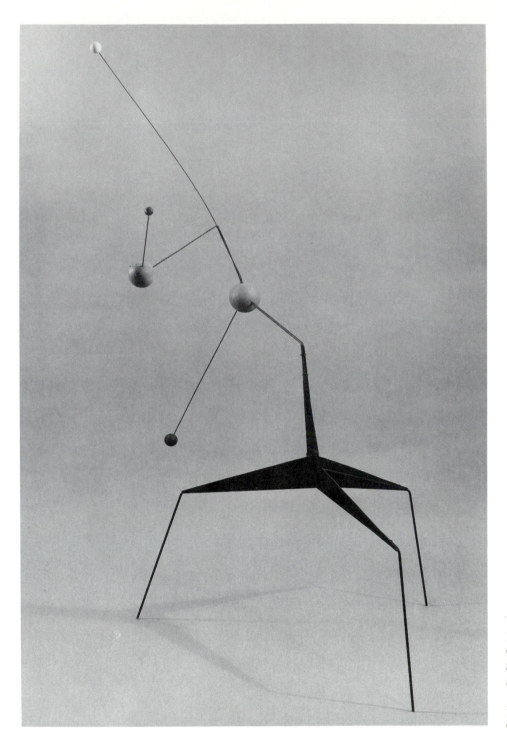

Figure 142. Alexander Calder. *Morning Star*, 1943. Stabile: painted sheet steel and steel wire, 76¾″ × 48¾″ × 45¾″. New York: The Museum of Modern Art. Gift of the artist.

fixed arrangement of wooden spheres extending from a tripod base. This construction of more than six feet suggests, visually, that Calder's interests in the cosmos continued into the 1940s. *Morning Star* appears to include a configuration of planets painted in bright colors. Its allusion to cosmic forms

made by wooden spheres harkens back to Calder's stabiles and mobiles of the early 1930s, such as *A Universe* (see Fig. 98). However, in an interview Calder suggested that *Morning Star* was not necessarily intended to be a reference to the planet Venus:

> Names are tags – my things are named later. Before the 1943 Museum of Modern Art show, when Sweeney insisted things should have names, I used to make a little drawing when talking about a thing instead of using a name. . . . A *Morning Star* – it's not a star – is a medieval weapon thrown from a horse – sort of a lance with a round head and little spikes.[9]

Clearly, Calder enjoyed introducing ambiguity into his titles as well as building it into his sculptures. Like the Surrealists, he suggested a range of meanings and associations by his deliberately ambiguous titles.

When the United States entered the war in 1942, Calder was classified 1A but was never drafted – possibly because he was already in his mid-forties. He did volunteer as an occupational therapist in a military hospital in Staten Island. But while David Smith worked in a locomotive factory, Theodore Roszak helped to build aircraft, Ibram Lassaw served in the army, and Isamu Noguchi voluntarily spent time in an internment camp for fellow Japanese Americans, Calder remained free to create sculpture. However, his contribution to the "Artists for Victory" benefit exhibition at the Metropolitan Museum of Art in 1942,[10] for which he won fourth prize, indicates he believed in the cause and was willing to help raise funds to support it.

Calder continued to explore ever more varied stabile–mobile combinations in subsequent years. As for his imagery, menacing creatures appear in Calder's works of the 1940s but nothing suggests a profound reaction to the destruction and privation of the war. Such works as *Black Beast* (1940), *Spiny* (1942; Fig. 143), and *Black Thing* (1942) are stabiles with jagged protuberances projecting in various directions. In a review of Calder's 1943 retrospective at the Museum of Modern Art, a critic wrote: "*Black Thing* has an incredibly bogey-like character and would be unpleasant to come upon unexpectedly."[11] The spiders and "menaced flowers" that also appeared among his standing mobiles are predatory, but nothing parallels the suggestions of torture and violence found in Herbert Ferber's *Hazardous Encounter II* (1947) or Seymour Lipton's harrowing cage holding a jagged abstract form entitled *Imprisoned Figure* (1948).[12]

Some American sculptors reacted to worldwide conflict, genocide, and the deployment of atomic weapons with expressionistic works in welded metal. The advanced technology that had evoked positive responses among artists of the 1930s now assumed sinister connotations; the promise of a world of peace and prosperity based on the successful use of scientific progress was irrevocably broken. Theodore Roszak's disillusionment resulting from the use of technology for destructive purposes caused him to abandon completely the

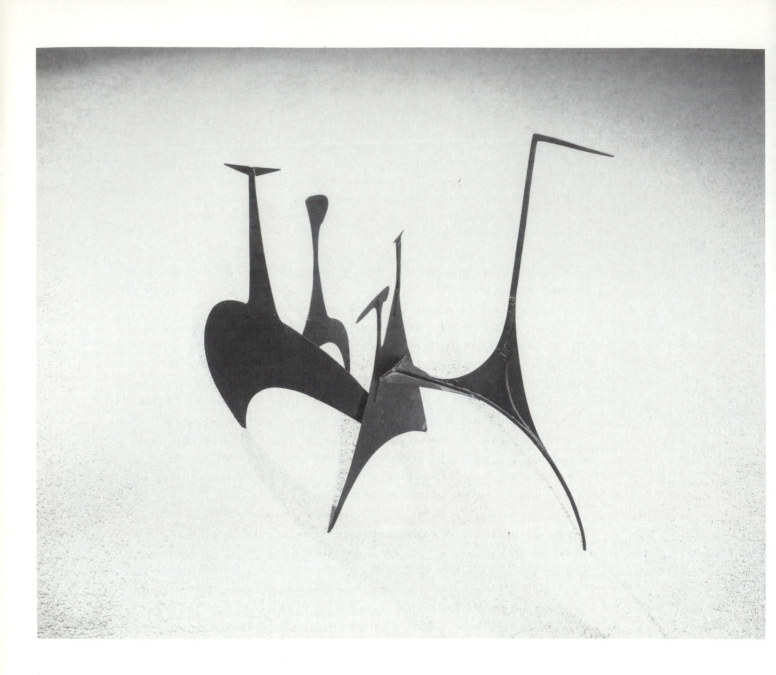

constructivist concepts that formed his sculpture from the early 1930s, and to develop disturbing images of menacing machines, with titles such as *Spectre of Kitty Hawk*. By the late 1940s, Roszak's early futuristic visions had been replaced by scenes of primordial strife and natural forms struggling for survival,[13] angst-ridden sculptures that never found the critical acclaim afforded to Calder.

David Smith's and Isamu Noguchi's sculptures resounded strongly with symbolic references in the 1940s. Smith reacted to war violence with images of cannons, tortured women, and devastated lands. His *Medals for Dishonor* of

FIGURE 143. Alexander Calder. *Spiny*, 1942. Stabile: sheet aluminum, painted, 26″ × 30″ × 14⅜″. New York: The Museum of Modern Art. Nelson A. Rockefeller Bequest.

the late 1930s were a premonition of the disasters of war, and the "War Spectres" and cannon-phallus images of the forties explicitly commented on the violence of the decade while alluding to personal experiences.[14] In *The Rape* of 1945, a nude woman is shown on the ground with a cannon-phallus preparing to attack her. (The cannon-phallus, a reference to the horrors of war and social injustice, also expressed Smith's potential for violence against women, whom he viewed as predatory creatures.)[15]

Noguchi was outraged by the actions of the United States government in detaining his fellow Americans of Japanese ancestry in internment camps. As already noted, he voluntarily entered one of these "relocation centers" in Poston, Arizona, where the black desert landscape inspired a later relief, *This Tortured Earth*. Another work, *Monument to Heroes* of 1943, is a cylindrical form in plastic from which bones and propeller shapes protrude. This strange tower, filled with allusions to death, Noguchi identified as a large flute that would emit mournful sounds.[16]

Thus, by the end of the war many American sculptors had taken decisive directions in their work: the utopianism of the Cubist–Constructivist style was abandoned for individualized approaches that were indebted to Surrealism but distinct from the European movement. Sculptors responded to contemporary events with violent imagery, or with archetypal or totemic forms. Myths, references to evolution and lost cultures, can be found in the works of Smith and Noguchi as well as in the paintings of the Abstract Expressionist generation. Primitivism was also seen as appropriate to a time of human irrationality: the vulnerability of man in the atomic age paralleled the state of precivilized man.

Although Calder was included in group exhibitions with the Abstract Expressionists at the Museum of Modern Art and the Whitney Museum of American Art, he was not closely associated with these artists. Many of the first-generation Abstract Expressionist painters were a full decade younger than Calder, but, even more importantly, these artists had common experiences. Many of them had met in the 1930s through their work for the Works Progress Administration, a relief project for artists: David Smith had been a technical adviser for the mural division of the Federal Art Project of the WPA and had developed friendships with painters who were to become leaders of Abstract Expressionism in the late forties and fifties; Lassaw, a founding member of the American Abstract Artists group, also maintained close contact with Jackson Pollock, Willem de Kooning, and other painters in the postwar period. These painters and sculptors frequented the Cedar Street Bar in New York City and formed "The Club," where discussions were held on contemporary issues. Calder participated in none of these group activities. Furthermore, while the Abstract Expressionists struggled to gain recognition for their art, Calder was already being championed by American critics and exhibited in museums.[17] Living in Paris for long periods during the 1930s, and main-

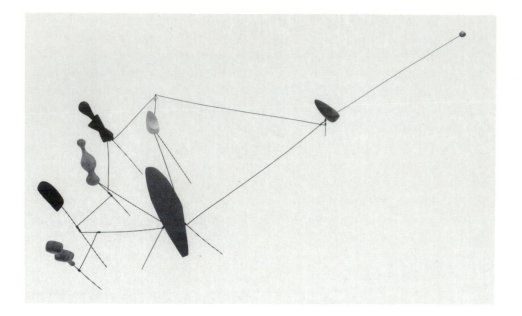

FIGURE 144. Alexander Calder. *Constellation*, 1943. Wood, metal rods, 22″ × 44½″. New York: The Solomon R. Guggenheim Museum.

taining a residence in France after 1946, Calder was more closely identified with European artists and was thus isolated from the leading American painters and sculptors during the 1940s and 1950s.

His work manifested no radical transformation in this period. Indeed, the principal effect of the war on Calder's art appears to have resulted from the shortage of metal. Later he recalled:

> In 1943, aluminum was being all used up in airplanes and becoming scarce. I cut up my aluminum boat, which I had made for the Roxbury pond, and I used it for several objects. I also devised a new form of art consisting of small bits of hardwood carved into shapes and sometimes painted, between which a definite relation was established and maintained by fixing them on the ends of steel wires. After some consultation with Sweeney and Duchamp, who were living in New York, I decided these objects were to be called "constellations."[18]

Calder devised the Constellations to mimic astral formations by attaching various elements to fragments of wire. Unlike the cosmic allusions in his works of the 1930s, where spheres were used, the Constellations featured biomorphic elements. Arp's wooden reliefs and Miró's series of paintings of the late 1930s, entitled "Constellations," come to mind in connection with such works as Calder's *Constellation* of 1943 (Fig. 144). On two-dimensional surfaces, Miró had represented dense patterns of polychrome biomorphs connected with a network of thin black lines. Calder's imagery in the Constellations seems

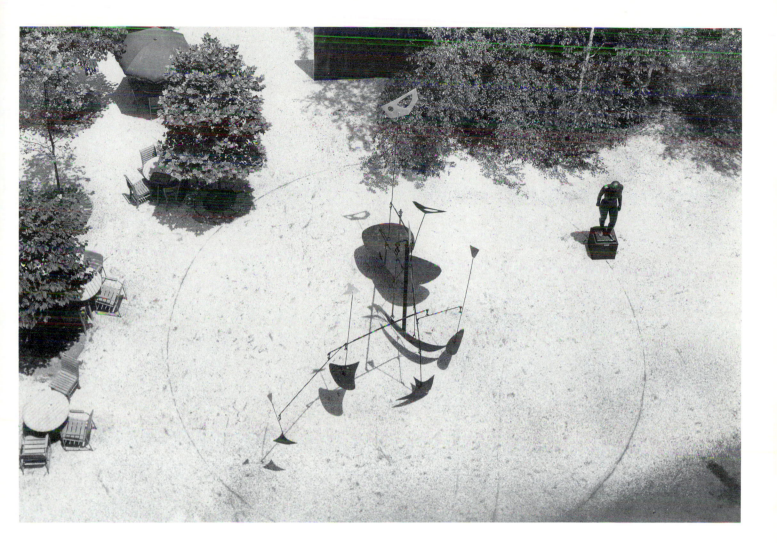

FIGURE 145. Alexander Calder. *Man-Eater with Pennants*, 1945. Standing mobile: painted steel rods and sheet iron, 14′ high × 30′ diameter. New York: The Museum of Modern Art. Commissioned for the Museum's Sculpture Garden.

indebted also to the Surrealist abstractions of Yves Tanguy. Bonelike formations poised on a "landscape" of the mind characterized the paintings of both Tanguy and his wife, Kay Sage. (During the early war years, when the émigré couple bought a house in Woodbury, Connecticut, they became friends of the Calders and frequently visited their Roxbury home.) In the spring of 1943, Pierre Matisse organized a joint show of Tanguy's paintings and Calder's Constellations, implicitly suggesting the interrelationship of the two artists' works.[19]

Calder produced a playful yet mildly disturbing work in 1945, *Man-Eater with Pennants* (Fig. 145). This standing mobile, commissioned for the sculpture garden at the Museum of Modern Art, was the largest to date and included a series of lancelike elements with pennants attached to the ends. The lances pivoted from supporting rods and could oscillate in various directions. Given the overall scale of the piece and the aggressive appearance of the pivoting

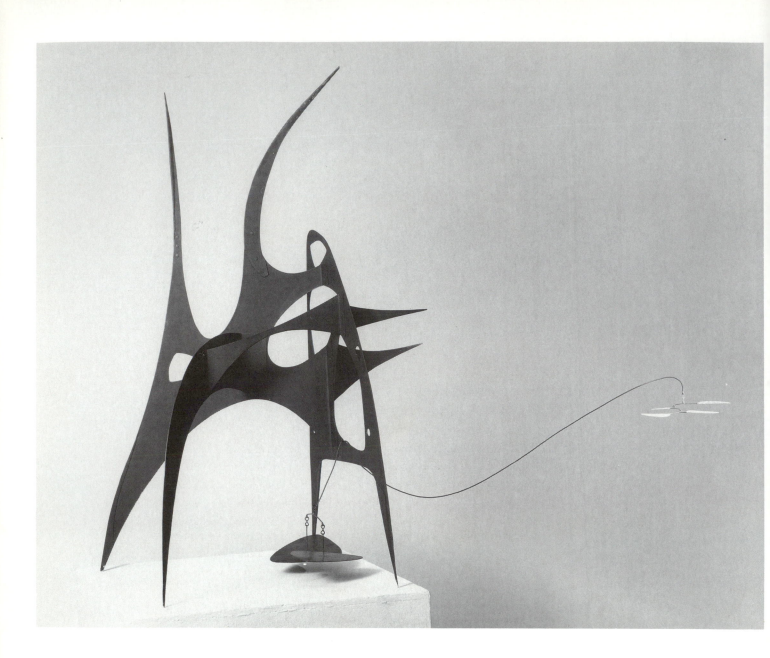

lances, this work seems to entrap the spectator. The title suggests a predatory beast of some kind, but the effect of the work is more like a funhouse encounter and has little of the profound cynicism found in the wartime imagery of other artists. *Bayonets Menacing a Flower* (1945; Fig. 146) is another stabile–mobile with pointed metal elements menacing small biomorphs. The title makes the association with war unquestionable.

In the postwar years such titles disappeared from Calder's work, and he resumed contacts with his European audience, who were delighted with the spirited optimism of his work. International recognition of Calder's achievement continued unabated for the following three decades. In 1946, for ex-

FIGURE 146. Alexander Calder. *Bayonets Menacing a Flower*, 1945. Painted sheet metal and wire, 45″ × 58¼″ × 19″. St. Louis: Washington University Gallery of Art.

ample, his mobiles were shown at the Galerie Louis Carré in Paris, and he made his first postwar trip to Paris. In his introduction to the catalogue, the Existentialist philosopher Jean-Paul Sartre stressed the life-affirming aspects of Calder's mobiles:

> Sculpture suggests motion, painting suggests light or space. Calder suggests nothing, he fashions real, living motions which he has captured. His mobiles signify nothing, refer to nothing but themselves: they are, that is all: they are absolutes.... These motions, which are meant only to please, to enchant the eye, have nevertheless a profound meaning, a metaphysical one. Motion must come to the mobile from some source. Once Calder supplied them with electric motors. Today he abandons them to nature, in a garden or near an open window. He lets them flutter in the wind like aeolian harps. They breathe, they are nourished by the air. They take their lives from the mysterious life of the atmosphere.[20]

Sartre's essay was translated for a Calder exhibition in New York in 1947 and published in the catalogue, reading in part:

> The "mobiles," which are neither wholly alive nor wholly mechanical, and which always eventually return to their original form, may be likened to water grasses in the changing currents, or to the petals of the sensitive plant, or to gossamer caught in an updraft. In short, although "mobiles" do not seek to imitate anything because they do not "seek" any end whatever, unless it be to create scales and chords of hitherto unknown movements – they are nevertheless at once lyrical inventions, technical combinations of an almost mathematical quality, and sensitive symbols of Nature, of that profligate Nature which squanders pollen while unloosing a flight of a thousand butterflies; of that inscrutable Nature which refuses to reveal to us whether it is a blind succession of causes and effects, or the timid, hesitant, groping development of an idea.[21]

American prosperity of the immediate postwar period created a building boom, and Calder was soon sought out by architects to participate in design projects. In one instance, Gordon Bunshaft of Skidmore Owings and Merrill, who had been given the commission for Cincinnati's Terrace Plaza Hotel, in 1948 asked Calder to construct a mobile for its lobby; the hotel was also to feature a large mural painted by Joan Miró for the rooftop restaurant.[22] Also in 1948, Calder designed a large mobile for the Cloud Room, a new airport restaurant in Chicago.[23] Traditional figurative sculpture positioned on pedestals seemed inappropriate for these elegant examples of modern architec-

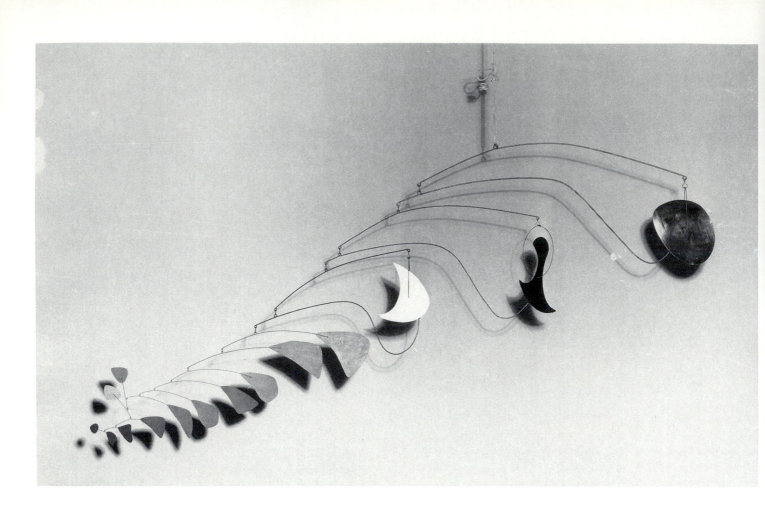

tural design. Not only did Calder's mobiles suspended from ceilings enliven stark metal and glass interiors, these kinetic works also eliminated the need for bronze casting, conventional materials, and heavy-handed symbolism.

When Calder had to enlarge the scale of his mobiles for commissions like these, he went to metal shops near his Connecticut home to construct his works. According to Klaus Perls, Calder's dealer from 1956 to 1976, the artist began cutting out his large elements in the shops of metal fabricators after the war, when the weight of the large mobiles became too heavy for him to handle in his Roxbury studio.[24] Although Calder always preferred to do most of the work himself, he received technical assistance in industrial shops. Friendships with Connecticut metalworkers developed into a regular working relationship in the late 1950s, when Calder began supervising the production of large-scale stabiles, based on his handcrafted maquettes.

Calder began two new series in 1951: the Gongs and the Towers. The Gongs were sound mobiles that recall his early experiments with noise in *Black Ball, White Ball* (see Fig. 88). In *Red Gongs* (1951; Fig. 147), as in other examples from this period, the random sounds produced by the clattering metal elements of the air-driven device suggest the noises produced by Chinese wind

FIGURE 147. Alexander Calder. *Red Gongs*, 1950. Painted aluminum, 60″ × 144″. New York: The Metropolitan Museum of Art, Fletcher Fund.

216

chimes. More than in mobiles of previous years, Calder now varied his means of attaching elements. At times circles of wire were threaded through clanging forms, allowing them to pivot, and curving bars with strikers at their tips created a provocative visual as well as aural effect. Before the Gongs, Calder had favored wire loops suspended from curved wire to attach his metal elements from above, and not the penetrating circular devices used here. A critic wrote with enthusiasm about these works, exhibited at the Curt Valentin Gallery in January 1952. He seemed to suggest that Calder's mobiles were the perfect antidote for worries over the Korean conflict and nuclear proliferation, issues causing much concern in this period:

> "Gongs and Towers" with cheerful musical noises set off by the deft mechanisms of our first and most famous sculptor of movement, launch the New Year in an appropriate and heartening way. Surrounded by so many buoyant inventions, circling and dipping in their discrete orbits, it is difficult to take a dark view of at least the artistic future. Even the mute disks, dangling on delicate stems, behave like accompanying choruses of bright notes.[25]

Calder's Towers are among his most architectonic constructions. At a time when the artist was frequently repeating a basic formula in his mobiles (although each is, of course, unique), the Towers were a refreshingly new development. An open scaffolding becomes the support for small mobiles and other elements made of wood or metal. *Bifurcated Tower* (Fig. 148) is a splendid example, with overall dimensions measuring six feet at the widest point. From various outcroppings of this tower, Calder attached single biomorphs of wood dangling on wires, and miniature mobiles introduce a surprising complexity to the appearance of the work. Calder seems to have envisioned an architectural structure – an unusually designed "museum" – where examples of his work could be presented in reduced size. Was Calder trying to exert more control over the spaces that he would enliven with his mobiles? In such wall-mounted examples as *The Aeroplane-Tower with Six Leaves and a Dot* (Fig. 149) of 1951, his familiar curving wires reminiscent of nature are replaced by an angular wire assemblage suggesting the triangular or rectangular skeletal structures of Constructivist monuments by Vladimir Tatlin and Naum Gabo. However, appended natural forms imply that the relation to the aesthetics of Constructivism should not be taken too literally, and the Dada humor of Calder's architectural invention is unmistakable.

In the immediate aftermath of the first atomic blasts, there was nothing in Calder's work to parallel the reaction of such artists as Roszak and David Smith. A few years later, however, Calder shaped his familiar mobile elements to assume an ominous appearance in the scenery he designed for *Nucléa*, a French play by Henri Pichette produced by the Théatre National Populaire

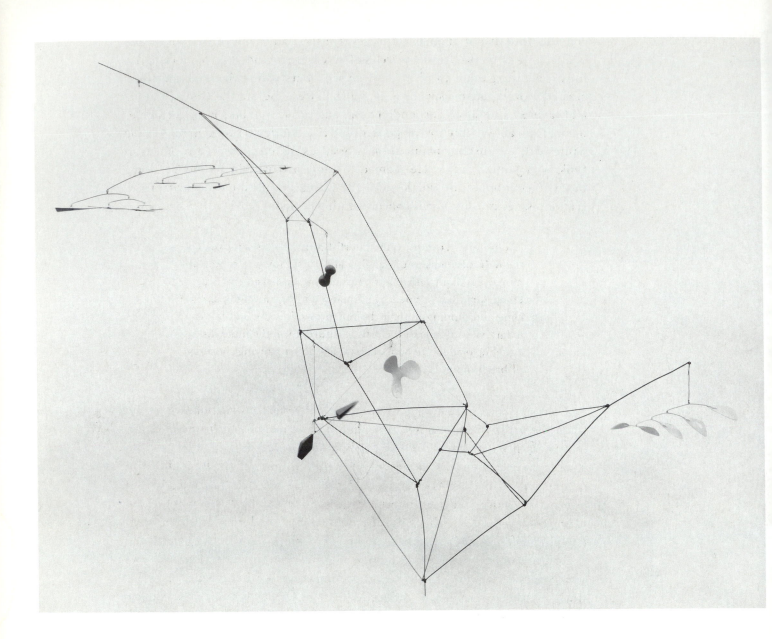

in Paris.[26] *Nucléa* starred Gérard Philipe and Jeanne Moreau and was directed by Jean Vilar. In the spring of 1952, Calder was asked to design the set for this play, which was intended to dramatize the horror of atomic warfare. Large-scale mobile elements were hung from the rafters like threatening clouds, while towerlike stabiles, with aggressive projections, symbolized war machines (Fig. 150). Costumes worn by the "soldiers" in the play included oversized helmet-masks with exaggerated features, while machine guns made of tin cans were carried by the actors. Critical reaction to the event was very favorable.[27] In this instance Calder, given a specific commission for a theatrical design, was able to adapt his customarily cheerful work to the serious themes of the atomic age.

FIGURE 148. Alexander Calder. *Bifurcated Tower*, 1950. Painted metal and wire, 58″ × 72″ × 53″. New York: Whitney Museum of American Art. Purchase, with funds from the Howard and Jean Lipman Foundation, Inc. and exchange 73.31.

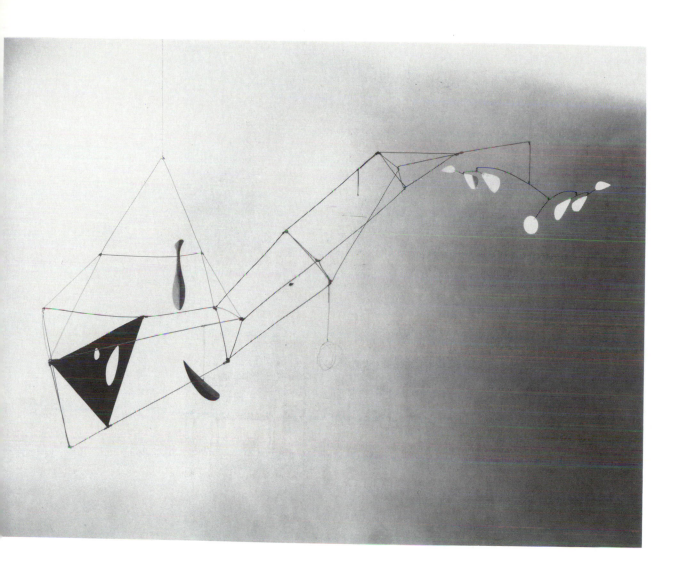

FIGURE 149. Alexander Calder. *The Aeroplane Tower with Six Leaves and a Dot*, 1951. Painted rod, sheet metal, wood, and wire, 53″. New York: Dr. and Mrs. Arthur E. Kahn.

In the summer of 1952, Calder was chosen to represent the United States at the Venice Biennale, which was installed by James Johnson Sweeney, who also wrote the catalogue. Calder received first prize for sculpture in Venice and, as a result, considerable attention in the popular press. In August 1952, for example, an article about Calder appeared in the *New York Times Magazine*,[28] and a substantial presentation followed in *Life*. With the exception of David Smith,[29] no American sculptor had received such acclaim in a popular news magazine. Dorothy Seiberling wrote in *Life*, "Alexander Calder has devised a fancifully original form of sculpture which has made him famous on every continent and this summer won him a top prize at the international art exhibition in Venice."[30] Although her assertion that Calder was now famous on every continent was exaggerated, he had by then received critical acclaim in Europe and in North and South America, and he continued to be an artist of international importance for the next quarter-century.

In Paris, Calder had established a fruitful association with the Galerie

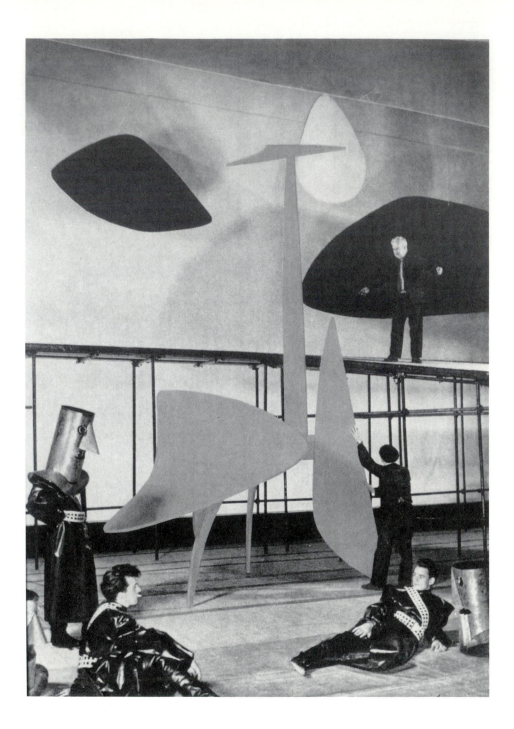

Maeght in the early 1950s, and from then until the end of his life he spent much of his time in France. In 1953 he purchased property in Saché, on the Indre River near Tours, where several studios and a new house were eventually built.[31] Four years later Calder bought an additional house in Brittany, near the mouth of the Tréguier River.

FIGURE 150. Alexander Calder. *Nucléa* scenery, 1952. *Life* Magazine 33 (August 25, 1952).

Aside from the Gongs and the Towers, Calder's most inventive works of the 1950s were large-scale public commissions, such as the acoustical ceiling for Aula Magna, the auditorium in University City, Caracas, Venezuela; *Ballet of the Seven Sisters* for the General Motors Technical Center in Warren, Michigan; and *Whirling Ear* (Fig. 151) for the Brussels World's Fair of 1958.

The acoustical ceiling at the University of Caracas is one of Calder's most unusual commissions. When asked to produce a large mobile for the lobby, Calder determined instead to take on the challenge of the auditorium itself. In 1936 he had made an initial effort at enlivening an interior by designing mobile coverings for the ventilating system in the auditorium of the Berkshire Museum (see Figs. 129 and 130), but he had never produced such a large-scale interior as that he now intended for the auditorium designed by Carlos Raul Villanueva – nor had he concerned himself with problems of acoustical engineering. Calder later recalled:

> I had met [Carlos Raul Villanueva] through Sert in 1951, and he came to Roxbury. I also saw him in 1952 in Paris. He had said then that he was doing an auditorium and wanted me to do something for the lobby, a mobile. I said, "I'd rather be in the main hall." And he said, "Oh! No! You can't do that because the ceiling is taken up with ribbons of acoustical reflectors." I said, "Let us play with these acoustical reflectors." And I made him a sketch. Carlos had engaged Bolt, Bereneck, and Newman of Cambridge, Massachusetts, as acoustical engineers. I had to collaborate with them, and had to redraw the whole layout all over, once or twice, for Carlos. Newman kept saying: "The more of your shapes, the merrier and the louder." So we drew large round and oval shapes, some of them to be thirty feet or so long, painted different colors, and hung from the ceiling on cables from winches. There were also some of these shapes on the side walls.[32]

The acoustical design was technically and visually successful. Colored biomorphs suspended from the ceiling and applied to the walls on either side of the stage of this otherwise unprepossessing interior add verve to the space. The free-form panels were painted black, red, dark blue, and green. However, one cannot help wondering if this extraordinarily lively presentation of enormous colored shapes detracts attention from the lecturers who address those assembled.

Although Calder considered his ceiling design to be a great success, he had some reservations about the ultimate disposition of his plans for a "dancing" fountain. His water ballet for the New York World's Fair (see Fig. 136) of 1939 had never operated, but in 1954 he had an opportunity to install a work similar in concept at the General Motors Technical Center in Michigan. The only difference in Michigan was the complexity of the lighting system.

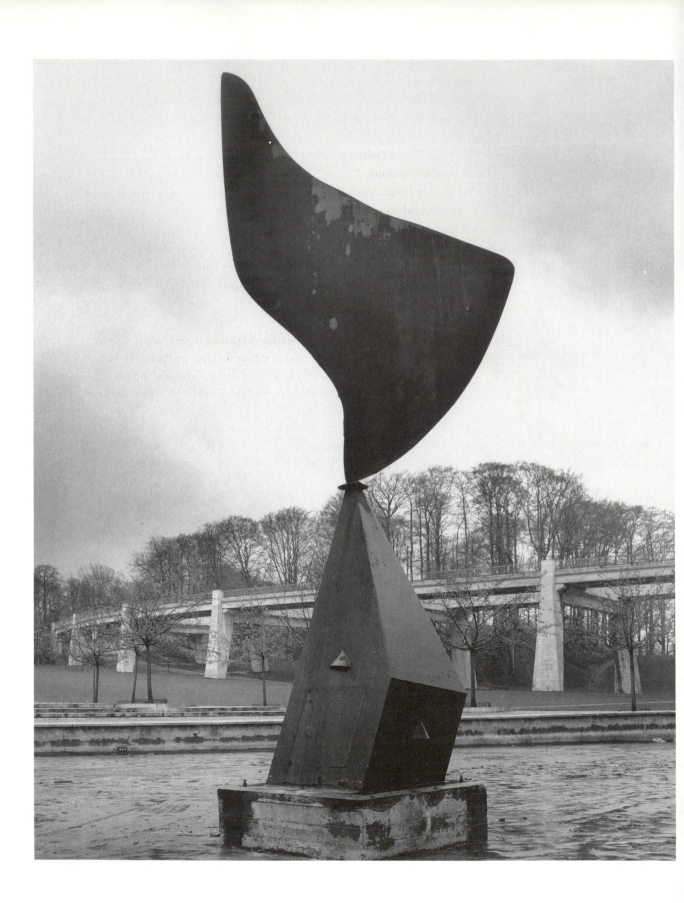

222

Five buildings had been planned by Eero Saarinen for an 813-acre site. When completed and dedicated in May 1956, the Technical Center was intended to be "one of the century's notable contributions to an integrated industrial architecture."[33] The research complex included a reflecting pool, and there Calder's aquatic display was installed. Calder designed no sculptural elements other than those created by the patterns of water from various sprays and jets. The "Seven Sisters" of the title were seven water nozzles designed to "play" together – seven rotating plumes of water that reach forty feet high. The artist recalled:

> The concept there was a large one, I'd say. Jets of water. Lines of water can be monumental too. I took one hundred feet and had one jet at each end rising and falling at different speeds, and then that comes to a halt. There were seven smaller jets that were almost vertical; I called them the seven sisters because they were slender jets, and some rotated one way and some the other way and they made a rotating pattern against the sky. Then there is a bathtub of water shot into the air to make a big boom when it hits. Then a bar rotating makes a fishtail – that's rather fine. They wanted the ballet, but now they are afraid to run it because the stockholders have complained that it costs money to run – probably waters their stock down – so it's only turned on for VIPs. I'm afraid I probably won't ever see it.[34]

Like a number of Calder's large-scale "theatrical" projects, this water ballet had a limited span of operation. However, Calder did finally see it in operation while visiting the General Motors Technical Center in 1969. Calder was certainly aware of traditional fountain design, for his father had used jets of water to accompany his sculptural designs at the Panama-Pacific Exposition in 1915, and had collaborated with Wilson Eyre in 1924 for *Swann Memorial Fountain* (see Fig. 158) in Philadelphia. For Calder's design, however, the visual effect was produced by jets of water alone; no sculptural elements were included.

Whirling Ear (see Fig. 151) was installed outside the United States Pavilion of the Brussels World's Fair of 1958. The theme of the event was "The Unity of Mankind," and fifty nations and seven international organizations planned exhibitions.[35] Participation at the fair was seen by the U.S. government as symbolic of American involvement in world affairs (a reaction to prewar isolationism), and ambitious plans were drawn up for housing the U.S. exhibits. Edward Durrell Stone was commissioned to design the United States Pavilion, which approximated the size of the Colosseum in Rome. An elliptical pool was to be adjacent to the carousel-shaped building, and Calder planned his motorized abstraction for this location. *Whirling Ear* was about twenty feet high and included a static polygonal "base" made of iron (enclosing a motor)

FIGURE 151. Alexander Calder. *Whirling Ear*, 1958. Sheet metal, 25′ × 15′. Brussels World's Fair. Photograph by Pedro E. Guerrero.

and a curving abstract shape of aluminum attached at the apex of the lower, angled element. The "ear-like" curving element rotated on the lower polygon. As in the *Mercury Fountain*, the upper portion was driven by the force of water – a single vertical jet of water caused the element to whirl about. The sculpture was complemented by jets of water that Calder designed as two ceremonial alleys approaching the object. In his drawings for the work Calder specified that "the pond shall be studded with nozzles, which shall be very nearly vertical and rotate slowly, all in the same direction."[36] It is clear that he had in mind not only a moving sculpture on a massive scale but a composition involving water jets in a uniform rotary motion to contrast with the revolving metal object. *Whirling Ear* combined actual sculptural parts with the energetic visual effects of water.

Standing mobiles abound in Calder's production of the 1950s and early 1960s. By attaching his mobiles to a base, the artist provided a practical solution to the problem of finding a suitable locus outdoors for "suspending" a kinetic device. Such works as *Spirale* (Fig. 152) and *Clouds over Mountain* (Fig. 153) are actually hybrids of stabiles and mobiles. Although the range of motion is limited by the placement of kinetic elements atop the static base and by the weight of these monumental constructions, this format offered the artist exciting possibilities for allusions to fantastic animals grazing or trees with waving branches.

One of Calder's major public works of the 1950s, *Spirale*, was permanently installed on the grounds of the UNESCO headquarters in Paris, for which works of Miró, Arp, Noguchi, and Picasso were also commissioned. Calder received this commission from the International Congress of Modern Architecture – which included Pier Luigi Nervi and Bernard Zehrfuss – probably through Marcel Breuer. *Spirale* seems to be a further development of a format for an outdoor mobile Calder had devised in 1935 (see Fig. 108), and it represents a new interest in greater monumentality for standing mobiles. As in the earlier example, a large "tripod" base balances a sequence of metal elements at its apex. These metal plates become smaller (and lighter in weight) as the sculpture reaches its full height. Calder described the piece as "a helix; the top is a sequence of bars and plates that spiral off in decreasing size."[37] Although *Spirale's* motion is less playful and varied than that of the usual hanging-size mobile, the slow and quiet dignity with which the piece describes spiral patterns in space seems appropriate for its site outside an office of the United Nations.

In another stabile–mobile, *Clouds over Mountain*, Calder chose what was for him an unusual reference: a landscape panorama. The jagged peaks of a distant mountain are presented as stationary, dignified forms while the "mobile" clouds trace playful patterns above. This work represents one of the more successful combinations of stabile and mobile elements, an interest that had appeared in the 1940s and that Calder continued to develop. Here the stabile elements foreshadow the monumentality of some of the large-scale

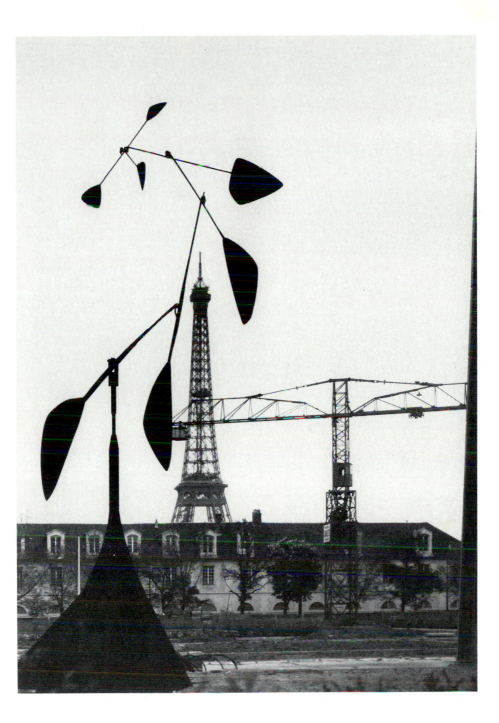

FIGURE 152. Alexander Calder. *Spirale*, 1958. Sheet metal, 30'. Paris: UNESCO. Photograph by Pedro E. Guerrero.

stabiles of Calder's later years, while the standing mobile resembles earlier examples of this genre. In 1976, the year of his death, Calder recast this image into a maquette for a fifty-foot stabile–mobile entitled *Mountains and Clouds* (see Fig. 170) for an atrium space in the Hart Senate Office Building, Washington, D.C.[38]

Calder's hanging mobiles had also assumed monumental proportions by

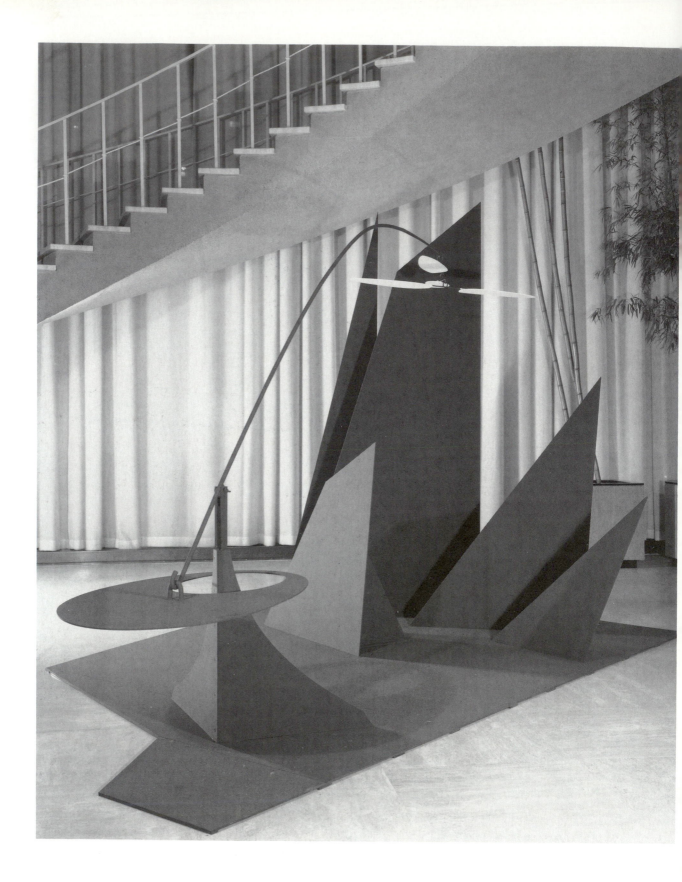

226

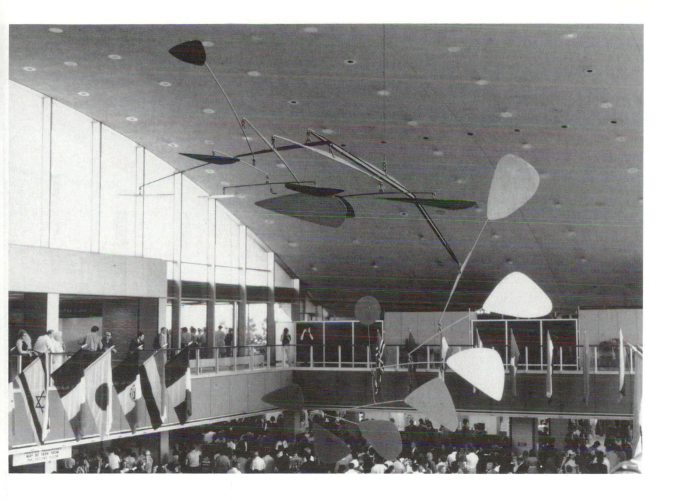

FIGURE 154. Alexander Calder. *.125*, 1957. Painted steel plate, rods, 45'. New York: International Arrivals Terminal, Kennedy Airport.

FIGURE 153. (*opposite*) Alexander Calder. *Clouds over Mountain*, 1962. Steel rods, 281.9 cm × 426.7 cm. Chicago: The Art Institute of Chicago. Gift of Kate Maremont Foundation, 1963.207

1958, and were industrially fabricated under Calder's supervision. Such a work, *.125* (Fig. 154), was created for the International Arrivals Terminal at New York's Idlewild (now Kennedy) Airport. The firm of Skidmore, Owings and Merrill designed the building, and Calder's successful commissions for earlier interiors by this firm undoubtedly contributed to his selection. Like many of the heavy, large-scale mobiles conceived for vast public places, this example moves very little. Much of the playful quality of the earlier mobiles is lost from these enormous examples with their heavy iron bars and large metal plates. Nevertheless hanging mobiles were particularly appealing for atriumlike interiors and had the advantage of not obstructing pedestrian traffic as standing sculptures might. Large-scale mobiles were occasionally installed contrary to Calder's instructions, becoming the focus of controversy over an artist's right to control the appearance of his or her works in public places.

Among the most flagrant violations of Calder's intentions was the disposition of *Pittsburgh* (Fig. 155), fabricated in 1958. This mobile, awarded first prize

227

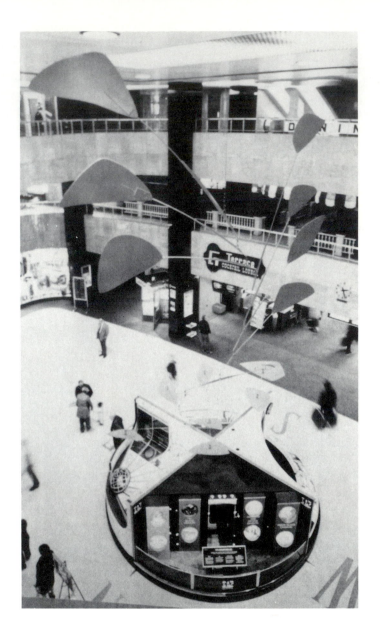

for sculpture at the 1958 Carnegie International Exhibition, was subsequently purchased by a private individual and donated to Allegheny County to be installed in the rotunda of the Greater Pittsburgh International Airport. When the mobile was accepted by the county, the white biomorphs in sheet metal were repainted green and gold (the colors of Allegheny County) without the artist's knowledge. Later, a large advertising kiosk was positioned beneath the sculpture. In addition, airport officials felt that the piece might swing too low. Weights added to two of the elements disturbed the mobile's balance and visual harmony. All of the changes in his original conception, but particularly the repainting of the elements, prompted a strong reaction by the artist. The

FIGURE 155. Alexander Calder. *Pittsburgh*, 1958. Painted steel plate, 28′ (as installed at Pittsburgh International Airport).

use of green and gold on his mobile was anathema to Calder, who maintained a lifelong commitment to the orthodoxy of Neo-Plasticism, limiting his palette to the primary colors, black, and white. After years of protest from the artist and his supporters, *Pittsburgh* was repainted and restored to a museum setting in 1978.[39] Currently, *Pittsburgh* is suspended above the grand staircase at the Carnegie Institute Museum of Art, where it is on loan. Eventually the work will be placed in a new airport terminal that can accommodate it.[40]

Whether it was because of the problems associated with these giant mobiles or Calder's need for a change of direction in his work, by 1959 he was primarily involved in designing large stabiles. Perhaps these commissions for large-scale works had given him the incentive to construct nonkinetic sculpture of monumental proportions. By this time he had three metal shops working on fabrication for him – two in Waterbury, Connecticut, and one in nearby Watertown. As Calder increased the scale of his stabiles, he prepared miniature maquettes that were enlarged by metalworkers under his supervision.

The first large stabiles were shown at Perls Galleries in New York in February–March 1958 and at the Galerie Maeght in Paris in the spring of 1959. Aimé Maeght, the owner of the gallery, purchased the entire show, and through him Calder's new production was widely disseminated to galleries and collectors in Europe. In 1959, the Stedelijk Museum in Amsterdam organized an exhibition of Calder's stabiles and mobiles, taking it on a year-long tour to various cities in Germany, Switzerland, and Belgium.

Calder's achievements meanwhile continued to be recognized both in the United States and abroad. In 1960 the Museo de Bellas Artes in Caracas purchased a large stabile entitled *The City*. In that same year, Calder was elected to the National Institute of Arts and Letters and received a Gold Medal from the Architectural League of New York; and in 1961 he was awarded a medal by the American Institute of Architects. In 1964 five stabiles were featured at Documenta II in Kassel, Germany.

The first of a series of colossal stabiles, which appeared in the early 1960s, signaled the change to the sculptor's late style. In the 1940s, Calder had curtailed his production of large stabiles partly because of the wartime shortage of industrial metals. By 1962, however, he was exhibiting stabiles twenty feet high, and had engaged Etablissements Biémont, an ironworks in Tours, to enlarge and fabricate them. When working with fabricators, Calder usually approved all enlargements of his original maquettes, and supervised the bolting and buttressing (Fig. 156). With the assistance of this establishment in France and Carmen Segre's ironworks in Connecticut, Calder embarked upon the production of colossal stabiles and mobiles, the principal occupation of his final years.

In 1962, Calder had a new studio constructed in Saché, France, of sufficient size to store a proliferating number of large stabiles. His "late period," which began in the early 1960s and continued until his death in 1976, can be characterized primarily by his fabrication of such monumental stabiles intended

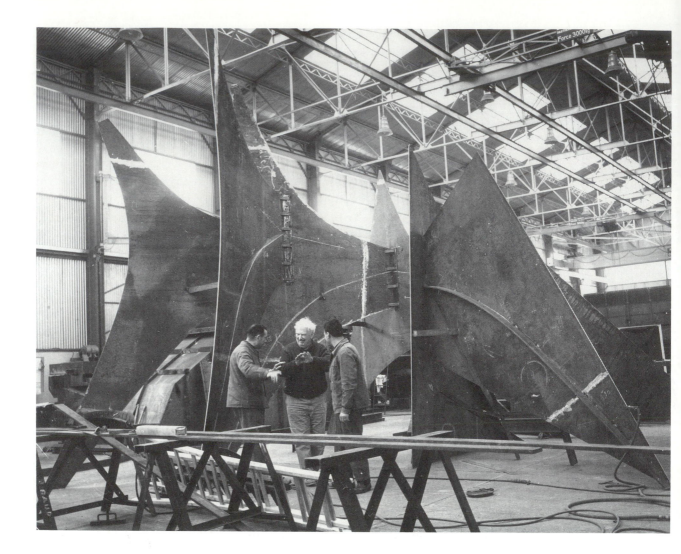

for public sites. Soon Calder, already favored by architects to decorate their elegant interiors with his lively mobiles, was being chosen for monumental stationary works to complement urban renewal projects, to "humanize" vast architectural complexes, and to punctuate an uninspiring urban design with a gigantic exclamation mark in Calder red. In his late years, Calder finally took his place as the third generation of his family to produce monumental public sculpture in America.

The middle years – the 1940s and 1950s – remain the most varied of Calder's career, as he assured his position as the leading American sculptor of his generation and the one with the most firmly established international acclaim. Calder's sculpture met the challenges offered by unusual commissions: a water

FIGURE 156. Photo of Calder and assistants, Tours: Biémont Iron Foundry, 1966. Photograph by Pedro E. Guerrero.

ballet, acoustical ceilings, and large-scale mobiles for public sites, but most of his smaller mobiles become decorative and idiomatic. They complement domestic interiors, and the underlying content refers to the natural world. Compared to the heavily worked metals of Smith, Lipton, Roszak, and Ferber, Calder's airy abstractions have a lighthearted buoyancy and comfortable similarity of effect. Whereas David Smith explored a full measure of expressionist possibilities in welded metal, offering social content and personal symbolism in the thematic range of his sculpture, Calder's art was predictable – and enjoyable.

"The Art of Assemblage" exhibition at the Museum of Modern Art in 1961 encapsulated the leading trends in American sculpture at the end of the fifties. For this show, which included the sculpture of John Chamberlain, Jean Tinguely, Louise Nevelson, Robert Rauschenberg, and Richard Stankiewicz, Calder was mentioned in the catalogue but not exhibited. He was considered a historical artist along with Duchamp, Moholy-Nagy, and Gabo, who had established the "tradition" of mobile constructions and influenced younger artists who combined assemblage with mechanical movement.[41]

Although many of the younger artists included in this exhibition favored "recycled" metals, Calder had set an example, both for his kinetic works and for his frank use of industrial metals. Calder, therefore, was acknowledged for his contributions to modern sculpture but was no longer considered an innovator in 1961. Furthermore, the unique standing among American sculptors that Calder held until the late 1950s was challenged in subsequent decades by David Smith and Louise Nevelson – sculptors of his own generation – and by a number of younger sculptors such as John Chamberlain, Mark Di Suvero, Claes Oldenburg, and Donald Judd. In his use of polychrome, his preference for industrial materials, his commitment to an abstract format, and his inventive disposition of works in public places, Calder contributed importantly to American sculpture after 1960. He also continues to be universally admired for joining childhood play with art, and for setting new parameters for the definition of sculpture.

6

Late Years:
Monumental Works

SIXTEEN YEARS BEFORE HIS DEATH in 1976, Calder claimed he had retired from making mobiles by hand because he regarded them as no longer challenging. The engineering of big objects and the solving of structural problems posed by large-scale works for specific sites became more important to him,' and in his later years he produced an impressive number of works on a monumental scale. The most successful are Calder's giant stabiles because the late, oversized mobiles fabricated by ironworkers can only parody the graceful movements and compositional harmony of the earlier examples he constructed in his studio. Other late projects, like the painting of airplanes and sports cars, provide insights into Calder's attitude in his late years but add nothing to his lifetime achievement as an artist.

After 1960 Alexander Calder received many commissions for public works, both in the United States and abroad. At home, the sixties saw a tremendous growth in the commissioning of large-scale sculptures for federal architecture projects and industrial complexes – and Calder, like other American sculptors, benefited from these circumstances. Moreover, Calder's international reputation helped to secure the placement of monumental stabiles on outdoor sites in Europe and Latin America as well. His stabiles became something of a "status symbol" – indicating by their presence in cities or at corporate headquarters the substantial commitment of their patrons to public art. Because the stabiles were visually appealing abstractions, but weren't so radical as to look outmoded within a decade, they were frequently chosen by commissioning panels. Furthermore, as public sculpture, these constructions were particularly suitable for placement at new architectural complexes designed almost exclusively in the International Style. In emulation of the elegance and severe linearity of such examples as Mies van der Rohe's *Seagram Building*, many towers featured gray- or black-tinted windows and black or dark brown outer walls. Calder's stabiles – frequently painted brilliant crimson to make a startling visual contrast – were often positioned on broad plazas adjoining

new office buildings. His biomorphic imagery and dynamic forms added life to the geometric severity of the surrounding architecture. Two aspects of modernism successfully coexist in these projects: rational, elegant architectural design; and randomly placed elements filled with expression and verve.

Calder's commissions for giant stabiles and mobiles during the 1960s indicate that he continued with his personal idiom while American art was changing dramatically. At the time Calder was designing his earliest monumental stabiles, two major movements, Pop art and minimal art replaced Abstract Expressionism, which had dominated postwar America. Painters and sculptors alike were involved in these new developments; they had similar approaches to the use of materials, and shared intentions to make art more accessible to its audience.[2] Both movements may also be viewed as having some indebtedness to Calder. Pop art returned to a representational approach based on the use of popular imagery and commercial products. The humor of Claes Oldenburg's oversized household items and food products bring Calder to mind – particularly his enchantment with metamorphosis. Oldenburg's own metamorphic sculpture in painted steel, *Geometric Mouse*, installed in 1969 in the Museum of Modern Art Sculpture Garden,[3] could be compared to Calder's smaller *Whale* and other stabiles in the collection. In the tradition of Duchamp and Dada, Calder had also incorporated commercial products into his work before the Pop artists began to do so. A remarkable comparison can be made, for example, between Calder's using Chock Full o' Nuts and Medaglia d'Oro coffee tins and Ballantine ale and beer cans to construct fanciful birds in the early 1950s,[4] and Jasper Johns's using Savarin coffee and Ballantine ale cans for his *Painted Bronze* (1960).[5] Calder, of course, cut up the actual cans and incorporated the labels into his design, whereas Johns made a meticulously painted equivalent, but both artists' works suggest the fusion of art with life. In fact, since the 1920s Calder had been attuned to the possibilities in joining art and popular culture. In his work Calder sought accessibility to his audience; he avoided private imagery and complicated symbolism. Like Pop artists and their predecessors Jasper Johns and Robert Rauschenberg, Calder had a long-standing admiration for Dada, particularly for Duchamp.

For artists creating minimal sculpture in the 1960s, the indebtedness to Calder was obvious, for he had provided a precedent for working on a large scale with industrial materials. A decade earlier, Calder had begun to use commercial fabricators in the production of his work, a practice that came to be favored by the minimalists and that continues to this day. Most important, Calder exemplified the effective use of abstraction as sculpture for public places. His stabiles and standing mobiles of the 1950s were already of a size to relate directly to their audience, and Calder contributed to the creation of more accessible sculptures, removed from plinths and displayed directly on the ground. Minimal sculptures were also installed without bases and were intended to relate directly to the spectator; but their difference from Calder's

stabiles was in their geometric regularity and elemental, reductive forms.[6] Furthermore, the constructions included in *American Sculpture of the Sixties*, an exhibition organized in 1967,[7] indicated that Calder's use of painted steel had an effect on younger artists of that decade, while his disposition of massive steel girders on exterior sites seems to have influenced Mark di Suvero, whose colossal constructions alluded to the dynamic equilibrium of elements espoused by Calder. Although young artists might have been inspired by Calder during the sixties, it is true as well that the appearance of many sculptors favoring abstraction gave further credibility to Calder's monumental stabiles, which were frequently chosen for prominent locations in American cities.

The forty- and fifty-foot stabiles produced from the mid-1960s until Calder's death developed from an earlier generation of stabiles, ranging in height from ten to twenty feet, that the artist began to fabricate in the late 1950s. With the increase in size added to its strongly curvilinear structure, a fifty-foot stabile like *Flamingo* (1974; Fig. 157) interacts aggressively with its site. Moreover, a Calder colossus positioned in a public setting changes the character of that outdoor space for all who walk through it. The stabiles enfold and define spatial volume. Fabricated in large dimensions, their spindly legs and splendid arches enclose the spectator or beckon the pedestrian to approach and experience the massive forms from a closer, sometimes awesome, perspective.

The descendant of two sculptors, Calder benefited from their experience in his own creation of public works. As discussed in Chapter 1, his grandfather, Alexander Milne Calder, and his father, Alexander Stirling Calder, had both created large-scale public monuments for American cities. Although the elder Calders worked in traditional materials and used conventional subjects, they had to consider issues relevant to any monumental sculptural design: the relationship of the work to its site, to surrounding architecture, and to pedestrian and vehicular traffic. In collaborating with an architect to create Philadelphia's *Swann Memorial Fountain* (1924; Fig. 158), Stirling Calder, for example, created a fountain that uses arching jets of water and large reclining "river gods" to form a highly successful focal point within a traffic circle.[8] As a youth Calder often frequented his father's studio and had certainly become aware of the site-specific considerations governing his work.

Similarly, his grandfather Alexander Milne Calder's colossal statue of William Penn for Philadelphia's City Hall (Fig. 159) prefigured the scale of the stabiles. In 1886 this thirty-six-foot statue was the largest bronze ever cast in a native foundry.[9] The elder Calder, was commissioned to produce numerous equestrian and other commemorative statues for outdoor sites.[10]

Despite the general acceptance of the modern idiom in the United States, through the 1950s public sculpture commissions continued much as they had since the nineteenth century: Figurative memorials were considered the only appropriate images. Even under the Federal Art Project of the Works Progress Administration in the 1930s, heroic themes were required. Only at the 1939

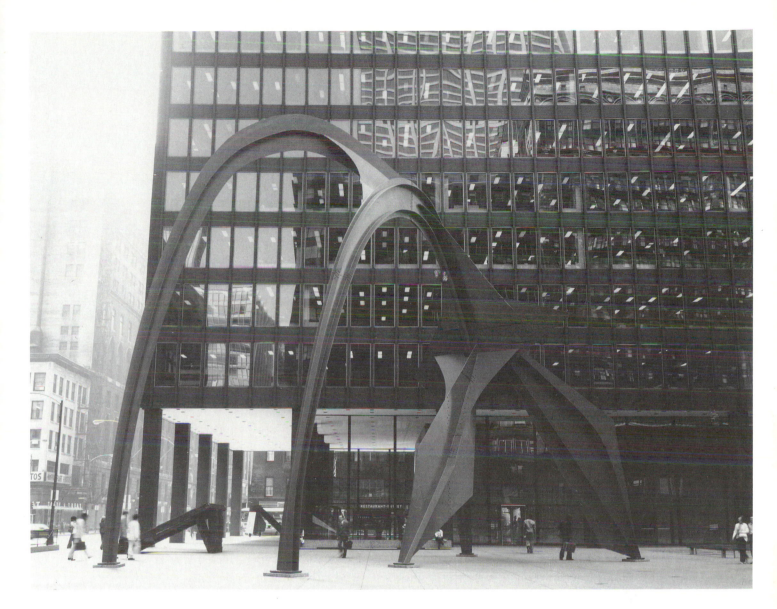

FIGURE 157. Alexander Calder. *Flamingo*, 1974. Structural steel, painted Calder red, 53′. Chicago: Federal Center Plaza.

New York World's Fair were abstract forms, the *Perisphere and Trylon* (a seven-hundred-foot triangular obelisk), chosen as the symbols of the World of To-morrow, but this was a temporary installation.[11] Not until the formation of the Art-in-Architecture Program of the U.S. General Services Administration (GSA) in the mid–1960s and the Works of Art in Public Places Program of the National Endowment for the Arts (NEA) did permanent installations of abstract sculpture become a reality. Calder's stabiles are among the first works commissioned under both government programs.[12]

Calder's legacy from his grandfather and father was a long-standing fa-miliarity with the process of fulfilling public sculpture commissions. He in his turn collaborated with architects, solved technical problems involved in the

235

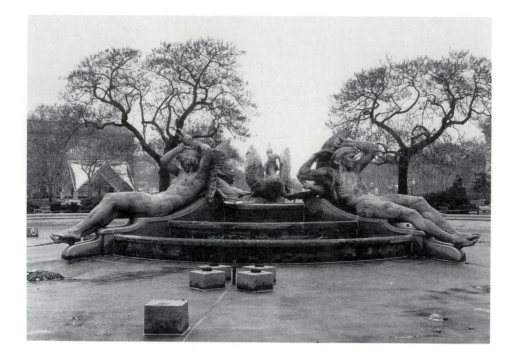

FIGURE 158. Alexander Stirling Calder. *Swann Memorial Fountain*, 1924. Philadelphia: Logan Circle.

execution of his works, and adapted his stabiles to specific outdoor spaces. He too was required to integrate his giant constructions with their urban settings. The considerations were similar – but the imagery had changed, as well as the relationship to the viewer. Calder's stabiles were not mounted on pedestals, like traditional sculpture, but were placed directly on public plazas, level with pedestrian traffic.

The older Calders had not faced the same technical problems that Sandy Calder now confronted in his huge sheet-metal works. Here again, his education in mechanical engineering at Stevens – and his practical experience working on freighters afterwards – proved useful. Indeed, Calder perceived the link between stabile building and shipbuilding. When questioned about bracing for the stabiles, Calder remarked: "I once crossed the Atlantic on the *Bremen*. The partitions were all going 'baroop, baroop, baroop, baroop.' That's what you have to avoid."[13] Calder apparently saw the fabrication of giant stabiles as akin to shipbuilding practices he had observed in his youth, and in designing supports for his stabiles, he sought to avoid the creaks and groans heard on a ship at sea.

When Calder first began making his very large stabiles, he sent full-size paper templates to his fabricators, as well as scale models. The templates were then duplicated in metal, a process also employed in the construction of ships. Instead of having the metal sheets welded together, which many sculptors would have preferred, Calder instructed his two shops – Segre Ironworks in Waterbury, Connecticut, and Etablissements Biémont in Tours, France – to

FIGURE 159. Alexander Milne Calder. *William Penn* and Sculptural Decoration for City Hall, 1886. Bronze, 36'. Installed in 1894, Philadelphia, Pennsylvania.

use shipbuilders' bolting and joining methods to produce the stabiles. The bolts are not concealed but openly reinforce the "structural" appearance of the stabiles, suggesting that the works' separate pieces need to be reinforced by bolts and ribbing.

 Calder's first colossal stabile, *Teodelapio* (Fig. 160), was fabricated in 1962 by Italsider, a shipbuilding company in Genoa that was engaged solely for this commission. Intended for an outdoor sculpture exhibition in Spoleto,

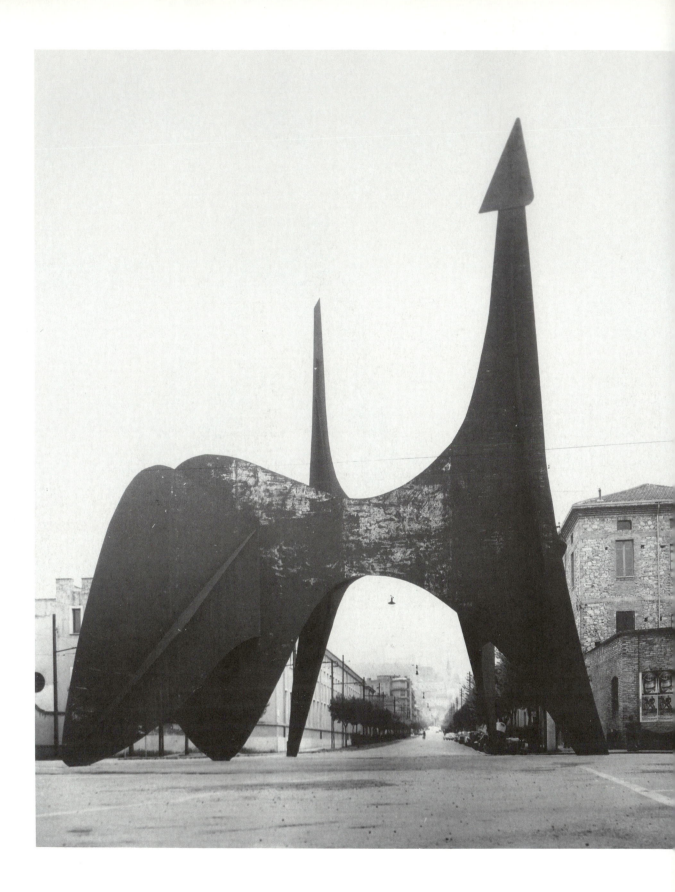

238

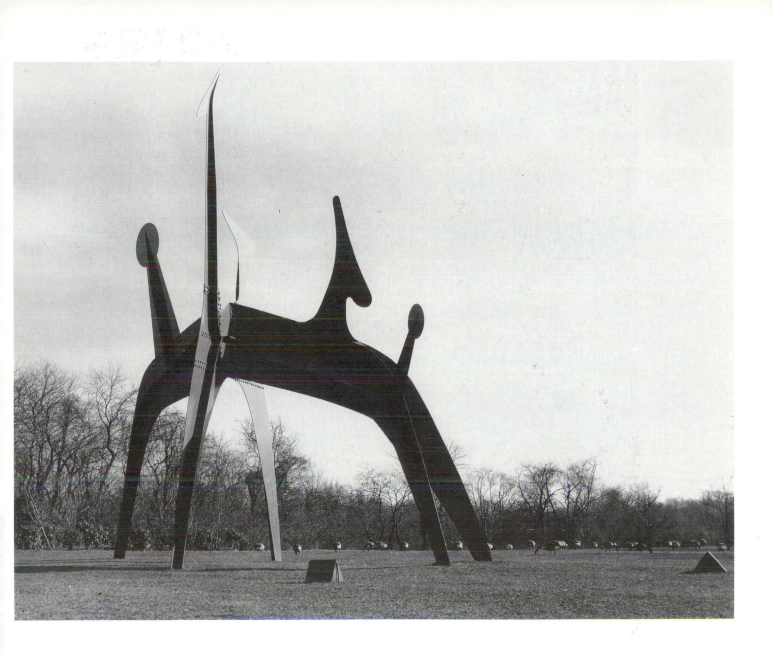

FIGURE 161. Alexander Calder. *Hats Off*, 1971. Painted sheet metal, 30′ high. Purchase, New York: Pepsico International Headquarters.

FIGURE 160. (*opposite*) Alexander Calder. *Teodelapio*, 1962. Painted steel plate, 59′. Spoleto, Italy. Photograph by Pedro E. Guerrero.

Italy, the sixty-foot work was installed at an intersection near the railroad station and subsequently presented by Calder as a gift to the city. The stabile's gigantic black arches give the effect of a monumental gateway to Spoleto, and its title refers to a historical figure of some local interest, Teodelapio, Duke of Spoleto.[14] From the time of its installation, Calder's audience saw a phallic form in the pointed, vertical projection. The artist commented, "I wasn't aware of any such influence, but that may give it its nice force."[15] This startling morphologic reference vitalizes an otherwise unprepossessing site; it is visible even from passing trains. Thus Spoleto became the first city to introduce a Calder stabile as a provocative landmark, and the artist's success with it resulted in commissions for other European cities.

239

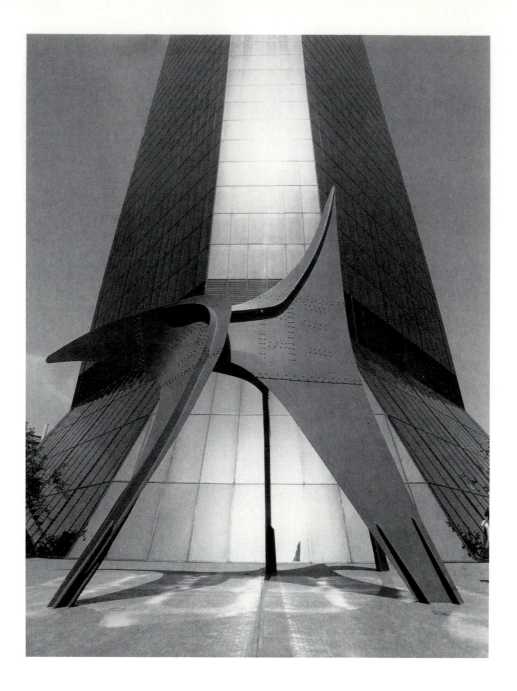

Inspiration for *Teodelapio's* imagery, and the frequent allusion to animal and human forms in other stabiles, can be traced back to Calder's 1930s constructions, which so often derived from the organic imagery of Miró and Klee.[16] An early antecedent for the late stabiles was Calder's *Big Bird* of 1936 (see Fig. 131), an eight-foot-high construction painted in vivid colors. Stabiles such as *Flamingo*, *Hats Off* (1971; Fig. 161), and *Eagle* (1973; Fig. 162) recall the sculptor's lifelong involvement with animal forms. Others such as *Man*

FIGURE 162. Alexander Calder. *Eagle*, 1973. Painted sheet metal, 40′. Fort Worth, Texas: Fort Worth National Bank.

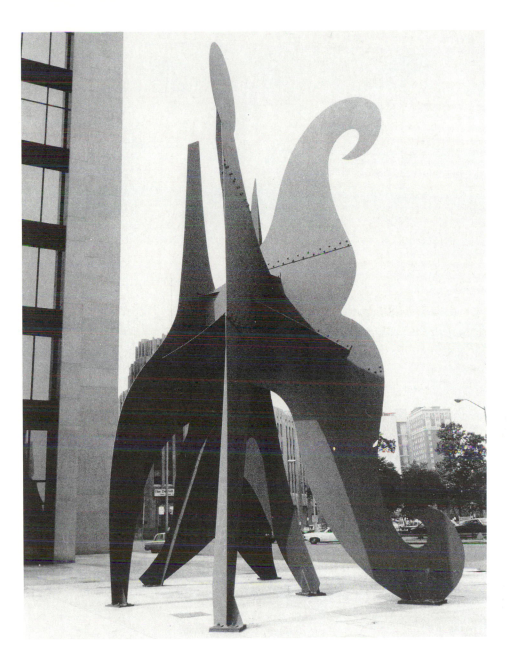

FIGURE 163. Alexander
Calder. *Jeune Fille et sa Suite*,
1972. Painted sheet metal,
30′. Detroit: Michigan Bell
Telephone.

(1967) and *Jeune Fille et sa Suite* (1972; Fig. 163) attest to his continuing interest
in abstractions of the human figure.

In creating these stabiles, Calder also acknowledged his attraction to the
work of Henri Matisse, whose paintings, such as *The Dance I* (1932; Fig. 164),[17]
present boldly articulated silhouettes of female figures in an arching format.
The simplicity of these forms, the energy of their implied motion, and the
scale of such works may have inspired Calder's early stabiles. The cut-paper
designs that Matisse produced in the early fifties[18] are another possible source

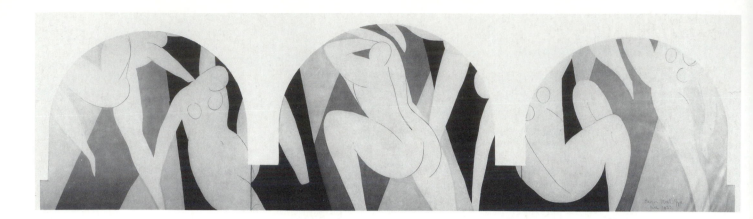

FIGURE 164. Henri Matisse. *The Dance I*, 1931–2. Oil, 11' × 42'. Paris: Musée National d'Art Moderne, Centre Georges Pompidou.

for the brilliantly painted organic forms cut from sheet metal that Calder used for his giant constructions.

Calder's monumental stabiles were vivid and exuberant images that attracted attention nationally, and a number of them were commissioned by American cities and large corporations during the last decade of his life. *La Grande Vitesse* (Fig. 165), installed in Grand Rapids, Michigan, in 1969, was an early example of cooperation on a federal project by the local art community and municipal officials. Commissioned by the city after a matching grant was awarded by the National Endowment for the Arts, the stabile stands in Vandenberg Center, a portion of an urban renewal program for the downtown area. This stabile was the first work to be funded under the Works of Art in Public Places Program of the National Endowment for the Arts.[19] The original plans for a fountain were abandoned when the Calder stabile was proposed, although large sums had already been spent on excavation and equipment for the installation. Disgruntled critics of *La Grande Vitesse,* who complained bitterly about the money wasted on the rejected fountain proposal, were silenced by the community's enthusiasm for the stabile. When it was dedicated in January 1969, thousands of local residents expressed their pride and sense of accomplishment in the result of their exhaustive fund-raising efforts to meet the cost of the Calder piece. The stabile has become the trademark of Grand Rapids,[20] and reference to it appears on everything from the city's stationery to its garbage trucks. Moreover, the presence of *La Grande Vitesse* in Vandenburg Center has stimulated local interest in modern art and can be related to recurring exhibitions of monumental sculpture in the city since 1969. Apparently it was the favorable reaction to *La Grande Vitesse* in his home state that convinced then Congressman Gerald R. Ford of the need to appropriate more funds for the NEA.[21]

After the successful installation and reception in Grand Rapids, stabiles were soon purchased for other American urban sites and corporate headquarters. A policy of allocating a percentage of total building costs for including works of art in federal, municipal, and corporate projects encouraged

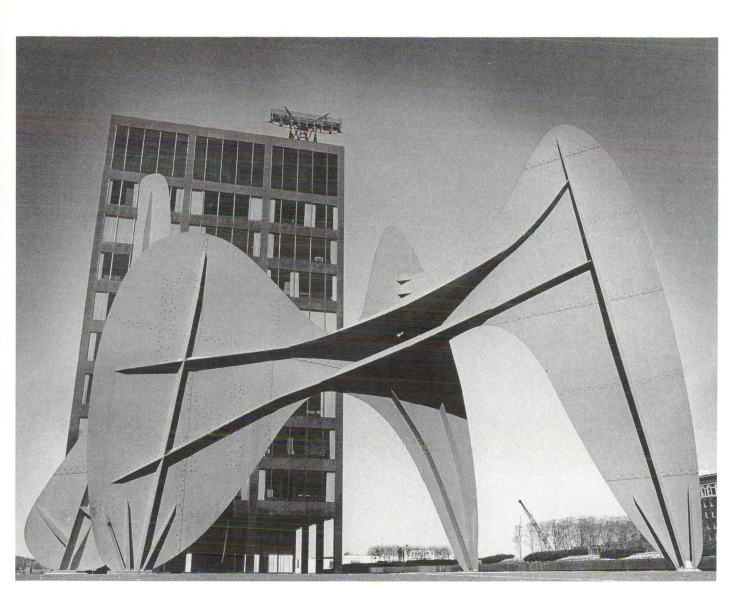

FIGURE 165. Alexander Calder. *La Grande Vitesse*, 1969. Painted sheet metal, 43'. Grand Rapids, Michigan: Vandenberg Center.

the commissioning of sculptors' works. The public generally responded favorably to the introduction of large-scale sculpture to urban sites, and there was a surge of funding for public art during the 1970s.

Flamingo (see Fig. 157), on Chicago's Federal Center Plaza, is among the most impressive results of this policy. Commissioned by the GSA, the stabile stands outside federal office buildings designed by Mies van der Rohe and provides a visual transition between human scale and the massive proportions of the monolithic flanking skyscrapers. Calder's scarlet stabile complements the black steel and is reflected in the tinted glass of the tower, while its curving forms counterpoise the severe geometry of the architect's design. Like a giant bird perched on spindly legs with beak lowered to the ground, *Flamingo* calls attention to itself, attracting the interest of those who traverse the broad plaza

243

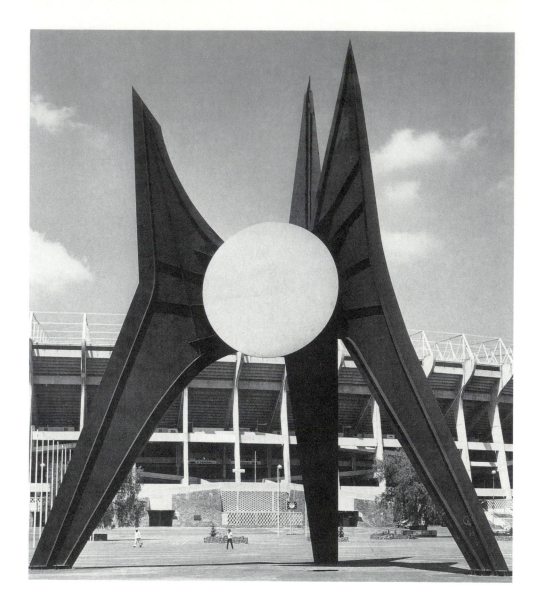

on which it is located and encouraging curious pedestrians to wander beneath its arching forms.

Calder also received commissions for stabiles intended for shopping centers, college campuses, and industrial sites. *El Sol Rojo* (1968; Fig. 166), installed outside Aztec Stadium in Mexico City at the time of the Olympic Games, consists of colossal black metal sheets that form a series of triangles at the top supporting a red sunlike disc. As in *Clouds over Mountain* (see Fig. 153), Calder again refers to a specific view of nature: *El Sol Rojo* evokes the brilliant Mexican sunset silhouetted against jagged mountains, thus introducing the character of the local terrain onto a site transformed by man into a modern recreational complex.

FIGURE 166. Alexander Calder. *El Sol Rojo*, 1968. Painted steel plate, 80′. Mexico City: Aztec Stadium.

244

Hats Off (see Fig. 161) was purchased by Pepsico International for a sculpture park adjoining its Purchase, New York, headquarters designed by Edward Durrell Stone. This stabile, a creature with five legs and five heads that extend in all directions, can be interpreted as a cluster of human subjects, or as exotic birds. The cranelike necks and spindly legs of the huge red beast make the stabile appear perfectly at home in a natural setting complete with geese and other wildlife.

Bird imagery is prevalent in many of Calder's later stabiles. From his earliest years Calder had been attracted to bird forms. He made many versions in wire, and was certainly indebted to decoys on spindly legs for his first abstract birdlike stabiles of the 1930s. *Eagle* (see Fig. 162), another example, was commissioned by the Fort Worth National Bank for its new headquarters downtown. Company officials considered they had found a piece "that would be most acceptable to the local art community and complement the other art collections in the city."[22] In *Flamingo*, Calder had caricatured the long legs of that species. In *Eagle*, he emphasizes the impressive wings. The red stabile is located on a small plaza adjacent to the bank's soaring glass tower designed by John Portman. Curving sheets of metal, resembling gigantic rhythmically moving wings, flank the central body of the stabile. As the curving planes extend outward and upward, they swell and then gradually taper for their "flight" into space.

Other monumental stabiles allude to fantastic insects and animals, even to human subjects. *Man*, commissioned for Expo '67 in Montreal, Canada, and *Jeune Fille et sa Suite* (see Fig. 163) in Detroit, are abstractions of human figures, whereas *L'Araignée Rouge*, (1975) at Rond Point de la Défense in Paris represents a gigantic red spider that serves as a gateway to a sprawling industrial center on the city's outskirts. Prehistoric creatures inspired *Stegosaurus* (1973), a wittily interpreted dinosaur grazing on the mall between the Wadsworth Atheneum and government offices in Hartford, Connecticut.

In Calder's late stabiles, structural ribbing assumes its own aesthetic, casting deep shadows and boldly articulating the dihedral angles and flat surfaces of the metal sheets. The interpenetration of interior and exterior space, the use of dynamic surfaces curving and tapering upward, and the illusion of buoyancy suggest the engineering feats of such architects as Felix Candela or Pier Luigi Nervi.[23]

During his late years, Calder was asked to design several giant mobiles for interior spaces. *White Cascade* (Fig. 167), created for the Federal Reserve Bank in Philadelphia, and the untitled mobile (Fig. 168) for the East Building of the National Gallery of Art, Washington, D.C., are dated 1976, the year of Calder's death. Although these two fabricated works were installed posthumously, they were constructed and positioned according to his explicit instructions. A comparison of these oversized mobiles with the monumental stabiles reveals that the stabiles are actually the more dynamic forms and, ultimately, more successful as public sculpture.

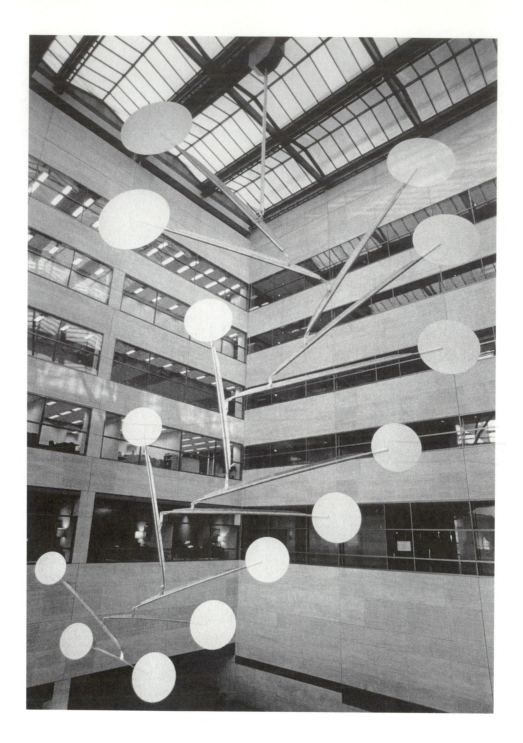

Calder first began to increase the scale of his mobiles in the late 1950s with *.125* (see Fig. 154), the forty-five-foot-wide work for the International Arrivals Building at Idlewild (now Kennedy) Airport. As already mentioned, this large mobile was heavy, as were the others fabricated for public spaces such as airports and bank interiors, and it moved slowly if at all.

FIGURE 167. Alexander Calder. *White Cascade*, 1976. Philadelphia: Federal Reserve Bank.

246

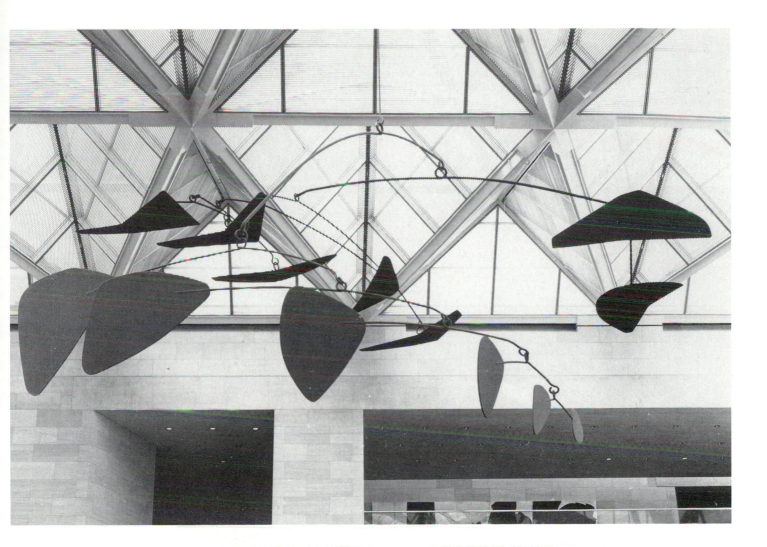

FIGURE 168. Alexander Calder. Untitled Mobile, 1976. Aluminum and steel, 29′10½″ × 76′. Washington, D.C.: National Gallery of Art. Gift of the Collectors Committee.

Although some of the gigantic mobiles from the late years may seem to resemble examples from earlier decades, Calder never plagiarized himself. According to his dealer Klaus Perls, Calder made new models for each of these large commissions and did not enlarge previous works.[24] Beginning with a handcrafted model measuring one or two feet across, Calder then increased the scale to one-fifth of the final dimensions for a giant mobile. The second model was made with the assistance of industrial fabricators, who also produced the full-sized version under Calder's supervision.

Unfortunately, the spirited movement of Calder's original handcrafted models was lost when the mobiles were enlarged to a colossal scale. The enormous mobile installed in 1977 in the East Building of the National Gallery of Art, for example, fails to satisfy Calder's original intention: a composition of motions. Its heavy biomorphs move in combination, in a single direction, and the random rotation of individual components caused by air currents

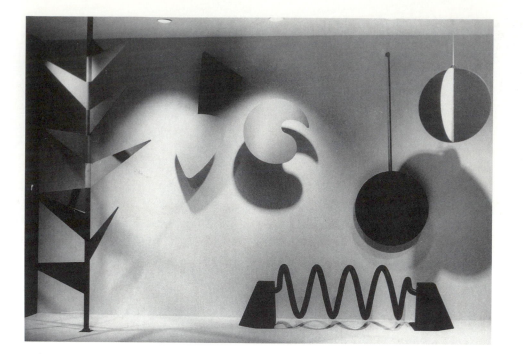

does not occur. Nonetheless, the mobile, designed by Calder in 1972, represents a technical feat in attempts to assure movement. Instead of solid panels of steel, it was made of aluminum honeycomb designed by Paul Matisse (grandson of Henri Matisse and son of Pierre Matisse). An engineer and sculptor, Matisse made the arms of aircraft aluminum alloy. The mobile now weighs 930 pounds, but previous estimates from Calder's foundry in Biémont exceeded 5,000 pounds. Because of the lighter materials, the mobile has been installed without a motor, and an air supply comes from vents above it in the East Building atrium designed by I. M. Pei.[25] Ultimately we must conclude that the mobiles did not lend themselves to enlargement to such colossal proportions and therefore were not suitable for interiors beyond the dimensions of a large room.

Some of Calder's early motor-driven constructions received a final realization in *Universe* (1974; Fig. 169) in the lobby of Sears Tower, Chicago. Here seven motors activate elements arranged before a colored panel of colossal proportions. This motorized device incorporating seven different motions seems to be a more successful kinetic sculpture suitable for the lobby or atrium of a public building. Although this is a unique example of such a commission for an indoor space, Calder had created an earlier freestanding construction outdoors: *Four Elements* (see Fig. 115), a motorized mobile for the Moderna Museet, Stockholm. Unlike the giant mobiles, dependent on air currents (which can seldom activate their ponderous elements), *Universe* is motorized and therefore a fully functional composition of shapes, colors, and motions. In this final example of a motorized construction, Calder increased the scale

FIGURE 169. Alexander Calder. *Universe*, 1974. Stainless steel plate, aluminum plates, and motors, 33′ × 55′. Chicago: Sears Tower.

FIGURE 170. Alexander Calder. *Mountains and Clouds*, 1976 (installed 1985). Painted sheet steel: stabile 51′ high; mobile 42½′ wide. Washington, D.C.: Hart Senate Office Building, United States Capitol.

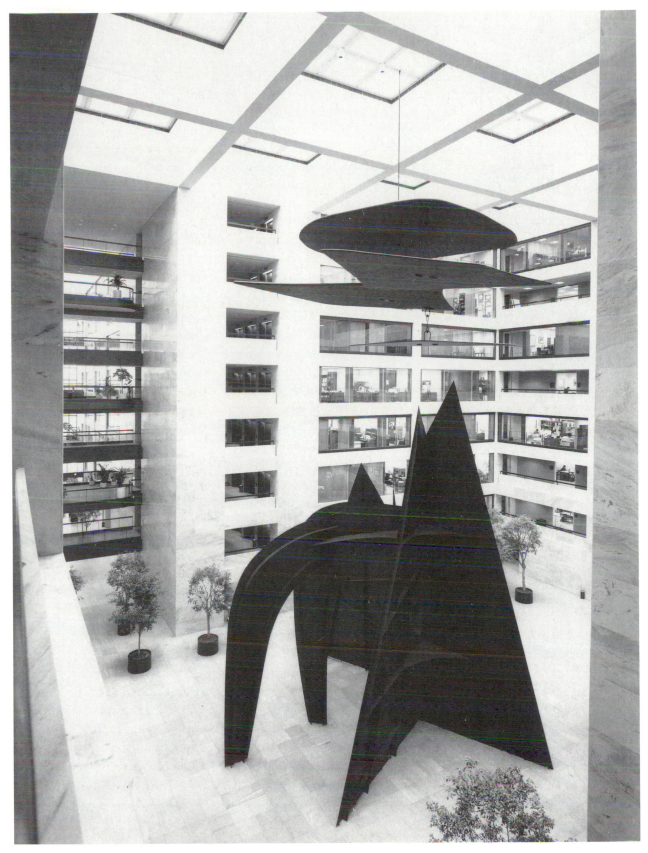

249

and complexity, expanding on ideas for public sculpture he had conceived forty years earlier.

One day before his death on November 11, 1976, Calder was in Washington, D.C., working on plans for the giant stabile–mobile *Mountains and Clouds* (Fig. 170), his last major work. At the time of Calder's trip to the United States Capitol, the extension of the Dirksen Senate Office Building – which eventually housed his work – was little more than a set of architectural drawings and models. Eleven years later the Hart Office Building was dedicated with Calder's largest indoor sculpture in an atrium. *Mountains and Clouds*, an ominous sculpture in black with large, motorized black elements overhead, is unique in Calder's oeuvre for combining the stabile with a separately suspended mobile (his early *Clouds over Mountains* had the mobile attached to the stabile). When viewed from the ground floor of the atrium, the colossal sculpture, seems to overwhelm the space: The quadrangular passage is blocked by massive steel surfaces. Most stabiles feature high arches that actually encourage pedestrians to traverse the area beneath the work. But at the Hart Office Building, passage from one section of the quadrangle to another is impeded by the sculpture. According to George White, Architect of the Capitol, Calder rejected the suggestion to make more openings in the stabile.[26] From the upper floors of the building, with a view into the atrium, satisfactory views can be gained of the stabile with the giant mobile suspended above it. The motif of black clouds hovering over a massive, almost impenetrable "mountains" seems a harbinger of Calder's death. The ominous effect of the total design is a remarkable contrast to the buoyancy of earlier stabiles.

Calder's late years are bracketed by two major New York retrospective exhibitions: one at the Solomon R. Guggenheim Museum in 1964 (which later traveled to four other American cities and Paris), and another at the Whitney Museum of American Art (which coincided with the artist's death in November 1976). The first, which featured a spectacular installation on the ground floor and lower ramps of the museum, has been claimed by many to be the most successful use ever made of Frank Lloyd Wright's controversial building. Here Calder's large stabiles of the late 1950s received their first serious exposure in America. More than a quarter-million people visited the Guggenheim exhibition, causing the retrospective to be held over for three weeks.

Twelve years later the Whitney Museum designated Calder its bicentennial artist and organized a major retrospective of his work. Many of Calder's solo exhibitions in museums had included his jewelry designs, but the full range of Calder's interest – from the design of household utensils to tapestry and wallpaper – was exhaustively represented in the Whitney exhibition of 1976. That Calder not only created "useful" and amusing objects but consented to their inclusion in a major retrospective of his art indicates his delight in "childplay" and problem solving throughout his life.

Calder considered artmaking a fun-filled activity. The toys he produced

as a child were not so different from the articulated performers he created for his miniature circus during his years as a struggling young artist in Paris. At times his deliberately playful works seem even vulgar. One thinks of such wire figures as *Spring* (see Fig. 39) and *Romulus and Remus* (see Fig. 40) and it is obvious that Calder was mimicking the allegorical and mythological subjects favored by his father. The colossal stabiles can be seen as yet another affront to traditional ideas about public sculpture. The artist's son-in-law and biographer, Jean Davidson, noted that "As a child [Sandy] was probably perturbed by his father's worried brooding."[27] Perhaps his sense of humor and his attitude toward artmaking-as-play were a reaction to the aesthetic struggles of the older generation.

In the many articles written by James Johnson Sweeney, Calder's childplay was duly noted. In "Alexander Calder: Work and Play," Sweeney wrote, "Calder has always played his art as he plays his life. But play with Calder is never frivolous."[28] While his lighthearted attitude and disdain for pretension resulted in much lively imagery throughout Calder's life, it also made him unwilling to discriminate among his art-related endeavors. Overcompensating for the self-criticism he had discerned in his father, Calder failed to develop a rigorous critical sensibility for his own art.

The publicity attached to Calder's designs for Braniff jetliners in 1973 and a BMW racing car two years later coincided with a proliferation of commissions for public sculpture in America and abroad. Could the energy he expended on these projects have been better spent on monumental sculpture? Obviously, he didn't think so, but in retrospect we should separate Calder's designs for jetplanes, tapestries, and wallpaper from the substantial achievement of his monumental stabiles. Like Picasso, the eternal näif, Calder brought to every new project the ingenuousness of an innocent eye – but also, as with the great Spanish master, the results were often uneven. It was in the colossal stabiles of his late years that Calder's childplay in an adult world came to a brilliant culmination.

An important aspect of Calder's legacy for younger artists was his ridicule of serious art. Klaus Perls once noted that Calder had "a great capacity for puncturing highfalutin nonsense – often in a short, consciously vulgar way."[29] If Calder's family worshiped at the shrine of "high art," the artist rebelled by studying engineering rather than sculpture, by stressing the amusing aspects of artmaking, and by using his international renown for commercial ventures such as painting aircraft.

More important is Calder's enduring legacy to the very definition of what constituted sculpture post–World War I. In addition to his invention of the mobile and the stabile, Calder, along with David Smith, was among the first American artists to explore the potential of industrial materials in the creation of a personal aesthetic. Calder cut, bent, and bolted industrial metals. Unlike

Smith, he did not weld, but the two American sculptors shared an interest in painting metal, expressing themselves with color as with form.

Calder also introduced improvisational effects into the creative process. In his wake, artists began to encourage the random interplay of elements in their sculpture. Moreover, Calder expanded the sphere of activity for a sculptor from object-making to designing projects as varied as acoustical ceilings and water ballets. In recent years, some sculptors have engaged in comparable experimental projects involving light, sound, and a variety of materials for interior spaces and outdoor sites (James Turrell and Robert Irwin, for example).

But it is Calder's contribution to kinetic sculpture of the twentieth century that is his most enduring and original achievement.[30] In his formative years he experimented with both motor-driven and wind-driven devices, and later works by Jean Tinguely, Harry Kramer, George Rickey, and others owe much to these early experiments. Calder's sticklike objects hanging in front of a panel and casting shadows in random patterns, his use of belt and wheel systems as an integral part of the composition, his motorized animation of coiled springs, and the use of hand-driven cranks are all important antecedents for later experimentation with kineticism. But his most innovative achievement, the wind-driven device that results in random motions, separates him from kinetic artists concerned mostly with mechanical elements.

Calder's achievement in kinetic sculpture is unique, for in his constructions he explored the use of motors, wind-driven devices, and liquid-powered works, and incorporated sound. Yet Calder had no disciples, and his imitators never measure up to his inventive genius. Although such American artists as George Rickey, Harry Bertoia, and Lin Emery have made moving sculpture in the postwar era, only occasionally do they approach Calder's achievements.

Rickey has the most problematical relationship with Calder's works. Nine years younger than the other artist, he studied in Paris in 1929–30 and met Calder's friends Stanley William Hayter and Fernand Léger. Rickey returned again in 1933 and stayed one year, but did not mention meeting Calder. After serving in the army during the war, he began producing mobiles such as *Square and Catenary* (1951), which seems openly derived from Calder's kinetic works. But Rickey claimed that although he used the catenary system favored by Calder, he did not borrow the biomorphic shapes Calder preferred. Later, Rickey continued to be interested in wind-driven kinetic devices but remained more committed to "forms as they move" than to Calder's fascination with shapes he hoped to deploy. As Selz suggested, "Unlike Calder, Rickey was from the very beginning more concerned with the organization of movement itself than with the shapes of the moving parts, and his forms appear more mechanical."[31] What Rickey suggested was that he overcame the technical problems in Calder's wind-driven mobiles while creating "purer," more geometric forms distinct from the witty and impulsive rhythms displayed by a Calder work.[32] Although Calder approximated nature with his mobiles of

painted steel biomorphs, Rickey's stainless steel elements were intended to explore the behavior of movement itself.

International figures Yaacov Agam, Pol Bury, Robert Jacobsen, Jesus-Raphael Soto, and Harry Kramer gravitated toward Dada or Constructivist concepts, or explored optical effects far different from Calder's kinetic works.[33] Only Swiss artist Jean Tinguely indicated the strong influence of Calder in his early works, his meta-mechanics. Tinguely wrote that "Calder with his mobiles had found a strong, direct medium of expression. He worked a quarter of a century before me and succeeded in creating an outstanding sculptural oeuvre, extraordinary, full of joy and even a certain humour. So that gave me confidence. You could say that the discovery of Alexander Calder opened a door for me that I could enter by."[34]

But Calder anticipated today's artists in his consideration of many issues. He was the first to venture "composing with motions." If he was not the first artist to make sculpture move, he was certainly the first to build an aesthetic based on actual motion. He also pioneered in eliminating the traditional base or pedestal and in releasing sculpture from the force of gravity. At the same time that Calder was freeing sculpture from the earth, he was exploring the extension of sculpture laterally over the ground.

Calder's career as an artist was a lifelong rebellion. He knew well the makings of traditional sculpture, given his family, yet he was determined to bring the thinking of an engineer to the service of the artist. In the conduct of his life and his art, the choice of abstract but anthropomorphized imagery, and especially in his choice of materials and approach, Calder always remained the child-tinkerer. His was an art with no didacticism, no heavy-handed symbolic message. His art was life-affirming, but with just a touch of cynicism.

Toward the end of his life Calder clearly believed he was a master, that his every gesture was worthy, and that "art" encompassed a whole range of activities including painting designs on cars and airplanes, making unwearable jewelry, and arranging for the fabrication of immobile mobiles that parody – in this case, perhaps unintentionally – his youthful works.

Writing about Calder in 1931, Fernand Léger noted, "He is 100% American."[35] Calder's first real success was in Europe, but avant-garde artists there were consistent in identifying him as an American. James Johnson Sweeney also repeatedly asserted Calder's American heritage. In his 1943 essay for Calder's retrospective at the Museum of Modern Art, Sweeney observed:

> Calder is an American. The most conspicuous characteristics of his art are those which have been attributed to America's frontier heritage – "that coarseness and strength combined with acuteness and inquisitiveness; that practical, inventive turn of mind, quick to find expedients." ... But Calder is a child of his own time. His vernacular is the vernacular of his

age in America — an age in which the frontiers of science, engineering and mechanics have dominated the popular imagination in the same way that the national frontier dominated it a century ago.[36]

With this statement Sweeney proposed that Calder's art could be related to the popular interest in science and technology among Americans. Indeed, Calder was ever mindful of the recreational activities, popular attractions, and current events that captured the attention of his countrymen. Calder's indebtedness to his engineering background — his use of pulleys, pendulums, and other laboratory devices — represents one aspect of his joining of the fine arts with technical instruments far removed from typical art practice. Drawings and constructions related to contemporary developments in astronomy constituted another new frontier of knowledge explored by this American artist.

As an American, Calder's special achievement was the joining of various aspects of popular culture to the creation of art. First and foremost was Calder's use of the circus — a popular form of entertainment even today. Whereas European artists created paintings that were inspired by the circus, Calder eschewed these traditional art forms for a novel use of circus imagery: the creation of a miniature circus with moving parts (like folk art objects or animated toys). He used the circus not only as the basis for miniature figures and animals that he presented in performance for decades, but as an inspiration for all of his work over a lifetime. Standing mobiles, giant stabiles, and suspended wind-driven devices derive from aerialists, acrobats, trapeze artists, clowns, and performing animals. The precarious interplay of elements in these constructions call to mind the dazzling effects of a death-defying circus act.

Calder chose not to be identified solely with the "high arts" of painting and sculpture, but to embrace the decorative arts. He designed jewelry, household furnishings, wallpaper, and cooking utensils at every stage of his long artistic career. But aside from his own production of a variety of decorative objects, Calder offered a sustained tribute to American folk art. The extent of his involvement with the folk art tradition has been overlooked, but a study of his wire and sheet metal animals, his amusing toys, and his fanciful stabiles of animal forms reveals a resemblance to traditional American weather vanes, bird decoys poised on spindly legs, bootjacks, and whirligigs (wind toys).[37] Emigré artists of the early twentieth century — notably Elie Nadelman and Robert Laurent — explored folk art as a source, but Calder used many variations on folk art items, particularly for his animal images, and was inspired as well by the folk artists' direct use of materials such as wood and sheet metal.

To summarize Calder's achievements as an American artist is not only to focus on his mechanical ingenuity but to recognize his brilliant fusion of the aesthetics of modernism with popular culture. Like Man Ray, Stuart Davies, and Arthur Dove in the early 1920s, Calder used "found" materials and imagery derived from commercial products (coffee cans and cigar boxes found

their way into his work early on). Man Ray, following Duchamp's example, in 1919 made early "mobiles" by suspending paper lampshades from metal stands, and in 1920 arranged wooden coathangers as a suspended "mobile" entitled *Obstruction*. Calder also used some "found" objects, but his creations are playful. As an American, Calder valued freedom of expression; he was unwilling to submit his creative spirit to the orthodoxy of any group.

As an American pioneer in monumental sculpture, Calder helped revitalize the appearance of public commissions. The legacy of his great innovations in public art continue to have an impact in many cities, both in the United States and abroad. From a family of sculptors, he had firsthand exposure to artistic conventions, but in Paris he learned of radical new approaches to art. These concepts he applied to large-scale sculpture, and his stabiles represent a fusion of Constructivism and abstract Surrealism with his American ingenuity and exuberance. Playful but imposing, static but stimulating "street traffic" beneath their arches, Calder's stabiles are unprecedented works. For his imagery Calder raided a museum of natural history and a zoo – fauna, giant insects, flora, and dinosaurs make an appearance in this art.

The legacy of Calder's stabiles extends into many aspects of contemporary sculpture. Humorous images using oversized or organic forms have been created by Claes Oldenburg, Nancy Graves, Judy Pfaff, and others. Colossal abstractions of industrial metals are produced by Mark di Suvero, Alexander Liberman, and sculptors identified with Primary Structures. Like Calder, these artists used fabricators to complete their large-scale works. Polychrome sculpture, indebted to Calder's example, has been created by George Sugarman, whose public works are also informed by Calder's monumental stabiles.[38] Although Calder opened various possibilities for abstract sculpture and kinetic works, his own art remains without parallel. Concepts initiated by the Futurists and Constructivists are realized in his work. Calder fused figuration and the abstract to create new forms, joining his knowledge of industrial materials with a vivid imagination for fantastic imagery.

Alexander Calder is one of the great innovators of the twentieth century, and his primary achievements – the mobile and stabile – remain unique expressions of American ingenuity fused with the aesthetics of modernism.

Notes

INTRODUCTION

1. In one of his earliest statements about the mobiles, Calder wrote in 1933: "The sense of motion in painting and sculpture has long been considered one of the primary elements of the composition. . . . Therefore, why not plastic forms in motion? Not a simple translatory or rotary motion, but several motions of different types, speeds and amplitudes composing to make a resultant whole. Just as one can compose colors, or forms, so one can compose motions." In "Alexander Calder," Berkshire Museum, Pittsfield, Mass., August 12–25, 1933.

2. James Johnson Sweeney, *Alexander Calder* (New York: Museum of Modern Art, 1943; 2nd ed. with bibliography, 1951).

3. Bernice Rose, *A Salute to Alexander Calder* (New York: Museum of Modern Art, 1969).

4. Albert E. Elsen, *Alexander Calder: A Retrospective Exhibition* (Chicago: Museum of Contemporary Art, 1974).

5. Maurice Besset, *Alexander Calder* (Munich: Haus der Kunst, 1975).

6. H. H. Arnason and Pedro Guerrero, *Calder* (New York: Van Nostrand, 1966); Ugo Mulas and H. Harvard Arnason, *Calder* (New York: Viking, 1971).

7. Jean Lipman, *Calder's Universe* (New York: Viking, 1976).

8. Giovanni Carandente, *Calder* (Milan: Electa, 1983); Daniel Marchesseau, *The Intimate World of Alexander Calder* (Paris: S. Thierry, 1989).

1. FORMATIVE YEARS

1. The month of Calder's birth is disputed. Calder himself checked with Philadelphia City Hall and received a birth certificate dated July 22, 1898, but his parents had always celebrated his birthday on August 22. In her family memoirs his sister, Margaret Calder Hayes, claimed she

found it difficult to believe that her parents would not remember the exact date of birth of their second child and only son. See Margaret Calder Hayes, *Three Alexander Calders: A Family Memoir* (Middlebury, Vt.: Eriksson, 1977), p. xiv.

2. Ibid., p. 106.

3. For information on Alexander Milne Calder and Alexander Stirling Calder, see Margaret Calder Hayes, *Three Alexander Calders*. Also see Registrar's Files, Pennsylvania Academy of the Fine Arts; Theo B. White, *The Calders from City Hall to the Guggenheim* (Philadelphia: The Athenaeum of Philadelphia, 1967); Wayne Craven, *Sculpture in America* (New York: Crowell, 1968), pp. 483–46, 570–3; Fairmount Park Art Association, *Sculpture of a City: Philadelphia's Treasures in Bronze and Stone* (New York: Walker, 1974), pp. 104–9; 118–23; 230–9; "Alexander Stirling Calder," in *Index of Twentieth Century Artists* (New York: College Art Association of America, 1935).

4. See George Gurney, "Alexander Milne Calder: William Penn," in Fairmount Park Art Association, *Sculpture of a City*, pp. 104–9.

5. For other works by Alexander Milne Calder, see Wayne Craven, *Sculpture in America*, pp. 483–6; George Gurney, "The Sculpture of City Hall," in *Sculpture of a City*, pp. 94–103; and Victoria Donahue, "Alexander Milne Calder: General Meade," in ibid., 118–23.

6. Victoria Donahue, "Swann Fountain," in ibid., pp. 230–9.

7. In a letter to Charlotte Whitney Allen dated October 10, 1935, Calder recommends his father to receive the commission for the Spanish War Veterans Memorial for Rochester and seeks Mrs. Allen's assistance in contacting the chairman of the Arts Commission. Allen Papers, Kenyon College, Kenyon, Ohio.

8. Hayes, *Three Alexander Calders*, pp. 117–18.

9. Ibid, p. 120.

10. Alexander Calder, *Calder: An Autobiography with Pictures* (New York: Pantheon, 1966), p. 13. The clay elephant is no longer extant. Young Calder also posed for several portraits painted by his mother.

11. Interview with Calder, October 18, 1972. This sculpture is no longer extant.

12. Calder, *Autobiography*, p. 21.

13. Ibid.

14. Arthur Jerome Eddy (1859–1920) was the author of a number of publications, but most notably *Cubists and Post-Impressionists* (Chicago: A. C. McClurg, 1914).

15. Calder, *Autobiography*, p. 25.

16. Hayes, *Three Alexander Calders*, p. 127.

17. Ibid.

18. For a discussion of Alexander Stirling Calder's association with Robert Henri, see William Innes Homer, *Robert Henri and His Circle* (Ithaca, N.Y.: Cornell University Press, 1969), p. 76.

19. Calder, *Autobiography*, p. 31.

20. Louis H. Frohman, "Everett Shinn, the Versatile," *International Studio* 78 (October 1923): 85.

21. Calder, *Autobiography*, p. 31.

22. Hayes, *Three Alexander Calders*, p. 41.

23. Ibid., p. 146.

24. Calder, *Autobiography*, p. 36.

25. For a complete listing of the Futurist paintings and sculptures exhibited in 1915, see *Catalogue of the Department of Fine Arts, Panama-Pacific International Exposition* (San Francisco: Wahlgreen, 1915), pp. 63–8.

26. Hayes, *Three Alexander Calders*, p. 49.

27. John D. Barry, *The Palace of Fine Arts and the French and Italian Pavilions* (San Francisco: Taylor & Taylor, 1915), p. 53.

28. Hayes, *Three Alexander Calders*, p. 68.

29. Clinton Balmer was an English artist who had studied with Augustus John and Frederick Burridge. He prepared murals for the Toxteth Library in Liverpool and for other buildings in the west of England. In 1912, Balmer began work on a set of murals for Grace Church in Nutley, New Jersey, in a style reminiscent of the Pre-Raphaelites. The paintings were later destroyed in a fire. René de Lombre, "A Great Mural Painter," *The American Art Student and Commercial Artist* 9 (May 1926): 18–22. According to *Who Was Who in American Art*, Clinton Balmer lived in Brooklyn, and joined New York's Salmagundi Club in 1921.

30. Calder, *Autobiography*, p. 51.

31. Ibid. Preliminary drawings for early mobiles that include this cross-hatching technique were found in the Calder file at Pierre Matisse Gallery, New York.

32. Ibid., p. 54.

33. Calder, *Autobiography*, pp. 54–5.

34. Hayes, *Three Alexander Calders*, p. 75.

35. Calder, *Autobiography*, p. 59.

36. Alexander Calder, "Mobiles" in Myfanwy Evans, ed., *The Painter's Object* (London: Gerald Howe, 1937), p. 67.

37. Calder, *Autobiography*, p. 20.

38. Ibid., p. 50.

39. For additional information on Alfred Stieglitz and his support of young modernists, see William Innes Homer, *Alfred Stieglitz and the American Avant-Garde* (Boston: New York Graphic Society, 1977).

40. For additional information, see Robert L. Herbert, Eleanor S. Apter, and Elise K. Kenney, eds., *The Société Anonyme and the Dreier Bequest at Yale University, A Catalogue Raisonné* (New Haven, Conn.: Yale University Press, 1984).

41. Hayes, *Three Alexander Calders*, p. 78.

42. For a complete list of instructors and a brief history of the Art Students League, see Marchal E. Landgren, *Years of Art: The Story of the Art Students League* (New York: McBride, 1940), pp. 112–16.

43. John Sloan encouraged his students to develop a personal style. For notes compiled from Sloan's classes, see John Sloan, *Gist of Art* (New York: American Artists Group, 1944).

44. Calder, *Autobiography*, p. 61. In Calder's oral recollections of his life, which were written down by his son-in-law, Jean Davidson, he referred to Graham as "John Debrowsky." Graham used several versions of his name at different times. A drawing made by Graham in John Sloan's class is signed "John Dabrowsky Graham/Nov 1923." Ivan Dombrowski (1881–1961) was born into a prominent Russian family and studied law. He served on the staff of Czar Nicholas II and received the St. George Cross for valor as a cavalry officer in World War I. In 1917, shortly after the Revolution began, Dombrowski was arrested. He was released and fled to Poland. After returning to Russia with counterrevolutionary forces in 1920, he left for the United States. In New York, Dabrowsky changed his name to John Graham and enrolled at the Art Students League. For additional information on Graham, see Eleanor Green, *John Graham: Artist and Avatar* (Washington, D.C.: Phillips Collection, 1987).

45. See letter from Nana Frank, c. 1924, quoted in Hayes, *Three Alexander Calders*, p. 83.

46. Calder's *Portrait of John Graham*, c. 1931–2, was given by Graham to David Smith and hung in his Bolton Landing home (interview with Dorothy Dehner, June 5, 1980). See Green, *John Graham*, 32.

47. Calder's enrollment records were supplied in a letter from Lawrence Campbell for the Art Students League, February 20, 1973.

48. It is interesting to note that Alexander Stirling Calder had joined the staff of the Art Students League in 1918. His son made no mention of this fact in his autobiography and did not enroll in sculpture classes while attending the League. Interview with Calder, October 18, 1972.

49. Calder, *Autobiography*, p. 61.

50. Ibid., pp. 66–7.

51. Memoirs of Clay Spohn, Spohn Papers, Archives of American Art, Smithsonian Institution. Other recollections of Calder's early years were supplied in an interview with Spohn, May 26, 1977.

52. Calder, *Autobiography*, p. 67.

53. Helen Farr Sloan was the second wife of John Sloan and a student at the Art Students League during the 1920s. Interview with Mrs. John Sloan, February 2, 1973.

54. Arnold Blanch, "Boardman Robinson, the Teacher," in Albert Christ-Janer, *Boardman Robinson* (Chicago: University of Chicago Press, 1946), pp. 74–5.

55. Calder, *Autobiography*, p. 61.

56. Calder's drawings first appeared in the *National Police Gazette* on March 22, 1924, and continued intermittently until October 31, 1925.

57. "Seeing the Circus with 'Sandy' Calder," *National Police Gazette* 126 (May 23, 1925): 14.

58. Alexander Calder, *Animal Sketching* (Pelham, N.Y.: Bridgman, 1926), p. 57. This small book had a second edition in March 1927 and a third edition in April 1929.

59. Calder, ibid., p. 9.

60. In a series of animal drawings produced at the zoo, Calder used a bottle of China ink and a brush. See *Calder at the Zoo*, Archives of American Art, Smithsonian Institution, 1974.

61. Sloan, *Gist of Art*, p. 149.

62. Ibid., p. 57.

63. Murdock Pemberton, "Review of Exhibitions," *The New Yorker* (January 1926): 35.

64. "Horse Show by Alexander Calder," *Boston Evening Transcript* (May 26, 1926): 26, illus. (Photo is listed as "Courtesy of Anderson Galleries.")

65. For additional discussion of Calder's early paintings, see Joan Marter, "Alexander Calder at the Art Students League," *American Art Review* 4 (May 1978): 54–61.

66. Barbara Rose, *American Art Since 1900* (New York: Praeger, 1967), pl. I–13.

67. Calder compared Guy Pène du Bois's painted figures to woodcarvings (*Autobiography*, p. 66).

68. Interview with Mrs. John Sloan, February 2, 1973.

69. Calder, *Autobiography*, p. 66.

70. For a consideration of the circus motif as it appears in Calder's later paintings, drawings, and sculpture, see Jean Lipman and Nancy Foote, eds., *Calder's Circus* (New York: Dutton, 1972).

71. For *Sandy*, 1924, see Hayes, *Three Alexander Calders*, p. 79.

72. In a later interview Calder mentioned that he wished he had been a Fauve in 1905. Katherine Kuh, ed., *The Artist's Voice: Talks with Seventeen Artists* (New York: Harper & Row, 1962), p. 41.

73. Sloan, *Gist of Art*, 116, 119.

74. The pigments of Hardesty G. Maratta were purchased by John Sloan and Robert Henri. For a complete account of Maratta's theories, see Elizabeth Handy, "H. G. Maratta's Color Theory and Its Influence on the Painters Robert Henri, John Sloan, and George Bellows," unpublished master's thesis, University of Delaware, 1969.

75. Such American artists as Max Weber, Marsden Hartley, Walt Kuhn, and Marguerite Thompson Zorach had already acknowledged the impact of the Fauves in their work of the previous decade.

76. *Catalogue of the Ninth Annual Exhibition of The Society of Independent Artists*, New York, March 6–29, 1925, cat. no. 167.

77. *Catalogue of the Tenth Annual Exhibition of The Society of Independent Artists*, New York, 1926, cat. no. 151.

78. Undated letter from Calder to Nana Frank, mother-in-law of Margaret Calder Hayes, is reproduced, complete with Calder's illustrations, in Hayes, *Three Alexander Calders*, pp. 91–3.

79. Ibid., p. 93.

80. Ibid.

81. Ibid., p. 88.

82. Information on this painting by Calder can be found in the Registrar's Files of the Whitney Museum of American Art. A letter from Calder dated September 1953, and notes by Jean Lipman from May 24, 1963, are included.

83. See Louis Bouché Papers, Archives of American Art; and Sidney Geist, "The Firemen's Dinner for Brancusi," *Archives of American Art Journal* 16 (1976): 8–11.

84. Registrar's Files, Whitney Museum of American Art. See, in particular, a letter from Calder dated September 1953.

85. Ibid.

86. Letter from Alexander Brook, July 31, 1976.

87. "Alexander Calder," in Kuh, ed., *The Artist's Voice*, p. 42.

2. FIRST YEARS IN PARIS

1. According to records at the Art Students League, Robert Laurent taught there from 1925 to 1942.

2. This wire sculpture was lost and is known only by a drawing executed by Calder in the 1960s. Calder, *Autobiography*, pp. 71–2.

3. For additional examples of rooster weather vanes, see Robert Bishop, *American Folk Sculpture* (New York: E. P. Dutton, 1974), p. 67.

4. Alexander Brook in *Charm* (February 1925). See discussion of the impact of folk art on early modernism in Tom Armstrong, "The Innocent Eye,

American Folk Sculpture," in Whitney Museum of American Art, *200 Years of American Sculpture* (New York: David R. Godine, 1976), pp. 76–86.

5. In his exhibition catalogue prepared for the Calder retrospective held at the Museum of Modern Art in 1943, James Johnson Sweeney mentioned that Calder's *Flat Cat* was made shortly before the artist left for Paris in June 1926: "A piece of oak fence rail picked up that spring in Connecticut reluctantly took the shape of his first wood carving – The Flattest Cat" (*Alexander Calder* [New York: Museum of Modern Art 1943], p. 14). This is the only documentation of the carving of a sculpture in wood before his trip to Paris. Calder has identified his first *Flat Cat* (see Fig. 22) as the one formerly in the collection of Charlotte Whitney Allen (interview with Calder, June 8, 1973).

6. In a letter to Charlotte Whitney Allen dated December 7, 1938, Calder identifies the work as either the second or the first wood sculpture he ever made. Allen Papers, Kenyon College, Kenyon, Ohio.

7. Robert Laurent exhibited at the Bourgeois Gallery in 1922, at the Valentine Gallery in 1926, and with the Salons of America during the 1920s. William Zorach was given his first one-man exhibition of sculpture in 1924 at Kraushaar Galleries. Works by John B. Flannagan were shown at Montross Gallery in 1923. He exhibited at the Whitney Studio Club in 1925.

8. For early exhibitions at Société Anonyme, see *Selected Publications: Société Anonyme*, vols. 1–3 (New York: Arno Press, 1972). Société Anonyme exhibited artists of the European avant-garde: Duchamp, Crotti, Arp, Archipenko, Klee. The Salons of America held annual exhibitions at the Anderson Gallery that included a number of artists originally associated with the artist and critic Hamilton Easter Field, such as Robert Laurent, Yasuo Kuniyoshi, Niles Spencer, and Maurice Sterne.

9. Brooklyn Museum, *Exhibition of Russian Painting and Sculpture*, January 23–March 4, 1923; Galleries of the Société Anonyme [Modern Russian Artists], February 13–March 6, 1924 (included Bortnyik, Braque, Gabo, Lissitzky, Lozowick, Malevich, Medunetsky, Udaltsova).

10. For a list of the art institutions, colleges, and universities where Archipenko taught, see Alexander Archipenko, *Fifty Creative Years* (New York: Tekhne, 1960), p. 95.

11. Alexander Archipenko, "Machine and Art," in *Machine-Age Exposition* (New York, 1927), p. 13.

12. Ibid.

13. Alexander Archipenko, "Archipentura, A New Development in Painting," in *Archipenko, Catalogue of Exhibition and Description of Archipentura* (New York: Anderson Galleries, 1928), pp. 5, 8.

14. *Brooklyn Museum Catalogue of an International Exhibition of Modern Art Assembled by the Société Anonyme*, introduction by Katherine S. Dreier (New York: Brooklyn Museum, 1926). The catalogue is discussed at length in Ruth L. Bohan, *The Société Anonyme's Brooklyn Exposition: Katherine Dreier*

and Modernism in America (Ann Arbor: UMI Research Press, 1982), pp. 67–82.

15. For full details of this exhibition, see Bohan, ibid., pp. 39–66.

16. Ibid., p. 123.

17. These museums are discussed in Chapter 5.

18. *The Little Review*: literature, drama, music art, vols. 1–12 (March 1914– May 1929). Editors: Margaret C. Anderson and Jane Heap. Also see Jackson R. Bryer, " 'A Trial Track for Racers': Margaret Anderson and the *Little Review*," Ph.D. dissertation, University of Wisconsin, 1965.

19. Interview with José de Creeft, December 18, 1972. Prohibition laws were not repealed until 1933.

20. Calder, *Autobiography*, p. 76.

21. William Wiser, *The Crazy Years: Paris in the Twenties* (New York: Atheneum, 1983), p. 29.

22. For additional discussion, see Elizabeth Hutton Turner, *American Artists in Paris, 1919–1929* (Ann Arbor, Mich.: UMI Research Press, 1988).

23. Ibid., p. 78.

24. Spohn Papers, Archives of American Art. For another description of Calder's appearance at the time and other recollections, see Stanley William Hayter, "Alexander Calder in Paris," in G. di San Lazzaro, ed., *Homage to Alexander Calder* (New York: Tudor, 1972), pp. 6–8.

25. The Salon of American Artists was held July 2–13, 1928, and included works by Paul Burin, John D. Graham, Alice S. Hay, and Katherine Fuller. A total of fifty American artists were represented.

26. During the period 1927 to 1930, Calder also met the critic Marc Réal, the circus devotee Legrand-Chabrier, musician Edgard Varèse, and architect Le Corbusier.

27. Interview with Stanley William Hayter, June 22, 1973.

28. Ibid.

29. José de Creeft was born in Spain in 1884 and moved to Paris in 1905, living at the Bateau Lavoir with Picasso and others. De Creeft carved in wood in 1915, and in stone beginning in 1916. From 1919 to 1928 he exhibited in all of the major salons in Paris. For further information, see Jules Campos, *The Sculpture of José de Creeft* (New York: Da Capo Press, 1972).

30. Interview with Stanley William Hayter, June 22, 1973.

31. According to Hayter, de Creeft was a close friend of Gargallo and kept works by the latter in his studio. De Creeft himself made a number of humorous metal pieces including *The Picador*, 1925–6. Pablo Gargallo (1881–1934) lived in Paris until his death. His work often includes folded, hammered, and curled sheets of metal. See Pierre Courthion

and Pierretti Anguera-Gargallo, *Catalogue Raisonné: Pablo Gargallo* (Paris: Société Internationale d'Art XXᵉ Siècle, 1973).

32. Calder, *Autobiography*, p. 79.

33. Interview with Hayter, June 22, 1973.

34. Spohn Papers, Archives of American Art.

35. Ibid.

36. "Futurist Toys for Advanced Kids," *New York Herald*, August 4, 1927.

37. Stanley William Hayter, "Alexander Calder in Paris," p. 7.

38. Spohn Papers, Archives of American Art.

39. "When he [Clay Spohn] visited my studio and saw the objects I made out of wood and wire – I had a cow, a four-horse chariot which was quite wonderful but some damn fool lost it – he said 'Why don't you make them completely out of wire?' I accepted this suggestion, out of which was born the first Josephine Baker and a boxing Negro in a top hat." Calder, *Autobiography*, p. 80.

40. Interview with Clay Spohn, May 26, 1977.

41. Spohn Papers, Archives of American Art.

42. Montross Gallery, New York, "Exhibition of Pictures by Jean Crotti, Marcel Duchamp, Albert Gleizes, Jean Metzinger," April 4–22, 1916, cat. no. 22. Crotti's work was also shown by the Société Anonyme in the early 1920s. For additional information on Crotti, see Waldemar George, *Jean Crotti* (Paris: Aux Editions Graphis, 1930).

43. Kynaston McShine and Anne d'Harnoncourt, eds., *Marcel Duchamp* (New York, Museum of Modern Art, 1973), illus. p. 193. The pencil sketch of Marcel Duchamp by Crotti is in the collection of the Museum of Modern Art.

44. See letter to Mr. Jean Crotti in *The Soil, A Magazine of Art* 1 (December 1916): 32. This letter is a response to an article about the Duchamp portrait that appeared in *The World Magazine* August 27, 1916, in which Crotti described his wire sculpture as "an absolute expression of my idea of Marcel Duchamp. Not my idea of how he looks, so much as my appreciation of the amiable character that he IS."

45. Jean Crotti first met Marcel Duchamp in 1915 in New York and shared his studio for a short time. He was included in a number of Dada exhibitions in New York. In 1919, Crotti married Duchamp's sister, Suzanne, in Paris, and they became part of Dada activities in the French capital, initiating the word TABU for their work in 1921. In March 1925, a portrait photo of Suzanne Duchamp by Man Ray appeared in *Charm*. For additional information, see William A. Camfield and Jean-Hubert Martin, eds., *Tabu Dada, Jean Crotti and Suzanne Duchamp* (Bern: Staempfli, 1983).

46. Bernice Rose, *A Salute to Alexander Calder*, p. 10.

47. Virginia Dortch Dorazio, *Giacomo Balla* (New York: Wittenborn, 1970), fig. 136. A reconstruction of the original wire sculpture is in the collection of the Hirshhorn Museum and Sculpture Garden, Washington, D.C.

48. Ibid., figs. 177–9. There is some question about the original dating of these "reconstructed" wire sculptures by Balla. Although the single-line drawings for Bal-Tik-Tak can be dated for certain in the early 1920s, whether Balla constructed wire sculptures in these years may be open to question. See, for example, Giovanni Lista, *Balla* (Modena: Galleria Fonte d' Abisso, 1982), where none of the wire sculptures is included in a "complete catalogue" of the artist's works. I wish to thank Valerie Fletcher at the Hirshhorn Museum and Sculpture Garden for bringing to my attention the problem of dating Balla's wire sculpture in the Hirshhorn collection.

49. John E. D. Trask and J. J. Laurvick, eds., *Catalogue Deluxe of the Department of Fine Arts*, Panama-Pacific Exposition, vol. 2 (San Francisco: Elder, 1915), pp. 273–4.

50. See, for example, Enrico Prampolini, "The Aesthetic of the Machine and Mechanical Introspection in Art," *Little Review* 10 (Autumn – Winter, 1924–5): 49–51, and Virgilio Marchi, "Giacomo Balla," *La Stirpe* (March 1928).

51. See reproductions of the first and last page of "Ricostruzione Futurista dell'Universo," in Maurizio Fagiolo dell' Arco, *Balla, The Futurist* (New York: Rizzoli, 1988), p. 33.

52. Deborah A. Stott, *Jacques Lipchitz and Cubism* (New York: Garland, 1978), pp. 178–9.

53. See Picasso's *Construction*, 1928–9 (Roland Penrose, *Sculpture of Picasso* [New York: Museum of Modern Art, 1967], p. 65).

54. Calder allegedly removed the rearing horse from a group exhibition at the Place Vendôme when he was not permitted to tack up a piece of paper behind the wire sculpture. Calder, *Autobiography*, p. 92.

55. Josephine Baker (1909–76) was acclaimed in the 1920s for the *Revue Négre* in Paris, and was the star of the Folies-Bergères for many years. Her scanty costumes, seductive dancing, and lively singing were important to the successful career of this American entertainer.

56. Albert Elsen, *Modern European Sculpture 1918–1945* (New York: Braziller, 1979), pp. 76–7.

57. Calder's admission charge for performances of his circus was recalled by Betty Parsons, who attended the event during the 1920s in Paris. Interview with Betty Parsons, October 28, 1973.

58. For posters of the Cirque Fratellini and other French circuses of the period, see Alain Weill, *Le Cirque Français* (Paris: Musée de l'Affiche, 1980), p. 113.

59. Calder, *Autobiography*, pp. 113–14.

60. *The Circus* is now owned by the Whitney Museum of American Art. A film was made of the complete circus performance by Carlos Vilardebo for Pathé Films in 1961.

61. Cleve Gray, "Calder's Circus," *Art in America* 29 (October, 1964): 23.

62. Ibid., p. 25.

63. Ibid.

64. Ibid.

65. Legrand-Chabrier, "Un petit cirque a domicile," *Candide* (June 1927).

66. Gustave Fréjaville, "Les Poupées Acrobats du Cirque Calder," *Comoedia*, April 24, 1929.

67. "Les Jouets de Calder," *Les Echoes des Industries d'Art* (August 1927).

68. Interview with José de Creeft, December 18, 1972.

69. Ibid.

70. For a brochure on Calder's *Action Toys*, see Calder Papers, Archives of American Art, Smithsonian Institution.

71. Interview with Carl Zigrosser, March 30, 1973. Calder constructed wire portraits of Zigrosser and Erhard Weyhe at the time of his exhibition at the Weyhe Gallery in 1928.

72. Calder, *Autobiography*, p. 86.

73. "Gallery Notes," *Creative Art* 2 (April 1928): 14.

74. Ibid. A more favorable article that mentioned Jean Cocteau's admiration for Calder's work was written later: Elizabeth Hawes, "More than Modern – Wiry Art, Sandy Calder Sculptures in a New Medium," *Charm* (April 1928): 46–7.

75. The Twelfth Annual Exhibition of the Society of Independent Artists, New York, March 9–April 1, 1928. Calder sent four pieces to the exhibition: *Spring*, no. 138, *Romulus and Remus*, no. 139, and two unidentified sculptures, nos. 140 and 141. Calder did not submit to the Independents exhibition after 1928.

76. Interview with Carl Zigrosser, March 30, 1973.

77. *Spring* was illustrated in the catalogue of the Independents exhibition of 1928 and was the only work Calder listed with a price.

78. See H. A. Groenewegen-Frankfort and Bernard Ashmole, *Art of the Ancient World* (New York: Abrams, 1971), pl. 598.

79. This postcard was later hung in the foyer of Calder's Roxbury home.

80. Interview with Mrs. John Sloan, February 2, 1973.

81. John Sloan was president of the Society of Independent Artists at the time.

82. Myfanwy Evans, ed., *The Painter's Object*, p. 63.

83. See, for example, *Shark Sucker* of 1930, in Bernice Rose, *A Salute to Alexander Calder*, p. 26.

84. Interview with Chaim Gross, October 25, 1974.

85. Ibid.

86. Calder, *Autobiography*, p. 88.

87. For a discussion of Calder's early carvings, see Roberta K. Tarbell, *Chaim Gross* (New York: The Jewish Museum, 1977), pp. 8–12.

88. Calder, *Autobiography*, p. 66.

89. Helen Appleton Read, "Robert Laurent," *The Arts* (May 1926): 253.

90. N. Calder, *Thoughts of Alexander Stirling Calder* (New York: privately printed, 1947): illus., p. 39.

91. Victor Keppler, *Man & Camera* (New York: Hastings House, 1970), pp. 49–50. Letter from Victor Keppler, August 2, 1976.

92. Calder, *Autobiography*, p. 89.

93. See debarkment stamp on Calder's passport, Calder Papers, Archives of American Art.

94. Calder, *Autobiography*, p. 91.

95. Calder may have shown works twice at the Salon de l'Araignée. He mentioned submitting a wire acrobat (*Autobiography*, p. 92), but the Eleventh Salon of 1930 lists Calder's entry as *Negress* (cat. no. 125). Calder Papers, Archives of American Art.

96. Calder, *Autobiography*, p. 95.

97. W. Gurth, ed., *The Complete Woodcuts of Dürer* (New York: Dover, 1963), pl. 103.

98. Jacques Dupin, *Joan Miró* (New York: Abrams, 1962), pl. 245–77. Miró created three *Spanish Dancers* in 1928.

99. Calder, *Autobiography*, p. 92.

100. Klee's works were exhibited regularly in Berlin and Paris during Calder's years of European residence. In 1929, for example, Klee was shown at Galerie Alfred Flechtheim, Berlin (October 20–November 15, 1929) and at Galerie Georges Bernheim, Paris (February 1–15, 1929). In 1930 he was exhibited in Berlin, and sixty-three of his works were shown at the Museum of Modern Art, New York. For a chronological catalogue of all works reproduced in these years, see Will Grohmann, *Paul Klee* (New York: Abrams, 1955), pp. 409–22.

101. See Klee's *Elle beugle, nous jouons* of 1928, in Will Grohmann, *Paul Klee* (Paris: Editions Cahiers d'Art, 1929), p. 48.

102. Interview with Stanley William Hayter, June 22, 1973.

103. "Alexander Calder: Wood Carvings," The Weyhe Gallery, New York, February 4–23, 1929; "Ausstellung Alexander Calder, Skulpturen aus Holz und aus Draht," Galerie Neumann-Nierendorf, Berlin, April 1929.

104. "Sculpture Bois et Fil de Fer d'Alexandre Calder," Galerie Billiet, Paris, January 25–February 7, 1929. Pascin's remarks were also published in reviews of the exhibition, such as "On remplace le crayon et la couleur par du fil de fer," *La Rumeur* (January 30, 1929).

105. Ibid.

106. George Bal, "Alexander Calder," *New York Herald*, January 31, 1929.

107. Katherine Kuh, ed., *The Artist's Voice*, p. 50.

108. Interview with Stanley William Hayter, June 22, 1973.

109. Calder, *Autobiography*, p. 89.

110. Joan M. Marter, "Alexander Calder: Ambitious Young Sculptor of the 1930s," *Archives of American Art Journal* 16 (1976): 2–8.

111. Zigrosser papers, University of Pennsylvania Rare Book Library. Early in 1929, Calder wrote to Zigrosser for information on the procedure for submitting a piece of sculpture to the National Sculpture Society. On February 14, 1929, Calder wrote a long letter to Zigrosser discussing the possibility of an exhibition in London and requesting information on suitable galleries to handle his work in Berlin.

112. Emil Szittya, "Alexander Calder," *Kunstblatt* (June 13, 1929): 185–6. (translation by H. H. Arnason and published in Mulas and Arnason, *Calder*, p. 21).

113. See *Creative Art* 4 (February 1929): illus. p. 89.

114. Passport stamped on embarkation at Le Havre, Calder Papers, Archives of American Art.

115. "Alexander Calder: Paintings, Wood Sculptures, Toys, Wire Sculpture, Jewelry, Textiles," Fifty-sixth Street Galleries, New York, December 2–14, 1929.

116. The wire sculpture *Aquarium* was a handwritten addition to the catalogue, which also was marked with the prices for the works. Calder Papers, Archives of American Art, item 61.

117. Kuh, ed., *The Artist's Voice*, p. 39.

118. Interview with Stanley William Hayter, June 22, 1973.

119. Reviews of Calder's first exhibitions published in French newspapers and a selection of early articles are found in Calder Papers, Archives of American Art.

120. For a complete list of exhibitions of the early years, see *James Johnson Sweeney, Calder*, pp. 73–4.

3. The Birth of an Abstract Style

1. Calder, *Autobiography*, p. 113.

2. Ibid., p. 152.

3. In his autobiography Calder admitted that Mrs. James became perturbed with him in 1934 when he was using Louisa's money to present her with flowers during her pregnancy. He recalled, "Once, she took me aside and made me promise to be a good businessman. I said I'd do my best." *Autobiography*, p. 151.

4. Letter from Nanette Calder to Margaret Hayes, December 1930, quoted in Hayes, *Three Alexander Calders*, p. 241.

5. Letter from Sandy Calder, Paris, to Mr. and Mrs. Alexander Stirling Calder, May 23, 1930. Quoted in Hayes, *Three Alexander Calders*, p. 233.

6. George Rickey, *Constructivism: Origins and Evolution* (New York: Braziller, 1967), pp. 37–9.

7. Paris, Galerie 23, "Première Exposition International du Group Cercle et Carré," April 18–May 1, 1930. The journal *Cercle et Carré* has been reprinted in *Circle et Carré, Collection complete 1930* (Paris: Editions Jean-Michel Place, 1977).

8. "Base de la peinture concrete: Manifesto," *Art concret* 1 (April 1930): 1. Quoted in Joost Baljeu, *Theo van Doesburg* (New York: Macmillan, 1974), p. 97.

9. *Abstraction, Création Art Non-Figuratif*, vols. 1–5 (Paris: Edition les Tendances Nouvelles, 1932–6).

10. Jean Gorin, "The Aim of Constructive Plastic Art," *Abstraction, Création Art Non-Figuratif* 5 (1936): 9 (translated in Stephen Bann, ed., *The Tradition of Constructivism* [New York: Viking, 1974], pp. 199–200).

11. For historical documentation of the group, see Musée d'Art Moderne de la Ville de Paris, *Abstraction–Création, 1931–1936* (1978), essay by Gladys C. Fabre.

12. André Breton, *Second Manifeste du Surrealisme* (Paris: Edition KRA, 1930). Originally published in *La Révolution Surrealiste* (December 15, 1929).

13. Calder, *Autobiography*, p. 113.

14. Mondrian's essay appeared in the first number of *i 10* (January 1927). The French version was published in *Vouloir* 25 (1927). For the English translation, see Harry Holtzman and Martin S. James, eds., *The New Art – The New Life, The Collected Writings of Piet Mondrian* (Boston, G. K. Hall, 1986), pp. 205–12.

15. Serge Lemoine, *Mondrian and De Stijl* (New York: Universe, 1987), pp. 47–8.

16. Michel Seuphor, *Piet Mondrian, Life and Work* (New York: Abrams, 1968), p. 160.

17. Quoted from "Alexander Calder, Mobiles," in Myfanwy Evans, ed., *The Painter's Object*, p. 63. Evans recalled that she transcribed Calder's remarks from a conversation with her. Interview with Myfanwy Evans, June 5, 1973.

18. Calder, *Autobiography*, p. 113.

19. Ibid.

20. Calder's visit to Mondrian's studio is discussed in a letter to Albert Eugene Gallatin, November 4, 1934, Gallatin Papers, New-York Historical Society, New York. See also Joan M. Marter, "Alexander Calder: Ambitious Young Sculptor of the 1930s," p. 4.

21. Letter to A. E. Gallatin, November 4, 1934, Gallatin Papers, New-York Historical Society.

22. A measure of Calder's close friendship with Mondrian was the sculptor's vigil near Mondrian's deathbed at Murray Hill Hospital in New York, where the Dutch artist died on February 1, 1944. Michel Seuphor claimed that among Mondrian's American friends, "Mondrian greatly admired Calder, who reciprocated." See Seuphor, *Piet Mondrian*, p. 192.

23. Evans, *Painter's Object*, p. 63.

24. Other than Calder, Dudley Vail Talcott was the only artist in his early thirties. The exhibition included sculptors Robert Laurent, Hunt Diederich, Gaston Lachaise, and William Zorach, and such painters as Andrew Dasburg, Stuart Davis, Arthur Dove, Guy Pène duBois, and Boardman Robinson, among others. See Museum of Modern Art, *Painting and Sculpture by Living Americans* (New York, December 2, 1930–January 20, 1931), nos. 90–3.

25. Hayes, *Three Alexander Calders*, p. 250.

26. *Constructivistes Russes: Gabo et Pevsner*, Galerie Percier, Paris, June 19–July 5, 1924. Preface to catalogue by Waldemar George.

27. Richard Marshall, *Alexander Calder: Sculpture of the Nineteen Thirties* (New York: Whitney Museum of American Art, 1987), p. 6.

28. "Alexander Calder, Volumes–Vecteurs–Densités–Dessins–Portraits," Galerie Percier, Paris, April 27–May 9, 1931, n.p.

29. Pierre Berthelot, "Alexander Calder," *Beaux-Arts* 9 (May 1931): 24.

30. See, for example, *Figures, One Large and Two Small*, 1930, in Herbert Read, *The Art of Jean Arp* (New York: Abrams, 1968), pl. 92.

31. Mulas and Arnason, *Calder*, p. 202 (quoted from an interview with the artist).

32. Seldon Rodman, ed., *Conversations with Artists* (New York: Devon-Adair, 1957), p. 139.

33. See Henri Michel, *Scientific Instruments in Art and History* (New York: Viking, 1967), p. 98.

34. Joseph Harris Caton, *The Utopian Vision of Moholy-Nagy* (Ann Arbor: UMI Research Press, 1984), pp. 46–7.

35. "Red Shift of Universes a Puzzle, Says Einstein," *The New York Times*, February 12, 1931, p. 15.

36. "What Abstract Art Means to Me," *Museum of Modern Art Bulletin* 18 (Spring 1951): 8. Stanley William Hayter also commented on Calder's visits to the planetarium in Paris, confirming his knowledge of astronomical instruments (interview with Hayter, June 22, 1973).

37. *Fables of Aesop / According to Sir Roger L'Estrange* (Paris: Harrison, 1931).

38. *Abstraction, Création Art Non-Figuratif* 1 (1932): 6.

39. Interview with Calder, October 18, 1972.

40. My appreciation to Barbara Lardieri, administrative assistant to Dean E. A. Friedman, Stevens Institute of Technology, for supplying me with the general scheme of instruction, the description of courses, and list of textbooks required during Calder's student years (1915–19).

41. Quotation is from a statement prepared by the artist and published in the catalogue for *Modern Painting and Sculpture*, Berkshire Museum, Pittsfield, Mass., August 12–25, 1933.

42. In his autobiography Calder wrote: "I had met Mary Reynolds when I went to pick up some photographs, rue de Montessuy. . . . We had gotten to be very good friends. . . . One evening she brought Marcel Duchamp to the rue de la Colonie, to see us and my work. There was one motor driven thing, with three elements. The thing had just been painted and was not quite dry yet. Marcel said: 'Do you mind?' When he put his hands on it, the object seemed to please him, so he arranged for me to show in Marie Cuttoli's Galerie Vignon, close to the Madeleine. I asked him what sort of a name I could give these things and he at once produced 'Mobile.' In addition to something that moves, in French it also means motive" (Calder, *Autobiography*, pp. 126–7). See also Calder's recollections of Duchamp in a letter of November 13, 1972, published in d'Harnoncourt and McShine, eds., *Marcel Duchamp*, p. 190.

43. "A Conversation with Alexander Calder," *Art in America* 57 (July–August 1969): 31.

44. Letter from Calder to Kynaston McShine and Anne d'Harnoncourt, November 13, 1972, in d'Harnoncourt and McShine, eds., *Marcel Duchamp*, p. 190.

45. Ibid., pp. 292–3.

46. Merry Foresta et al., *Perpetual Motif, The Art of Man Ray* (New York: Abbeville, 1989), pp. 80–1.

47. See Duchamp's *Rotary Discs* in Arturo Schwarz, *The Complete Works of Marcel Duchamp* (New York: Abrams, 1969), pl. 132, 133.

48. Statement by Calder in *Modern Painting and Sculpture*, Berkshire Museum catalogue, August 1933.

49. "Alexander Calder, A Retrospective Exhibition," Museum of Contemporary Art, Chicago, October 26–December 8, 1974 (essay by Albert Elsen).

50. Commenting on a mobile for the Pittsburgh airport, the artist wrote to Gordon Washburn, director of the Museum of Art, Carnegie Institute: "If they paint it that red and put lights on it, it ought to be wonderful," and "I hope they are going to put a spotlight on it, and I have suggested it." These comments are quoted in Diana Rose, "Calder's *Pittsburgh*: A Violated and Immobile Mobile," *Artnews* 77 (January 1978): 40–1.

51. *Abstraction, Création Art Non-Figuratif* 1 (1932): 24.

52. Laszlo Moholy-Nagy, *The New Vision* (New York: Brewer, Warren of Putnam, 1930). Only the first English edition of the book has the selection of reproductions of works by Moholy-Nagy and Bauhaus students that were possible sources for early constructions by Calder and other early constructions by American sculptors.

53. Ibid., p. 108.

54. Ibid., p. 124.

55. Ibid., p. 132.

56. Ibid., pp. 120–3.

57. Ibid., p. 124.

58. Statement by Calder in *Modern Painting and Sculpture*, Berkshire Museum catalogue, August 1933 ("The supports have been painted to disappear against a white background to leave nothing but the moving elements, their forms and colors, and orbits, speeds, and accelerations").

59. Statement by Calder in Berkshire Museum catalogue, August 1933.

60. Frank Popper, *Origins and Development of Kinetic Art* (Greenwich, Conn.: New York Graphic Society, 1968); pp. 95–6.

61. *Abstraction, Création Art Non-Figuratif* 2 (1933): 7.

62. Ibid.

63. See works by these artists published in *Abstraction–Création* and Jean Hélion's *Tensions Circulaires* (1932), in *Hélion*, Centre National d'Art Contemporain (Paris, 1970), illus. p. 20.

64. See, for example, Naum Gabo's constructions from the 1920s reproduced in *Abstraction, Création* 1 (1932): 14, and 2 (1933): 16. Also see *Kinetic Construction* and *Tower*, in Steven A. Nash and Jorn Merkert, eds., *Naum Gabo, Sixty Years of Constructivism* (Munich: Prestel, 1985), pp. 205–9.

65. Jean Gallotti, "Sculpture Automobile," *Vu* 212 (April 6, 1932): 445.

66. Calder, *Autobiography*, pp. 148–9.

67. Interview with Calder, October 18, 1972.

68. Interview with Calder, June 9, 1973.

69. See, for example, the four-ball pendulum illustration in *Apparatus for Physics* (Cambridge, Mass.: L. E. Knott Apparatus Company, 1925), p. 56, no. 25–225.

70. For Foucault's pendulum, see *Apparatus for Physics*, p. 45, no. 21–80.

71. "La selection opérée sous la responsabilité du comité de l'association abstraction création est basée sur le fait de non-figuration; toutefois ne sont invités a participer au groupement que les artistes qui se considerent comme definitivement non-figurateurs"; *Abstraction, Création Art Non-Figuratif* 1 (1932): 1.

72. Calder, *Autobiography*, p. 130.

73. Ibid., pp. 136–7.

74. Levy, *Memoir of an Art Gallery*, pp. 115–7.

75. Edward Alden Jewell, "Alexander Calder's Mobiles at the Julien Levy Gallery Suggest Majestic Swing Through Space," *New York Times*, May 13, 1932.

76. Henry McBride, "Sculpture That Moves May Be Art and May Be Machinery," *New York Sun*, May 21, 1932; reprinted in Daniel Catton Rich, ed., *The Flow of Art: Essays and Criticisms of Henry McBride* (New York: Atheneum, 1975), pp. 292–3.

77. Ibid.

78. Interview with Ibram Lassaw, May 27, 1978.

79. Ibid. This work has not survived.

80. See John R. Lane and Susan C. Larsen, eds., *Abstract Painting and Sculpture in America* (New York, Abrams, 1983).

81. Joan Marter, "Constructivism in America: The 1930s," *Arts Magazine* 56 (June 1982): 73–80.

82. Joan Marter, "Theodore Roszak's Early Constructions: The Machine as Creator of Fantastic and Ideal Forms," *Arts Magazine* 54 (November 1979): 110–14.

83. Joan Marter, *José de Rivera Constructions* (Madrid: Taller Ediciones JB, 1980).

84. Joan Marter, "Ibram Lassaw," in Lane and Larsen, eds., *Abstract Painting and Sculpture in America*, pp. 182–3.

85. Karen Wilkin, *David Smith* (New York: Abbeville, 1984), pp. 21–7.

86. "International Artist Pays Visit to Concord," *The Concord Herald*, June 16, 1932.

87. Letter from Calder to Carl Zigrosser, July 26, 1932, Zigrosser Papers, University of Pennsylvania Library, Philadelphia.

88. Letter to Zigrosser, August 10, 1932, in Zigrosser Papers, University of Pennsylvania.

89. "Calder i el circ mes petit del mon," *La Veu de Catalunva*, February 1933.

90. See Miró's painting in William Rubin, *Dada, Surrealism and Their Heritage* (New York: Museum of Modern Art, 1968), p. 67.

91. Anatole Jakovski, *Six essais: Arp, Calder, Hélion, Miró, Pevsner, Seligmann* (Paris: Jacques Povolozky, 1933). See also Anatole Jakovski, "Alexander Calder," *Cahiers d'Art* 8 (1933): 244–6.

92. See *Abstraction, Création* 3 (1934): 8.

93. Paul Recht, "Alexander Calder," *Mouvement*, June 1933.

94. Calder, *Autobiography*, p. 142.

95. Ibid., p. 143.

96. Ibid., p. 145.

97. Statement by Calder in *Modern Painting and Sculpture*, Berkshire Museum catalogue, August 1933.

98. See "Museum Acquires Calder's Art in Motion," *Art Digest* 9 (November 1, 1934); and letter from Stuart C. Henry, Director, Berkshire Museum, February 9, 1973.

99. Jack Burnham, *Beyond Modern Sculpture* (New York: Braziller, 1968), illus., p. 231.

100. Interview with Pierre Matisse, May 4, 1973.

101. "Mobiles by Alexander Calder," Pierre Matisse Gallery, New York, April 6–28, 1934. Introduction by James Johnson Sweeney was found in artist's files, Pierre Matisse Gallery.

102. Interview with Pierre Matisse, May 4, 1973.

103. See sales records for Calder's work in 1930s, and artists' files, Pierre Matisse Gallery. Works were received on consignment and returned to the artist after the show if not sold.

104. "First Municipal Art Exhibition," Rockefeller Center, New York (March 1934): cat. no. 156. See artists' files at Museum of Modern Art for additional information about *A Universe*.

105. This mobile included a number of elements suspended within a wire circle and is described in a letter from Alfred H. Barr to Abby Aldrich Rockefeller, October 16, 1934, in artists' files, Museum of Modern Art, New York.

106. Ibid.

107. Alfred H. Barr, ed., *Painting and Sculpture in The Museum of Modern Art* (New York: Museum of Modern Art, 1948), pp. 299–324 (catalogue of the collection).

108. See Joseph Harris, *The Description and Use of the Globes and Orrery* (London, 1740), pp. 152–19; Harriet Wynter and Anthony Turner, *Scientific Instruments* (New York: Scribner, 1975), pp. 43–9.

109. "Modern Works of Art: Fifth Anniversary Exhibition," Museum of Modern Art, New York, November 19, 1934–January 20, 1935.

110. Two versions of Brancusi's *Fish*, one in marble and the other in bronze, had been exhibited at the Brummer Gallery, New York, in 1926. Calder must have seen this show, which was taking place at the time of the dinner for Brancusi attended by Penguin Club members (see Chapter 1). For illustrations of *Fish*, see Sidney Geist, "Constantin Brancusi Retrospective" (New York: The Solomon R. Guggenheim Museum, 1969), pp. 108–9.

111. See, for example, Henry Moore's *Figure*, 1932, in Robert Melville, *Henry Moore Sculpture and Drawings 1921–1969* (New York: Abrams, 1968), fig. 64.

112. "Sculptor Shows New Art Medium at the University of Chicago," *Chicago Sunday Tribune*, January 20, 1935.

113. Ibid. See "Mobiles by Alexander Calder," Arts Club of Chicago, February 1–26, 1935.

114. Calder, *Autobiography*, p. 154.

115. Calder described the work as a device for amusing oneself when the sun was shining. Letter to Charlotte Whitney Allen, April 1, 1935, Allen Papers, Kenyon College, Gambier, Ohio.

116. See record of sales and artists' files, Pierre Matisse Gallery, New York.

4. Calder as Choreographer

1. George Amberg, *Art in Modern Ballet* (New York: Pantheon, 1946).

2. Calder's statement is quoted in Myfanwy Evans, ed., *The Painter's Object*, pp. 64–7.

3. *Panorama* was a dance in three parts choreographed by Martha Graham to music by Norman Lloyd. Although no reproductions of Calder's mobiles can be located, the stage design by Arch Lauterer is illustrated in Frederick Morton, "A Forum on the Modern Dance," *Theatre Arts Monthly* 19 (October 1935): 795.

4. Don McDonagh, *Martha Graham* (New York: Praeger, 1973), p. 108.

5. Music for *Horizons* was written by Louis Horst, and Calder was listed as set designer on the program. McDonagh, *Graham*, p. 113.

6. Henry Gilford, "Martha Graham and Dance Group," *The Dance Observer* 3 (April 1936): 40.

7. McDonagh, *Graham*, p. 113.

8. See Stephen Polcari, "Martha Graham and Abstract Expressionism," *Smithsonian Studies in American Art* 4 (Winter 1990).

9. Evans, ed., *The Painter's Object*, p. 84. Also see program from performance of *Socrate*, Beacon Theater, New York, November 10, 1977.

10. Quoted in program notes to performance of *Socrate*, Mobile set by Alexander Calder, Beacon Theater, New York, 1977.

11. The English text used for *Socrate* was written by Virgil Thomson. The French text for Satie's composition was based on three dialogues by Plato as translated from the Greek by Victor Cousin. *Socrate* included four performers: Alcibiades, Socrates, Phaedrus, and Phaedo. There were four singers (three women and one man), but only two singers performed in each "scene": the male singer who played Socrates was joined by one of the three women.

12. Quoted in Evans, ed., *Painter's Object*, p. 64.

13. Among those theatrical pieces Calder himself considered most successful were the two designs for Martha Graham's dances *Panorama* and *Horizons*, Satie's *Socrate*, and *Work in Progress*, a ballet about the creation of the world, performed at the Rome Opera House in 1968. This piece, which was originated and fully choreographed by Calder, is a full development of the artist's ideas for the mechanical theater that he began to explore in the 1930s. Stabiles and huge painted backdrops of biomorphic and geometric forms were the setting for enormous mobiles that performed to the accompaniment of electronic music written by three Italian composers. Dancers appear only in the final scene of this ballet, and most of the performance features mechanical elements alluding to the progress of all forms of life through the ages. Calder also made set designs and costumes for *Amériques*, a ballet set to the music of his friend the composer Edgard Varèse, performed in Amiens, France, in 1971. For a complete listing of Calder's theatrical productions, see Lipman, *Calder's Universe*, pp. 171–81.

14. London, Victoria and Albert Museum, *Modern Swedish Ballet* (1970).

15. The International Theatre Exposition, Steinway Building, 109–113 West 57th Street, New York (February 27–March 15, 1926), was organized by Frederick Kiesler and Jane Heap.

16. See "Special Theatre Number," *Little Review* II (Winter 1926). Editors were Margaret Anderson and Jane Heap. The issue's twenty-four essays included Remo Bufano, "The Marionette in the Theatre"; Frederick Kiesler, "Debacle of the Modern Theatre"; and Enrico Prampolini, "The Magnetic Theatre."

17. "Modern Painting and Sculpture" was held at the Berkshire Museum, Pittsfield, Massachusetts, in August 1933. Calder's statement appeared in the accompanying catalogue.

18. *Ballet Mécanique*, an experimental film without scenario, was produced by Léger in 1924. Photography was by Man Ray and Dudley Murphy, music by George Antheil. For a complete description and shot analysis of this film, see Standish D. Lawder, *The Cubist Cinema* (New York: New York University Press, 1975), pp. 117–259.

19. "Ballet Mécanique," in Fernand Léger, *Functions of Painting* (New York: Viking, 1965), pp. 48–9.

20. James Johnson Sweeney, "Léger and the Cinesthetic," *Creative Art* 10 (June 1932): 441.

21. Walter Gropius and Laszlo Moholy-Nagy, *Die Bühne im Bauhaus* (Munich: Albert Langen Verlag, 1925).

22. H. H. Arnason, *Calder*, p. 65.

23. For Moholy-Nagy's ideas about theater, see "Theater, Circus, Variety" in Walter Gropius, ed., *The Theater of the Bauhaus* (Middletown, Conn.: Wesleyan University Press, 1961), pp. 49–70.

24. "Special Theatre Number, The International Theatre Exposition, New York 1926," *Little Review* 11 (February–March 1926): nos. 618–23.

25. Schlemmer's statement was included in his lecture–demonstration given at the Bauhaus March 16, 1927, and published in Gropius, ed., *The Theater of the Bauhaus*, p. 88.

26. Schlemmer's Bauhaus dances were reconstructed by Debra McCall in 1983 and performed at the Stage Workshop of the Dessau Bauhaus. These dances were presented at the Solomon R. Guggenheim Museum in January 1984. See Debra McCall, "Reconstructing Schlemmer's Bauhaus Dances: A Personal Narrative," in Arnold L. Lehman and Brenda Richardson, eds., *Oskar Schlemmer* (Baltimore: Baltimore Museum of Art, 1986), pp. 149–59; *Oskar Schlemmer und die abstrackte Bühne* (Zurich, Kunstgewerbemuseum, 1961).

27. Oskar Schlemmer, in "Stage Elements," a 1931 lecture quoted in Karin von Maur, *Oskar Schlemmer: Sculpture* (New York: Abrams, 1972), p. 43.

28. Interview with Alexander Calder in Kuh, ed., *The Artist's Voice*, p. 39.

29. "Mobiles and Objects by Calder," Pierre Matisse Gallery, New York, February 10–29, 1936.

30. "Alexander Calder," *New York Sun*, February 15, 1936.

31. "Calder's Mobiles Are Like Living Miró Abstractions," *New York Times*, February 15, 1936.

32. Alfred H. Barr, *Fantastic Art, Dada, and Surrealism* (New York: Museum of Modern Art, December 9, 1936–January 17, 1937), cat. no. 530.

33. Alfred H. Barr, *Cubism and Abstract Art* (New York: Museum of Modern Art, 1936), p. 197.

34. Ibid., p. 200.

35. "International Surrealist Exhibition," New Burlington Galleries, London, June 11–July 4, 1936, cat. nos. 44 and 45.

36. "Alexander Calder Named to Design Radio Award," clipping with no identifiable newspaper, Calder papers, Archives of American Art, Smithsonian Institution, Washington, D.C.

37. Calder, *Autobiography*, 155.

38. Letter from Stuart Henry, Director, Berkshire Museum, February 9, 1973.

39. Rosamund Frost, "Calder: A Humorous and Inventive Artist," *Artnews* 25 (March 13, 1937): 14.

40. Kuh, ed., *The Artist's Voice*, p. 42.

41. Calder, *Autobiography*, pp. 157–8.

42. Catherine Blanton Freedberg, *The Spanish Pavilion at the Paris World's Fair* (New York: Garland, 1986), pp. 472–3.

43. See also Phyllis Tuchman, "Alexander Calder's Almadén Mercury Fountain," *Marsyas* 16 (1972–3): 97–106.

44. Alexander Calder, "Mercury Fountain," *Technology Review* 40 (February 1938): 202.

45. Alexander Calder, "Mercury Fountain," *Stevens Indicator* 55 (May 1938): 7.

46. Letter from Lord Clark, August 11, 1976. The mobile was destroyed when Kenneth Clark's house was bombed in the war.

47. "Calder Mobiles," *Manchester Guardian*, December 28, 1937. This newspaper clipping and others from the London reviews of Calder's show at the Mayor Gallery are in the Calder Papers, Archives of American Art, Washington, D.C.

48. Naum Gabo, "The Constructive Idea in Art," in J. L. Martin, Ben Nicholson, and N. Gabo, eds., *Circle, International Survey of Constructive Art* (London: Faber & Faber, 1937), p. 1.

49. Alexander Calder, "A Water Ballet," *Theatre Arts Monthly* 23 (August 1939): 578.

50. A stroboscopic photograph of a Calder mobile in motion (1941) is included in the catalogue. See *First Papers of Surrealism*, October 14–November 7, 1942 (New York: Coordinating Council of French Relief Societies), n.p.

51. Ibid., n.p.

52. Willard Gallery, New York, "Calder Jewelry," December 3–25, 1940.

53. "Calder Mobiles," George Walter Vincent Smith Art Gallery, Springfield, Massachusetts, November 8–27, 1938 (essay by James Johnson Sweeney).

54. George Rickey, "Origins of Kinetic Art," *Studio International* 173 (February 1967): 67.

55. Henri Gabriel, "The Hanging Mobile: A Historical Review," *Leonardo* 18 (1985): 40.

5. CALDER AS A PUBLIC ARTIST

1. Henry McBride, "Calder," *New York Sun*, October 29, 1943. Reprinted in Rich, ed., *The Flow of Art*, p. 394.

2. This untitled mobile is now in the collection of the Aluminum Company of America. See John Lane and Susan Larsen, eds., *Abstract Painting and Sculpture in America, 1927–1944* (Pittsburgh: Museum of Art, Carnegie Institute, 1983), p. 62.

3. Sweeney, *Alexander Calder* (1951).

4. Ibid., pp. 7–8.

5. James Johnson Sweeney, "The Position of Alexander Calder," *Magazine of Art* 37 (May 1944): 180.

6. Rosamund Frost, "Calder Grown Up: A Museum-Size Show," *Artnews* 42 (November 1–14, 1943): 11.

7. Maude Riley, "The Modern Opens Retrospective Show of Calder's Light-Hearted Art," *Art Digest* 18 (October 1, 1943): 6.

8. Calder, *Autobiography*, p. 184.

9. Interview with Bernice Rose, quoted in *A Salute to Alexander Calder*, p. 14.

10. For a presentation of this mobile, see Sweeney, "The Position of Alexander Calder," p. 180.

11. Rosamund Frost, "Calder Grown Up: A Museum-Size Show," p. 11.

12. Works created by David Smith, Theodore Roszak, Herbert Ferber, and Seymour Lipton in the 1940s and 1950s are illustrated in Wayne Andersen, *American Sculpture in Process* (Boston: New York Graphic Society, 1975), pp. 66–77.

13. See Theodore Roszak, "Some Problems of Modern Sculpture," *Magazine of Art*, 42 (February 1949): 53–56.

14. Karen Wilkin, *David Smith* (New York: Abbeville Press, 1984), pp. 27–29.

15. This material is taken from interviews with David Smith's first wife, Dorothy Dehner, June 1985. I intend to develop these ideas further in a book on American sculpture, 1925–80. See also Joan Marter, *Dorothy Dehner and David Smith: Their Decades of Search and Fulfillment* (New Brunswick, N.J.: Zimmerli Art Museum, Rutgers University), pp. 4–19.

16. Sam Hunter, *Isamu Noguchi* (New York: Abbeville, 1978), p. 82.

17. David Smith, for example, had no solo exhibitions abroad during his lifetime. He did participate in some group exhibitions in Paris, Venice, São Paulo, and London during the 1950s (see Wilkin, *Smith*, pp. 119–21).

18. Calder, *Autobiography*, p. 179.

19. Ibid., p. 180. For a review of this show, see "Calder and Tanguy," *Art Digest* 17 (June 1, 1943): 12.

20. "Les Mobiles de Calder," by Jean-Paul Sartre, originally appeared in the exhibition catalogue *Alexander Calder: Mobiles, Stabiles and Constellations* (Paris: Galerie Louis Carré, October–November, 1946). An English

translation of this essay appeared in Jean-Paul Sartre, "Existentialist on Mobilist," *Artnews* 46 (December 1947): 22; 55–6.

21. Jean-Paul Sartre, "Calder's Mobiles," Buchholz Gallery, New York, 1947 (reprinted in Mulas and Arnason, *Calder*, p. 48).

22. See "Twenty Leaves and an Apple, Mobile for Cincinnati's Terrace Plaza Hotel," *Architectural Forum* 88 (April 1948): 148. A small photo of the mobile is included.

23. "Artists Join Architects," *Artnews* 47 (May 1948): 10.

24. Interview with Klaus Perls, November 26, 1988.

25. Dorothy Seckler, "Reviews and Previews: Calder," *Artnews* 50 (January 1952): 40.

26. Calder, *Autobiography*, pp. 209–10. Calder recalled that he met Henri Pichette at lunch with Giacometti in Paris. *Nucléa*, according to Calder, included a first act "about war, the second, about love."

27. Georges Neveux, "Pichette et Molière au Théâtre National Populaire," *Arts Spectacles* (May 8–14, 1952): 3.

28. E. Newton, "Critic Wiretaps Alexander Calder," *New York Times Magazine* (August 10, 1952): 16–18.

29. See, for example, "Artistic Smith at Work," *Life* 33 (September 22, 1952): 75–6, 78.

30. Dorothy Seiberling, "Calder, His Gyrating 'Mobile' Art Wins International Fame and Prizes," *Life Magazine* (August 25, 1952): 83.

31. For an illustrated account of Calder's properties in Saché, see "Alexander Calder's Place in France," *Architectural Record*, 165 (February 1979): 99–101.

32. Calder, *Autobiography*, pp. 240–2.

33. "G. M. Technical Center," *Fortune* 44 (December 1951): 25.

34. Robert Osborn, "Calder's International Monuments," *Art in America* 57 (March–April 1969): 32–3. For other details of the General Motors Technical Center, see J. McAndres, "First Look at the Technical Center," *Art in America* 44 (Spring 1956): 26–33. McAndrew mentions Calder's "liquid ballet-mobile," which included a sequence titled by the sculptor "scissors," "fantails," "the seven sisters," and "the plops."

35. For information on the Brussels Fair and drawings for commissioned sculptures by Calder, Harry Bertoia, and José de Rivera, see "Brussels '58, the United States Speaks to the World," *Interiors* 117 (September 1957): 128–38.

36. Ibid., p. 138. This article includes a full-page drawing of the fountain with explanation in Calder's own writing.

37. Geffrey Hellman, "Calder Revisited," *New Yorker* 36 (October 22, 1960): 175.

38. Benjamin Forgey, "Calder's Final Triumph," *Washington Post*, November 21, 1984; Kara Swisher, "Calder's Capital Creation, Senate Dedicates 'Mountains, Clouds,' " *Washington Post*, May 6, 1987.

39. In 1960, the mobile was repainted red, but Calder was never satisfied with the color, which he considered "pink." Not until after the artist's death did storms of protest result in the readjustment of *Pittsburgh* and its return to the Museum of Art at the Carnegie Institute. For a discussion of this controversy, see Diana Rose, "Calder's *Pittsburgh*: A Violated and Immobile Mobile," pp. 38–42; "Mobilizing for Pittsburgh," *Artnews* 77 (April 1978): 26–7; and Bonnie Hayes, "Alexander Calder's *Pittsburgh*," *Carnegie Magazine* 53 (October 1979): 12–17.

40. Vernon Gay and Marilyn Evert, *Discovering Pittsburgh's Sculpture* (Pittsburgh: University of Pittsburgh Press, 1983), pp. 170–1.

41. William Seitz, *The Art of Assemblage* (New York: Museum of Modern Art, 1961), p. 89.

6. LATE YEARS

1. Geffrey Hellman, "Calder Revisited," p. 169. "It's true that I've more or less retired from the smaller mobiles. I regard them as sort of fiddling. The engineering on the big objects is important; they're mostly designed for a particular spot."

2. For more information on Pop art and minimalism, see Irving Sandler, *American Art of the 1960s* (New York: Harper & Row, 1988).

3. Barbara Rose, *Claes Oldenburg* (New York: Museum of Modern Art, 1970), p. 205.

4. See, for example, *Chock* (c. 1950) and *Chock Full o' Nuts* (c. 1955) in Daniel Marchesseau, *The Intimate World of Alexander Calder* (Paris: Solange Thierry, 1989), pp. 154–5.

5. Mario Amaya, *Pop Art and After* (New York: Viking, 1965), p. 47.

6. Sandler, *American Art*, pp. 242–60.

7. Maurice Tuchman, ed., *American Sculpture of the Sixties* (Los Angeles: Los Angeles County Museum of Art, 1967).

8. Victoria Donahue, "Swann Fountain," in Fairmount Park Art Association, *Sculpture of a City: Philadelphia's Treasures in Bronze and Stone* (New York, 1974), pp. 230–9. Stirling Calder himself wrote an article entitled "The Relation of Sculpture to Architecture," *The American Architect* 118 (December 8, 1920): 723–32. As discussed in Chapter 1, Alexander Stirling Calder's other major works include a colossal statue of Leif Eriksson and a statue of George Washington at Washington Square in New York City. For further sculptural commissions by Stirling Calder, see Wayne Craven, *Sculpture in America* (New York: Crowell, 1968), pp. 570–73.

9. See George Gurney, "Alexander Milne Calder: William Penn," in Fairmount Park Art Association, *Sculpture of a City: Philadelphia's Treasures in Bronze and Stone* (New York, 1974), pp. 104–9.

10. For other works by Alexander Milne Calder see Wayne Craven, *Sculpture in America*, 1968), pp. 483–6; George Gurney, "The Sculpture of City Hall," in *Sculpture of a City*, pp. 94–103; Victoria Donahue, "Alexander Milne Calder: General Meade," in *Sculpture of a City*, pp. 118–23.

11. See Joan M. Marter, "Modern American Sculpture at the New York World's Fair, 1939," in Joan Marter, Roberta K. Tarbell, and Jeffrey Wechsler, *Vanguard American Sculpture 1913–1939* (New Brunswick: Rutgers University Art Gallery, 1979), pp. 141–9.

12. Donald W. Thalacker, *The Place of Art in the World of Architecture* (New York: Chelsea House, 1980).

13. Robert Osborn, "Calder's International Monuments," *Art in America* 57 (March–April 1969): 49.

14. For a discussion of this commission, see Giovanni Carandente, *Calder*, pp. 214–27.

15. Osborn, "Calder's International Monuments," *Art in America*, p. 38.

16. When Calder was asked in an interview to name the artists he most admired, he mentioned Klee, Goya, Miró, Matisse, and Bosch. See Kuh, ed., *The Artist's Voice*, p. 50.

17. See Alfred H. Barr, *Matisse: His Art and His Public* (New York: Museum of Modern Art, 1951), pp. 462–5. The first version of *The Dance* was a mural commissioned by the Barnes Foundation, Merion, Pennsylvania, now in the Musée d'Art Moderne de la Ville de Paris. *The Dance II* was installed at the Barnes Foundation in 1932–3, and reproduced in *Cahiers d'Art* 1 (1935): 13.

18. Calder's designs bear some resemblance to the arching figures in Matisse's *The Swimming Pool* of 1952, now in the collection of the Museum of Modern Art, New York. See John Elderfield, *The Cut-Outs of Henri Matisse* (New York, 1978), pl. 27.

19. Further details on NEA's Works of Art in Public Places Program are given in Brian O'Doherty, "Public Art and the Government: A Progress Report," *Art in America* 62 (May-June 1974): 44–47.

20. The NEA matching grant provided $45,000 of the total construction cost, but the remainder was raised from private donations in Grand Rapids, Michigan. My thanks to the staff of the Works of Art in Public Places Program, National Endowment for the Arts, Washington, D. C., for assistance in the examination of newspaper clippings and documents related to the Calder commission.

21. Robert Sherrill, "What Grand Rapids Did for Jerry Ford and Vice Versa," *New York Times Magazine* (October 20, 1974): 31–2.

22. Irvin Farman, Director of Public Relations, Fort Worth National Bank, to Marter, January 6, 1976.

23. See, for example, Nervi's reinforced concrete hangar at Ortobello, in Vittorio Greggott, *New Directions in Italian Architecture* (New York, 1968), p. 37.

24. Interview with Klaus Perls, November 26, 1988.

25. Details of this commission are in the archives of the Planning Office, National Gallery of Art, Washington, D.C.

26. George M. White, Architect of the Capitol, report dated May 17, 1983, archives of the United States Capitol. I am indebted to Barbara Wolanin, Curator of the collection of the Capitol, for her assistance with the records concerning this commission.

27. Jean Davidson, "Four Calders," *Art in America* 50 (Winter 1962): 70. Stirling Calder's attitudes are well presented in *Thoughts of A. Stirling Calder on Art and Life* (New York: privately printed, 1947). On page 39, for example, he observed, "Life is irritation. Humanity groaning beneath the necessity of toil, yearns for respite from the driving cares of time that know no rest, unless by gentle art, beguiled to make believe that what we wish is true."

28. James Johnson Sweeney, "Alexander Calder: Work and Play," *Art in America* 51 (August 1963): 9.

29. Richard Lemon, "The Soaring Art of Alexander Calder" *Saturday Evening Post* (27 February 1965): 31.

30. See, for example Henri Gabriel, "The Hanging Mobile: A Historical Review," *Leonardo* 18 (1985): 39–44.

31. Peter Selz, *George Rickey, Sixteen Years of Kinetic Sculpture* (Washington, D.C.: Corcoran Gallery of Art, 1966); n.p.

32. Nan Rosenthal, *George Rickey* (New York: Abrams, 1977), pp. 34–7.

33. See, for example, Peter Selz, *Directions in Kinetic Sculpture* (Berkeley: The University Art Museum, 1966).

34. Quoted from "Tinguely on Tinguely," 1982 radio broadcast, in Pontus Hultén, *Jean Tinguely, A Magic Stronger Than Death* (New York: Abbeville, 1987), p. 350.

35. Fernard Léger, "Erik Satie Illustrated by Calder" (Paris: Galerie Percier, 1931).

36. James Johnson Sweeney, *Alexander Calder* (1943), p. 7 (quoted passage within Sweeney's text is from Frederick Jackson Turner, *The Frontier in American History*, p. 37).

37. See, for example, Beatrix T. Rumford and Carolyn J. Weekley, *Treasures of American Folk Art* (Boston: Little, Brown, 1989).

38. Holliday T. Day, *Shape of Space: The Sculpture of George Sugarman* (Omaha, Neb.: Joslyn Art Museum, 1982).

Solo Exhibitions

1928

"Wire Sculpture by Alexander Calder." Weyhe Gallery, New York, February 20–March 3 [also 1929].

1929

"Sculpture Bois et Fil de Fer de Alexander Calder." Galerie Billiet, Paris, January 25–February 7.

"Alexander Calder: Skulpturen aus Holz und aus Draht." Galerie Neumann-Nierendorf, Berlin, April 1–15.

"Alexander Calder." Fifty-sixth Street Galleries, New York, December 2–14.

1930

"Alexander Calder" [exhibition of sculptures in wire and wood]. Harvard Society for Contemporary Art, Cambridge, Massachusetts, January 27–February 4.

1931

"Alexandre Calder: Volumes–Vecteurs–Densités–Dessins–Portraits." Galerie Percier, Paris, April 27–May 9.

1932

"Calder: ses Mobiles." Galerie Vignon, Paris, February 12–29.

"Calder: Mobiles / Abstract Sculptures." Julien Levy Gallery, New York, May 12–June 11.

1933

"Calder." Galerie Pierre Colle, Paris, May 16–18.

1934

"Mobiles by Alexander Calder." Pierre Matisse Gallery, New York, April 6–28 [also 1936, 1937, and annually 1939–43].

1935

"Mobiles by Alexander Calder." Renaissance Society of the University of Chicago, January 14–31 [and Arts Club of Chicago, February 1–26].

1937

"Calder: Mobiles and Stabiles." Mayor Gallery, London, December.

1938

"Calder Mobiles." George Walter Vincent Smith Art Gallery, Springfield, Massachusetts, November 8–27.

1940

"Calder Jewelry." Willard Gallery, New York, December 3–25 [also 1941, 1942].

1941

"Calder, Mobiles, Stabiles, Jewelry; A Few Paintings by Paul Klee." Design Project, Los Angeles, California, September 27–October 27.

1942

"Mobiles by Alexander Calder." San Francisco Museum of Art, November 4–19.

"Alexander Calder: Sculptures and Constructions." Museum of Modern Art, New York, September 29–January 16, 1944.

1944

"Calder." France Forever (The Fighting French Committee in the United States), Washington, D.C., March 27–April 9.

"Recent Work by Alexander Calder." Buchholz Gallery, New York, November 28–December 23 [also 1945, 1947, 1949].

1945

"Calder Gouaches." Samuel M. Kootz Gallery, New York, September–October 6.

1946

"Calder: Mobiles, Stabiles, Constellations." Galerie Louis Carré, Paris, October 25–November 16.

1947

"Alexander Calder Mobiles." Portland Museum of Art, Portland, Oregon, January.

1948

"Alexander Calder." Ministério da Educacao e Saude, Rio de Janeiro, September [and tour to Museu de Arte, São Paulo, October–November].

"Alexander Calder: Mobiles and Articulated Sculpture." California Palace of the Legion of Honor, San Francisco, October 2–November 21.

1949

"Calder." Margaret Brown Gallery, Boston, October 25– November 12 [also 1952].

1950

"Calder: Mobiles et Stabiles." Galerie Maeght, Paris, June 30–July 27 [also 1952, 1954, 1959, 1963, 1966, 1968, 1971, 1973, 1975, 1976, 1981].

"Alexander Calder." Stedelijk Museum, Amsterdam, October 6–November 15.

"Alexander Calder: Mobiles et Stabiles." Galerie Blanche, Stockholm, December [also 1958, 1962, 1970].

"Calder, New Gallery." Charles Hayden Memorial Library, Massachusetts Institute of Technology, Cambridge, Massachusetts, December 5–January 14, 1951.

1951

"Mobiles and Stabiles by Alexander Calder." Lefevre Gallery, London, January. [also 1955].

"Alexander Calder." Neue Galerie, Vienna, May 10–June 15.

1952

"Alexander Calder: Gongs and Towers." Curt Valentin Gallery, January 15–February 10. [also 1955].

"Calder Mobile." Galerie Parnass, Wuppertal, West Germany, June.

1953

"Alexander Calder." Walker Art Center, Minneapolis, March 22–April 19.

"Alexander Calder." Frank Perls Gallery, Beverly Hills, California, May–mid-June.

"Mobiles by Alexander Calder." San Francisco Museum of Art, September 2–27.

1954

"Alexander Calder: Stabiles, Mobiles, Gouachen." Kestner-Gesellschaft, Hannover, March 18–May 2.

1955

"Calder." Graduate School of Design, Harvard University, Cambridge, Massachusetts, April 25–May 25.

"Exposición Calder," Museo de Bellas Artes, Caracas, September 11–25.

1956

"Calder," Perls Galleries, New York, February 6–March 10. [also 1958 and annually 1960–4, 1966–76].

"Calder." Gallerie dell'Obelisco, Rome, March 14–31 [also 1971].

"Alexander Calder." Galleria del Naviglio, Milan, April 7–17. [also 1964].

"Jewelry and Drawings by Alexander Calder." Institute of Contemporary Art, Boston, October 18–November 21.

1957

"Alexander Calder." Kunsthalle Basel, May 22–June 23.

1959

"Alexander Calder." Stedelijk Museum, Amsterdam, May 5–June 22 [tour to Kunsthalle, Hamburg; Museum Haus Lange, Krefeld; Kunsthalle, Mannheim; Haus der Jugend, Wuppertal-Barmen; Kunst und Museumverein, Wuppertal; Kunstgewerbemuseum, Zurich; Palais des Beaux-Arts, Brussels].

"Alexander Calder." Museu de Arte Moderna, Rio de Janeiro, September–October.

1961
"Alexander Calder: The Gouaches." Lincoln Gallery, London, November.

1962
"Michel Butor 'Cycle' sur Neuf Gouaches d'Alexandre Calder." Galerie La Hune, Paris, June.

"Alexander Calder: Sculpture, Mobiles." Tate Gallery, London, July 4–August 12.

"Alexander Calder: Mobiles, Gouaches, Tapisseries." Musée de Rennes, France, December 4–January 20.

1964
"Alexander Calder: Circus Drawings, Wire Sculpture and Toys." Museum of Fine Arts, Houston, Texas, November 24–December 13.

"Alexander Calder: A Retrospective Exhibition." Solomon R. Guggenheim Museum, New York, November–January 1965 [and, in altered form, tour to Milwaukee Art Center; Washington University Art Gallery, St. Louis, Missouri; Des Moines Art Center; Art Gallery of Toronto].

1965
"Calder." Musée National d'Art Moderne, Paris, July–October.

1966
"Alexandre Calder." Galerie Krugier, Geneva, June.

"Mobiles by Alexander Calder." The Berkshire Museum, Pittsfield, Massachusetts, July 2–31.

"Alexander Calder: Drawings." Institute of Contemporary Arts, London, September 29–October 29.

1967
"Calder: Nineteen Gifts from the Artist." Museum of Modern Art, New York, February 1–April 5, 1967.

"Recent Stabiles by Alexander Calder." Phillips Collection, Washington, D.C., April 8–May 30.

"Alexander Calder." Akademie der Kunste, Berlin, May 21–July 16.

1968
"Calder." Maison de la Culture, Bourges, March 15–May [tour to Musée des Augustins, Toulouse, September].

1969
"Alexander Calder: Large Standing Mobiles." Gimpel Fils, London, February 18–March 15 [also 1971].

"Calder." Fondation Maeght, St-Paul-de-Vence, April 2–May 31 [tour to Louisiana Museum, Humlebaek, Denmark; Stedelijk Museum, Amsterdam].

"Alexander Calder: Mobiles and Stabiles." Grand Rapids Art Museum, Michigan, May 18–August 24.

"Calder en Venezuela." Fundación Eugenio Mendoza, Caracas, July 6–August 3 [also exhibited at Universidad Central de Venezuela and Museo de Bellas Artes, Caracas].

"A Salute to Alexander Calder." Museum of Modern Art, New York, December 18–February 15, 1970 [tour to Museo de Art Moderno, Bogota; Museo Universitario de Ciencias y Arte, Mexico City; Museo Nacional de Artes, Buenos Aires; Museo Nacional de Bellas Artes, Santiago].

1970

"Calder Gouaches: The Art of Alexander Calder." Long Beach Museum of Art, California, January 11–February 8 [tour to Fine Arts Gallery, San Diego; Phoenix Art Museum].

1971

"Calder." Musée Toulouse-Lautrec, Albi, France, June–September [tour to Maison des Arts et Loisirs, Sochaux, France].

"Alexander Calder Tapestries." Whitney Museum of American Art, New York, October 5–November 14.

"Early Works: Alexander Calder." Taft Museum, Cincinnati, December 12–January 31, 1972.

1972

"Aubusson Tapestries by Calder." Leonard Hutton Galleries, New York, April 14–May 31 [also 1974].

"Alexander Calder: The Circus." Whitney Museum of American Art, New York, April 21–June 11.

1973

"Alexander Calder." Galerie Maeght, Zurich [also 1975, 1982].

"Calder Airplanes." Solomon R. Guggenheim Museum, New York, August 9–October 7.

"Alexander Calder: Prints, Drawings and Illustrated Books." Detroit Institute of Arts, October 18–November 18.

1974

"Alexander Calder" [exhibition of mobiles and stabiles]. Musée Municipal, Cluny, France, June.

"Alexander Calder: A Retrospective Exhibition, Work from 1925 to 1974." Museum of Contemporary Art, Chicago, October 26–December 8.

"Alexander Calder." Galerie Denise Rena–Hans Meyer, Düsseldorf, October 17–November 22.

1975

"Calder." Haus der Kunst, Munich, May 10–July 13 [tour to Kunsthaus, Zurich, August 16–November 2].

1976

"Calder's Universe." Whitney Museum of American Art, New York, October 14–February 6, 1977 [tour to High Museum of Art, Atlanta; Walker Art Center, Minneapolis; Dallas Museum of Fine Arts; Seibu Museum of Art,

Tokyo; Kita-kyushu City Museum of Art, Japan; Prefectural Museum of Modern Art, Kobe, Japan; City Gallery, Yokohama, Japan].

1977

"Calder: Exposición Antologica." Galeria Maeght, Barcelona, April–May.

"Alexander Calder Memorial." American Academy and Institute of Arts and Letters, New York, November 15–December 30.

1978

"Images de Calder." Centre George Pompidou, Paris, February 17–March 27.

"Alexander Calder: Sculpture of the 1970s." M. Knoedler Galleries, New York, October 4–November 2 [also 1979, 1980/1, 1982, 1983].

1981

"Alexander Calder, A Concentration of Works from the Permanent Collection." Whitney Museum of American Art, New York, February 17–May 3.

1982

"Calder: Small Scale." Knoedler Gallery, New York, May 15–June 3, 1982.

1983

"Alexander Calder: Mobiles, Stabiles, Gouaches, Drawings from Michigan Collections." Flint Institute of Arts, February 20–March 27.

"Calder, Mostra Retrospettiva." Palazzo a Vela, Turin, July 2–September 25.

1986

"Alexander Calder: Artist as Engineer." List Visual Arts Center, Massachusetts Institute of Technology, Cambridge, January 31–April 13.

"Alexander Calder: Sculpture of the Nineteen Thirties." Whitney Museum of American Art, November 14–January 17, 1987.

1987

"Alexander Calder Bronzes." The Pace Gallery, New York, March 20–April 18, 1987.

1989

"The Intimate World of Alexander Calder." Cooper-Hewitt Museum, Smithsonian Institution, New York, October 17, 1989–March 11, 1990.

Selected Bibliography

INTERVIEWS AND STATEMENTS BY CALDER

Calder, Alexander. "Comment réaliser l'art?" *Abstraction, Création Art Non-Figuratif* 1 (1932): 6.

Statement in *Modern Painting and Sculpture,* exhibition catalogue. Pittsfield, Mass.: The Berkshire Museum, 1933.

"Mobiles." In *The Painter's Object*, edited by Myfanwy Evans. London: Gerald Howe, 1937.

"Mercury Fountain." *Technology Review* 40 (March 1938): 202.

"Mercury Fountain." *Stevens Indicator* 55 (May 1938): 2–3, 7.

Statement in *Maud and Patrick Morgan / Alexander Calder.* Exhibition catalogue. Andover, Mass.: Addison Gallery of American Art, 1943.

Statement in "The Ides of Art: 14 Sculptors Write." *The Tiger's Eye* 1 (June 15, 1948): 74.

"A Piece of My Workshop '48." In *Calder, Matisse, Matta, Miró: Mural Scrolls.* New York: Katzenbach & Warren, 1949.

Statement in "What Abstract Art Means to Me." *The Museum of Modern Art Bulletin* 18 (Spring 1951): 8–9.

Calder: An Autobiography with Pictures. New York: Pantheon, 1966.

"A Conversation with Alexander Calder." *Art in America* 57 (July–August 1969): 31.

Kuh, Katherine, ed. *The Artist's Voice: Talks with Seventeen Artists.* New York: Harper & Row, 1962.

Osborn, Robert. "Calder's International Monuments." *Art in America* 57 (March–April 1969): 32–49.

Rodman, Selden, ed. *Conversations with Artists.* New York: Devon-Adair, 1957.

Staempfli, George W. "Interview with Alexander Calder." *Quadrum* 6 (1959): 9–11.

Taillandier, Yvon. "Calder: personne ne pense à moi quand on un Cheval à faire." *XXe siècle* (March 15, 1959).

Books Illustrated by Calder

Calder, Alexander. *Animal Sketching*. Pelham, N.Y.: Bridgman, 1926.

Coleridge, Samuel Taylor. *The Rime of the Ancient Mariner*. New York: Reynal & Hitchcock, 1946.

Fables of Aesop / According to Sir Roger L'Estrange. Paris: Harrison, 1931.

La Fontaine, Jean de. *Selected Fables*. New York: Quadrangle, 1948.

Sweeney, James Johnson, ed. *Three Young Rats and Other Rhymes*. New York: Curt Valentin, 1944.

Wilbur, Richard, ed. *A Bestiary*. New York: Pantheon, 1955.

Monographs and Selected Solo-Exhibition Catalogues

Arnason, H. H[arvard], and Pedro Guerrero. *Calder*. New York: Van Nostrand, 1966.

Bellew, Peter. *Calder*. Barcelona: Ediciones Poligrafa, 1969.

Besset, Maurice. *Alexander Calder*. Exhibition catalogue. Munich: Haus der Kunst, 1975.

Bourdon, David. *Calder: Mobilist, Ringmaster, Innovator*. New York: Macmillan, 1980.

Bruzeau, Maurice. *Calder*. New York: Abrams, 1979.

Carandente, Giovanni. *Calder: Mobiles and Stabiles*. New York: New American Library in association with UNESCO, 1968.

Calder. Exhibition catalogue. Milan: Electa, 1983.

Cassou, Jean. *Alexander Calder: Mobiles, Gouaches, Tapisseries*. Exhibition catalogue. Rennes, France: Musée de Rennes, 1963.

Calder. Exhibition catalogue. Paris: Musée National d'Art Moderne, 1965.

Elsen, Albert E. *Alexander Calder: A Retrospective Exhibition*. Exhibition catalogue. Chicago: Museum of Contemporary Art, 1974.

Fondation Maeght. *Calder*. Exhibition catalogue. St-Paul-de-Vence: Fondation Maeght, 1969.

Hayes, Margaret Calder. *Three Alexander Calders: A Family Memoir*. Middlebury, Vt.: Eriksson, 1977.

Killy, Herta Elisabeth. *Alexander Calder*. Exhibition catalogue. Berlin: Akademie der Kunst, 1967.

Léger, Fernand. *Alexander Calder: Volumes–Vecteurs– Densités–Dessins–Portraits*. Exhibition catalogue. Paris: Galerie Percier, 1931.

Lipman, Jean. *Calder's Universe*. New York: Viking (with the Whitney Museum of American Art), 1976.

Lipman, Jean, and Nancy Foote, eds. *Calder's Circus*. New York: Dutton (with the Whitney Museum of American Art), 1972.

Mancewicz, Bernice Winslow. *Alexander Calder: A Pictorial Essay*. Grand Rapids, Mich.: William B. Eerdmans, 1969.

Marchesseau, Daniel. *The Intimate World of Alexander Calder*. Paris: Solange Thierry, 1989 (translated by Eleanor Levieux and Barbara Shuey).

Marshall, Richard. *Alexander Calder: Sculpture of the Nineteen thirties*. Exhibition catalogue. New York: Whitney Museum of American Art, 1987.

Marter, Joan. *Alexander Calder, Artist as Engineer*. Exhibition catalogue. Cambridge: List Visual Arts Center, Massachusetts Institute of Technology, 1986.

Merkel, Jayne. *Early Works: Alexander Calder*. Exhibition catalogue. Cincinnati: Taft Museum, 1971.

Messer, Thomas M. *Alexander Calder: A Retrospective Exhibition*. Exhibition catalogue. New York: Solomon R. Guggenheim Museum, 1964.

Mindlin, Henrique E. *Alexander Calder*. Exhibition catalogue. Rio de Janeiro: Ministerio da educacao e Sauder, 1948.

Mulas, Ugo, and H. Harvard Arnason. *Calder*. New York: Viking, 1971.

Ragon, Michel. *Calder: Mobiles and Stabiles*. New York: Tudor, 1967.

Rose, Bernice. *A Salute to Alexander Calder*. Exhibition catalogue. New York: Museum of Modern Art, 1969.

di San Lazzaro, G., ed. *Homage to Alexander Calder*. New York: Tudor, 1972.

Sartre, Jean-Paul. *Alexander Calder: Mobiles, Stabiles, Constellations*. Exhibition catalogue. Paris: Galerie Louis Carré, 1946.

Sims, Patterson. *Alexander Calder: A Concentration of Works from the Permanent Collection of the Whitney Museum of American Art*. Exhibition catalogue. New York: Whitney Museum of American Art, 1981.

Sweeney, James Johnson. *Alexander Calder*. Exhibition catalogue. New York: Museum of Modern Art, 1943; 2nd ed. with bibliography, 1951.

Alexander Calder: Sculpture/Mobiles, exhibition catalogue. London: Tate Gallery, 1962.

Alexander Calder: Circus Drawings, Wire Sculptures and Toys. Exhibition catalogue. Houston: Museum of Fine Arts, 1964.

Calder, l'Artiste et l'Oeuvre. Paris: Archives Maeght, 1971.

PERIODICALS, BOOKS, AND GROUP-EXHIBITION CATALOGUES

Andersen, Wayne V. "Calder at the Guggenheim." *Artforum* 3 (March 1965): 37–41.

Berthelot, Pierre. "Alexander Calder." *Beaux-Arts* 9 (May 1931): 24.

Bruguière, P. G. "L'Objet-mobile de Calder." *Cahiers d'Art* 29 (1954): 221–8.

Buffet-Picabia, Gabrielle. "Alexander Calder, ou le Roi de Fil der Fer." *Vetigral* 1 (1932): 1.

 "Sandy Calder, Forgeron Lunaire." *Cahiers d'Art* 20–21 (1945/1946): 324–33.

Canaday, John. "Mobile Visit with Alexander Calder." *New York Times Magazine* (March 25, 1962): 32–33.

Coan, Ellen Stone. "The Mobiles of Alexander Calder." *Vassar Journal of Undergraduate Studies* 15 (May 1942): 1–19.

Davidson, Jean. "Four Calders." *Art in America* 50 (Winter 1962): 68–73.

Derrière le Miroir 31 (July 1950): 1–8. Includes James Johnson Sweeney, "Les Mobiles d'Alexander Calder"; Henri Laugier, "Calder le Constructeur"; Henri Hoppenot, "Ces Météores tombés du ciel"; and Fernand Léger, "Calder."

 69–70 (October–November 1954). Includes Frank Elgar, "Calder."

 113 (1959). Includes George Salles, "Stabiles," and Jean Davidson, "Le luron aux protégé-genoux."

 141 (November 1963). Includes James Jones, "L'Ombre de l'avenir," and Michel Ragon, "Qu'est-ce qu'un Calder?"

 156 (February 1966). Includes Alexander Calder, "De l'Art Students League aux Totems"; Meyer Shapiro, "Alexander Calder"; J. Prévert, "Oiseleur du fer"; and Nicholas Guppy, "Les Gouaches de Calder."

 173 (October 1968). Includes Giovanni Carandente, "Un géant enfant," and Jacques Dupin, "Notes sur les Flèches."

 190 (February 1971). Includes Carlos Franqui, "Calder la liberté."

 201 (January 1973). Includes Maurice Besset, "Ratour au mobile," and Andre Balthazar, "Calder ou le poids de l'air."

 212 (January 1975). Includes Mario Pedrosa, "Un tournant chez Calder."

 221 (December 1976). Includes Jean Frémon, "L'art et la comédie," and Jean Davidson, "Forme Humaine."

 248 (October 1981). Includes manuscript letters from Calder to Galerie Maeght.

Descarques, Pierre. "Calder entre Ciel et Terre." *XXe siècle* 33 (December 1971): 3–19.

[Drexler, Arthur]. "Calder." *Interiors* 109 (December 1949): 80–7.

Fréjaville, Gustave. "Les Poupées Acrobats du Cirque Calder." *Comoedia* (April 24, 1929).

Gasser, Helmi. "Alexander Calder." *Werk* 46 (December 1959): 444–50.

Gaussin, Yvon. "On Remplace le Crayon at la Couleur par Fil de Fer." *La Rumeur* (January 30, 1929).

George, Waldemar. "Sculptures de Calder." *La Presse* (February 14, 1929).

Goldin, Amy. "Alexander Calder" [obituary]. *Art in America* 65 (March 1977): 70–3.

Gray, Cleve. "Calder's Circus." *Art in America* 52 (October 1964): 23–48.

Guppy, Nicholas. "Alexander Calder." *Atlantic* 214 (December 1964): 53–60.

Haskell, Douglass. "Design in Industry, or Art as a Toy." *Creative Art* 4 (February 1929): 16–17.

Hawes, Elizabeth. "More than Modern – Wiry Art." *Charm* (April 1928): 46, 68.

Hayes, Bonnie. "Alexander Calder's *Pittsburgh*, 1958/1979." *Carnegie Magazine* 53 (October 1979): 12–19.

Hellman, Geoffrey. "Everything Is Mobile." *New Yorker* (October 4, 1971): 25–30.

"Calder Revisited." *New Yorker* (October 22, 1960): 163–78.

Hobhouse, Janet. "Witty, Inventive Anti-monumental *Universe* of Alexander Calder." *Artnews* 75 (December 1976): 38–41.

Hochfield, Sylvia. "Goodbye *Hello Girls!*" *Artnews* 77 (January 1978): 42.

Howard, Jane. "Close-up: Mobile Maker's Giddy Whirl." *Life* (March 5, 1965): 47–52.

Jakovski, Anatole. "Alexander Calder." *Cahiers d' Art* 8 (1933): 244–6.

Six essais: Arp, Calder, Hélion, Miró, Pevsner, Seligmann. Paris: Jacques Povolozky, 1933.

Janis, Harriet. "Mobiles." *Art and Architecture* 65 (February 1948): 26–8, 56–8.

Jouffrey, Alain. "Les Tapisseries de Calder: La sublimation de la simplicité." *XXe siècle* 47 (December 1976): 47–51.

Kepes, Gyorgy, ed. *The Nature and Art of Motion.* New York: Braziller, 1965.

Kramer, Hilton. "Alexander Calder." *New York Times Magazine* (October 17, 1976): 70–5.

Lelong, Daniel. "Calder: Comment Pieger le Mouvement?" *Beaux-Arts* 4 (July–August 1983): 48–55, 96.

Lemon, Richard. "Mobiles: The Soaring Art of Alexander Calder." *Saturday Evening Post* (February 27, 1965): 30–5.

Levy, Julien. *Memoir of an Art Gallery.* New York: Putnam, 1977.

Liebmann, Lisa. "Sun Rising in Calder." *Artforum* 25 (November 1986): 122–8.

Marter, Joan M. "Alexander Calder: Ambitious Young Sculptor of the 1930s." *Archives of American Art Journal* 16 (1976): 2–8.

"Alexander Calder at the Art Students League." *American Art Review* 4 (May 1978): 54–61, 117–18.

"Alexander Calder: Cosmic Imagery and the Use of Scientific Instruments." *Arts Magazine* 53 (October 1978): 108–13.

"Alexander Calder's Stabiles: Monumental Public Sculpture in America." *American Art Journal* 11 (July 1979): 75–85.

"Interaction of American Sculptors with European Modernists: Alexander Calder and Isamu Noguchi." In *Vanguard American Sculpture 1913–1939*. Exhibition catalogue. New Brunswick, N.J.: Rutgers University Art Gallery, 1979.

"Constructivism in America: The 1930s." *Arts Magazine* 56 (June 1982): 73–80.

"Alexander Calder." In *Beyond the Plane: American Constructions 1930–1965*. Exhibition catalogue. Trenton: New Jersey State Museum, 1983.

"Alexander Calder." In *Abstract Painting and Sculpture in America 1927–1944*, edited by John R. Lane and Susan Larsen. New York: Abrams, 1983.

Masson, André. "L'Atelier de Calder." *Cahiers d'Art* 24 (1949): 274–5.

Mitgang, Herbert. "Alexander Calder at 75: Adventures of a Free Man." *Artnews* 72 (Summer 1973): 54–8.

Morgan, Ted. "A Visit to Calder Kingdom." *New York Times Magazine* (July 8, 1973): 10–11, 29–31.

Nicholson, Ben. *The Sculpture of This Century*. New York: Braziller, 1960.

Parinaud, A. "Calder ou le Génie du Mouvement." *Galerie Jardin des Arts* 145 (March 1975): 61–5.

Pincus-Witten, Robert. "Entries: Childe Sandy in Italy." *Arts Magazine* 58 (December 1983): 70–3.

Popper, Frank. *Origins and Development of Kinetic Art*. Greenwich, Conn.: New York Graphic Society, 1968.

Prévert, Jacques. "Couleurs de Calder." In *Couleurs de Braque, Calder, Miró*. Paris: Maeght, 1981.

Rickey, George. "Calder in London." *Arts Magazine* 36 (September 1962): 22–7.

Constructivism: Origins and Evolution. New York: Braziller, 1967.

Ritchie, Andrew Carnduff. *Abstract Painting and Sculpture in America*. Exhibition catalogue. New York: Museum of Modern Art, 1951.

Rose, Barbara. "Joy, Excitement Keynote Calder's Work." *Canadian Art* 22 (May–June 1965): 30–3.

Rose, Diana. "Calder's *Pittsburgh*: A Violated and Immobile Mobile." *Artnews* 77 (January 1978): 38–42.

Russell, John. "Alexander Calder, leading U.S. artist, dies." *New York Times* (12 November 1976): 1, D14.

Sartre, Jean-Paul. "Des Mobiles." *Style en France* 5 April 15, 1947): 7–11.

Sartre, Jean-Paul. "Existentialist on Mobilist," *Artnews* 46 (December 1947): 22; 55–6.

Sweeney, James Johnson. "Alexander Calder." *Axis* 3 (July 1935): 19–21.

"Alexander Calder: Movement as a Plastic Element." *Architectural Forum* 70 (February 1939): 144–9.

"The Position of Alexander Calder." *Magazine of Art* 37 (May 1944): 180–3.

"Alexander Calder: Work and Play." *Art in America* 44 (Winter 1956–7): 8–13.

Szittya, Emil. "Alexander Calder." *Kunstblatt* 13 (June 1929): 185–6.

Tuchman, Phyllis. "Alexander Calder's Almadén Mercury Fountain." *Marsyas* 16 (1972–3): 97–107.

Wolfe, Ruth. "Calder's 'Ballet Without Dancers'." *Artnews* 77 (February 1978): 108–109.

FILMS

Alexander Calder. 1929. Directed by Dr. Hans Cürlis; filmed by Walter Turck.

Alexander Calder: Sculpture and Constructions. 1944. Written and narrated by Agnes Rindge; filmed by Herbert Matter; produced by the Museum of Modern Art.

Alexander Calder: From the Circus to the Moon. 1963. Produced by Hans Richter. New York: McGraw-Hill Films.

Alexander Calder: The Creation of a Stabile. 1967. Directed by D. G. Hannaford. New York: International Nickel Co.

Calder: un Portrait. 1972. Charles Chaboud with Daniel Lelong; music adapted from scores by Edgard Varèse; produced by Aimé Maeght, Paris.

Calder's Universe. 1977. Directed and produced by Paul Falkenberg and Hans Namuth; narration by Louisa Calder, Tom Armstrong, and John Russell. New York: Museum of Modern Art.

Cirque Calder. 1961. Directed by Carlos Vilardebo. Paris: Pathé Cinema.

Dreams That Money Can Buy. 1948. Directed and produced by Hans Richter.

Les Gouaches de Sandy. 1973. Directed by Carlos Vilardebo. Paris: Pathé Cinema.

The Great Sail. 1966. Directed by Robert Gardner. New York: Phoenix Films.

Mobiles. 1966. Directed by Carlos Vilardebo. Paris: Pathé Cinema.

Works of Calder. 1950. Produced and narrated by Burgess Meredith; photographed and directed by Herbert Matter; music by John Cage. New York: Museum of Modern Art.

Alexander Calder: The Creation of a *Stabile*, 1967. International Nickel Company, New York.

Unpublished Material

Alexander Calder Papers. Archives of American Art, Smithsonian Institution, Washington, D.C.

Alexander Calder files. Museum of Modern Art, New York.

Alexander Calder files. Musée National d'Art Moderne, Paris.

Alexander Calder files. Whitney Museum of American Art, New York.

Index

Photographic and Literary Credits

PHOTOGRAPHIC CREDITS

E. Irving Blomstrann, New Britain, Conn. (109)
Edward J. Bonner, Upper Darby, Pa. (167)
Photographie Bulloz, Paris (164)
Geoffrey Clements, Staten Island, N.Y. (36, 38, 56, 61, 69, 83, 86, 148)
Pedro E. Guerrero, New Caanan, Conn. (115, 127, 151, 152, 156, 160, 166)
Bartlett Hendricks, Williamstown, Mass. (78, 93, 129, 130)
Ruth Hollos-Consemuller (121)
Peter A. Juley & Son, New York, N.Y. (Frontispiece, 24, 25, 51, 54, 94, 96)
Robert E. Mates, New York, N.Y. (29, 40, 100, 138, 141, 144)
Herbert Matter (97, 131, 133)
Eric Pollitzer, Hempstead, N.Y. (15)
Oliver Raker Associates, Inc., New York, N.Y. (19)
Charles Uht (143)
A. J. Wyatt, Staff Photographer, Philadelphia Museum of Art (5, 72)

Figure 36, *Calder's Circus*, 1926–31, was purchased with funds from a public fundraising campaign in May 1982. One half the funds were contributed by the Robert Wood Johnson Jr. Charitable Trust. Additional major donations were given by the Lauder Foundation; the Robert Lehman Foundations, Inc.; the Howard and Jean Lipman Foundation, Inc.; an anonymous donor; The T. M. Evans Foundation, Inc.; Mac-Andrews & Forbes Group, Inc.; The De Witt Wallace Fund; Martin and Agneta Gruss; Anne Phillips; Mr. and Mrs. Laurence S. Rockefeller; the Simon Foundation, Inc.; Marylou Whitney; Bankers Trust Company; Mr. and Mrs. Kenneth N. Dayton; Joel and Anne Ehrenkranz; Irvin and Kenneth Field; Flora Whitney Miller. More than 500 individuals from 26 states and abroad also contributed to the campaign.

LITERARY CREDITS

Quotations on pages 10, 12–13, 14, 27–8, 103, 127, 212, and 221 are reprinted from *Calder: An Autobiography with Pictures* by Alexander Calder and Jean Davidson by permission of Pantheon Books, a division of Random House, Inc. Copyright © 1966 by Alexander Calder and Jean Davidson.